"In this wonderfully bold and speculative anthology of writings, artists and critics offer a highly persuasive set of arguments and pleas for imaginative, socially responsible, and socially responsive public art. *Mapping the Terrain*'s wide-ranging compendium broadens the discourse even further with its short accounts of over ninety artists working in this remapped genre. Edited by artist-theorist Suzanne Lacy, this book will prove as valuable to art and cultural historians and critics as it will be to public policy makers, students, and a diverse 'public' audience."
—MOIRA ROTH, MILLS COLLEGE

"*Mapping the Terrain* is essential reading for anyone who wants to understand the complexities of public art today. Artists working outside traditional venues have employed art-making strategies that are more akin to social activism and politics than to the creation and distribution of art objects. This socially engaged art has disrupted art criticism, compelling artists and critics to reexamine the theoretical language that informs the work and provides a basis for its evaluation. . . . While providing a clear overview of the historical origins of socially engaged art, this book initiates a much needed dialogue—building a critical language that better reflects the complexities confronting artists, curators, and critics within this dynamic field."
—JAMES CLARK, EXECUTIVE DIRECTOR, PUBLIC ART FUND INC.

"In the past twenty years a flood of art for public spaces has been created, yet there remains considerable tension between 'public' and 'art.' *Mapping the Terrain* contains an important group of essays that draw our attention to new models of engagement with place and audience. Energized by ideas and experiences in performance art, community art, installation, social history, and urban planning, artists are creating an invigorating new public art that imbues daily life with meaning and significance."
—RICHARD ANDREWS, DIRECTOR, HENRY ART GALLERY,
 UNIVERSITY OF WASHINGTON

MAPPING THE TERRAIN

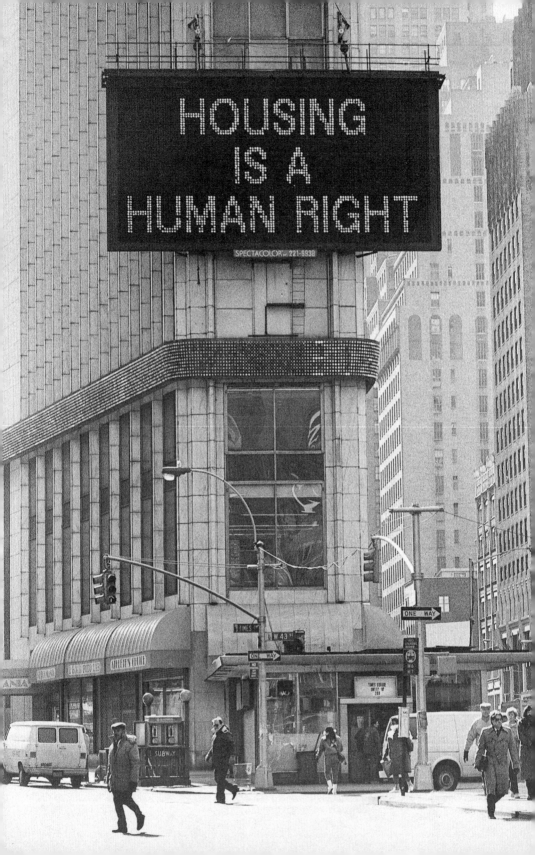

MAPPING THE TERRAIN

New Genre Public Art

Edited by Suzanne Lacy

Bay Press

Seattle, Washington

Printed in the United States of America.

First Printing 1995

Second Printing 1996

Bay Press

115 West Denny Way

Seattle, Washington 98119

Library of Congress Cataloging-in-Publication Data

Mapping the terrain: new genre public art / edited by Suzanne Lacy.

 p. cm.

 Includes illustrated compendium of artists and their works.

 ISBN 0–941920–30–5

 1. Arts—Political aspects. 2. Politics in art. 3. Social problems in art. 4. Performance art. 5. Artists and community. 6. Arts, Modern—20th century. 7. Artists—Biography—History and criticism. I. Lacy, Suzanne. II. Title: New genre public art.

NX650.P6M36 1995

700' .1'03—dc20

 94-35417

 CIP

Edited by Patricia Draher

Designed by The Office of Michael Manwaring

Set in Stempel Garamond and Gill Sans

Cover design by Michael Manwaring; cover text by Estella Conwill Májozo; photo by Gail Smithwalter

FRONTISPIECE: Martha Rosler, *Housing Is a Human Right,* 1989, Messages to the Public program, Public Art Fund

FACING PAGE: Kate Ericson and Mel Ziegler, *Loaded Text,* 1989

PAGE 10: dominique gw mazeaud, *The Great Cleansing of the Rio Grande,* 1987–continuing

PAGE 18: Joseph Beuys, *Coyote: I Like America and America Likes Me,* 1974

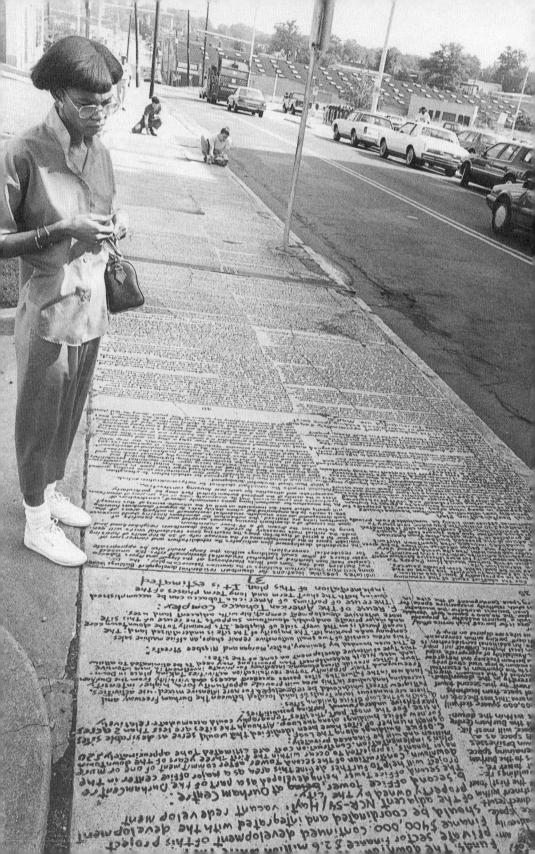

CONTENTS

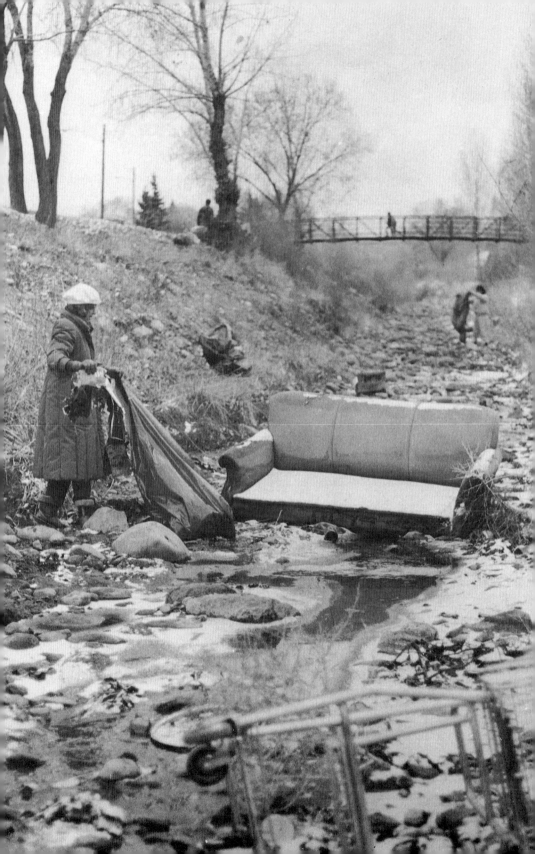

Whenever art introduces radically different working methods and challenges reigning tenets, the critical task is complicated. With this book the other authors and I hope to make concrete a discourse that, while part of a thirty-year history, is reinvigorated today by the idealism of young artists and students. The tremendous recent interest in engaged, caring public art demands a context in art history and present criticism. It demands as well the guidance of predecessors who can pass on strategies that allow the wheel to move forward, not suffer endless reinvention.

Like the work it attempts to explain, the approach we have chosen is consciously collaborative. None of us own these ideas. They have grown out of a complicated history over three decades. The writers were selected because of their understanding of various aspects of that history. Rather than simply collect individually written essays into a whole, we have deliberately set out to divide and examine new genre public art from various perspectives.

The idea for the book arose from a program called "City Sites: Artists and Urban Strategies," sponsored in 1989 by the California College of Arts and Crafts.[1] A series of lectures was delivered at nontraditional sites in Oakland by ten artists whose work addressed a particular constituency on specific issues but also stood as a prototype for a wider range of human concerns. The artists discussed their work and the strategies they had developed for reaching audiences. They spoke from locations directly linked to their community or subject matter—from homeless shelters, Spanish-language community libraries, churches, maintenance garages for city workers, convalescent homes, elementary schools, and nightclubs. Those who attended included not only students and arts professionals but people from a wide range of backgrounds who had a special interest in the subject matter of these artists.

In addition to lecturing, the artists took part in special events they had designed, such as programs for senior citizens, workshops on waste disposal, and a Happening with ninety fourth-graders. Artists from Oakland mentored students in a class at the California College of Arts and Crafts held in tandem with the public series; these students developed proposals for their own interactive artworks. Local newspapers ran articles that explored the social issues taken up by the visiting lecturers. The "City Sites" series was itself a model for new genre public art—socially engaged, interactive art for diverse audiences—as it featured mass media, education, and the identification and development of specific constituencies.

The purpose of the program was to speculate on the connections between the ten artists. If a new direction in public art was indeed taking shape—and the work itself as well as several recent articles and curatorial projects seemed to suggest this—then the next question was whether current criticism provided an appropriate context in which to consider this work. The California College of Arts and Crafts and the Headlands Center for the Arts sponsored a public symposium at the San Francisco Museum of Modern Art and a three-day retreat for thirty critics, curators, and artists.[2] During the symposium, entitled "Mapping the Terrain: New Genre Public Art," the participants considered issues including the need to develop a critical language that would identify and evaluate this work, uniting its political and aesthetic aspirations.

Interestingly, until recently such artists have not been linked to each other in the critical discourse. They have been examined within their artistic disciplines—performance, video, installation, photography, or murals, for example—or seen as isolated and idiosyncratic examples. If they are contextualized at all it is as socially conscious or political artists, more or less in vogue depending upon the currency of their subject matter; that is, the unifying characteristics have been seen as subject-specific. The structural models and underlying assumptions of their works are specific to their topics and personal styles, to be sure, yet there are major points of unity that this book sets out to explore.

At the "Mapping the Terrain" retreat those helping to develop this book listed issues that could be covered, and suggested other writers who,

unable to be present, were nevertheless very much a part of the conversation about new genre public art. At least once during the process of drafting their essays, before the final rewrite, the authors were able to read and respond to each other's manuscripts. The writers were directed away from reviewing or describing individual artists and toward considering questions and theory, but all played a role in suggesting the artists whose works are included in the compendium of this book. Readers can thus make their own connections between the overviews and speculations within the essays and the actual examples of artworks.

Although nearly ninety artists are included in the compendium, no doubt many whose works might illustrate these discussions were missed, and for this we who made the final decisions apologize. The artists selected do fit several criteria: they have been practicing within this genre of public art for years, many for over two decades, so that their work has a developed, mature, and often distinct language. They have engaged broad, layered, or atypical audiences, and they imply or state ideas about social change and interaction. Most important, the artists selected provide different models of practice and ideology.

In considering whom to include, we realized that not all the work met our criteria equally. We opted to include more rather than fewer examples. The boundaries of this choice were in keeping with the newness of the genre as well as the critical writing about it. This area of art making is still too tentative to condense the field of inquiry. Instead, the examples are meant as a reference, and the reader is invited to join with the writers in considering the connections and differences encompassed by the work.

Of necessity, the essays in this book are speculative, but they mean to redress current deficiencies in thinking about public art and to point out possible criteria for the assessment of new genre public art. This collection thus is not doctrinaire but associative in nature, and its scope is intended to respond to the scope entertained by the artists themselves. As Houston Conwill and Estella Conwill Májozo expressed it during the "Mapping the Terrain" symposium, "We create maps of language that represent cultural pilgrimages and metaphoric journeys of transformation and empowerment."

—*Suzanne Lacy*

NOTES

1. "City Sites: Artists and Urban Strategies" (March–May 1989) included artists Marie Johnson-Calloway, Newton and Helen Mayer Harrison, Adrian Piper, John Malpede, Mierle Laderman Ukeles, Judith Baca, Allan Kaprow, Lynn Hershman, and Suzanne Lacy. Sponsored by the California College of Arts and Crafts in collaboration with the Oakland Arts Council, it was funded by the National Endowment for the Arts (NEA) and the California Arts Council.

2. "Mapping the Terrain: New Genre Public Art" (November 1991) was sponsored by the California College of Arts and Crafts and the Headlands Center for the Arts and funded by the Rockefeller Foundation, the Gerbode Foundation, the NEA, the Napa Contemporary Arts Foundation, and the education department of the San Francisco Museum of Modern Art.

"Mapping the Terrain" was also the title of a panel at the College Art Association Conference in February 1992. Cochaired by Leonard Hunter and Suzanne Lacy, the conference included panelists Suzi Gablik, Richard Bolton, Guillermo Gómez-Peña, Daryl Chin, Mary Jane Jacob, and Patricia Phillips.

ACKNOWLEDGMENTS

As editor, I wish to thank those writers and artists, most of whom have works included in this book, who are my brother and sister travelers on the road of relevant art. Rather than list them by name, I refer you to the compendium and the essays themselves. I am particularly indebted to the writers of these essays, who waited patiently for me to attend to this book project and remained my friends. Susan Leibovitz Steinman deserves acknowledgment for her good humor as she tirelessly tracked down the many contemporary artists, assisted by Judith Blankman and Karen Sakahara. Zánte River, as usual, has been a key support in this as well as many other writing projects. Most enthusiastically I acknowledge the publishers, Sally Brunsman and Kimberly Barnett, and the editor, Patricia Draher, for their cheerful dedication to this book. By rights I should also thank Oliveto Cafe and Restaurant in Oakland, my office away from home.

The California College of Arts and Crafts and its enlightened administration—particularly Neil Hoffman, Lorne Buchman, John Stein, and Mark Denton—created an institutional home for this project. The Irish Museum of Modern Art, through the kindness of its director, Declan McGonagle, was another such home during the first-draft stages while I was in Ireland for a fellowship from the Lila Wallace–Reader's Digest Arts International Artists Program, developed and managed by Arts International/IIE with the support of the Lila Wallace–Reader's Digest Fund. In addition, I am grateful to the Rockefeller Foundation, Alberta Arthurs, Suzanne Sato, and Tomás Ybarra-Frausto for early and primary support of the "Mapping the Terrain" retreat and this book.

The staff of the Visual Arts Program at the National Endowment for the Arts, particularly Bert Kubli and Michael Faubian, encouraged me at various stages of the project. Leonard Hunter and Jennifer Dowley were involved from the beginning, and our long conversations as we planned the

retreat gave birth to this book. Deborah Kirshman and Celeste Connor helped it on its way, as have conversations, carried on over twenty years, with Judith Baca, Lynn Hershman, Leslie Labowitz, Lucy Lippard, Moira Roth, Sheila Levrant de Bretteville, Arlene Raven, Mary Jane Jacob, and many others, including David Antin, Eleanor Antin, Conrad Atkinson, Newton and Helen Mayer Harrison, Margaret Harrison, John Malpede, Adrian Piper, Martha Rosler, Rachel Rosenthal, Barbara Smith, and Mierle Laderman Ukeles. Most important to me are the many invisible communities whose courage, presence, and persistence have inspired my work over the years, those who suffer various forms of discrimination, violence, and injustice.

Finally, I want to especially acknowledge my debt to my teachers Judy Chicago and Allan Kaprow, profoundly public artists who go by many other names. Allan's enthusiasm for and curiosity about the blurred boundary between art and life, and Judy's passionate articulation of art in the service of change, challenged and expanded our notion of audience. Their work and ideas will eventually prove to be among the most influential for new genre public art.

—*Suzanne Lacy*

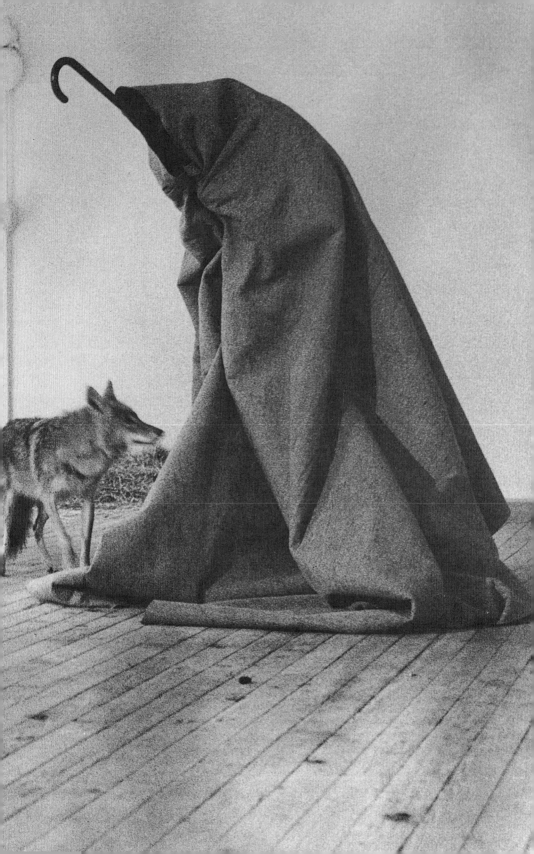

CULTURAL PILGRIMAGES AND METAPHORIC JOURNEYS ⎬ *Suzanne Lacy*

Artists and writers throughout the continent are currently involved in a . . .
redefinition of our continental topography. We imagine either a map of the
Americas without borders, a map turned upside down, or one in which . . .
borders are organically drawn by geography, culture, and immigration, not
by the capricious fingers of economic domination.

—*Guillermo Gómez-Peña*

For the past three or so decades visual artists of varying backgrounds and
perspectives have been working in a manner that resembles political and
social activity but is distinguished by its aesthetic sensibility. Dealing with
some of the most profound issues of our time—toxic waste, race relations,
homelessness, aging, gang warfare, and cultural identity—a group of visual
artists has developed distinct models for an art whose public strategies of
engagement are an important part of its aesthetic language. The source of
these artworks' structure is not exclusively visual or political information,
but rather an internal necessity perceived by the artist in collaboration
with his or her audience.

We might describe this as "new genre public art," to distinguish
it in both form and intention from what has been called "public art"—a
term used for the past twenty-five years to describe sculpture and installa-
tions sited in public places. Unlike much of what has heretofore been called
public art, new genre public art—visual art that uses both traditional and
nontraditional media to communicate and interact with a broad and diver-
sified audience about issues directly relevant to their lives—is based on
engagement. (As artist Jo Hanson suggests, "Much of what has been called
public art might better be defined as private indulgence. Inherently public
art is social intervention.")[1] The term "new genre" has been used since the

describe art that departs from traditional boundaries of media.

lly painting, sculpture, or film, for example, new genre art

e combinations of different media. Installations, performances, conceptual art, and mixed-media art, for example, fall into the new genre category, a catchall term for experimentation in both form and content. Attacking boundaries, new genre *public* artists draw on ideas from vanguard forms, but they add a developed sensibility about audience, social strategy, and effectiveness that is unique to visual art as we know it today.

Although not often included in discussions about public art, such artists adopt "public" as their operative concept and quest. According to critic Patricia C. Phillips, "In spite of the many signs of retreat and withdrawal, most people remain in need of and even desirous of an invigorated, active idea of public. But what the contemporary polis will be is inconclusive." This indeterminacy has developed as a major theme in new genre public art. The nature of audience—in traditional art taken to be just about everyone—is now being rigorously investigated in practice and theory. Is "public" a qualifying description of place, ownership, or access? Is it a subject, or a characteristic of the particular audience? Does it explain the intentions of the artist or the interests of the audience? The inclusion of the public connects theories of art to the broader population: what exists in the space between the words public and art is an unknown relationship between artist and audience, a relationship that may *itself* become the artwork.

Whether or not this work is "art" may be the central question to some. Modernist assumptions about art's necessary disengagement from "the masses" die hard, although multiple examples during the past twenty or more years imply deep interaction between "high art" and popular culture. During the seventies, for instance, Lowell Darling ran for governor of the state of California, in a performance that won him almost sixty thousand votes in the primaries. At the same time Judith F. Baca intervened in gang warfare in East Los Angeles with her mural project *Mi Abuelita*. Appropriated, performative, conceptual, transient, and even interactive art are all accepted by art world critics as long as there appears to be no real possibility of social change. The underlying aversion to art that claims to

"do" something, that does not subordinate function to craft, presents a resonant dilemma for new genre public artists. That their work intends to affect and transform is taken by its detractors as evidence that it is not art. As we will see in this book, however, the issues raised by this work are much more profound for the field of art than such reductivism implies.

ALTERNATIVE CARTOGRAPHY: PUBLIC ART'S HISTORIES

Depending on how one begins the record, public art has a history as ancient as cave painting or as recent as the Art in Public Places Program of the National Endowment for the Arts. While no overview has been agreed upon yet, a quasi-official history of recent public art in the United States can be tracked through commissions, distribution of percent-for-art moneys, articles, conferences, and panel discussions. But with history as well as maps, the construction of meaning depends on who is doing the making.

Art in Public Places

One version of history, then, begins with the demise of what Judith Baca calls the "cannon in the park" idea of public art—the display of sculptures glorifying a version of national history that excluded large segments of the population. The cannon in the park was encroached upon by the world of high art in the sixties, when the outdoors, particularly in urban areas, came to be seen as a potential new exhibition space for art previously found in galleries, museums, and private collections. In the most cynical view, the impetus was to expand the market for sculpture, and this included patronage from corporations. The ability of art to enhance public spaces such as plazas, parks, and corporate headquarters was quickly recognized as a way to revitalize inner cities, which were beginning to collapse under the burden of increasing social problems. Art in public places was seen as a means of reclaiming and humanizing the urban environment.

For all intents and purposes, the contemporary activity in public art dates from the establishment of the Art in Public Places Program at the National Endowment for the Arts in 1967 and the subsequent formation of state and city percent-for-art programs.[2] Governmental funding seemed

to promise democratic participation and to promote public rather than private interests. These goals were nominally achieved by selection panels of arts and civic representatives appointed by the mayor, who, "as the representative of all the people," was initially enlisted to authorize NEA applications. The late sixties and early seventies were the era of the civic art collection that related more to art history than to city or cultural history, and which fulfilled the NEA goal "to give the public access to the best art of our time outside museum walls." These works, which were commissioned from maquettes and closely resembled smaller-scale versions in collections, moved the private viewing experience of the museum outdoors. Festivals, rallies, or other plaza gatherings were supplemental to the art, but were not communal activities integral to it. Because these works were art monuments indicative of the author's personal manner of working, not cultural monuments symbolic of contemporary society, the ensuing public debate centered on artistic style (e.g., abstract versus figurative art) rather than on public values.

Throughout the seventies administrators and arts activists lobbied for percent-for-art programs, and these, combined with NEA grants and private sector money, fueled public art. The size of commissions created a viable alternative to the gallery system for some artists. In time, and partly because of the pressure to explain the work to an increasingly demanding public, a new breed of arts administrator emerged to smooth the way between artists, trained in modernist strategies of individualism and innovation, and the various representatives of the public sector. Collaboration with other professionals, research, and consultative interaction with civic groups and communities became more common, and teams of artists, architects, designers, and administrators were formed. Except in unusual circumstances, the full creative and cooperative potential of such teams rarely materialized.

More commissions and scrutiny brought further bureaucratization in what curator Patricia Fuller has identified as "the public art establishment . . . [with] an increasing tendency toward complication and rigidification of processes, the codification of a genre called public art, [and] ideas of professionalism which admit artists and administrators to the

fraternity. This all seems to have created an apparatus which can only be justified by the creation of permanent objects."

According to Fuller, early in the seventies some artists and administrators in the field began to differentiate between "public art"—a sculpture in a public space—and "art in public places," a focus on the location or space for the art. Beginning in 1974, the NEA stressed that the work should also be "appropriate to the immediate site," and by 1978 applicants were encouraged "to approach creatively the wide range of possibilities for art in public situations."[3] The NEA encouraged proposals that integrated art into the site and that moved beyond the monumental steel object-off-the-pedestal to adopt any permanent media, including earthworks, environmental art, and nontraditional media such as artificial lights.

Some artists saw public art as an opportunity to command the entire canvas, as it were, to allow them to operate with a singular and uncompromised vision. Site-specific art, as such art in public places began to be called, was commissioned and designed for a particular space, taking into account the physical and visual qualities of the site. As site became a key element in public art, the mechanisms by which works were commissioned also required revision.[4] Therefore, in the eighties the NEA tried to promote the artist's direct participation in the choice and planning of the site. By 1982 the Visual Arts and Design programs had joined forces to encourage "the interaction of visual artists and design professionals through the exploration and development of new collaborative models."

Scott Burton, one of the most recognized public artists in this period, believed that "what architecture or design or public art have in common is their social function or content. . . . Probably the culminating form of public art will be some kind of social planning, just as earthworks are leading us to a new notion of art as landscape architecture."[5] Eventually, as the practice matured, artists turned their attention to the historical, ecological, and sociological aspects of the site, although usually only metaphorically, and without engaging audiences in a way markedly different from in a museum.

By the late eighties public art had become a recognizable field. Conferences were held, and a small body of literature, dealing for the most

part with bureaucratic and administrative issues, considered the complexities of the interface between visual artists and the public.[6] NEA guidelines of 1979 had called for a demonstration of "methods to insure an informed community response to the project."[7] This directive was extended in 1983 to include planning activities "to educate and prepare the community" and "plans for community involvement, preparation, and dialogue." By the beginning of the nineties, the NEA encouraged "educational activities which invite community involvement."[8]

At the same time, the economic downturn, deepening urban troubles, and a new distrust of art led to attacks on public art and its funding sources. Provocative situations marked the last years of the eighties, most notably the controversy surrounding Richard Serra's *Tilted Arc*, when office workers' demands to remove the sculpture from its site in a civic plaza led to calls for greater public accountability by artists. As the conventions of artistic expression continued to come into conflict with public opinion, the presentation of an artist's plans to community groups became de rigueur. This in turn compelled a greater reliance on the intermediary skills of the public arts administrator, since social interaction was neither the forte nor the particular aesthetic interest of many established public artists. Thus skills were differentiated, and artists were able to maintain an aesthetic stance apart from notions of public education.

From the beginning, public art has been nurtured by its association with various institutions and, by extension, the art market. Although the move to exhibit art in public places was a progressive one, the majority of artists accommodated themselves to the established museum system, continuing to focus their attention on art critics and museum-going connoisseurs. The didactic aspects of art were relegated to the museum education department. "What too many artists did was to parachute into a place and displace it with art," comments Jeff Kelley. "Site specificity was really more like the imposition of a kind of disembodied museum zone onto what already had been very meaningful and present before that, which was the place."

In recent years, artists, administrators, and critics alike have looked at this progression from objects in museums, to objects in public places, to

site-specific installations and have framed present social and political artworks within the context of this essentially formalist movement. They have understood the emergence of collaborative notions in art as a reflection of "design teams," modeled after architectural practices. (Most public artists who developed within the preceding historical progression have worked closely with landscape architects, designers, and architects.) However, it is the premise of this book that an alternative reading of the history of the past thirty years results in a different interpretation of these same present concerns. Indeed, many of the artists listed in the compendium of this book had been working for years outside the purview of the accepted public art and art in public places narrative, dominated as it was by sculpture. Artists as diverse as Allan Kaprow, Anna Halprin, and Hans Haacke in the sixties and Lynn Hershman, Judy Chicago, Adrian Piper, and Judith Baca in the seventies were operating under different assumptions and aesthetic visions. Not easily classifiable within a discourse dominated by objects, their work was considered under other rubrics, such as political, performance, or media art; hence the broader implications for both art and society were unexplored by art criticism.

Art in the Public Interest[9]

An alternative history of today's public art could be read through the development of various vanguard groups, such as feminist, ethnic, Marxist, and media artists and other activists. They have a common interest in leftist politics, social activism, redefined audiences, relevance for communities (particularly marginalized ones), and collaborative methodology. By re-visioning history through the lens of these interests, rather than artistic media-specific concerns, we understand the present moment, new genre public art, and its implications for art making in a way that focuses our critical investigation.

We might begin in the late fifties, when artists challenged the conventions of galleries and museums through Happenings and other experiments with what was to become known as popular culture. Allan Kaprow has recounted his version of that history. The artists "appropriated the

real environment and not the studio, garbage and not fine paints and marble. They incorporated technologies that hadn't been used in art. They incorporated behavior, the weather, ecology, and political issues. In short, the dialogue moved from knowing more and more about what art was to wondering about what life was, the meaning of life."

Over the next decades popular culture, which included the media and its mass audience, became more attractive to artists. In the seventies artists such as Chris Burden, Ant Farm, Lowell Darling, Leslie Labowitz, and myself interrupted television broadcast programming with performances (Shu Lea Cheang later called them "media break-ins"). During the subsequent decade, media-related art was more analytic than activist, but the relative availability of media and its possibilities of scale encouraged artists to think more critically about audiences. The relationship between mass culture, media, and engaged art was recognized by Lynn Hershman: "The images and values of the culture that produces the [television] programs invade the subconscious cultural identity of its viewers. It's essential that the dialogue becomes two-way and interactive, respects and invites multiple points of view."

The connection between an activist view of culture and new genre public art had been forged during the Vietnam War protests of the late sixties by U.S. artists who were in turn influenced by political activists.[10] At the same moment, also drawing from the radical nature of the times, women artists on the West Coast, led by Judy Chicago, developed feminist art education programs.[11] Activist art grew out of the general militancy of the era, and identity politics was part of it. Women and ethnic artists began to consider their identities—key to the new political analysis—central to their aesthetic in some as yet undefined manner. Both groups began with a consciousness of their community of origin as their primary audience.

Ethnic artists such as Judith Baca worked in ghettos and barrios with specific constituencies, struggling to bring together their often highly developed art-school aesthetic with the aesthetics of their own cultures. Emphasizing their roles as communicators, these artists drew upon their heritage for an art language, such as public murals, that would speak to their people. Their work reflected this bridging of European and ethnic

cultures, and they became particularly adept at translation and cultural critique. Almost invariably this led to activism. According to Yolanda López, "In an era when the state has disintegrated to the degree where it can no longer attend to the needs of the people, artists who work in the community need to consciously develop organizing and critical skills among the people with whom they work." For this they were called "community artists," and critics refused to take their work seriously.

"The personal is political" was the koan of the feminist art movement, meaning that personal revelation, through art, could be a political tool. The seventies brought a high degree of visibility to women's issues. Feminist art, based in activism, grew out of a theoretical framework provided by Judy Chicago, the most visible feminist artist from that era, along with others including Miriam Schapiro, Arlene Raven, Sheila Levrant de Bretteville, Mary Beth Edelson, June Wayne, and Lucy Lippard. Chicago thought that the suppression of an empowered female identity through popular culture's misrepresentations could be counteracted by articulate identity constructions in art. In this way, art making was connected both to a broad public and to action.

Moving into the public sector through the use of public space, including the media, was inevitable for artists who sought to inform and change. Because of their activist origin, feminist artists were concerned with questions of effectiveness. They had fairly sophisticated conceptions of the nature of an expanded audience, including how to reach it, support its passage through new and often difficult material, and assess its transformation or change as a result of the work. Seeing art as a neutral meeting ground for people of different backgrounds, feminists in the seventies attempted artistic crossovers among races and classes. Collaboration was a valued practice of infinitely varying possibilities, one that highlighted the relational aspects of art. By the end of the seventies feminists had formulated precise activist strategies and aesthetic criteria for their art.

Though their art was not based in identity politics, other political artists were working during the seventies. Marxist artists in particular used photography and text to portray and analyze labor. They interacted with the audience by interviewing workers, constructing collective narratives,

and exhibiting those narratives within the labor community. Their analysis extended to a critique of art and its markets as well and was exhibited in museums and art magazines. For the most part, the theoretical aspects of this work were more developed than its activism until the mid-eighties, and while the work's analysis was comprehensive, it often didn't attempt actual change. Martha Rosler and Fred Lonidier, however, are among several whose work was interactive from the beginning.

Throughout the seventies, considerable but often unacknowledged exchange occurred among ethnic, feminist, and Marxist artists, particularly on the West Coast, making it difficult to attribute ideas to one group or another. That people were simultaneously members of more than one group also accounted for cross-influences. It is safe to say, however, that working during the same decade and within earshot of each other, these artists reached similar conclusions from different vantage points, and these conclusions about the nature of art as communication and the articulation of specific audiences form the basis for new genre public art.

Recent History: Calls to Action

This construction of a history of new genre public art is not built on a typology of materials, spaces, or artistic media, but rather on concepts of audience, relationship, communication, and political intention. It is my premise that the real heritage of the current moment in public art came from the discourses of largely marginalized artists. However visible the above cited "movements" were, they were not linked to each other, to a centralized art discourse, or to public art itself until the late eighties. Four factors conspired to narrow the distance between our two historical narratives and bring about an interest in a more public art.

First, increased racial discrimination and violence were part of the eighties conservative backlash. As immigration swelled the ranks of ethnic populations, their new political power and articulate spokespeople brought ethnicity to the attention, if not the agenda, of the U.S. public. The introduction of diversity raised profound questions about culture itself. Visual artists, participating in international artistic and literary ex-

changes, expressed the shifts in cultural expectations of people of color throughout the world. "What if," mused Guillermo Gómez-Peña, "our internationalism was no longer defined by New York, Paris, Berlin, or even Mexico City but . . . between San Antonio and Bangkok?" "The geographical is political" became the new koan of political artists.

A second factor in the political conservatism of the eighties and early nineties was the attempt to circumscribe the gains women had made during the previous decades. Antiabortion forces gathered momentum as an increasingly conservative Supreme Court threatened constitutional attacks on abortion rights. Several events, including Anita Hill's testimony on sexual harassment at the televised hearings for Clarence Thomas's Supreme Court nomination, reignited a national discussion of women's rights. In the nineties artists were once again working with issues of gender violence, echoing feminist artists of the seventies, but this time the makers included both men and women.

Not surprisingly, given the political climate, the end of the eighties saw an exercise in cultural censorship on a scale not known since the fifties. This third factor is closely linked to the first two. Censorship efforts of politicians in league with conservative fundamentalists targeted women, ethnic, and homosexual artists. The attacks made abundantly clear the connections between the rights of these social groups and those of artists in general, evoking an almost unilateral response from the art world. These attacks on publicly visible artworks, most of which were temporary or photographic (but also included Judy Chicago's *Dinner Party*), created a lasting and chilling influence on public art.

Finally, interest in new forms of public art was provoked by deepening health and ecological crises. Concerned about AIDS, pollution, and environmental destruction, artists began looking for strategies to raise awareness. Artists with AIDS brought the disease into the gallery, literally and figuratively, and AIDS activists staged street actions inspired by performance art of the sixties and seventies. Environmental crises were the subject of artworks in diverse media, including photo-texts, paintings, installations, and performances.

Although in theory new genre public art might be made by those at either end of the political spectrum, both the history of avant-garde forms upon which it draws and the social background of those attracted to its practice effectively position this work as liberal or radical. The issues just cited—opposition to racism, violence against women, censorship, AIDS, and ecological damage, for example—are as much a recounting of a traditional leftist agenda as they are the subject matter of new genre public art.

Within the ranks of the artists who have contributed to this alternative public art history are several who, having predicted the current social and aesthetic situation in their work, have created their own road maps. Concerned with issues of race, gender, sexuality, ecology, and urbanization, for twenty years in some cases, their theoretical perspectives and activist strategies were well developed. These artists, most of whom are included in the compendium, were quickly held up by members of the "official" public art establishment as models for a new form of public art. Unfortunately, this sporadic recognition and the failure to understand the history of these artists' concerns and influences have disassociated them from their radical heritage. This dismemberment has allowed us to continue along a critical "blind path" without coherent theories uniting aesthetic, personal, and political goals. This book, in attempting to reframe an extensive body of work, suggests that new genre public art is not only about subject matter, and not only about placement or site for art, but about the aesthetic expression of activated value systems. "The new public art is not so much a movement of the nineties, a new way of working, as a way of working that has found its time," reflects independent curator Mary Jane Jacob.

EXPLORING THE TERRITORY IN QUESTION

The stage is set. Enter the various players, each with a different history but with similar social concerns that lead to a unique and identifiable aesthetic language. This book attempts to throw a spotlight on the work of new genre public artists with the goal of developing a critical dialogue. The essays and the entries in the compendium provide a multivocal over-

view of the territory in question. From the discussion among artists and critics at the "Mapping the Terrain" retreat emerge the following related themes—of social analysis and artists' roles, responsibilities, and relationships with audiences—that may contribute to a formal language for this type of public art.

Social Analysis and Democratic Processes

We are living in a state of emergency. . . . Our lives are framed by a sinister kind of Bermuda Triangle, the parameters of which are AIDS, recession, and political violence. I feel that more than ever we must step outside of the strictly art arena. It is not enough to make art.

—*Guillermo Gómez-Peña*

References to the broader context of political and social life are never far from the works of new genre public artists. Their artworks reflect varying degrees of urgency, but all see the fate of the world as what is at stake. "I feel a great urgency in my own work to address the issues of our destruction and not to make works of art that keep our society dormant" (Juana Alicia, muralist). In one form or another, social theories are linked closely with the making of this art, and their expression is taken as the prerogative of the artist as well as of the curator and critic.

Some artists emphasize Otherness, marginalization, and oppression; others analyze the impact of technology. Some draw from the ecology movement or from theories of popular culture. As might be expected, feminist and racial politics are evident. Art's potential role in maintaining, enhancing, creating, and challenging privilege is an underlying theme. Power relationships are exposed in the very process of creating, from news making to art making. "We need to find ways not to educate audiences for art but to build structures that share the power inherent in making culture with as many people as possible. How can we change the disposition of exclusiveness that lies at the heart of cultural life in the United States?" (Lynn Sowder, independent curator).

Seeking consensus seems to be at the core of these artists' works. As critic and activist Lucy Lippard suggests, the Eurocentric view of the

world is crumbling: "Nothing that does not include the voices of people of color, women, lesbians, and gays can be considered inclusive, universal, or healing. To find the whole we must know and respect all the parts."

The idealism inherent in this work is reflected in an inclusive uniting of issues and concerns. As artists Estella Conwill Májozo and Houston Conwill stated in presenting their work with collaborator Joseph De Pace, "We . . . address issues of world peace, human rights, rights of the physically challenged, democracy, memory, cultural diversity, pro-choice, ecology, and caring . . . and the common enemies of war, hatred, racism, classism, censorship, drug addiction, ageism, apartheid, homophobia, hunger, poverty, joblessness, pollution, homelessness, AIDS, greed, imperialism, cross-cultural blindness, and fear of the Other." Given the litany of social ills that are the subjects of this work, there is remarkably little despair or cynicism. Optimism is a common response, although tempered with political realism.

One question such working modes generate is how to evaluate the artist's choice of subjects and social analysis. Is work that, for example, deconstructs media coverage of the "Desert Storm" war in Iraq automatically laudable because of its particular position on war, technology, or media? Is the sophistication of its analysis, in this case its media theory, a measurable aspect of the work?

Internal and External Transformation: The Artist's Responsibility

Implicit or explicit in the artists' references to a larger social agenda is their desire for a more connected role for artists. The distance placed between artists and the rest of society is part of their social critique. "What I find myself thinking about most these days is the isolation of artists from our culture. It seems that as society declines both economically and socially there's an even stronger need for the kind of humanism and creativity of artists' works. Paradoxically, artists are more spurned and discounted than ever" (Jennifer Dowley, director, Visual Arts Program, National Endowment for the Arts). The longing for a centralized position, however,

is often countered by the artist's conflicting desire to remain outside as a social critic.

"Public art in the Eurocentric cultures has served the value systems and the purposes of an unbroken history of patriarchal dominance that has despoiled the earth and its inhabitants and seriously threatens the future. Responsible social intervention must hold up a different image. It must advance other value systems" (Jo Hanson, public and installation artist). The question is, whose value systems? The definition of what constitutes beneficial intervention by artists and how responsibility is expressed in aesthetic terms is in part a consideration of artists' intentions. A less obvious relationship is between the artist's interiority and the making of a work. The conversation about the psychological, spiritual, and ethical dimensions of this work is still superficial, halted by a focus on its more overt political aspects. Yet more than a few artists temper their reformatory zeal with an understanding that an internalized agenda is being externalized through their art.

The fallibility of our own conceptions of "good" for others presents an ongoing dilemma for new genre public artists. "Fritz Perls calls responsibility 'response-ability,' the ability to respond. He considers 'obligation' a synonym for 'megalomania,'" performance artist John Malpede says. "Your responsibility is your ability to respond to your own needs." A resolution of the ethical dilemma inherent in political proselytizing is to consider the impulse to respond in the context of self.

Allan Kaprow strikes a balance between internal and external necessity. "It's not only the transformation of the public consciousness that we are interested in, but it's our own transformation as artists that's just as important. Perhaps a corollary is that community change can't take place unless it's transformative within us. That familiar line—'I see the enemy and it is I'—means that every prejudice, every misunderstanding that we perceive out in the real world is inside of us, and has to be challenged." This philosophical positioning of "self" in the context of culture is an unexamined characteristic of this work, along with how its structural, temporal, and iconographic nature is shaped by the artists' psychological processes.

Continuity and Responsibility

The strong personal relationships forged through new genre public art are often maintained by the artists over time and distance. Part of their humanistic style, this characteristic has obvious political implications for continuing and enhancing the changes set in motion by the work. When Malpede works with the homeless in cities other than his hometown of Los Angeles, for example, he may link them to local activists and artists in the process of creating a performance. "When we work in other communities, I feel like one thing we can offer to local artists is how to maintain the work after we leave, logistically speaking."

The notion of sustaining or continuing a connection begun through the artwork is an expression of personal responsibility that has a pedagogical thrust, often expressed as educating engaged community members, students, or even the art world. This pedagogy is rarely as doctrinaire as its critics would have it. Rather, the artist imparts options for developing activist and aesthetic work, generally on the constituency's own terms. According to Malpede, "We can offer an aesthetic structure they can transform and carry on. Some community artists get involved and have a completely different aesthetic agenda than our own, and then it's 'Good! Do that!' It's really important that people have a strong artistic vision. It doesn't have to be congruent with ours."

If the artist does have stated political intentions—and the overtness of these varies from artist to artist—then continuity may be a measure of both the artist's responsibility and the work's success. "It has to be sustained. You can't have a flash in the pan and expect that's going to change things" (Judith Baca). The issue of continuity, and time in general, is a crucial one for new public art, taxing the resources of a funding and support system built around time-limited installations and exhibitions in controllable spaces.

The emotional and physical demands on artists are high in this labor-intensive work. The financial costs of developing the work over an extended time and of continuing contacts after the piece is finished are rarely built into budgets, and artists who work in regions outside their

own are faced with perplexing questions. Some resolve them by working locally within their communities; others build relationships that accommodate the distance.

Collaborative Practice: Notions of Public and Private

"Whatever I did publicly I was thinking of at least one person in the general public to whom my work would speak" (Leopoldo Maler, Argentinian installation and performance artist). All art posits a space between the artist and the perceiver of the work, traditionally filled with the art object. In new genre public art, that space is filled with the relationship between artist and audience, prioritized in the artist's working strategies.

For some, the relationship *is* the artwork. This premise calls for a radically different set of skills. For example, "juxtaposition" as an aesthetic practice may mean, in this case, bringing together diverse people within the structure of the work, exploring similarities and differences as part of a dialogic practice. Building a constituency might have as much to do with how the artist envisions the overall shape and texture of a work as it does with simply developing an audience.

These approaches become part of the artist's expanded repertoire. "We can't do works without talking with people in the site. We do a tremendous amount of talking to people in the communities we work in . . . and it's a transformative experience. It transforms the work and it transforms us" (Houston Conwill). This process of communication describes not only a way of gathering information but of conceptualizing and representing the artist's formal concerns. The voices of others speak through this artwork, often literally. Of her project in Little Tokyo in Los Angeles, Sheila de Bretteville says, "It matters to me that their names and the dates on which they said it are there, because they're speaking and I'm not mediating their speech. I'm not interpreting it. I'm simply gathering it and giving it form for others."

The skills needed for this relational work are communicative in nature, a stretch for the imaginations of artists and critics used to the monologic and studio-based model of art. Suzi Gablik calls for an art "that

is more empathic and interactive and comes from a gentle, diffused mode of listening . . . a kind of art that cannot be fully realized through monologue. It can only come into its own in dialogue, in open conversation in which one is obliged to listen and include other voices."

The transition from a model of individual authorship to one of collective relationship suggested in this work is not undertaken simply as an exercise in political correctness. A longing for the Other runs as a deep stream through most of these artists' works, a desire for connection that is part of the creative endeavor in all its forms. Estella Conwill Májozo considers the blues a structural model for her art, the goal of which is to link African American history to current community. "In blues, I find the notion of twinning, of connection with the Other, and find, in the search, that the perceived two are one at the end."

This relational model, whether expressed psychologically or politically, draws upon a spiritual tradition in art. Many new genre public artists express their connection, through memory, to traditions of ethnicity, gender, or family. They talk about their habitation of the earth as a relationship with it and all beings that live there. These essentially ethical and religious assertions are founded on a sense of service and a need to overcome the dualism of a separate self. That dilemma is played out not only between self and Other but between perceived public and private components of the artist's self. "I think this sense of what it means to be a social persona and the fact that every social person has a private person inside is vital to the sense of community and to any meaningful sense of 'public'— of public service. The way to get to those issues sometimes is organizational and structural, but often it has to do with compassion, with play, with touching the inner self in every individual who recognizes that the next individual has a similar self. And it is that community, whether literal or metaphorical, that is in fact the real public that we as artists might address" (Kaprow).

Engaging Multiple Audiences

Empathy begins with the self reaching out to another self, an underlying dynamic of feeling that becomes the source of activism. Whether or not

one wants to discard the model of isolated authorship (and I personally do not), it is certainly not the only possible alternative for visual artists. The work of these artists suggests that another fundamental premise is being constructed—that creative works can be a representation of or an actual manifestation of relationship. A very significant relationship is between the artist and his or her audience.

One of the distinguishing characteristics of the work in question is the factoring of the audience into the actual construction of the work. This work activates the viewer—creating a participant, even a collaborator. It might be said that all art takes its audience into account, even if only in the subconscious mind of the artist working for some imaginary Other. One traditional notion of late modern art suggests that if this is true, it is not something one ought to admit—as if making art for anyone other than oneself is a failure of the imagination. The makeup of the audience for art was not heretofore scrutinized, but was assumed to be largely white, middle-class, and knowledgeable in contemporary art. Artists worked for each other, a select few critics, and potential buyers.

Given the desire for relationship with the Other, it was inevitable that the audience would become increasingly prominent as this form of public art developed. "Where before the audience was prepared through various museum programs in order to like the work of public art, or such a work was left for a time to soften the blow so that reactions to it were mediated in some way . . . in this truly public art the audience is very much engaged, from the start, in the process of making" (Jacob).

As one begins to articulate forms of actual rather than metaphorical engagement, one must come to terms with exactly whom one is speaking to. "When she abandons certain mythologies of public in order to create new ones, the artist cannot be dismissive about the realities of place" (Patricia Phillips). Potential audiences are real people found in real places. Bearing witness to an identifiable person or group challenges the monolithic image of the audience that has been enshrined in the value systems and criticism of late modern art.

If the audience is no longer a given, neither is it singular. Artists are beginning to conceive of complex and multiple audiences as distinct

groups, including integral participants, occasional viewers, and the art world itself. The content of the artwork defines its audience groupings, as does the venue. These influences are reciprocal, with choices of venues affecting the content as well, amounting to a more fluid and process-oriented approach.

"Who is the public now that it has changed color?" asks Judith Baca. The single most explosive idea to the myth of a coherent and generalized art audience has come from the recognition of difference. "An earlier heroic and modernist idea of public art suppressed the significant differences, while looking for some sort of normative and central idea of public. The big question for public artists and for critics is, how do we develop a public art that acknowledges and supports and enriches these differences while at the same time discovering how these differences contribute to an idea of public life that is, in fact, a kind of common ground?" (Phillips).

Ethnic minorities have challenged the assumptions of culture premised in the work of European, primarily male artists, as have feminists, whose theory of differences has effectively demonstrated the patterns of dominance deeply embedded in the language and symbols of representation. "In the future, whose idea of beauty and order will be in public spaces? That is perhaps the greatest question we have to face. You can look at a landscape and you can see it as perfect in itself. Or you can look at it as undeveloped land. Those are two very different points of view. Who will make the public art in that space?" (Baca).

The road to reconciling differences is not as straightforward as we might have thought ten years ago. "We're still working on dismantling all those old binary oppositions and the differences between the center and the edge. All those centers and all those margins are really parts of a very large framework of centers and margins together. We get community without unity, without understanding, accepting all the different parts without having to really understand everything, because there are some places where we truly can't" (Sheila de Bretteville).

Ambiguity and paradox resonate within this artwork, recognized by the artists through their active participation in the realities of community. Differences, whether reconciled or simply tolerated, must be accom-

modated somehow within the artwork. "We all have multiple identities, and that's how we cope with things. To take any of us as simply a two-dimensional system is to not really understand. We all have distinct backgrounds but a common foreground" (Peter Jemison, curator and theorist).

Negotiating the complicated field introduced by the destruction of a unified art audience is tricky. Where and how the artist locates her voice within the work's structure is critical, as is the representation of the community voice. What if there is disagreement? This practical question figures significantly in art censorship controversies and is at the heart of new genre public art. "One of the big challenges that we're going to have to figure out in this country and in democracy is the role of individuals and communities—individuals and their freedom and communities and their rights, or standards. How do we make those two things come together in some way that still allows us to be very different but live together?" (David Mendoza, executive director, National Campaign for Freedom of Expression).

New Roles for Artists

Integrity is based not on artists' allegiances to their own visions but on an integration of their ideas with those of the community. The presence of a diversified audience in these works leads us back to issues of power, privilege, and the authority to claim the territory of representation. Inevitably, then, we must reconsider the possible "uses" of artwork in the social context and the roles of the artist as an actor in the public sector.

In finding new ways to work, artists have drawn on models outside the arts to reinterpret their roles. Allan Kaprow called attention to the inherently pedagogical nature of art in a series of articles in the seventies called "The Education of the Un-Artist."[12] Artist as educator is a construction that follows from political intentions. "If art is to ever play a role in the construction of shared social experience, it must reexamine its pedagogical assumptions, reframing strategy and aesthetics in terms of teaching" (Richard Bolton, writer and artist).

This was well understood by Judy Chicago and other feminist artists of the seventies, whose ideas about art were developed from an examination of issues of authority, representation, historical revision, and

the pedagogical effects of public disclosure on political systems. As the audiences for women's art became more populist, mandated by the breadth of the artists' aspirations for change, the discursive aspects of the work became as urgent as the aesthetic. Media appearances, classes, exhibitions, discussion groups, public demonstrations, consultations, and writings were all developed as integral to the artwork, not as separate activities. "When the artist designs the program as well as the work of art—or shall I say when the artistic strategies become one with the educational events, we have a new way of thinking about the purpose of the work. The process that involves all of these activities needs to be recognized as the central part of the work of art. We're not just talking about a final product to which all else is preliminary. The artist him- or herself as a spokesperson is a very different kind of role" (Jacob).

A more thorough analysis of the various claims artists make for redefining their roles is needed to keep from substituting one set of mythologies for another. Some ideas clarify and others simply confuse. "Maybe this generation is unloading the myth of the artist, the myth of immediate gratification, of genius and superiority and entering the more real space of disappointments, of slow processes that need to be undertaken before something can be changed" (Kaprow).

In recent literature and at symposiums, many suggestions for redefining roles have been put forward. Yolanda López invokes a model of citizenship: "Exercising the social contract between the citizen and the state, the artist works as citizen within the intimate spaces of community life." Helen Mayer Harrison suggests, "We artists are myth makers, and we participate with everybody else in the social construction of reality." In a fanciful flight of metaphor, Guillermo Gómez-Peña suggests that artists are "media pirates, border crossers, cultural negotiators, and community healers." These metaphorical references drawn from outside the arts propose a different construction of visual arts practice and audience. When "public" begins to figure prominently in the art-making equation, the staging area for art becomes potentially any place—from newspapers to public restrooms, from shopping malls to the sky. These expansive venues allow not only a broader reach but ultimately a more integrated role for the artist in society.

CRITICISM OF NEW GENRE PUBLIC ART

At this date there seem to be more questions than answers, more rhetoric than inquiry. Criticism flounders with outmoded and unexamined constructions, far outstripped by artists' ongoing investigations. It is time to do more than describe this artwork, time to look more closely at what exists within the borders of this new artistic territory.

How do we begin pulling together the various strands of new genre public art, much of the thinking about which is located within the artists' own practice and writing? First, we must analyze the work in a more challenging and complex fashion. I suggest the following areas as a beginning construct: the quality of the imagery, including the question of beauty and the relevance of invention; the artist's intention and the effects of the work, whether measurable or hypothesized; and the work's method of conveying meaning. As a preface, the roles of the curator and critic must be considered with respect to this work.

Curators, Critics, and Artists as Collaborators

"As a curator, I do become involved in the creative process. The curator becomes a collaborator, a sounding board, and ultimately a facilitator. It's very important to play a role of giving permission, if you will, that anything is possible while we're thinking about how to create a work" (Jacob). Critics and curators who work with new genre public artists actively participate in the ethos and assumptions of the art. They see themselves as contextualizing and expanding the artist's reach.

Whether she works inside or outside of institutions, the curator presents and promotes the artwork to the art world and the culture at large. Increasingly, curators align themselves with the artists' visions for expansive audiences. "I'd like to build bridges, linkages between what artists are thinking and doing to our daily lives. I'd like to provide our culture with access to the ideas of artists, to pursue situations where artists can reengage as part of the mainstream discourse, where they can participate as citizens. I'd like to explore situations where artists are activators, articulators, and legitimate participants in the community, not offering

benedictions or accusations from the sidelines" (Dowley). With aspirations such as these, curators support the artists' belief that visual art can play a larger role in setting the public agenda.

In addition, some curators, having worked for years with artists of this genre, have either adopted artists' educational and outreach strategies or arrived at the same point following a similar analytic process. Experimenting with presentational venues and curatorial styles, they serve as educators for the profession as well as for lay audiences, even initiating younger artists into interactive modes. They facilitate opportunities for artists to work within the community by contacting community groups, arranging resources, and planning informational and educational activities. Notable projects in the past few years have adopted the models inherent in earlier public artworks, with curators taking on roles formerly assumed by artists. The Spoleto Festival USA exhibition and Sculpture Chicago's *Culture in Action*, both curated by Mary Jane Jacob, and Lynn Sowder's *Women's Work: A Project of Liz Claiborne, Inc.* are examples of expanded projects in which the curator envisions and coordinates extensive public media and artistic approaches to themes and issues.

The critic provides the written context that expands the artwork's potential meanings, explains it to different audiences, and relates it to the history and contemporary practices of art. "The critic's role is to spread the word, propagate ideas, conceptualize, and network publicly with artists. We're mediums. And we need to help find complex and diverse ways to connect the private and the public, the personal and the political" (Lucy Lippard). The critic evaluates, describing the standards by which the work will be measured and pointing out flaws in thinking. Their scrutiny is vital, as it is too easy to simply applaud the work's social intentions at the price of its aesthetics or, conversely, to ignore them.

The critical task is not an easy one, as we have tended to separate our political and aesthetic language in this country since the ascendancy of formalist criticism in the forties. "It seems to me that arriving at some sort of a model [for criticism] involves getting past this bifurcation between the aesthetic and the social. There's a whole there; someone has to figure out how to negotiate the territory, because this dualism just doesn't explain the

work" (Patricia Fuller). Often functions between the disciplines overlap—artists and curators write critically; critics and curators work collaboratively with artists; critics curate; and artists curate others' artworks as part of a larger work they author. New genre public art calls for an integrative critical language through which values, ethics, and social responsibility can be discussed in terms of art.

The Question of Beauty and the Relevance of Invention

The discussion of beauty, invention, and the artful manipulation and assembling of media need not be excluded from the consideration of work that represents values and is contextualized within the public. Such separation is divisive, at best an overreaction to conventional and confining notions of beauty, and at worst an excuse to dismiss out of hand a large body of contemporary art.

Carol Becker, in an essay on the education of artists, quotes James Hillman's description of experiencing beauty as "this quick intake of breath, this little *hshshs* the Japanese draw between their teeth when they see something beautiful in a garden—this *ahahah* reaction is the aesthetic response just as certain, inevitable, objective and ubiquitous as wincing in pain and moaning in pleasure."[13] We recognize this gasp of recognition, a recognition at once of the newly invented and the already known.

The problem of beauty in the artworks considered in this book is a legacy of the dematerialization of art and the development of conceptual and performance art forms during the sixties—how do we as visual artists judge the beauty in ideation or temporal shape? Frustrated, some critics simply abandon the territory, leaving beauty to the domain of materialized and media-specific constructions. Interestingly, the interrogation of notions of beauty through, for example, certain deconstructive work of the eighties is more institutionalized within art criticism than is the implication, often inherent in new genre public art, of non-museum-oriented forms of beauty. That is, a critique of beauty is acceptable as long as the current language of art is maintained and the makeup of the art audience is not actually challenged.

The role of invention in beauty is more complex, especially within an art world driven by novelty. Our reward system, based on the appearance of innovation, often leads us to deny the work of intellectual and spiritual predecessors, unless they are long enough dead that association with them enhances rather than competes. This hysteria for the new, a prejudice of our society, has reached a climax in contemporary art. The implications for building a sustained and effective argument for art's social role are severe if activist artists cannot acknowledge how they are building on each other's works and theories.

And yet, in spite of the political uses to which notions of invention are put, in a very real sense beauty—the *ahahah* experience—results from reassembling meaning in a way that, at that moment, appears *new* and unique to the perceiver. This paradox must be grappled with in new genre public art: the desire for what has not been seen and the politically isolating demand for originality. The perception of beauty, subject as it is to cultural training and political manipulation, is still a necessary aspect of human existence. The quality of imagery and use of materials, including time and interaction, must be included in critical analysis of new genre public art.

Artists' Intentions and Effects

Another dilemma for criticism is what relationship evaluative criteria should have to the artist's expression of intentionality. Assumptions about authorship, beauty, and what constitutes a successful work might change with an understanding of artists' theoretical constructions, and some knowledge of their intentions seems necessary if one is to understand fully. For example, Judith Baca suggests two working models that might result in different critical treatments: "In some productions where you are going for the power of the image, you can get a large amount of input from the community before the actual making of the image, then you take control of the aesthetic. That's one model. Another is a fully collaborative process in which you give the voice to the community and they make the image. Both of these processes are completely valid, but there's very little room for the second because artists take such huge risks becoming associated

with a process that might not end up as a beautiful object. The confusion is massive when you talk to people who are writing about it; whose art is it, the kids, the homeless, or yours?"

Can we trust the artist's claims for the work? Some critics have suggested that the distance between the artist's political intentions and real social change is the only criterion. This idea reflects the dualistic conundrum at the heart of critical thinking about this work—is it art or is it social work? Methods traditionally used to measure change, drawn from the political or social sciences, are never, to my knowledge, actually applied. The language for doing so is not in place, and even if it were, we are reluctant to reduce our critical evaluation to one of numbers, or even, for that matter, to personal testimonies. Concrete results in the public sphere, and how these reflect the artist's intentions, may occasionally be illustrative of a work's success but fall short, as they do not capture all the varied levels on which art operates.

Art and Meaning

By leaning too far in the direction of evaluating the work's social claims, critics avoid giving equal consideration to its aesthetic goals. Our current critical language has a difficult time coming to terms with any process art. Yet as Jeff Kelley states, "Processes are also metaphors. They are powerful containers of meaning. You have to have people [critics] who can evaluate the qualities of a process, just as they evaluate the qualities of a product. There's a false dichotomy that's always talked about, even by us, between objects and processes. Any time we objectify consciousness, it's an object in a sense, a body of meaning. Looking at a product at the end, or looking only at the social good intentions or effectiveness of the work is certainly not the whole picture."

As variable as the individual perceptions of meaning may be, at least this terrain is a familiar one to art criticism—social meaning as it is embodied in symbolic acts. "Part of what we're doing is to dream. [An artist] is not changing the homeless problem. How many million homeless are there in the world? How many people is that one artist working with? No, this

is an issue about identity and history" (Alf Lohr, German critic and artist). Whether the art operates as a concrete agent of change or functions in the world of symbolism (and how such symbolism will affect actual behavior) is a question that must inform a more complex critical approach.

Even when the artist's intentions are to evoke rather than merely to suggest social transformation, the question of whether art operates differently than, say, direct action must be considered. Why does this work assume the position, "shape," and context of art? If indeed it does, one of the evaluative sites must be the meaning to its audience, a meaning not necessarily accessible by direct query.

Perhaps, in the end, the merit of a single and particular work in and of itself will not be the sole concern of our criticism. If new genre public artists are envisioning a new form of society—a shared project with others who are not artists, working in different manners and places—then the artwork must be seen with respect to that vision and assessed in part by its relationship to the collective social proposition to which it subscribes. That is, art becomes one's statement of values as well as a reflection of a mode of seeing.

In a public art dialogue focused on the bureaucratic and the structural, the visionary potential of public art, its ability to generate social meaning, is lost. Inherent in seeing where we are going is asking why we are going there. If in *Mapping the Terrain* we reframe the field within which this artwork operates, reuniting it with its radical heritage and the artists' ethical intentions, then perhaps our understanding of this art will be redirected along a different road.

Whether it operates as symbolic gesture or concrete action, new genre public art must be evaluated in a multifaceted way to account for its impact not only on action but on consciousness, not only on others but on the artists themselves, and not only on other artists' practices but on the definition of art. Central to this evaluation is a redefinition that may well challenge the nature of art as we know it, art not primarily as a product but as a process of value finding, a set of philosophies, an ethical action, and an aspect of a larger sociocultural agenda.

NOTES

This essay appeared in a slightly different form in *Public Art Review*, Spring/Summer 1993 and Summer/Fall 1993.

1. Unattributed quotations are drawn from transcripts of the symposium "Mapping the Terrain: New Genre Public Art" sponsored by the California College of Arts and Crafts in 1991.

2. The balance of this paragraph is drawn from Mary Jane Jacob's essay "Outside the Loop," *Culture in Action: A Public Art Program of Sculpture Chicago* (Seattle: Bay Press, 1995).

3. Ibid.

4. Ibid.

5. *Design Quarterly*, no. 122 (1983).

6. One such series of conferences sponsored by the NEA resulted in a book, *Going Public: A Field Guide to Developments in Art and Public Places*, published by the Arts Extension Service in cooperation with the Visual Arts Program of the NEA. It was written by Jeffrey L. Cruickshank and Pam Korza.

7. Jacobs, "Outside the Loop."

8. The title of the program was changed twice, reflecting shifts in the field, changing from Art in Public Places to the current Visual Artists' Public Projects. Each change suggested a growing awareness of the roles and results of art in a public setting. "What has changed recently," asserts Bert Kubli, program officer of the NEA, "is the necessity to have a conversation with the audience in the public space and a renewed focus on the artist."

9. This phrase is drawn from Arlene Raven, ed., *Art in the Public Interest* (Ann Arbor: UMI Research Press, 1989).

10. See Lucy Lippard, *A Different War: Vietnam in Art* (Seattle: Real Comet Press, 1990).

11. Judy Chicago pioneered feminist art education at California State University in Fresno, California, in 1969. Between 1970 and 1972 she brought her program to the California Institute of the Arts in Valencia with painter Miriam Schapiro, and in 1973 she expanded it at the Feminist Studio Workshop with designer Sheila de Bretteville and art historian Arlene Raven. Feminist art education, as Chicago and her colleagues conceived it, was dramatically different from most art education at the time. Its goal was to help students identify personal subject matter and produce "content-oriented artworks" that reached a broad audience.

12. Allan Kaprow, "The Education of the Un-Artist, Part I," *Art News* 69, no. 10 (1971), pp. 28–31; "The Education of the Un-Artist, Part II," *Art News* 71, no. 3 (1972), pp. 34–39; and "The Education of the Un-Artist, Part III," *Art in America* 62, no. 1 (1974), pp. 85–89.

13. James Hillman, "The Repression of Beauty," *Tema Celeste* 4, no. 31, international edition (1991), pp. 58–64, quoted in Carol Becker, "The Education of Young Artists and the Issue of Audience," in *Between Borders: Pedagogy and the Politics of Cultural Studies,* ed. Henry Giroux (New York: Routledge, 1994).

JUDITH F. BACA, *The Great Wall of Los Angeles, 1976–continuing*

AN UNFASHIONABLE AUDIENCE ⟩ *Mary Jane Jacob*

The mainstream contemporary art world focuses on the production
(artists and works of art) and the distribution (museums, galleries, and
publications) of contemporary art. Mediation between the work of art and
the audience is usually the purview of professionals designated as educa-
tors, and the reception of the art is measured once it appears in its respec-
tive venues. Fault—the inability to comprehend and appreciate the work
of art—is often attributed to a notion of deficiency: lack of art knowledge
on the part of the viewer, lack of labels on the part of the museum, and, less
often, lack of clarity or quality on the part of the artist. This gap between
art and its audience is dramatically pointed out by the example of public
art, since it is on the street that, it is felt, the work of art meets an unin-
formed and unwilling general public.

But what if the audience for art (who they are and what their relation-
ship with the work might be) were considered as the goal at the center of art
production, at the point of conception, as opposed to the modernist West-
ern aim of self-expression? And what if the location of art in the world was
determined by trying to reach and engage that audience most effectively?

WHO DEFINES IMPORTANT CONTEMPORARY ART?

Twentieth-century Western art has always been positioned according to
its avant-garde edge—that is, the degree to which it departs from tradition
and demonstrates innovation. At times, the avant-garde is defined by its
political roots as the revolutionary advance; at other times, it is understood
as a function of stylistic innovation. Contemporary art museums, in bring-
ing exposure to the new, have acquired by association the connotation of
being avant-garde institutions. Yet, at the same time, like all museums,
they operate according to principles of connoisseurship derived from their
eighteenth-century origins.

In spite of the rebelliousness of art in this century, museums and the mainstream art establishment remain the arbiters of style and the validators of art, as "museum standards" for defining and distinguishing important art continue to prevail. The assessment of the work of art is accomplished through the museum practice of identifying the makers of the art object; categorizing it according to genre; evaluating it according to a hierarchy of media; assessing its quality; placing it within a continuum of art history; and displaying, interpreting, and publishing the work as part of a mono-graphic or thematic program.

Within museums, the audience is often conceived as self-reflexive. The audience for art is that which comes to the museums, and the issues related to audience revolve primarily around the question of museum attendance. Even though demands are being placed on museums today to be audience responsive, increase accessibility, provide didactic materials and educational programming, and expand beyond the roles of keeper and presenter of culture into the community, the identification of the audience remains bounded by the institutions' own conventions. In the seventies and eighties, new approaches to audience development centered on mem-bership perks or building amenities such as museum stores and cafes; that is, museums attempted to attract the viewer as patron and consumer. By the end of the last decade, in an era of increased multicultural awareness, the focus shifted to in-house education and outreach programs, though the aim still was more to colonize persons and communities and turn them into museum-goers than to establish new relationships and continuing, permanent vehicles of exchange and mutual respect.

But art existed for centuries before museums. For institutions within the art world to define what is art—or, at least, *important* art—is a relatively recent phenomenon in our culture. With this power is also made a distinction between high art and low art—to indicate that which is significant in the history of contemporary art as opposed to the popular arts. Hence, forms of cultural expression outside the museum's sanctioned space are demeaned or devalued. This system of division and classification permeates the institution's class-oriented structure of patrons, trustees, membership, special events, and so on. Thus, when foundations or

community spokespersons call for a revamping of the system to open up art to new audiences, they are met with resistance or the inability to re-shape the museum's collections, facilities, exhibitions, programs, staff, and boards; instead, a token representation or temporary trend occurs. In other words, reformers discover that at the very core such art institutions are at odds with new social agendas.

So the art museum may not be the most appropriate starting point for larger, new audiences for contemporary art. Instead, by departing from the institution, new meaningful ways to engage a wider audience for con-temporary art can be greatly multiplied. Moreover, these non-art-world venues may be equally or more appropriate than museums as the setting for some of the most important artistic statements emerging from current mainstream thought.

WHY WORK "IN PUBLIC"?

An artist choosing to step outside the domain of the museum, intention-ally or by virtue of his or her interest, gains a bittersweet freedom from the hierarchies and definitions imposed by traditional art institutions. The extended edges that define art as avant-garde, explored as early as the beginning of the century, were pushed wide open by artists in the early seventies. Their work includes art that is produced collaboratively or anonymously; process-based art that exists within a limited time frame; art that uses nontraditional media; art that might be identified with other fields (for example, science) or everyday life itself; art that requires assess-ment according to quality of experience, or requires non-Western or newly formed evaluation systems to chart its success; art that is open to interpre-tation by the audience as well as by professionals; and art that uses routes such as public media to generate discourse, rather than art magazines and exhibition catalogs.

The roots of these changes can be found in artists' practices of the last twenty-five years and come from several sources. Some artists intended their work to resemble, even be mistaken for, life; being in the reality of the world increased the work's readability as part of the environ-ment rather than artifice. For those artists with a more pronounced social

and political agenda, the role of art as a forum for dialogue or social activism gained in power and effectiveness by being situated in the real world. It was necessary to remain outside the institution to maintain an independent artistic or politically revolutionary stance. Forced initially to work outside art institutions because of discriminatory selection processes, politicized artists—especially those who must defend their place in the art world because of their ethnicity, race, gender, or sexual preference—have used the public venue as a potent means of speaking about personal issues of a public dimension.

While the art museum, too, moved to the use of alternative, outside locations by the eighties because of the additional gallery space and visibility they afforded, many special exhibitions were offered in such locations because of their potential as a meaningful context for art. Commissioning new works for site-specific shows is, therefore, aligned with contemporary public art practice rather than conventional curatorial practice, which is founded on connoisseurship. These exhibitions, however, do not necessarily constitute public art. They are essentially museum exhibitions outside museums; they might exist in public view, but they are rarely directed toward engaging that audience unfamiliar with the artists on view; they appealed instead to a new breed of art tourist that emerged during this period of active international art-world travel in the eighties.

The "new public art" that has come into the spotlight in the nineties is not actually new; rather, the application of the genre of public art has made digestible some art known under more specific political labels (such as feminist performance or Chicano installations). Yet the recent increase of activity around public art that addresses social issues is dramatic. It is an art whose time, if not wholly its acceptance by the art establishment, has come. The work of this rapidly growing group of artists ranges from the expression of identity (which itself can be a political act), to the creation of art as social critique, to the production of art as an instrument for change. The latter category may be thought of as encompassing three types of work. One is emblematic: objects or actions that embody the social problem or make a political statement and by their presence in a public setting hope to inspire change. A second is supportive: works conceived and

created by the artist that, upon presentation, are designed to be linked to others, ultimately feeding back into an actual social system (for example, public service messages benefiting a particular group, or schemes to generate revenue for the cause evoked by the work). A third type is participatory, whereby the concept of the work and perhaps its actual production come out of a collaborative process. It aims to make a lasting impact on the lives of the individuals involved, be of productive service to the social network, or contribute to remedying the social problem.

For the meaning of this art to be conveyed, its presence in public is essential. It is not art for public spaces but art addressing public issues. This art is dependent upon a real and substantive interaction with members of the public, usually representing a particular constituency, but not one that comes to art because of an identification or connection with the art world. Such work must reach those for whom the art's subject is a critical life issue. This work deals with audience first: the artist brings individuals into the process from the start, thus redefining the relationship between artist and audience, audience and the work of art. This work departs from the position of authority over and remove from the audience that has become a hallmark of twentieth-century Western art. It reconnects culture and society, and recognizes that art is made for audiences, not for institutions of art.

THE RECEPTION FOR THE "NEW PUBLIC ART"

Much of the internal dynamic within the art world results from the conflict between the devaluing of certain nonmainstream art by the critical and cultural establishment and the desire for recognition and reevaluation on the part of the work's practitioners and supporters. In recent decades, we have seen this battle played out in regard to work in so-called crafts media, primarily clay, glass, and fiber; work in the so-called new genre, such as video, performance, and installation; work by so-called regional artists, that is, those living outside New York; work by so-called minorities, such as women, African Americans, Latinos, or Native Americans; and work by foreigners, beginning around 1980 with German and Italian artists, then French, Spanish, and British, then Dutch, Japanese, Brazilian—the list goes

on around the world as other countries try to prove, for reasons of cultural and economic power, that their work is part of a vital, current scene.

The latest "art outside the mainstream" that is claiming recognition, being praised as "the new" and damned as "not art," is the new, community-based public art. Its status fluctuates between disregard and promotion as it is offered as the latest thing—the new avant-garde—or deemed socially concerned but aesthetically insignificant.

Inevitably, art outside the mainstream is initially met with criticism and suspicion; then some stars are identified and propelled to demonstrate the incorporation of yet another area, such as a new style, into the art scene. But it is unclear whether the power relationships that for so long favored white male American and European painters can be said to have truly changed in response to the above-named movements and the entry into the canon of contemporary art history of a Robert Arneson, Dale Chihuly, Magdalena Abakanowicz (sculptors in clay, glass, and fiber, respectively); a Nam June Paik, Laurie Anderson, Ann Hamilton (who work in video, performance, and installation); a Siah Armajani or James Surls (from Minneapolis and Texas, far from New York); a Susan Rothenberg, David Hammons, Guillermo Gómez-Peña, Jimmie Durham (who escape the limitations of gender, race, or ethnicity); or a Yasuo Morimura, Cildo Mиereles, and many from European countries (who broke the U.S. domination of the post–World War II art scene). Perhaps we have just allowed a few "others" into the academy? Perhaps within, nothing has changed? Will the new public art be absorbed likewise, with some artists rising to the top and others fading as the movement wanes from view? Or is there something fundamentally different about this work—its community base, social subject matter, political strategy—that will prevent it from following the same pattern? Will that difference keep it forever outside the mainstream?

There is already a groundswell of opinion in the art community that this work is getting too much attention. Art should "speak for itself," so why should an artist be out there explaining? Art should be primarily visual, and since this work uses and mixes any media, takes forms associated with traditional popular arts, or involves community organizing, where's the art? Isn't this social work after all? The artist's role is being

co-opted or compromised; it's not the work of the artist but of the community, thus, it's not art. (Interestingly, questions of authorship raised by art using appropriation have not affected the status or prices of Sherrie Levine's or Jeff Koons's work.)

Like the move to pressure museums to expand their audiences, this work has caused consternation and outrage in the field: to appeal to and attract the uninitiated audience, quality must be lowered. For instance, it is believed that such an audience, with no art history training, could not possibly understand public projects emanating from a conceptual art base. Therefore, if locally appreciated (on the street level, if you will), such public art works must not be of interest to those situated geographically and socially outside, and the art must lack universality, must not be of aesthetic significance.

Ironically, new public art's avant-garde status—both stylistically innovative *and* politically advanced—does not easily win for it a place of distinction in art world media and institutions. Rather, its premises are dismissed because of characteristics that run against the grain of an art-establishment ideology based on the collectible nature and private appreciation of the object. Its offenses are its connectedness to the actual (not just artifice); its practical function (not just aesthetic experience); its transitory or temporary nature (rather than permanence and collectibility); its public aims and issues as well as public location; its inclusiveness (reaching beyond the predefined museum-going audience); and its involvement of others as active viewers, participants, coauthors, or owners. Moreover, because so many artists have felt the urgency to work this way in the face of the critical needs of our cities and communities, this community-responsive, audience-directed work is put down for being trendy, "do-gooder," and opportunistic, taking advantage of funds created out of new governmental or foundation agendas.

CHANGING ARTISTIC PRACTICES

When the artist designs the contextualizing program as well as the work of art, or when the artistic strategies become one with the points of audience engagement, what emerges is a new way of thinking about the purpose of

education and the artwork as a totality. To understand this work is to recognize that process and all associated activities are central to, even part of, the art; this is not just a case of a final product or object to which all else is preliminary. To carry out such labor-intensive, time-consuming, multidisciplinary work, conventional definitions of the artist, the curator, the critic, and the institutions of art and society must be challenged. But this poses a threat to the continued operations of those institutions and the professional identity of most in the art world.

A number of artists today, perceiving the possibility of deconstructing society and possessing a vision to reinvent or aid in remedying it, have begun to rearrange cultural institutions as well. Making exhibitions is a way for artists to demonstrate some of their ideas about art as social critique. Blurring traditional roles within the field, artist-made exhibitions range from Group Material's assembling of other artists' works according to a political theme, to the Incest Awareness Project's exhibitions of artists alongside social scientists and activists, to Fred Wilson's reinstallations of existing museum collections, to Betti-Sue Hertz's curating of indigenous artworks that parallel current themes in the art discourse. Furthermore, to produce works that bring together social groups and issues in experimental forms outside any social or cultural system, artists have become adept at fund-raising, community organizing, managing extensive logistics, and a host of other, heretofore nonart, skills.

In areas that were previously off limits as the artists' domain, curators are playing a part in the making of art, in its conception and realization. When art moves outside studio production and becomes a process of community or institutional negotiation, when it must be responsive to a social dynamic and address the needs of others, when it is collaborative by nature, or when it draws upon the expertise of other fields, it becomes a more open-ended and fluid process. The new public art demands and invites communication and the engagement of others. In this, the role of the curator can be key, as this individual becomes at various times client or commissioner; information resource or researcher; sounding board and friend; administrative and artistic collaborator; exhibitor and presenter; educator, tour guide, and interpreter. The creative process is opened to the

curator by nurturing and supporting a broadly experimental and innovative art-making approach as well as by directly having the curator participate in the creative process. The resulting alliance between artist and curator is beneficial, even essential to making socially complex works that can exist on many levels, and to weathering logistical and political obstacles endemic to art but compounded here. Meanwhile, some social institutions are welcoming artists whose energies they see as gifts to their campaign, while those in the art establishment seem baffled, mildly curious, or antagonistic.

Most important, however, is the change that is occurring in the audience for contemporary art. What happens when the primary audience is not that which is educated in art or financially and socially aligned as supporters of the art world? What happens when the most in-depth and privileged experience of the art is not reserved for the person who distinguished him- or herself by wealth or reputation, but is available to any who cared about the issues and wished to become involved?

In the seventies we worked to extend the definition of the artist along the lines of nationality or ethnicity, gender and sexual orientation, and in the eighties the place of exhibitions was expanded to include any imaginable alternative venue. Now, in the nineties, we are grappling with broadening the definition of the audience for contemporary art.

With the new public art, the traditional audience for art is changed in several significant ways: by being placed at the center of the art making, with their concerns and issues adopted as artistic subject matter; by reacting to the work, their critical viewpoint ultimately determining its artistic success, i.e., its *quality*; and by taking on a diversified and more active role. In fact, the audience-participation factor in the genesis of this public art gives the work relevancy within the community, not in the usual public art sense of promoting art appreciation, but by offering the potential for this art to affect the lives of those in and outside of the community.

Public art works that are audience generated and audience responsive appear to the established art world to be necessarily unsophisticated. It seems the mainstream equates the audience's involvement in and comprehension of the work of art (particularly of those on the margins of society) with a limitation of the artwork's status as avant-garde or contem-

porary, and assumes a lessening of its applicability and appropriateness to other audiences beyond the specific and the local, especially the art-world audience. Perhaps its very nature of being nonexclusionary makes the new public art a challenge to the art system. Perhaps the art world clings to the arts for its refinement and remove from the everyday and everyone. The concentration of projects around the subjects of marginalized groups (women, youth, the lower classes) may be seen as exclusionary—an act of reverse discrimination—or as exploiting or romanticizing a community's problems. But others would argue that the issues evoked—those we see in the news every day—are not only relevant beyond the community in which they are sited but affect us all and are echoed around the world.

As artists have given greater, primary, consideration to the audience in developing their projects and in bringing those usually outside art institutions into their work—through the subject matter, neighborhood or other public venue, or nonart participants who personally invested themselves in the process—many of the art world audience have fled. The audience has not expanded but has been substituted. Indeed, it is this change in the composition of the audience, and their position at the creative center, that makes this public art so new.

PUBLIC CONSTRUCTIONS } *Patricia C. Phillips*

In spite of an appealing, ambitious agenda to make art available, if not central, to the lives of individuals and communities, public art remains theoretically and practically marginalized. It is often ignored, occasionally enjoyed, and sometimes disputed. Although it openly challenges the conventions of art production, distribution, and reception, it is not situated at the crossroads of art discourse in the late twentieth century. Why is public art excluded from an emergent interdisciplinary dialogue on urban conditions, civic life, and cultural and social change? Why does it remain so inconspicuous—and possibly incidental—except to a small circle of attentive friends and followers? Like other important cultural work (feminist and activist art, for example) that challenges modernist conventions circumscribing art practice, public art occupies the edges of discourse. Paradoxically, this particular position may be public art's most instrumental appeal. The perspective from the borders provides a point of view—a critical vision of the relation between institutionalized culture and participatory democracy.

This is a disquieting yet stimulating moment for any cultural critic who writes about public art. In addition to the obvious fact that there are few international publications or forums committed to an ongoing critical discussion of public art and its relation to urban structures and critical theory, the field is in philosophical and aesthetic confusion. The idea of "public" raises significant questions about cities, spaces, systems, and communities, but the processes of public art production often thwart serious analysis. The relation of art to urban form and civic life is an ambitious and urgent investigation; but too frequently, questions of content or instrumentality are diminished by a preoccupation with the procedures and policies that guide—and sometimes tyrannize—creative production. Common practice situates public art in conspicuous, clearly designated center-city sites, but its theory travels the quiet side streets of cultural research, rarely influencing political, social, and aesthetic programs.

In a recent interview, education theorist Henry A. Giroux described radical education not as a theoretical construct but as a practice that questions received institutions and assumptions. By definition, radical pedagogy operates effectively in the borders of discourse. Questions and observations are formed and sustained by interdisciplinary work, the challenge to fundamental categories in disciplines, and a mission to make society more democratic.[1]

Rather than serving as predictable urban decor or diversion, public art can be a form of radical education that challenges the structures and conditions of cultural and political institutions. Public art, like radical education, by necessity occupies a marginal position. Critics and theorists need to see this location as an opportunity rather than a disadvantage: public art can frame and foster a discussion of community and culture specifically because of its border conditions.

Curiously, the current examination of the culture of schools clarifies the most central questions of public art. What is a public, and how does it operate? If we acknowledge the rich plurality of cultures, can "public" assume a singular meaning or identification? If not, is it a useful concept? Can "public" represent a common place that accepts differences?

While public schools across the nation struggle to define their institutional roles and responsibilities, one case in particular illuminates issues of relevance to public art production. In summer 1992 the Maryland State Board of Education passed unprecedented legislation: graduation from a state public high school would require fulfillment of a service-learning component of the curriculum. No service, no diploma. Following enactment of this legislation, each county in Maryland has elected to create its own plan for fulfillment of the requirement. Generally students have four to seven years (middle school through high school) to perform seventy-five hours of community work or some other suitable project approved by the school district.

Maryland's hotly debated resolution has galvanized extreme factions of support and dissent. Proponents believe that the legislation will help reinstate a greater dedication to public service and involved citizenship and that the requirement, met during adolescence, will preordain a lifetime of

efforts that—along with others' contributions—will invigorate public life. The message of the referendum is clear: there is an aching need in public life. The proposal accepts that every individual makes a difference, that the prescription for a meaningful, constructive public life is like a barn raising. If individuals help out here and now, they, too, may be the beneficiaries of collective vision and effort in the future.

Opponents of the legislation believe that it undermines the very idea of public life and community service. To them, mandatory volunteerism (an optimistic oxymoron) encroaches on individual civil rights—a much-guarded foundation of a participatory democracy. By legislating service, they fear that the state threatens the give-and-take of free citizens and the constructive tension of individual desire and public good. More pragmatically, skeptics wonder if required service, even with the persuasive support for experiential learning within a community, can actually instill an ongoing commitment to community "good works." Is the optimistic message of service learning that is reportedly delivered the one high school students actually receive? Does the legislation nurture public values, or does community service become an onerous obligation?

The Maryland measure assumes that public institutions—schools—can affect the formation of future publics. More solemnly, the bill, only one example of self-examination and restructuring of schools, reacts to a widespread reading of anomie and estrangement—a disinterest in the public domain coupled with the perceived inadequacy or disinclination of individuals to influence change. Supporters may settle for the argument that if nothing else seems to slow the decay of community-mindedness and civic participation, perhaps aggressive, curative legislation will.

Ironically, the legislation is one of many signs of public opinion indicating that contemporary public life is eviscerated. Having little faith in the ability of current citizens to restore depleted community values, the legislators cast a hopeful gaze toward the children—toward the next generation of citizens and cultural participants. Clearly, experiential service learning contends that there is no genetic blueprint for a public vision; commitment to community is an acquired characteristic that requires attentive development.

Although this new legislation mandates community service and suggests that social responsibility can be taught, it offers no new insights into a contemporary conception of public life. Educators, theorists, critics, and others may recognize the mercurial configurations of diverse publics and accept that they have little correspondence with well-known historical models that envisioned a public as a more homogeneous, compliant group. Many may feel that an active, questioning, constructive, and cohesive public life is not possible. Others accept its possibility—or even inevitability—but believe it will assume forms that are difficult for contemporary citizens to anticipate or identify. According to Mark Lewis, "This is the ambiguity of 'the public,' an ambiguity that haunts the etymology of its taxonomic conjugations (publicity, publish, publicize . . .)."[2]

Given all this ambivalence about "public," it is curious that public art has reemerged with such tenacity—and with its own enabling legislative initiatives—in the past two decades. After all, even the most banal public art requires a level of support and consensus. Why public art? To fill cities drained of civic content with new, conspicuous signs of collective effort? To transfuse new iconographies into public circulation because old ones provide only the most obvious and enervated ideas? Does public art attempt to reach new audiences—participants that formulate an equation between viewer and citizen, observer and actor? Or is it criticizing the dominant conventions of art practice and the cultural marketplace? Public art generally relocates reception and experience away from the accepted sites of aesthetic encounter; it provides its own (often cumbersome) apparatus for the production, distribution, and reception of art.

In the past twenty years, public art has presented, often inadvertently, a series of disturbing scenarios. Traditional public art has cheerfully cooperated with prevailing and questionable urban (and suburban) initiatives. For example, the carefully conceived, obsessively managed public art package at New York's Battery Park City is part of an overall aesthetic orthodoxy of the site. The design guidelines and policies of the ambitious development illustrate how aesthetics—art and design—are often an agent in social and environmental control. At worst, public art has been purposefully or unsuspectingly complicitous with repressive urban planning

practices, either endorsing irresponsible development and community displacement or serving as a diversion, a distracting attention from a contentious site.

Never an independent, autonomous event, public art is embedded in the political, economic, and ethical considerations of cities and communities. Thus it is important to question consistently, vigilantly: What are the politics governing the production of public art at a particular site? What is behind our backs when we stop to look at it? What does art encourage us to see—and urge us to overlook? Does public art involve the viewer in the complexities of urban experience, or is it offered as decoration or distraction, a sedative that quiets legitimate concerns or objections?

Perhaps the reappearance of public art in the last quarter of this century is not unlike Maryland's recent curricular initiatives. At a time of profound lethargy or impending crisis, aggressive legislation is enacted. Mandated community service becomes the training ground for future citizens in a participatory democracy. Is the reemergence of public art another acknowledgment that "public" is a concept which has almost ceased to exist in an instrumental way?

The many problematic manifestations of contemporary public art might offer another version of the Maryland debate. The current activity could convey a powerful belief that art can influence productive change—that it does have a recuperative social and political capacity to replenish a depleted public domain. Or perhaps, as the skeptics believe of the enforced volunteerism, the capacity of art to effect change at the public level will be short-lived, if not nonexistent.

It is instructive to pursue the connection between this recent compulsory amendment to school curricula and the past two decades of public art incentives such as percent-for-art programs and the emergence of other public and private agencies that sponsor temporary or permanent public art projects. Artists who accept the daunting challenges of this kind of aesthetic production must not only consider the changing conditions and uncertain destinies of local communities and cities (variables normally not encountered in the museum or gallery), but also seek to identify and coalesce an audience. How can one expect to have an engaged audience for a work when there are so few strategies to galvanize new publics other than

rigid mandates, self-conscious means, and exhausted models of volunteerism (as critics of the Maryland plan might suggest)? Where does the audience for public art come from if public life is so dangerously depleted?

Public art frequently is predetermined by its own bureaucracies, dulling legislation, and compromising requirements. While these mandates often support public art, they invariably thwart challenging ideas for fear of controversy. Public art becomes just another piece of evidence, another confirmation, of the fatigue of public life and the loss of urban vitality.

The designation "public art" once may have clarified formal characteristics and physical dimensions. Expectations were established about scale, presence, materials, and occasionally subject matter. Many communities installed public art as a confirmation of dominant ideologies, safe platitudes, spent recollections, or user-friendly aesthetics. Public art was placed in designated areas—in plazas, on walls. An orthodoxy of suitable sites and conditions for public art emerged. As often occurs, the defining parameters effectively rationalized the inflexible models applied to most public art projects. The legislation, administration, and cultural criticism that initially focused on a contemporary public art have served to separate it from a lively cultural debate.

Cities and communities have ample and disturbing evidence of the public art process gone awry, of art succumbing to the same grinding pressures that have led to the evacuation of the public domain. Some objects register little else than the tenacity it took to install them in a certain site—a "why bother?" manifestation of public art that has nothing to do with a renewed idea of public. Such work codifies the current paradox of "public." Is something public because everyone has a stake in it—or because no one feels responsible for it? While it is assumed that public is inclusive, itinerant occupants and absentee owners characterize a prevailing attitude about public spaces. Ownership is exaggeratedly privatized (in the case of the carefully supervised plazas provided by private corporations) or visibly unaccepted by any collective group. Innocuous art becomes just another public menace—and one that requires maintenance.

Given these sober observations, it is difficult to imagine why people require, or even desire, public art. What does the current production indicate? Although a sustained critical and theoretical discussion of public art

has faltered, significant signs point in new directions, suggesting an alternative cartography for travel and occupancy of the public domain. It remains uncertain what aptitudes will be required to inscribe and interpret these new maps.

Ironically, it was the arduous defeat of the narrow, exclusive, and privileged canons of modernism that enabled public art to reappear in modified forms in the seventies. The challenge to modernism expanded the contexts and circumstances in which art could occur. Bearing no representation of national significance, a new family of overscaled abstract sculpture made its way into the streets. Meaning was embedded not in historic events or values of national or regional significance, but in the artist's intention. Communication moved from the literal to the abstract.

This "enabling" atmosphere was also a dilemma from the very beginning. The dialogue of public art was handicapped by exhausted, inoperative models from the past—the equestrian statue or war monument. At the same time, the general public had little access to the new intellectual resources that contemporary art provided for considering the future. Overblown versions of studio-based sculpture were supplicants to a vacancy of meaning in the communities in which they were located.

While the concept of public fills a perceived void in cultural production, it continues to operate in a critical vacuum. There remain feelings that public art is a mutant—a difficult stepchild in the family of art, unworthy of the attention of devoted critics of culture and society. The powerful, provocative alchemy of "public" and "art" in the context of contemporary urban space has been only superficially examined. Any consideration of public art must ask and accept questions about social and political contexts. If "public" is going to be used as a qualifying characteristic of some art (and it is reasonable to consider whether this is a fruitful strategy or will instead eventually quiet or derail debate), then this mutable term requires vigilant review. Although there may be some essential—perhaps psychological—core to the experience of public, received layers are repeatedly developed and shed in the context of social and political change. The notion of public beings is a contingent concept. Any prolonged consider-

ation of public art means that observers/actors/citizens must constantly revisit and readjust their observations and ideas. The play of variables mixing from so many areas asks for constant, supple revision. Public is an animate idea.

In the past few years promising strategies of public art have emerged. A growing number of artists and agencies believe that the responsibility of public artists is not to create permanent objects for presentation in traditionally accepted public places but, instead, to assist in the construction of a public—to encourage, through actions, ideas, and interventions, a participatory audience where none seemed to exist. Inherent in public art is the issue of its reception. The formation of audience is the method and objective, the generative intention and the final outcome. Community involvement is the raw material of artistic practice. The more restive, speculative visions of public art require radical adjustments of expectation, thought, and perception. They implore citizens/viewers to discover the relation between art production and democratic participation.

For artists and organizations that have employed innovative, experimental strategies, aesthetic practice seeks a prolonged, productive correspondence between people and the public sphere; sometimes material productions may seem secondary to a more ambitious, long-term objective. Not surprisingly, there is concern whether this is actually a promising development in public art production. Are artists relinquishing their power as image makers in order to function as social catalysts? Has the work of artists moved beyond even the most generous, open-minded conception of an aesthetic practice?

Questions concerning the instrumentality of public art are essential but elusive. Can art change consciousness and affect actions? Can artists excite such persuasive—and enduring—dynamics in public life and local communities? Or is this another crazed, slightly megalomaniacal notion of the artist's influence and role in contemporary culture? New forms of public art do not relinquish the power of images, but their variable and volatile nature requires scrutiny. There is rarely an observable cause and effect, a reliable reading of art, response, and long-term implications. In a

contemporary environment dramatically altered by urban development, communication technologies, social realignments, and enhanced cultural identifications, artists have assumed unusual, multiple, and often complex roles.

Testing the boundaries of production, artists have become agents. Often engaged in long-term political processes that inform and form the work, they achieve results that, while not inconsequential, must be understood within an expanded time frame and conception of art practice. The work of the artist is art. In other words, the plans, preparations, and encounters with community members are demonstrated, insistent gestures that form the final results. Art requires a new reading that accepts work—production—as the site of praxis and meaning. Not an empirical, direct cause-and-effect process, public art cannot be endorsed or refuted by quantifiable data.

As a critic, I have encouraged expanded conceptions of the artist and public art. Artists do not have to predictably assume a narrow role or place of practice. Historically, they have served many capacities in diverse cultures and regions; contemporary artists can embrace this rich legacy in the emergence of their own philosophy of cultural work.

Public art criticism can—and must—move beyond limiting ideas. Critics have either relied on traditional forms of analysis that privilege art over context, or they have erred by defining a taxonomy of public art so precisely that discourse deteriorates to a rarefied, exclusive position. Given the extremes, public art is severed from the public sphere and popular culture theory, or it is isolated from art theory. New critical strategies have attempted to transcend these extreme positions, often exploring extra-artistic concepts. Metaphors of time or place, for example, offer access to the issues raised by a public, aesthetic practice.

More speculative proposals of artists' roles and public art have caused many to wonder, "Where's the art?" This leading rhetorical question may in fact open new passages for the future. The questions—and controversies—that art raises can consolidate an audience of citizens/participants. In *The Human Condition* Hannah Arendt observed: "What makes mass society so difficult to bear is not the number of people

involved, or at least not primarily, but the fact that the world between them has lost its power to gather them together to relate and also to separate them."[3] In her thoughts on mass society, Arendt made an essential observation about the challenges of contemporary public art. Public art is not the grinding, arduous discovery of a common denominator that absolutely everyone will understand and endorse. It actually assists in the identification of individuals and groups and what separates them, so that agreement on a common purpose is an impassioned deliberation rather than a thoughtless resignation.

Public art can convene a constituency to engage in collective exploration—even a difficult interrogation—of public ideas, individual requirements, and communitarian values. It accepts the differences and constituencies inherent in public life that can be focused on a singular idea.

Public art needs to pursue and support strategies that encourage artists, critics, and audiences to accept the instrumentality of art. For all of the recent bashing of the monument, it is still a dominant model. Fixed objects and circumscribed sites frequently confirm recalcitrant aesthetics and inflexible notions of public. In this difficult, uncertain, but perhaps hopeful time of change, public art needs to be a more modest, transitional, revisable, and sustained activity in communities. Often, short-lived projects and more negotiable ideas of public art can challenge and galvanize. There need to be many small excursions that consider and embrace the multiple conditions of public life—and not the singular view promoted by the sponsor of projects, the public agency, or the private developer.

Artists who choose to explore public and space as subjects need to poach and intervene in existing systems and situations rather than simply create new independent objects for contemplation. Objects that people can live without proliferate, images to which they must bring skeptical, involved observation grow more abundant. If public art is to exist in the future (and there is reason to doubt its viability unless new methods are embraced), the inherent radicality of its objectives and processes must be accepted. Public art implies significant social, political, and aesthetic agendas. If it is not truly about something *other* than the conditions and

restrictions of private art production and distribution, then a continued distinction is not only inappropriate but misleading.

The critic is not exempt from the unaccepted challenges of contemporary public art. The critic's role in a future public art is to examine the prevailing legend of cheerful amendments of art in unconscionable situations. Criticism can help to give artists courage for new ideas and elevate the audience's (the public's) expectations of public art. Criticism can assist in the creation of environments in which citizens/participants can pursue different sight lines through democratic discussion. The critic offers an intellectual space and opens the possibility of many kinds of images, encounters, and occupancies of the public realm. Critics and artists must explore inventive, intellectual partnerships that have not existed before. In the reliably random, increasingly frayed edges of cities and communities, both art and criticism are summonses for active, connected public beings.

Public art cannot mend, heal, or rationalize a nostalgia-driven desire to return to less volatile times. It can, however, provide routes to new conceptions of community so that the fragmented elements of personal experiences and the epic scale of urban dramas collaborate to define a contemporaneous idea of public. Public art appeals for serious, spirited response to the daunting complexity of contemporary issues; it requires agile readings of art and life. Public art is about the free field—the play— of creative vision. The point is not just to produce another thing for people to admire, but to create an opportunity—a situation—that enables viewers to look back at the world with renewed perspectives and clear angles of vision. This image embraces the instrumentality, intimacy, and criticality of public art. Public life cannot be decreed; it has to be constantly reinvented. Meaning is not missing in action; it is made through the constructive, collaborative process called "the public." Sometimes overlooked, often misread, public art is a sign of life.

NOTES

1. Henry A. Giroux, "The Hope of Radical Education," in *What Schools Can Do*, ed. Kathleen Weiler and Candace Mitchell (Albany, N.Y.: State University of New York Press, 1992), p. 14.

2. Mark Lewis, "Introduction: Remembering Signs of the New," *Public* 6 (1992), p. 6.

3. Hannah Arendt, *The Human Condition* (Chicago: University of Chicago Press, 1958), pp. 52–53.

Section Two } CALL AND RESPONSE:
PARADIGMS FOR PUBLIC ART

CONNECTIVE AESTHETICS: ART AFTER INDIVIDUALISM ⟩ *Suzi Gablik*

As a critic in the nineties, I am not really interested in writing catalog essays or art reviews. What I am concerned with is understanding the nature of our cultural myths and how they evolve—the institutional framework we take for granted but which nevertheless determines our lives. One question that has preoccupied me, for instance, is what it means to be a "successful" artist working in the world today, and whether the image that comes to mind is one we can support and believe in. Certainly it seems as if that image is undergoing a radical re-visioning at this time.

The dominant modes of thinking in our society have conditioned us to characterize art primarily as specialized objects, created not for moral or practical or social reasons, but rather to be contemplated and enjoyed. Within the modern era, art was defined by its autonomy and self-sufficiency, and by its isolation from the rest of society. Exposing the radical autonomy of aesthetics as something that is not "neutral" but is an active participant in capitalist ideology has been a primary accomplishment of the aggressive ground-clearing work of deconstruction. Autonomy, we now see, has condemned art to social impotence by turning it into just another class of objects for marketing and consumption.

Manic production and consumption, competitive self-assertion, and the maximizing of profits are all crucial to our society's notion of success. These same assumptions, leading to maximum energy flow and mindless waste at the expense of poorer countries and of the environment, have also become the formula for global destruction. Art itself is not some ancillary phenomenon but is heavily implicated in this ideology. In the art world, we are all aware of the extent to which a power-oriented, bureaucratic professionalism has promoted a one-sided, consumeristic attitude toward art. Institutional models based on notions of product development and career achievement echo the stereotypic patriarchal ideals and values that

have been internalized by our whole culture and made to pervade every experience. It is not hard to see how the institutions and practices of the art world have been modeled on the same configurations of power and profit that support and maintain our society's dominant worldview. This "business as usual" psychology of affluence is now threatening the ecosystem in which we live with its dysfunctional values and way of life; it is a single system manipulating the individual into the spiritually empty relationship of the producer to the product.

Many people are aware that the system isn't working, that it is time to move on and to revise the destructive myths that guide us. Our entire cultural philosophy and its narrowness of concern are under intense scrutiny. Among artists, there is a greater critical awareness of the social role of art, and a rejection of modernism's bogus ideology of neutrality. Many artists now refuse the notion of a completely narcissistic exhibition practice as the desirable goal for art. For instance, performance artist Guillermo Gómez-Peña states: "Most of the work I'm doing currently comes, I think, from the realization that we're living in a state of emergency. . . . I feel that more than ever we must step outside the strictly art arena. It is not enough to make art." In a similar vein, arts administrator Linda Frye Burnham has claimed that gallery art has lost its resonance for her, especially gallery art by what she terms "white yuppies." "There is too much going on outside," she says. "Real life is calling. I can no longer ignore the clamor of disaster—economic, spiritual, environmental, political disaster—in the world in which I move." Perceptions such as these are a direct challenge to the artist's normative sense of his or her role in the world: at stake is one's personal identity in relation to a particular view of life that our culture has made available to us.

That the art world's values, structures, and behaviors are in great ferment has been evident for some time, and the deconstructions of the eighties continue to reverberate profoundly. A climax in these upheavals was reached for many with the controversial 1993 Biennial at the Whitney Museum of American Art—the first multicultural and political Biennial—which demonstrated that the art world is undergoing a dismantling of its professional elitism and that its closed, self-referential ranks are under

heavy siege. Much of the new art focuses on social creativity rather than on self-expression and contradicts the myth of the isolated genius—private, subjective, behind closed doors in the studio, separate from others and the world. As I shall argue in this essay, creativity in the modern world has gone hand in hand with individualism and has been viewed strictly as an individual phenomenon. I believe this conception of art is one of the things that are now changing.

As the work of artists who are discussed in this book makes clear, there is a distinct shift in the locus of creativity from the autonomous, self-contained individual to a new kind of dialogical structure that frequently is not the product of a single individual but is the result of a collaborative and interdependent process. As artists step out of the old framework and reconsider what it means to be an artist, they are reconstructing the relationship between individual and community, between art work and public. Looking at art in terms of social purpose rather than visual style, and setting a high priority on openness to what is Other, causes many of our cherished notions to break down: the vision of brisk sales, well-patronized galleries, good reviews, and a large, admiring audience. As Richard Shusterman writes in *Pragmatist Aesthetics,* "The fact that our entrenched institutions of art have long been elitist and oppressive does not mean that they must remain such. . . . There is no compelling reason to accept the narrowly aesthetic limits imposed by the established ideology of autonomous art."

In February 1994, I had occasion to tape a conversation with the art dealer Leo Castelli, in which he commented about the Whitney show: "It was a sea change, not just any change. Because I had to accept the fact that the wonderful days of the era that I participated in, and in which I had played a substantial role, were over." In *Has Modernism Failed?* I wrote, "Generally speaking, the dynamics of professionalization do not dispose artists to accept their moral role; professionals are conditioned to avoid thinking about problems that do not bear directly on their work." Since writing this a decade ago, it seems as if the picture has changed. The politics of reconceptualization has begun, and the search for a new agenda for art has become a conscious search.

In considering the implications of this "sea change," one thing is clear: to be able to see current aesthetic ideology as actively contributing to the most serious problems of our time means breaking the cultural trance and requires a change of heart. The whole framework of modernist aesthetics was tied to the objectifying consciousness of the scientific worldview; like scientists, artists in our culture have been conditioned not to worry about the applications or consequences or moral purpose of their activity. It is enough to generate results. But just as the shortcomings of "objective" science are becoming apparent, we are also beginning to perceive how the reductive and neutralizing aspects of aesthetics and "art for art's sake" have significantly removed art from any living social context or moral imperative except that of academic art history and the gallery system. We are beginning to perceive how, by disavowing art's communal dimension, the romantic myth of autonomous individualism has crippled art's effectiveness and influence in the social world.

The quest for freedom and autonomy has been nowhere better summarized for me than in these comments by the painter Georg Baselitz, published in the catalog of his exhibition at the Whitechapel Art Gallery in London in 1983:

The artist is not responsible to anyone. His social role is asocial; his only responsibility consists in an attitude to the work he does. There is no communication with any public whatsoever. The artist can ask no question, and he makes no statement; he offers no information, and his work cannot be used. It is the end product which counts, in my case, the picture.

More than a decade old, these comments by now may sound hopelessly out of date, but in a more recent interview in *Art News*, it was clear that the artist had in no way altered his views. "The idea of changing or improving the world is alien to me and seems ludicrous," Baselitz said. "Society functions, and always has, without the artist. No artist has ever changed anything for better or worse." Hidden behind these comments is the personal and cultural myth that has formed the artist's identity in the modern world: the myth of the solitary genius whose perfection lies in absolute independence from the world. "Life is so horrible," Gustave

Flaubert wrote at the beginning of the modern era, "that one can only bear it by avoiding it. And that can be done by living in the world of art." For Jean-Paul Sartre, the existential truth of the human situation was its contingency, man's sense that he does not belong—is not necessary—to the universe. Since life was arbitrary and meaningless, Sartre advised that we must all learn to live without hope, and the English writer Cyril Connolly summed up a whole cultural ethos of alienation with these now legendary comments: "It is closing time in the gardens of the West. From now on an artist will be judged only by the resonance of his solitude and the quality of his despair." Writing about this form of ontological distrust, this vote of "no confidence" in the universe, Colin Wilson in *An Introduction to the New Existentialism* refers to the paradigm of alienation as the "futility hypothesis" of life—the nothingness, estrangement, and alienation that have formed a considerable part of the image we have of ourselves.

My friend Patricia Catto, who teaches at the Kansas City Art Institute, now refers to this particular mind-set as "bad modernism." In a course she gives on reframing the self, her students are instructed about the danger of believing that humans (whether they are artists or not) are somehow outside of, or exempt from, a responsibility to society, or to the environment. We have been taught to experience the self as private, subjective, separate, from others and the world. This notion of individualism has so completely structured artistic identity and colored our view of art that even for an artist like Christo, whose public projects such as *Running Fence* and the more recent *Umbrellas* require the participation and cooperation of thousands of people, inner consciousness is still dominated by the feeling of being independent, solitary, and separate. In an interview in *Flash Art,* Christo commented:

The work of art is irrational and perhaps irresponsible. Nobody needs it. The work is a huge individualistic gesture that is entirely decided by me. . . . One of the greatest contributions of modern art is the notion of individualism. . . . I think the artist can do anything he wants to do. This is why I would never accept a commission. Independence is most important to me. The work of art is a scream of freedom.

Christo's scream of freedom is the unwavering, ever-present moral imperative that continues to be brandished politically as well as philosophically in all the modern traditions of Western thought. It reverberated loudly in the intense controversy that raged for several years over the proposed removal of Richard Serra's commissioned sculpture *Tilted Arc* from its site at Federal Plaza in downtown Manhattan. Although conceived specifically for the site, the seventy-three-ton leaning curve of welded steel, which was installed in 1981 by the government's Art in Architecture Program, proved so unpopular and obstructive to local office workers that they petitioned to have it removed. As one employee of the U.S. Department of Education stated at the time: "It has dampened our spirits every day. It has turned into a hulk of rusty steel and clearly, at least to us, it doesn't have any appeal. It might have artistic value but just not here . . . and for those of us at the plaza I would like to say, please do us a favor and take it away."

Serra's response, awash in the spirit of "bad modernism," was to sue the government for thirty million dollars because it had "deliberately induced" public hostility toward his work and tried to have it forcibly removed. To remove the work, according to Serra, was to destroy it. Serra sued for breach of contract and violation of his constitutional rights: ten million dollars for his loss of sales and commission, ten million for harm to his artistic reputation, and ten million in punitive damages for violation of his rights. In July 1987, the Federal District Court ruled against Serra, and in March 1989, the sculpture was removed from the site.

What the *Tilted Arc* controversy forces us to consider is whether art that is centered on notions of pure freedom and radical autonomy, and subsequently inserted into the public sphere without regard for the relationship it has to other people, to the community, or *any* consideration except the pursuit of art, can contribute to the common good. Merely to pose the question, however, indicates that what has most distinguished aesthetic philosophy in the modern paradigm is a desire for art that is absolutely free of the pretensions of doing the world any good. "I don't know what public art is, really," the sculptor Chris Burden once said. "I just make art. Public art is something else, I'm not sure it's art. I think it's

about a social agenda." Just as disinterested and "value-free" science contains no inner restraint within its methodology that would limit what it feels entitled to do, "value-free" aestheticism reveals nothing about the limits art should respect, or the community it might serve.

Modernist aesthetics, concerned with itself as the chief source of value, did not inspire creative participation; rather, it encouraged distancing and depreciation of the Other. Its nonrelational, noninteractive, nonparticipatory orientation did not easily accommodate the more feminine values of care and compassion, of seeing and responding to need. The notion of power that is implied by asserting one's individuality and having one's way through being invulnerable leads, finally, to a deadening of empathy. The model of the artist as a lone genius struggling against society does not allow us to focus on the beneficial and healing role of social interaction, nor does it lend itself to what philosopher David Michael Levin calls "enlightened listening," a listening that is oriented toward the achievement of shared understandings. As Levin writes in *The Listening Self,* "We need to think about 'practices of the self' that *understand* the essential intertwining of self and other, self and society, that are aware of the subtle complexities of this intertwining."

Certainly the sense of being isolated from the world and alone with one's creations is a common experience for artists in our culture, the result of modernism's historic failure to connect with the archetypal Other. As Nancy Fraser puts it in her book *Unruly Practices:* "The monologic view is the Romantic individualist view in which . . . a solitary voice [is] crying out into the night against an utterly undifferentiated background. . . . There is no room for a reply that could qualify as a different voice. There is no room for interaction." "The artist considers his isolation, his subjectivity, his individualism almost holy," states film director Ingmar Bergman. "Thus we finally gather together in one large pen, where we stand and bleat about our loneliness without listening to each other and without realizing that we are smothering each other to death." "Art cannot be a monologue," the French writer Albert Camus once wrote. "Contrary to the current presumption, if there is any man who has no right to solitude, it is the artist."

All of which brings me directly to the question of whether art can build community. Are there viable alternatives to viewing the self in an individualistic manner? And if so, how does this affect our notion of "success"? Can artists and art institutions redefine themselves in less spectatorially oriented ways in order to regain the experience of interconnectedness—of subject and object intertwining—that was lost in dualistic Enlightenment philosophies, which construed the world as a spectacle to be observed from afar by a disembodied eye?

When California artist Jonathan Borofsky and his collaborator, Gary Glassman, traveled in 1985–86 to three different prisons in California in order to make their video documentary *Prisoners,* they did not go in the mode of network reporters intending to observe at a distance and then describe the conditions they found. Instead they went to *listen* to the prisoners in order to try and understand their plight. They wanted to understand for themselves what it means to be a prisoner in this society, to lose your freedom and live your life locked up in a cement box. Borofsky and Glassman invited prisoners to talk about their lives and about what had gone wrong for them. In the video some of the prisoners share poems they have written or show artworks they have made. Conversing with the video makers, they describe the oppressiveness of life inside a prison, where everything is programmed and people never get to talk spontaneously about themselves because no one is interested. The knowledge that one is being heard, according to Glassman, creates a sense of empowerment.

In Suzanne Lacy's *The Crystal Quilt,* performed in Minneapolis on Mother's Day in 1987, a procession of 430 older women, all dressed in black, sat down together at tables in groups of four, to discuss with each other their accomplishments and disappointments, their hopes and fears about aging, in a ceremonially orchestrated artwork. A prerecorded sound track of the voices of seventy-two women at the tables projected their reflections loud enough to be heard by the audience. "We're no longer sitting home in the rocking chair and knitting, like you think of grandmas in the old days. We grandmas aren't doing that anymore," comments one of the women on the audiotape. "I think a lot of senility comes from the

fact that nobody asks you anything," states another. "Nobody asks you to speak. Pretty soon, you lose your memory. I suffer a lot from people not listening to me."

Empathic listening makes room for the Other and decentralizes the ego-self. Giving each person a voice is what builds community and makes art socially responsive. Interaction becomes the medium of expression, an empathic way of seeing through another's eyes. "Like a subjective anthropologist," writes Lacy, "[the artist enters] the territory of the other, and . . . becomes a conduit for [their] experience. The work becomes a metaphor for relationship—which has a healing power." When there is no quick fix for some of our most pressing social problems, according to Lacy, there may be only our ability to witness and feel the reality taking place around us. "This feelingness is a service that artists offer to the world," she says.

After Mierle Laderman Ukeles became the unsalaried, self-appointed artist-in-residence at the New York City Sanitation Department in 1978, she went on rounds with sanitation workers and foremen from fifty-nine municipal districts, talking with them and getting to know them. Her first piece of art was a performance work called *Touch Sanitation*, which went on for eleven months. During that time she visited the five boroughs of New York and shook hands with 8,500 workers. "It was an eight-hour-day performance work," she states. "I'd come in at roll call, then walk their routes with them. . . . I did a ritual in which I faced each person and shook their hand; and I said, 'Thank you for keeping New York City alive.' The real artwork is the handshake itself. When I shake hands with a sanitation man . . . I present this idea and performance to them, and then, in how they respond, they finish the art." *Touch Sanitation* was Ukeles's first attempt to communicate as an artist with the workers, to overcome barriers and open the way to understanding—to bring awareness and caring into her actions by listening.

Art that is rooted in a "listening" self, that cultivates the intertwining of self and Other, suggests a flow-through experience which is not delimited by the self but extends into the community through modes of reciprocal empathy. Because this art is listener-centered rather than vision-oriented, it cannot be fully realized through the mode of self-expression; it

can only come into its own through dialogue, as open conversation, in which one listens to and includes other voices. For many artists now, this means letting previously excluded groups speak directly of their own experience. The audience becomes an active component of the work and is part of the process. This listening orientation challenges the dominant ocularcentric tradition, which suggests that art is an experience available primarily to the eye, and represents a real shift in paradigms. As David Michael Levin states in *Modernity and the Hegemony of Vision*, "This may be the time, the appropriate historical moment, to encourage and promote a shift in paradigms, a cultural drift that, to some extent, seems already to be taking place. I am referring, of course, to the drift from seeing to listening, and to the historical potential for a paradigm shift displacing vision and installing the very different influence of listening."

New models put forward by quantum physics, ecology, and systems theory that define the world in terms of interacting processes and relational fields call for integrative modes of thinking that focus on the relational nature of reality rather than on discrete objects. Lacy states, "Focusing on aspects of interaction and relationship rather than on art objects calls for a radical rearrangement in our expectations of what an artist does." It calls for a different approach to making art and requires a different set of skills. To transcend the modernist, vision-centered paradigm and its spectatorial epistemology, we need a reframing process that makes sense of this more interactive, intersubjective practice which is emerging. We cannot judge the new art by the old standards. "Informed by an interactive and receptive normativity, listening generates a very different *episteme* and ontology—a very different metaphysics," writes Levin.

Modernism's confrontational orientation resulted from deep habits of thinking that set in opposition society and the individual as two contrary and antagonistic categories, neither of which could expand or develop except at the expense of the other. The free and self-sufficient individual has long been the ideal of our culture, and artists especially have seen themselves as quintessential free agents, pursuing their own ends. But if modernism, and the art that emerged with it, developed around the notion of a unique and separate self, the art generated by what I have called

"connective aesthetics" is very different. As I have argued in *The Reenchantment of Art,* radical relatedness has dramatic implications for our understanding of art and contributes to a new consciousness of how the self is to be defined and experienced. For one thing, the boundary between self and Other is fluid rather than fixed: the Other is included within the boundary of selfhood. We are talking about a more intersubjective version of the self that is attuned to the interrelational, ecological, and interactive character of reality. "Myself now includes the rainforest," writes Australian deep ecologist John Seed. "It includes clean air and water."

The mode of distanced, objective knowing, removed from moral or social responsibility, has been the animating motif of both science and art in the modern world. Objectivity strips away emotion, wants only the facts, and is detached from feeling. Objectivity serves as a distancing device, presuming a world that stands before us to be seen, surveyed, and manipulated. How, then, can we shift our usual way of thinking about art so that it becomes more compassionate? How do we achieve the "world view of attachment"—attachment to and continuity with the world—that archetypal psychologist James Hillman talks about? To see our interdependence and interconnectedness is the feminine perspective that has been missing not only in our scientific thinking and policy making but in our aesthetic philosophy as well. Care and compassion do not belong to the false "objectivism" of the disinterested gaze; care and compassion are the tools of the soul, but they are often ridiculed by our society, which has been weak in the empathic mode. Gary Zukav puts it well in *The Seat of the Soul,* when he states that there is currently no place for spirituality, or the concerns of the heart, within science, politics, business, or academia. Zukav doesn't mention art, but until recently there has been no particular receptivity there either.

Not long ago, I had occasion to share a lecture podium with the critic Hilton Kramer, who proclaimed, with the force of a typhoon, that art is at its best when it serves only itself and not some other purpose. Things that in his opinion have no relation to art are now being accepted and legitimized as art when, according to Kramer, art is incapable of solving any problems but aesthetic ones. I would argue that much of the work

included in this book contradicts, absolutely, these comments. However, there is no denying that the art world subtly disapproves of artists who choose interaction as their medium, rather than the disembodied eye. Just as creativity in the Western world has been based on an understanding of the self as autonomous and separate, the hegemony of the eye is very strong in our culture. We are obsessed with the gaze. At this point, to challenge the vision-centered paradigm by undermining the presumed spectatorial distance of the audience, or by empowering others and making them aware of their own creativity, is to risk the complaint that one is producing not art but social work. Personally, I have never heard of a social worker who was interested in shaking hands with 8,500 sanitation workers, or who tried to orchestrate a public conversation among four hundred older women about aging. Social workers proceed quite differently from artists in what they do.

To all these objections, I can only say that comparing models of the self based on isolation and on connectedness has given me a different sense of art than I had before and has changed my ideas about what is important. My conclusion is that our culture's romance with individualism is no longer adequate. My own work and thinking have led me to a fieldlike conception of the self that includes more of the environment—a selfhood that releases us into a sense of our radical relatedness. It seems that in many spheres we have finally come up against the limits of a worldview based only on individualism. In the field of psychotherapy, to give just one example, James Hillman, in his book *We've Had a Hundred Years of Psychotherapy—And the World's Getting Worse,* castigates therapy for encouraging us to disengage from the world. He maintains that therapy increases our preoccupation with individual fulfillment and personal growth at the expense of any concern for community or the communal good. Many hackles have been raised in the therapeutic community by Hillman's assertion that therapy has become a self-improvement philosophy which turns us inward, away from the world and its problems. Psychotherapy is only working on the "inside" soul, according to Hillman, while outside, the buildings, the schools, the streets, are sick—the sickness is out there. The patient in need of healing is the world.

Connective aesthetics strikes at the root of this alienation by dis-
solving the mechanical division between self and world that has prevailed
during the modern epoch. World healing begins with the individual who
welcomes the Other. In Ukeles's work, for instance, empathy and healing
are the parameters, the test of whether the work is, in fact, being carried
out paradigmatically. The open hand, extended to each worker, evokes
qualities of generosity and care. We need to cultivate the compassionate,
relational self as thoroughly as we have cultivated, in long years of abstract
thinking, the mind geared to scientific and aesthetic neutrality. As more
people acknowledge the need for a new philosophical framework, we are
learning to go beyond our culture of separation—the gender, class, and
racial hierarchies of an elite Western tradition that has evolved through a
process of exclusion and negation.

With its focus on radical individualism and its mandate of keeping art
separate from life, modern aesthetics circumscribed the role of the audience
to that of a detached spectator-observer. Such art can never build commu-
nity. For this we need interactive and dialogical practices that draw others
into the process and challenge the notion, in the words of Gary Snyder, that
"only some people are 'talented' and they become artists and live in San
Francisco working in opera and ballet and the rest of us should be satisfied
with watching television." Connective aesthetics sees that human nature is
deeply embedded in the world. It makes art into a model for connectedness
and healing by opening up being to its full dimensionality—not just the
disembodied eye. Social context becomes a continuum for interaction, for a
process of relating and weaving together, creating a flow in which there is
no spectatorial distance, no antagonistic imperative, but rather the reciproc-
ity we find at play in an ecosystem. Within a listener-centered paradigm, the
old specializations of artist and audience, creative and uncreative, profes-
sional and unprofessional—distinctions between who is and who is not an
artist—begin to blur.

To follow this path, I would argue, is more than just a matter of
personal taste; it represents the opening of an experimental space in which
to institute and practice a new art that is more in tune with the many inter-

active and ecological models emerging in our culture. I believe we will see over the next few decades more art that is essentially social and purposeful, and that rejects the modernist myths of autonomy and neutrality. This book bears witness to the increasing number of artists who are rejecting the product orientation of consumer culture and finding ever more compelling ways of weaving environmental and social responsibility directly into their work. In this complex and worthy endeavor, I sincerely wish them well.

BIBLIOGRAPHY*

Fraser, Nancy. *Unruly Practices: Power, Discourse and Gender in Contemporary Social Theory*. Minneapolis: University of Minnesota Press, 1989.

Gablik, Suzi. *Has Modernism Failed?* New York and London: Thames and Hudson, 1984.

_____. *The Reenchantment of Art*. New York and London: Thames and Hudson, 1991.

Hillman, James, and Michael Ventura. *We've Had a Hundred Years of Psychotherapy—And the World's Getting Worse*. New York: HarperCollins, 1992.

Levin, David Michael. *The Listening Self: Personal Growth, Social Change and the Closure of Metaphysics*. New York and London: Routledge, 1989.

_____, ed. *Modernity and the Hegemony of Vision*. Berkeley and Los Angeles: University of California Press, 1993.

Shusterman, Richard. *Pragmatist Aesthetics: Living Beauty, Rethinking Art*. Oxford, England, and Cambridge, Mass: Blackwell, 1992.

Wilson, Colin. *An Introduction to the New Existentialism*. New York: Houghton Mifflin, 1967.

Zukav, Gary. *The Seat of the Soul*. New York: Simon and Shuster, 1989.

**In keeping with the nonacademic format of her previous two books, the author chooses to eliminate footnotes from her writing.*

TO SEARCH FOR THE GOOD AND MAKE IT MATTER 〉 *Estella Conwill Májozo*

To search for the good and make it matter: this is the real challenge for the artist. Not simply to transform ideas or revelations into matter, but to make those revelations actually matter. This quest is measured as much in the truths we attempt to enflesh as in the clay we might aesthetically design. At best, artistic works not only inspire the viewer but give evidence of the artist's own struggle to achieve higher recognition of what it means to be truly human. The works are testaments to the artist's effort to convert a particular vision of truth into his or her own marrow.

As I meditated on the theme of this book, I found myself thinking about territories, both public and private—about political turf and definitive lines, those that exclude and those that include. I began to reflect on the earth and all the redrawn borders that we who are involved in public art must bring to the map if there are to be positive new directions for the world's cultures. I found myself contemplating, as any artist might, the corresponding territory—the terrain of the soul, that sacred space within the self that must be acknowledged and tended, that dream space where Eden and womb are ritualistically related, where conception is possible, where we can receive in order to give again.

The dream space of the soul is the real terrain that we should map. If not, then nothing else that we are fighting for or against has any possibility of transformation: not the militarism that we resist, not the oppression we deplore, not the toxic waste dumping on the land of the poor, not the racism or the sexism that we expose. None of these concerns can be taken on unless they are examined, acknowledged, and confronted within the inner territory of the self, the earth that, in fact, we are.

The soul is the seedbed of our actions. Everything that we conceptualize, create, or destroy has its beginnings there. What we see cultivated and thriving in the outer terrain is a manifestation of our inner creative or destructive impulses. There is connectedness between what we see in the

world and who we are, between who we are and what we do. The artist tends the private garden of the soul and gives evidence of this process publicly through the art that, in turn, inspires others to tend their own gardens.

The often-asked question as to how one moves from being artist to activist I find interesting, because I do not make the separation in my own mind. For me, the two roles exist as a single entity: the artist *is* the activist. Indeed, within the African tradition, the artist's work has a function just like everything else in the world. As the mask is for festivals, and the ground-drawing for marking a sacred space, and the dance for healing and drawing energies to oneself, so, too, the rituals that we perform and the monuments that we make have a function: the transformation of self and community, which is the extended self. Art is a necessity, as the poet Audre Lorde says, not a luxury. The assumption that art could be something separate from the life that sustains us, that art is indeed a luxury, is as false a theory as the notion that the outer terrain can undergo transformation without affecting the soul. And yet, many believe that the places outside, in the world, are the true sites of change. Notions of separation and otherness are ingrained in Western thought, and it is this very way of thinking that has wreaked havoc on the cultures of the world.

While no single culture has a copyright on truth, perhaps embracing an African view of the intrinsic connectedness of all things would help us to recall the mother from whom we have all come. And in remembering her, perhaps we can begin more profoundly to "re-member" ourselves. This charge of remembering the mother is important because without it our cultural and cross-cultural amnesia is never lifted; our common humanity is never fully acknowledged. We never know who we are, and having no true identity, we end up like a person who suffers amnesia, fearing every face that is not the exact replication of our own. And sometimes in our desperation, we even fear our own face. We never develop a sense of continuity or wholeness among people. The cultures that remember this connectedness are recalling the crucial element that has been part of our survival since our beginning.

The artists who remember our common humanity and instigate recognition of our true nature are those like Anna Halprin, who would have people living with AIDS and those who are not afflicted circle the

earth in a dance in an attempt to break down the barriers of fear. They are those like Suzanne Lacy, who would produce a crystal quilt of women whose choreographed laying on of hands helped change the patterns of their lives and make visible the bonding and power among them. They are those like Mel Chin, who would move us into the mystery of metaphor by working with scientists to develop hybrid plants that absorb poisons from the earth into leaves which can be plucked from our children's surroundings. They are those like the husband and wife team Newton and Helen Mayer Harrison, who have collaborated for over twenty years, and Mierle Laderman Ukeles, artist-in-residence of the New York City Sanitation Department, and Sheila Levrant de Bretteville, and Peter Jemison, and many more who recognize the illusion of duality, the miracle of collaboration, and the beauty of making truth matter.

None of this is to suggest that the aesthetic quality of any work need ever be sacrificed. I say this knowing that it is a critical issue of public art projects involving community participants who are not necessarily artists. Somehow, it is feared, the participants' aesthetics will bring down the quality of the work. But since the aesthetic is determined by the artist, perhaps this is not the ultimate fear of those who are leery of the new, more collaborative public art. Perhaps the greater fear is that elitism will be destroyed, that the function of art will once again be recognized, that freedom of expression will carry the impulse and stark beauty of our first breath, and that our own relevance as human beings will come to be seen in the meaning of our acts. If this is what is so fearful, then we must continue to make such art and to redefine the ways in which the making is itself a celebrated process.

In deciphering the mystery of this process, the blues form, or formula, from African American culture can provide insight. As ethno-musicologists tell us, the blues has three lines: the first line is the call, the second is the response, and the third is the release. The second line might be the same as the first but with some slight variation, and the last is a departure. The last line rhymes with the first and, essentially, sets you free. The whole notion is transcendence, as exemplified in this stanza I composed for illustration:

Water water you ain't so blue
I say, water water you ain't so blue
I done checked for myself and there's a sky in you.

This form—call, answer, and release—is a metaphor for art itself and the potential that it holds. The call is incited by the experiences we have with the world, by the human conditions and predicaments within our terrain that arouse our interest or consciousness. Next comes the response, the artist's creation—the attempt to name, recognize, and instigate change through his or her creative expression. But the artist's creation is not the end of the process, as it is often thought to be. The process continues as members of the community experience the release, the inspiration that allows them to enflesh the message and begin activating change in their own terrains.

This basic human-to-human interaction signals the symbiotic relationship among human beings. When we understand this, we can go on to better appreciate the breath dynamic between ourselves and the trees. We can understand our relationship to oceans and ozones and other zones within the universe.

The blues form is not about being down and out. The blues calls to and transforms the hollerer, and continues on to transform the community. It makes those singers willing to "work the sound" into new and knowing people who go about the business of making the truth matter. Bessie Smith could not leave halfway through a concert. We, as the communal singer, cannot afford to do it either. The poet Maya Angelou reminds us that our depth of experience is in direct proportion to the dedication of our artists. Indeed, we artists have to sing the second line in such a way as to signal the possibility for variation in the song. We have to create relevant art, art that invites its audience into the creative process and empowers them. We must sing in such a way as to promise our listeners who would become singers that the third line is a breakthrough, proclaiming without a doubt that "I done checked for myself and there's a sky in you."

It seems to me that in order for this transformation to happen, we artists must prepare ourselves to respond creatively and appropriately to

the calls in our environment. This is no small chore, especially for those of us in the public realm, who find ourselves taking on challenging, often emotionally draining issues; writing and rewriting proposals to obtain funding for projects; meeting for what seems like an entire lifetime with artistic collaborators; addressing community participants and relentlessly rallying their interest in the project; getting no funding at all, or just enough to present only half of the envisioned project; meeting again with collaborators about the meeting on the meeting; encountering those critics who themselves have not decided to be imaginative in their own work; and, last but not least, never finishing because we are still actively listening to the community's response and remaining sensitive to the sounds and feelings in both the inner and outer life.

To be an artist amid all these currents is demanding. How is the artist to prepare? Development of one's craft and keen awareness of one's surroundings are important but are hardly enough. To be able to make truly visionary art, we artists must have in our lives the crucial element called dream time, that is, time when we leave this world and go into our own sacred space, seeking the grace needed to create our work. Dream time holds the turmoil and trauma of the world at bay and allows the vision to be granted and the healing notes to attune us.

Some sound levels in the world's chaos can be deafening. Our work in the outer terrain can become so demanding that we think we cannot stop to meditate. But this deliberate pausing is also part of our work, and, in reality, it may be the only thing that distinguishes us from those community members who simply cannot make the time to take this inner space. Yet they are depending as much on us to hear the calls and to sound the first responses as we are depending on them to form a chorus for the song in order to release the healing and magnify the truth. And as odd as it may sound, this is the native territory of the public artist. It is a space to which the community, time and time again, banishes us for its own salvation, a space that we ourselves eventually choose as a healing haven and hallowing cave. The soul, a difficult but necessary terrain of retreat, holds the blueprint, or one might say the "blues-print," of the world we inhabit.

Though the encounter with dream time is enlivening, it can also be frightening. The problem is not our descent into the soul; it is our emergence, or coming forth. Once we emerge, we must begin reconciling what we have come to know with what we still see in the world. We tell ourselves there is no time to retreat; we tell ourselves anything to keep from repeating the ritual of departure. But if we do succeed in avoiding future descents into the soul, we will more than likely fall into the trap of making art that is simply creative rather than truly visionary.

There is, indeed, a distinction between creative art and visionary art. It parallels the difference between the artist who is an observer, or reporter, and one who is a participant in the creative process—a matter of investment or soul involvement. Quite simply, the visionary artist has not merely sight but vision, the light the soul makes to illuminate the path for us all. This notion of the visionary being apart from life, going into his or her dream space, is not synonymous with the Western notion of the mystic's separation. The visionary artist in the community works in the fields of the personal self, dreams time *and* engagement with others.

All artists are able to display their craft without the exertion and engagement that marks a performance from the soul. An artist can simply project his or her persona while remaining detached from the performance and the audience. But if you are "working the sounds"—if you are involved in something that engages you; confronting your own prejudices, fears, and limitations, rather than merely presenting what you already know; feeling your own discomfort and taking that discomfort into the terrain where the truth exposes you—then you are quite possibly in the territory of the vision. You are close to grasping the mystery of the healing. You are then, only then, within reach of the gift that you can bring back to the world.

Once you have glimpsed this vision, then you are indeed a participant. And the duality between you and your audience, you and your work, becomes an illusion. And you have written a poem. You have done a performance. You have enfleshed the beauty. You have made it matter. And the community, taking part in the art, completes the last line of the blues refrain, initiating a new reality.

FROM ART-MAGEDDON TO GRINGOSTROIKA: A MANIFESTO AGAINST CENSORSHIP } *Guillermo Gómez-Peña*

Editor's note: Originally published in 1991, this article has been slightly revised. One section, which focused on the then-upcoming quincentennial celebration of Columbus's landing, was eliminated. In addition, two extracts from a later article, "Fourth World and Other Utopian Cartographies," have been included at the end to extend the debate.

TRACK I: FINISECULARTE
[Soundbed of Gregorian chant]

We encounter the final decade of the twentieth century with great perplexity. Unprecedented changes in the world have taken place in the past five years: from Tiananmen Square to the Persian Gulf and from Berlin to Panama City, we all felt the overwhelming birth pains of the new millennium. Massacres, civil wars, ecological disasters, epidemics, and abrupt transformations of political regimes and economic structures shook both the planet and our individual psyches.

Major borders disappeared and others were instantly created. The communists finally crossed the Iron Curtain to go shopping, while the capitalists searched for nostalgia as tourists in the Eastern bloc. We felt like uninvited actors in a cyberpunk epic. The amount, complexity, and intensity of the changes made it impossible for us to decodify them adequately. Just as it had been in the Europe of the late 1400s, everything seemed to be up for grabs: ideology, identity, religious faith, language, and aesthetics. And in the middle of this fin-de-siècle earthquake, my contemporaries and I have been looking for a new place to speak from, and a new vocabulary to describe this bizarre *tierra ignota* we inherited.

The house of postmodernity is in ruins. We are citizens in a new society no longer defined by geopolitics, culture, or ideology, but by time.

The clock of the decade is running. As members of the end-of-the-century society, the world in danger is our true and only neighborhood.

We are living inexplicable contradictions that shatter our understanding of the world: as the former Soviet Union and Eastern Europe welcome structural changes, the U.S. power structure withdraws into its old republican model. As Latin America finally gets rid of its last military dictators, the United States becomes more heavily militarized. While diplomatic negotiation and intercultural dialogue emerge as viable options to construct a peaceful future (haven't we seen enough examples of transition-without-rupture in other countries?), the United Nations begins to practice panic politics in the Middle East. While other societies are being led by utopian reformists such as Mandela and Havel, we are being misled by hemispheric machos.

While artists and writers in other countries are leading the way to the next century, we are being cut back, censored, and excluded from the political process. We face a strange historical dilemma: we stand equidistant from utopia and Armageddon, with one foot on each side of the border, and our art and thought reflect this condition.

TRACK II: THE CHILDREN OF THE FIRST AND THIRD WORLDS
[Soundbed of punk-arachi music]

In the eighties, an increased awareness of the existence and importance of multicentric perspectives and hybrid cultures within the United States made us rethink the implications of Otherness. As a result of demographic shifts, generalized social turmoil, global media, and the exposure to non-Anglo-European art and thought—leading to intensified traffic between North and South and East and West—ethnocentric notions of "postmodernism" and "Western culture" were toppled by their own weight.

Latin America and Asia are already entrenched in North America; Africa slowly moves north into Europe; and, after a four-decade-long ideological divorce, Eastern and Western Europe are commingling again.

The "West" is no longer West, and the "Third World" is no longer confined to the South. Old binary models, legacies of European colonialism

and the Cold War mentality, have been replaced by a border dialectic of ongoing flux. We now inhabit a sociocultural universe in constant motion, a moving cartography with a floating culture and a fluctuating sense of self. As artists, we now understand that we can speak two or more languages, have two or more identities and/or nationalities, perform different roles in multiple contexts, and not necessarily be in conflict with ourselves and others. Contradiction is no longer penalized. Hyphenated, transitional, and multiple identities are no longer just theories of radical anthropologists but familiar pop-cultural realities. Furthermore, the "hybrids" of this and other continents (whether mulattos, mestizos, Chicanos, Nuyoricans, French Algerians, German Turks, British Pakistanis, or other more eccentric children of the First and Third worlds) are sliding toward the center of society. In doing so, they are rearranging the parameters of culture. The border experience is becoming "central," and the art and literature produced in the past five years can testify to this.

In this moving cartography, it becomes increasingly difficult to sustain separatist or essentialist positions. Multilingualism, syncretic aesthetics, border thought, and cultural pluralism are becoming common practices in the artistic and intellectual milieus of this continent, not because of matters of fashion, as the dominant art world wishes to think, but because of a basic political necessity. To study the history, art, and political thought of our neighboring Others and to learn Spanish and other languages becomes indispensable if we want to cross borders, regain our lost "American" citizenship, and participate in the drafting of the next century's cartography.

The holders of political, economic, and cultural power—including the broadcasting systems that shape and define our notions of the world—act extremely scared of these changes. Unable to comprehend their new place and role in this still incomprehensible cartography, they feel that the world and the future are no longer theirs, and they anxiously want them back. Their fears have reached neurotic proportions, and their responses have been far from enlightened. They are currently doing everything they can to control the entry of the Other, and to reconquer the not-so-New

World, a territory that they feel by historical and cultural right belongs only to them.

TRACK III: LA MULTI-CONFUSIÓN CULTI-MULTURAL
[Soundbed by the Gypsy Kings or Mano Negra at the wrong speed]

In many ways multiculturalism soured. We managed to turn the continent upside down, so to speak, and insert into the central discussion the discourse, the terminology, and the attention toward non-Anglo-European experimental artists. We even managed to alter the funding trends a bit. But we were unable to reform the administrative structure of the art institutions. They remain largely monocultural.

Today, many talk of how "exciting," "necessary," "confusing," or "exclusionary" multiculturalism is. Responses range from total willingness to fund and promote this cause, to militant anger at the prospect of sharing money and notoriety with artists from other ethnic backgrounds, to fighting about whose suffering deserves more attention.

The debate has already reached the mainstream, yet crucial political issues are still being avoided. Blockbuster exhibits present multicultural art as the "cutting edge"; yet, with a few exceptions, there is no mention of the historical crimes and social inequities that lie beneath the neocolonial relationship between Anglo-European culture and its surrounding Others. Like the United Colors of Benetton ads, a utopian discourse of sameness helps to erase all unpleasant stories. The message becomes a refried colonial idea: if we merely hold hands and dance the mambo together, we can effectively abolish ideology, sexual and cultural politics, and class differences. Let's face it, the missing text is very sad: in 1995 racism, sexism, xenophobia, and ethnocentrism are alive and well in the U.S.A., and the communities that more proportionately reflect the multicultural composition of society are the homeless, the prisoners, people with AIDS, and the soldiers who returned from the Persian Gulf.

The word "multicultural" hasn't even been defined. Due to the lack of an accumulative memory that codifies public debate in America, it seems that every year we have to restart the discussion from zero, and therefore

we still can't agree on a basic definition. What are the differences between the multi-, inter-, intra-, and cross-cultural? What exactly do we mean by cultural equity, diversity, and pluralism? What are the differences between coexistence, exchange, dialogue, collaboration, fusion, hybridization, appropriation, and creative expropriation? These terms are very different. Some overlap and others even have opposite meanings; however, we often use them indiscriminately. As philosophers, practitioners, or impresarios of multiculturalism, we must ask some key questions: Which of these forms of relationship between cultures are more symmetrical and desirable, and which are more reactionary? Which are those that truly empower marginalized groups? Which are new names for old ideas, and which are new realities in search of a better name? Where exactly do we stand?

Artists and writers of color are losing patience. They have repeatedly stated that it is time to begin talking about economic and labor realities. In 1995 we should no longer need to be reevaluating paradigms, contexts, and canons. Several years of excellent books, articles, and catalogs are available for those who arrive late to the intellectual banquet. Today, multiculturalism must also be understood as a question of workplace. All cultural institutions that claim to profess it must hire people of color in important administrative, artistic, and technical positions. They must be willing to share the paycheck, the desk, and the decision-making process with the Other, not just the excitement of the artwork.

The enigmatic unwillingness of some "minority" artists and organizations to participate in the debate is also a matter of economics. They know that if they blindly join in, the larger organizations, which have more connections, "credibility," and better grant writers, will intercept their funding and function as multicultural meta-sponsors.

We must watch out. The debate hasn't even engendered significant change and there is already a backlash: many Anglo-Americans who have been unable to find a place at the multicultural dinner table are becoming increasingly vocal against racial, sexual, and political difference. The far right is lumping all politicized matters of Otherness under the label of "political correctness" and branding it "the new intellectual tyranny." After five hundred years of systematic exclusion and indifference they

don't want to give us a few more years of attention. If we don't act fast to restore clarity to the debate, we might soon lose the little territory gained so painfully in the past few years.

The impulse behind the clumsy multicultural debate is the collective realization of the need to readjust our anachronistic national institutions and policies to the new social, cultural, linguistic, and demographic realities of this country. What we all are trying to say is that we want to be part of a "multi"-participatory society that truly embraces us all, including the multiracial and multisexual communities, the "hybrids," the recent immigrants from the South and the East, the children and elderly people—our most vulnerable and beloved ones—the people with AIDS, and the homeless, whose only mistake is not being able to afford housing. This is not radical politics but elemental humanism. From rap music to performance art, and from neighborhood politics to the international forums, our contemporary culture is already reflecting this quest.

TRACK IV: PERFORMANCE POLITICS OR POLITICAL PERFORMANCE ART
[Sounds of crowds fading in and out of Brazilian heavy metal]

Joseph Beuys prophesied it in the seventies: art will become politics and politics will become art. And so it happened in the second half of the eighties. Amid abrupt changes in the political cartography, a mysterious convergence of performance art and politics began to occur. Politicians and activists borrowed performance techniques, while performance artists began to mix experimental art with direct political action.

An outstanding example is Superbarrio, the self-proclaimed "social wrestler" and charismatic political activist who emerged out of the ruins of a Mexico City devastated by the 1985 earthquake. Utilizing the mask and attire of a traditional Mexican wrestler, he became the leader of the Asamblea de Barrios, a grass-roots organization that helped to rebuild the working-class neighborhoods affected by the quake and lobbied successfully for expanded housing programs. Behind the mask of Superbarrio there are at least four different activists, each involved in a specialized task: media intervention, grass-roots politics, political theory, and real wrestling.

Another Mexican performance activist is Fray Tormenta, a Catholic priest who ventured into professional wrestling in order to earn the necessary money to build orphanages and bring media attention to the plight of abandoned children. In church, he wears his wrestling mask to say mass; in the wrestling ring, he challenges his opponents wearing religious vestments.

In Peru, Alberto Fujimori, the politically inexperienced son of Japanese immigrants, managed to win the last presidential election by utilizing performance and media art tactics. At certain strategic moments of his electoral campaign he appeared in public dressed as a samurai. In these Latin American examples, the mythical personae created by politicians and social activists function as both pop-cultural allegories and sophisticated media strategies.

During the same time, on this side of the border, East Coast art collectives such as Group Material, Gran Fury, and the Guerrilla Girls used guerrilla theater, installation, and media-art strategies to draw attention to the AIDS crisis and to the art world's racist and sexist practices. On the West Coast, groups like the Border Art Workshop and the Los Angeles Poverty Department employed experimental art methodologies to intervene directly in the realms of immigration and homelessness. In one way or another, most artists, thinkers, and arts organizers were affected by the activist spirit of art and the performance nature of politics during the late eighties.

The system tried to develop its antidotes. In Mexico, the government responded to the popularity of Superbarrio by creating a performance rival: Superpueblo. In the Southwest, many corporations hyped the border as a *maquiladora* (assembly plant) heaven to seduce investors, and many mainstream cultural institutions followed suit. The pseudo-Mexican food chain Taco Bell began designing place mats inspired by the conceptual murals of border artists. Even the far right began to appropriate the performance tactics of its opponents. In 1990, a large caravan of anti-Mexican "concerned citizens" and white supremacists started monthly gatherings at the San Diego–Tijuana border fence, with their car headlights pointing south as a protest against "the Mexican invasion." When questioned by artist Richard Lou, San Diego's former mayor Roger Hedgecock, who spearheaded the entire campaign, answered, "We are

doing border art." Fortunately, the reaction of the Tijuanenses was more original and poetic: in their counter-performances, they responded with mirrors and candles.

TRACK V: CENSURA NO ES CULTURA
[Soundbed of porno-rap]

During these troubled years, art in the United States became a highly symbolic territory of retaliation. Ultraconservative religious and government sectors began to target noncommercial art depicting sexual, racial, and ideological alternatives to patriarchal WASP culture. As in the McCarthy era, artists once again were confronted with the specter of a blacklist, spaces were closed, and cultural organizers were sent to court. This time the strategy was to use sexual morality instead of ideology as a pretext to condemn works of art that confronted mythical American values. Not coincidentally, most of the artwork chosen as "controversial" was done by gay, women, African American, and Latino artists.

This time, censorship was part of a much larger political spectrum. Symptoms of a totalitarian state, the logical progression of a decade under the Reagan-Bush administration, were being felt everywhere. The overreaction of Jesse Helms and the American Family Association to sexually explicit art, the attempts to dismantle affirmative action and bilingual education, the efforts to ban the basic right of women to control their own bodies, the silent militarization of the Mexican border, the government's unwillingness to respond to AIDS and homelessness, the euphemistic war on drugs, the illegal invasion of Panama, the display of military bravado in the Persian Gulf, and the presidential veto of the civil rights legislation were all different expressions of the same censoring mentality, and fear of Otherness was at its core.

Since its foundation, the United States has used the strategy of attacking the cultural and ideological Other to consolidate itself. From above, American identity has been defined in opposition to an evil Other. From Native Americans to Soviets, this Other first had to be demonized and dehumanized in order to then be justifiably caricatured, controlled, exploited, or destroyed.

With the end of the Cold War and the sudden disappearance of the communist threat, new enemies had to be invented. First on the list were Mexican migrant workers blamed for the growing unemployment created by elitist government policies. Then came Colombian and Mexican drug lords led by General Manuel Antonio Noriega, but their past association with the White House made them a bad choice. Then came African American and Latino "gangs" from the inner cities who were blamed for urban violence and for the drug problem of the American middle and upper class. Next on the list were Japanese businessmen who were "silently buying our country," and, later on, gay and "controversial" artists of color whose art reflected a society in crisis, a reflection that Washington didn't want to look at. Finally came the "monstrous" Iraqis, and by extension, all Arabs, Arab-looking people, and people who opposed the war.

All progressive and disadvantaged Others who weren't born Christian, male, white, and wealthy seem to be, in one way or another, impeding the construction of the New World (Dis)Order. This much-touted order is a unique autocratic utopia based on one point of view—theirs. All Others inside and outside the United States—whether experimental artists, nonaligned intellectuals, undomesticated African Americans and Latinos, women, gays, homeless people, or foreigners from unfriendly countries— have now begun to suffer in our own skin the repercussions of this sinister order.

We are astonished and profoundly scared, for now we know that after the exoneration of Oliver North and the Baghdad genocide, the victorious politicos in Washington and their European sidekicks are capable of anything. The militant ethnocentrism of these new crusaders reminds us of the original Spanish and British colonizers of the American continent, who perceived cultural differences as signs of danger.

Despite our fear, we must never lose this perspective. Any artist, intellectual, or arts organizer who believes in and practices civil and human rights, cultural pluralism, and freedom of expression is voluntarily or involuntarily a member of a resistance against the forces that seek to take our basic rights away from us. And his/her words, images, and actions are

expressions of the zeitgeist of America, the other America, the one to which we truly belong.

TRACK VI: RESPONSES TO PANIC CULTURE
[Music by Jello Biafra and the Native American Bird Singers]

My generation was born and raised in a world of multiple crises and continuous fragmentation. Our current lives are framed by the sinister Bermuda triangle of war, AIDS, and recession. We seem to be closer than ever to the end, and precisely because of this, our actions have twice as much meaning and moral weight, though perhaps fewer repercussions.

Our fragile contemporaries are starving, migrating, and dying at a very young age, and the art we are making already reflects this sense of emergency. But it is not enough just to make art. We must step outside of the safe art arena and attempt to recapture our stolen political will and mutilated civic self.

As the nineties unfold, U.S. artists, cultural organizers, and intellectuals must perform central roles in remaking society. We must fine-tune our multiple roles as intercultural diplomats, border philosophers, chroniclers, and activists for world glasnost and local gringostroika. More than ever, we must practice, promote, and demand access, tolerance, dialogue, and reform.

We must speak with valor and clarity, from the new center, not the old margins, and we must do it in large-scale formats and for large and diverse audiences. We must use public-access TV, National Public Radio, printed media, video, film, and fax art. We must take advantage of high technology. We must redefine and expand the activist legacy of the late eighties to form more intercultural collectives, computer data banks, and publications linking various artistic, political, and media communities within and outside the country.

We must defend the survival of the art world as a demilitarized zone. We must continue to support the community centers and the alternative spaces that are potentially facing extinction. Large institutions must try to

keep the smaller ones from sinking, for without them, the large institutions would lose their roots and their seeds. Successful painters might contemplate donating the proceeds from the sale of an artwork to a community center or an alternative space. In some cases, one painting or sculpture might be enough to pay for several months of operational expenses. If some of the smaller spaces cannot survive the crisis, we must develop different models that respond to the new conditions of cultural emergency.

We must listen carefully to other cultures that have a long history of facing repression, censorship, and exclusion. Native Americans, Latinos, African Americans, and Asian Americans have been fighting these battles for centuries.

We must rebuild community through our art, for our communities have been dismembered. The insidious colonial tendencies that we have internalized—and that express themselves in sadistic competition for money and attention, political cannibalism, and moral distrust—must be overcome. We must realize that we are not each other's enemies and that the true enemy is currently enjoying our divisiveness.

We must dialogue and collaborate with artists from other disciplines and ethnic communities, as well as with political activists, educators, lawyers, journalists, cultural critics, and social scientists. The old schism between artists and academics must be resolved once and for all. We must come to the realization that we have been equally marginalized by society and that therefore we need one another. Artists need the intellectual rigor of academics, and they need our skills to popularize issues. Academics have access to more extensive information, and we have access to more diverse audiences. Together, we can develop a national consensus of priorities and strategies for the new decade.

Some people say that the nineties will be "the decade of the environment," and I wish with all my heart they are right, but, as performance artist Ellen Sebastian says, "We, the human beings, are the ultimate environment." From São Paulo to Baghdad, and from Soweto to the Bronx, we are a fauna in danger of extinction. Our ecosystems, the deteriorated multiracial cities we inhabit, are part of the nature we must save. If we don't

save the human being and his/her concentrated habitat, we won't even be here to witness the extinction of the great whale and the California condor.

In times such as these, nationalism is no longer useful. The survival of the human species is a concern to all communities. As responsible artists of this end-of-the-century society, we must challenge the anachronistic notion that says we are only meant to work within our particular ethnic, political, or sexual communities, strictly art contexts, or marginal leftist milieus. Our place is the world-in-danger, as big as it can be for each of us, and our communities have multiplied exponentially. Regardless of age, race, gender, métier, or nationality, any socially responsible person—not just artists—from this or other continents who truly believes in and practices cultural democracy and racial and sexual equity must be considered a member of "our" community.

Parallel to this major project, a much more private, but equally important, path must be pursued: the humanization of our personal universe. We must learn to take good care of ourselves and our loved ones. If we are not responsible and loving friends, sons and daughters, parents, lovers, neighbors, and colleagues, how can we possibly be responsible citizens at large? If we don't recapture the necessary time and personal space to enjoy community rituals, friendship, food, exercise, and sex, where will we get the strength to continue?

The humanization of our disjointed lives is also an expression of the search for a new social order, and the reawakening of our total self— civilian, political, spiritual, erotic, and aesthetic—will inevitably demand a new social body to contain it.

TRACK VII: THE CULTURE OF THE END OF THE CENTURY
[Soundbed composed by the reader]

I want to exercise my political vision for a moment and try to imagine the place of the artist in a post-gringostroika society.

Perhaps by the end of the nineties politicized artists and intellectuals in the United States will no longer be border pirates or alternative

chroniclers but respectable social thinkers. Perhaps a multiracial group of artists and arts organizers will head a Ministry of Cultural Affairs. Perhaps there will even be a Ministry of Cultural Affairs with a budget equivalent to that of other countries, and more than a hundred experimental artists will be able to survive exclusively on their art. Perhaps there will be a Free Art Agreement between the United States, Mexico, and Canada, and we will be able to exchange ideas and artistic products, not just consumer goods and hollow dreams. Perhaps the Spanish-only initiative will replace the English-only. Perhaps the border with Latin America, the Great Tortilla Curtain, will finally collapse. Perhaps one of these days Chicana artist Amalia Mesa-Bains will become governor of California, and performance artist Tim Miller or John Malpede the mayor of Los Angeles. Perhaps poet Víctor Hernández Cruz will become president of Independent Puerto Rico, and Noam Chomsky U.S. Secretary of Information. Perhaps Ralph Nader will be Secretary of the Environment, and Luis Valdez the head of a generous INS. Perhaps performance artists will be heard regularly on National Public Radio, and poets and philosophers of color will publish daily in the major newspapers. Wouldn't you like to read the opinions of Cheri Moraga, James A. Luna, or Essex Hemphill in your local paper? Perhaps we will be able to watch Trinh T. Minh-ha, Jessica Hagedorn, Gayatri Spivak, Michele Wallace, Coco Fusco, Gloria Anzaldúa, Cornel West, Rubén Martínez, James Clifford, and many other thinkers from the other America on multilingual national television. Perhaps there will be at least five cultural television channels in every city, and every independent film and video art piece will be available in the local video store. Perhaps we will be able to purchase books by Chicano, African American, Asian American, and Native American writers at the supermarket, and even at the 7-Eleven. Perhaps there will be so many alternative spaces that they will no longer be called alternative. Perhaps there will no longer be a need for community centers, since every city will function as a real community. Perhaps there will be so many artists and intellectuals of color working in our cultural, educational, and media institutions that there will no longer be a need to label us by our ethnicity. Perhaps we will no longer need to imagine.

<p style="text-align:center">* * *</p>

INTERCULTURAL WARFARE

To wake up here
already means
to be an accomplice
to all this destruction.

—*Argentine rock song*

It won't cut it anymore to pretend that the enemy is always outside. The separatist, sexist, and racist tendencies that we condemn others for perpetrating also exist within our own communities and within our own individual selves. Likewise, the art world is a dysfunctional family—a micro-universe reflecting the larger society. We can't continue to hide behind the pretext that the all-purpose "dominant culture" or "straight white men" are the source of all our problems. We must now have the courage to turn our gaze inward and begin to raise the touchy issues that most of us avoided in the past decade:

Men of color are active protagonists in the history of sexism, and Anglo-American women share the blame in the history of racism. We must accept this with valor and dignity. African Americans and Afro-Caribbeans have a hard time getting along. U.S.-born Latinos and Latin Americans cannot fully understand one another. Despite our cultural similarities, we are separated by invisible idiosyncratic borders. Third World feminists and American feminists still haven't reached a basic agreement regarding priorities and strategies. The "boys' clubs" of the sixties and seventies can hardly be in the same room with the multiracial and multisexual artists of the eighties and nineties. The embittered veterans resent the irreverence of the youth and the intensity and directness of the women artists and intellectuals. In fact, most straight men are still irritated when sexism is mentioned. My lover has consistently pointed out the hypocrisy of my hiding behind ethnicity to avoid gender issues.

The borders keep multiplying. Artists and academicians rarely talk to one another. So-called community artists and politicized artists working in major institutions still see one another as enemies, not as allies working

on different fronts. Politicized artists who work directly with troubled communities such as the homeless, prisoners, migrant workers, or inner city youth are seen as opportunistic, and their intentions are often questioned by people who do absolutely nothing for those communities. "Successful" artists of color are perceived as "co-opted," and those who venture into theory are seen as elitist and not "organic" in relation to their community. Both Anglo liberals and essentialists of color are still immersed in Byzantine debates about who is "authentic" and who isn't. Politicized artists who favor hybridity and cross-cultural collaboration are seen with distrust by all sides.

Well-meaning liberals have learned the correct terminology to not offend us, but they remain unwilling to give up control and stop running the show. When called on their benign bigotry, they suddenly become monsters. Many white multiculturalists are currently experiencing an acute case of "compassion fatigue." Tired of being rejected and scolded by people of color, they are either bailing out for good or retrenching to pre-multicultural stances. Their thin commitment to cultural equity evaporates before our very eyes.

In the nineties, our communities are ferociously divided by gender, race, class, and age. An abyss—not a borderline—separates us from our children, our teenagers, and our elders. The Columbian legacy of divisiveness is more present than ever. This is contemporary America, a land of such diversity where no one tolerates difference, a land of such bizarre eclecticism where everyone must know his/her place. Here, artists and activists spend more time competing for attention and funding than establishing coalitions with other individuals and groups.

Chicano theoretician Tomás Ybarra-Frausto suggests that in the nineties we must resist all attempts at intercultural warfare, and I completely subscribe to his call. In order to begin the great project of racial, gender, and generational reconciliation, we must sign a temporary peace treaty. Perhaps the key here is the recognition that we all are partially guilty, and that most of us are partially disenfranchised. At least among ourselves, like in a family reunion, we must face these issues frontally but with respect, without indicting anyone, without calling names.

Our cultural institutions can perform an important role in this respect: they can function as laboratories to develop and test new models of collaboration, and as "free zones" for intercultural dialogue and radical thinking.

THE GREAT COLLABORATIVE PROJECT

"The people from the South are coming to save us."
—Leslie Marmon Silko at a panel discussion

"The people from the North are heading south to save themselves."
—Gómez-Peña whispers to his neighbor

Our "ethnic" communities have changed so dramatically in the past ten years that they might no longer be just "ours." Our neighborhoods and barrios have become much more multiracial and impoverished. Our families, schools, and community centers are falling apart. Interracial violence, homelessness, AIDS, and drugs have increased exponentially. It becomes harder to differentiate between the South Bronx and Soweto, between South Central Los Angeles and the São Paulo *favelas*. Our outdated social theories have been rendered inadequate by these changes. And artists and activists have become foreigners and exiles in our own communities.

Despite the fact that in the nineties the word "community" has taken on myriad meanings (most of which are open ended and ever changing), some people still utilize the demagogic banner of a mythical and unified community to infuse their actions with moral substance. They attack and exclude others who express different views on racial identity, sexuality, and aesthetics: "I represent my community. He/she doesn't." "His community doesn't back him anymore." "This art is not community based. . . ." This self-righteous BS must stop. Not only does it widen already existing divisions but it provides the media and dominant institutions with the confirmation of their stereotype—that artists and people of color who demand change simply can't get along.

Under the current fog of confusion, something is clear: we must rediscover our communities in turmoil, redefine our problematic relationship

to them, and find new ways to serve them. And those who choose for whatever reasons never to go back to their original communities must be respected. No one has the moral right to question their decision.

The art world, too, is a particularly strange community. It has no elders or children. The elders are ignored, and the children are seen as a nuisance. This fact is a microcosmic expression of the dehumanization of the larger society. Latino leaders insist that everything we think and do in the future must be shared with other generations. We must invite our elders, teenagers, and young children to the table and reconnect with them, for they can remind us of the truly important things in life. We must bridge this grave generational gap and make sure that when we leave the table others will take our place.

The case of the distrustful teenagers is particularly sensitive. They rightfully believe we are partially responsible for the dangerous world they are inheriting. They see us as inefficient and intransigent, and they have a point. We must learn to accept responsibility and seek more effective languages to communicate with them. The teenagers have tremendous things to teach us: they have fewer hang-ups about race and gender; they are much more at ease with crisis and hybridity; and they understand our cities and neighborhoods better than we do. In fact, if there is an art form that truly speaks for the present crisis of our communities, this form is rap.

The indigenous philosophies of the Americas remind us that everything is interconnected. All destructive and divisive forces have the same source, and all struggles for the respect of life in all its variants lead in the same direction. The great project of reform and reconciliation must be, above all, a collaborative one, and all "disenfranchised" communities must take part in it. We all need to begin sharing our secrets, skills, strategies, and infrastructures. The indigenous communities of the Americas can teach us more enlightened ways to produce food and medicine without continuing to destroy the air and land. The recent Latin and Asian immigrants can make our cities walkable and livable again. They can also teach us how to respect our children and elderly people, since their familial structures are much stronger than ours. The artists and writers of color can help us understand the bizarre racial and cultural topography of contem-

porary America. The radical intellectuals can monitor the behavior of our governments with regard to human rights and environmental standards. Politicized women can teach us how to organize and collaborate more democratically. The gay and lesbian communities can show us how to reclaim our bodies as sites for pleasure and celebration. Many more communities must join in.

It's about time that politicians and civic and corporate leaders begin to take note: no effective solution to the multiple crises that afflict contemporary society can be implemented without the consent, consensus, and direct participation of each of these overlapping communities. My colleagues and I politely ask you to join in.

Please forgive my incommensurable arrogance.

Section Three } PLACES IN COMMON

LOOKING AROUND:
WHERE WE ARE, WHERE WE COULD BE } *Lucy R. Lippard*

LOOKING AROUND

I've spent a lot of my life looking, but less of it looking around. Art history and the art world "make progress," focusing on an invented vanishing point, losing sight of the cyclic, panoramic views. And of course it's not easy to be visionary in the smog. Meanwhile, Hazel Henderson's "think globally, act locally" has become a truism—an overused idea important enough to remain true. The notion of the local, the locale, the location, the locality, the *place* in art, however, has not caught on in the mainstream because in order to attract sufficient buyers in the current system of distribution, art must be relatively generalized, detachable from politics and pain.

The social amnesia and antihistorical attitudes that characterize our society at large affect the art world as well. "Change increasingly appears to be all that there is. . . . There is no sense of progress which can provide meaning or depth and a sense of inheritance."[1] But, perhaps because we are at a retrospective moment in history—nearing the end of a millennium and just past the five hundredth anniversary of the most heralded point of colonialism—many of us are looking back to find solid ground from which to leap forward, into the shifting future. It seems significant that what the historian Lawrence Grossberg calls the "very cornerstones of historical research" can also be called the very cornerstones of the art to which this book is devoted: "appreciation of difference, understanding of context, and ability to make critical comparative judgments on the basis of empathy and evidence."[2]

Ecological crisis is obviously responsible for the current preoccupation with place and context, as is an ongoing nostalgia for lost connections. The Greek root of the word "ecology" means home, and it's a hard place to find these days. Precisely because so many people are not at home in the world, the planet is being rendered an impossible home for many. Because

we have lost our own places in the world, we have lost respect for the earth, and treat it badly. Lacking a sense of microcosmic community, we fail to protect our macrocosmic global home. Can an interactive, process-based art bring people "closer to home" in a society characterized by what Georg Lukacs called "transcendental homelessness"?

Not since the regional art of the thirties have so many people looked around, recorded what they see or would like to see in their own environments, and called it art. Some have gone beyond the reflective function of conventional art forms and the reactive function of much activist art. Those who have been at it for a long time are represented individually in this book. But they also have heirs and colleagues among younger artists, writers, and activists who regard the relationship between people and people unlike them, between people and place, between people, place, flora, fauna, and now, necessarily, even atmosphere, as a way of understanding history and the future.

The growing "multicultural" (and cross-cultural, intercultural) contributions of the last decade have opened up fresh ways of understanding the incredibly complex politics of nature. Culture and the concept of place are in fact inseparable, yet people (and ideologies) are often left out of art about land and landscape. As Kenneth Helphand has observed, landscapes (which I would define as place at a distance) "carry legacies and lessons" and can create "an informed landscape citizenry."[3]

National, global, collective narratives are especially accessible through one's family history—by asking simple questions about why we moved from one block or city or state or country to another, gained or lost jobs, married or didn't marry whom we did, kept track of or lost track of certain relatives. A starting point, for example: simple research about the place where you live or were raised. Who lived there before? What changes have been made? have you made? When was the house built? What do the deeds in the county records have to say about it and the land it stands on? How does it fit into the history of the area? Has its monetary value appreciated or depreciated? Why? When did your family move there? From where? Why? What Native peoples first inhabited it? Does your family have a history in the area, or in any area? Do relatives live nearby? What is

different now from when you were young? Why? How does the interior of your house relate to the exterior? How does its style and decoration reflect your family's cultural background, the places from which your people came? Is there a garage? a lawn? a garden? Is the flora local or imported? Is there water to sustain it? Do any animals live there? And on a broader scope, are you satisfied with the present? If not, are you nostalgic for the past or longing for the future? And so forth.

Questions like these can set off a chain of personal and cultural reminiscences and ramifications, including lines of thought about interlinking histories, the unacknowledged American class system, racial, gender, and cultural divisions and common grounds, land use/abuse, geography, environment, town planning, and the experience of nature that has made a "return" to it so mythical. When this kind of research into social belonging is incorporated into interactive or participatory art forms, collective views of place can be arrived at. It provides ways to understand how human occupants are also part of the environment rather than merely invaders (but that too). According to Wendell Berry, the most consistently inspiring writer on American place, "The concept of country, homeland, dwelling place becomes simplified as 'the environment'—that is, what surrounds us. Once we see our place, our part of the world, as *surrounding* us, we have already made a profound division between it and ourselves."[4]

Real immersion is dependent on a familiarity with place and its history that is rare today. One way to understand where we have landed is to identify the economic and historical forces that brought us where we are—alone or accompanied. (Culture, said one contemporary artist, is not where we come from; it's where we're coming from.) As we look at ourselves critically, in social contexts, as inhabitants, users, onlookers, tourists, we can scrutinize our own participatory roles in the natural processes that are forming our futures. Similarly, the study of place offers access to experience of the land itself (and what we call "nature") as well as to current ecological politics and a sense of responsibility to the future.

Jeff Kelley has distinguished the notion of place from that of site, made popular in the late sixties by the term "site-specific" sculpture: "A site represents the constituent physical properties of a place ... while

places are the reservoirs of human content."[5] While place and home are not synonymous, a place must have something of the home in it. In these chilling times, the concept of place has a warm feeling to it. The implication is that if we know our place we know something about it; only if we "know" it in the historical and experiential sense do we truly belong there. But few of us in contemporary North American society know our place. (When I asked twenty university students to name "their place," most had none; the exceptions were two Navajo women, raised traditionally, and a man whose family had been on a southern Illinois farm for generations.) And if we can locate ourselves, we have not necessarily examined our place in, or our actual relationship to, that place. Some of us have adopted places that are not really ours except psychologically. We have redefined place as a felt but invisible domain.

In contrast to the holistic, earth-centered indigenous peoples of this hemisphere (who, over thousands of years, had also made changes in the land), the invading Europeans saw the natural world as an object of plunder to be conquered, exploited, and commodified. They imported denial, still a prevalent disease among their descendants. The causes of the exhausted resources, the scarcity of wood and arable land in an "old world" were never acknowledged; old habits were simply reasserted in the "new world." Although a sense of collective loss spread through this country at the end of the nineteenth century, when most of the arable land had been parceled out, most people in the United States today still want to believe that our resources—water, topsoil, forests, fuels, oxygen—are infinite. Not unrelated is the scant attention paid to the ways rural and urban spaces are structured and how they affect our national psychology. (Historian John Stilgoe says that in colonial New England, towns planned in odd shapes were seen as disorderly and were "more likely to harbor civil and ecclesiastical unrest.")[6]

Today, according to Rosalyn Deutsch, space as a reflection of power relations (produced by social relations) "is on the political agenda as it never has been before."[7] This is true for artists who have been "framing" landfills, shopping malls, parks, and other social contexts for many years now. Yet the overall tone is not exuberant. I've been struck by three recent

naming phenomena: First, the postmodernist impulse (now at least a de-
cade old, and supremely retroactive in its own right) has spawned a
plethora of exhibitions, articles, and books called re-viewing, re-visioning,
re-mapping, re-thinking, re-photographing. Second, the titles of exhibi-
tions about land and nature are becoming melancholic and even apocalyp-
tic: for instance, *Against Nature, The Demoralized Landscape, The
Unmaking of Nature, Lost Illusions,* and *Utopia, Post-Utopia.* Third, the
terms "territory," "land," "earth," "terrain," and "mapping" are also
ubiquitous in both theory and practice. The map as a micro/macro visual
concept has long been of interest to artists, and particularly to "concep-
tual" and "earth" artists from 1965 to 1975. On one hand, mapping the
turf can be seen as abetting surveys, fences, boundaries, zoning, and other
instruments of possession. On the other hand, maps tells us where we are
and show us where we're going.

Understanding our cultural geography will be a necessary compo-
nent of the reinvention of nature. We need to stop denying difference and
pretending a woozy universalism that masks and maintains deep social
divisions. We have to know more about our relationships to each other, as
part of the cultural ecology, to know where we stand as artists and cultural
workers on homelessness, racism, and land, water, cultural, and religious
rights, whether or not we ever work directly on these issues. Because they
are linked, to be ignorant of one is to misunderstand another. Yet such
awareness demands extensive visual and verbal (and local) research that is
not included in traditional art education. Multicultural studies especially
need to be incorporated into art about history and place. If only white
history is studied, the place remains hidden. For instance, when I taught a
seminar on land in Colorado, I found I had to include the way land was
used and conceptualized by the original inhabitants, the tragic histories of
Native lands and lives and of the continuing struggle on Mexican land
grants, the roles of black farmers and cowboys, Chinese railroad and
agricultural workers, and the desert internment of Japanese Americans
during World War II.

White America has been deeply affected (so deeply it doesn't often
show on the surface) by the land-based traditions of Native and mestizo
cultures; colonists inherited agricultural sites and techniques and survived

by modeling themselves on Indians even while wiping them out.[8] The resurgence of mainstream interest in Native culture in the last few years (a process that began in the sixties) is partly due to Indians' grass-roots strength and pride at having survived, partly bolstered by their rage at the cost in Native culture, health, and land. But it is also a product of the growing recognition among Euro-Americans that the five-hundred-year-old dream went awry. The search for place is the mythical search for the axis mundi, for some place to stand, for something to hang on to. (Seneca artist Peter Jemison has said it is not the flag but the pole and eagle on top that mean something to his people; they connect earth and sky, body and spirit.) At the same time, a de-idealization of nature and of Native attitudes toward nature is necessary because anything set on a pedestal can so easily be undermined.

A responsible art of place must be part of a centering process. Wave after wave of exiles is still coming through this land, and we have made internal exiles even of those who are its natives. The immigrant population in the United States (all of us) has no center, no way of orienting itself. We tend to presume our ancestors had one, but my family, for example, constantly moved around; from the 1700s on, few generations stayed in the same town. When a place-oriented sculptor says, "Place is what you have left,"[9] I'm not sure whether she means "all that remains" or "that which is left behind."

Although art has often been used in the past as propaganda for colonialism and expansionism (especially during the nineteenth-century movement west), and much contemporary public art is still propaganda for existing power structures (especially development and banking), no better medium exists in this society to reimagine nature, to negotiate, in Donna Haraway's words, "the terms on which love of nature could be part of the solution rather than part of the imposition of colonial domination and environmental destruction."[10]

The upper middle class (from which the majority of artists emerges) tends to confuse place with nature, because it has the means and leisure time to indulge its wanderlust, to travel to sites of beauty, difference, curiosity, to have second homes on shores, in mountains, on abandoned farms.

But urban environments are also places, although formed differently, more likely to spawn the multiple selves that ease cross-cultural communications, that in fact are the result of cross-cultural communication. Those of us living in any big city today are confronted by a vast mirror whenever we step outdoors. It reflects us and those who, like us, live on this common ground; our appearances and lives often differ, but we can't look into the mirror without seeing them too. The reciprocal nature of cultural communication is the nail James Baldwin hit on the head when he said, "If I am not who you thought I was, then you are not who you thought you were either."[11]

The dialectic between place and change is a creative crossroads. I'm experimenting with the ideas sketched above as teaching tools, as ways in which teachers and students can collaborate to find their places; an increasing number of artists are becoming involved in similar ideas. Innately interdisciplinary and multicultural, this line of inquiry and production relates to contexts and content rather than to style and trends. My models are the artists whose concepts of place and history include people and form the grass roots of much interactive or "new genre" art—from Judith Baca's *Great Wall of Los Angeles,* which brings together teens from different cultural backgrounds to create a mural on the nonwhite history of California, to Mierle Laderman Ukeles's work with the New York City Sanitation Department exposing how we maintain ourselves and manage our waste (and with whom); from John Malpede's small-scale examinations of homelessness to Newton and Helen Mayer Harrison's large-scale environmental rescue attempts. Artists envision (a verb that embraces a noun) a process that results in an artwork.

WHERE WE ARE

I've been struggling with these questions for a long time. In 1967 I wrote that visual art was hovering at a crossroads "that may well turn out to be two roads to one place: art as idea and art as action. . . . Visual art is still visual even when it is invisible or visionary."[12] In 1980 I wrote:

Any new kind of art practice is going to have to take place at least partially outside of the art world. And hard as it is to establish oneself in the art world, less circumscribed territories are all the more fraught with peril. Out there, most artists are neither welcome nor effective, but in here is a potentially suffocating cocoon in which artists are deluded into feeling important for doing only what is expected of them. We continue to talk about "new forms" because the new has been the fertilizing fetish of the avant-garde since it detached itself from the infantry. But it may be that these new forms are only to be found buried in social energies not yet recognized as art.[13]

Not all the varied (but still not varied enough) forms that have come to be called "public art" deserve the name. I would define public art as accessible work of any kind that cares about, challenges, involves, and consults the audience for or with whom it is made, respecting community and environment. The other stuff is still private art, no matter how big or exposed or intrusive or hyped it may be. In order to sort out where we stand at the moment, I've made a necessarily tentative list of the existing genres of "outlooking" art about place. These are not intended as frozen categories, and many obviously overlap:

1. Works prepared for conventional indoor exhibition (installations, photographs, conceptual art, and project proposals) that refer to local communities, history, or environmental issues. Examples are Deborah Bright and Nancy Gonchar's *Chicago Stories,* Newton and Helen Mayer Harrison's proposed Boulder Creek Project, and Richard Misrach's *Bravo 20: The Bombing of the American West.*

2. Traditional outdoor public art (not "plunk art," which has simply been enlarged and dropped on the site) that draws attention to the specific characteristics or functions of the places where it intervenes, either in predictable locations such as parks, bank plazas, museum gardens, and college campuses (such as Andrew Leicester's mining memorial in Frostburg, Maryland; Athena Tacha's *Memory Path* in Sarasota,

Florida; and Barbara Jo Revelle's *People's History of Colorado,* in Denver), or in unexpected and sometimes inaccessible locations, such as streets, store windows, a cabin in the woods, a laundromat, a golf course, an office, a supermarket, a crater in the desert, a residential neighborhood (such as Charles Simonds's imaginary landscapes and civilizations for "Little People" and David Hammons's *House of the Future* in Charleston, South Carolina). This group would also include innovative and officially funded public art and memorials with social agendas and local references, such as Maya Lin's Vietnam Veterans Memorial and Barbara Kruger's Little Tokyo mural at the Museum of Contemporary Art, Los Angeles.

3. Site-specific outdoor artworks, often collaborative or collective, that significantly involve the community in execution, background information, or ongoing function. Examples are officially condoned graffiti walls; Joel Sisson's *Green Chair Project* in Minneapolis; Olivia Gude and Jon Pounds's *Pullman Projects* in Chicago; the Border Art Workshop in San Diego and Tijuana; Dr. Charles Smith's African American Heritage Museum in Aurora, Illinois; and works by many progressive muralists.

4. Permanent indoor public installations, often with some function in regard to the community's history, such as post office murals across the country and Houston Conwill, Estella Conwill Májozo, and Joseph De Pace's *The Rivers* at the Schomburg Center for Research in Black Culture in New York City. This group also includes history-specific community projects that focus on ongoing educational processes, such as the Chinatown History Project in New York City and the Lowell, Massachusetts, national industrial park.

5. Performances or rituals outside of traditional art spaces that call attention to places and their histories and problems, or to a larger community of identity and experience. Like street posters, stencils, or stickers,

these works often function as "wake-up art," a catalyst to collective action. Examples are Suzanne Lacy's *Three Weeks in May* in Los Angeles, and Guillermo Gómez-Peña and Coco Fusco's *The Year of the White Bear* at several sites in the United States and Europe.

6. Art that functions for environmental awareness, improvement, or reclamation by transforming wastelands, focusing on natural history, operating utilitarian sites, making parks, and cleaning up pollution. An example is Alan Sonfist's *Time Landscape of New York City*.

7. Direct, didactic political art that comments publicly on local or national issues, especially in the form of signage on transportation, in parks, on buildings, or by the road, which marks sites, events, and invisible histories. Examples are REPOhistory's sign project in Lower Manhattan, David Avalos, Louis Hock, and Elizabeth Sisco's San Diego bus project, and Hachivi Edgar Heap of Birds's Host projects at multiple sites.

8. Portable public-access radio, television, or print media, such as audio- and videotapes, postcards, comics, guides, manuals, artists' books, and posters. Examples are Carole Condé and Karl Beveridge's book and poster work with Canadian unions and Paper Tiger public-access television, demonstration art such as the AIDS quilt, and the *Spectacle of Transformation* in Washington, D.C.

9. Actions and chain actions that travel, permeate whole towns, or appear all over the country simultaneously to highlight or link current issues. Examples are John Fekner's stencils in the Bronx, New York; the Shadow Project, a nationwide commemoration of Hiroshima Day; and Lee Nading's highway ideograms.[14]

For decades now a few artists have ventured out into the public context and made interactive, participatory, effective, and affective art relating to places and the people in them. Since the late fifties there have

been attempts by artists utilizing form, materials, participation, context, and content (e.g., Happenings by Allan Kaprow, Claes Oldenburg, and Carolee Schneeman) to escape from galleries and museums. In the sixties the gerund (the grammatical form of process) overcame sculpture, which began scattering, leaning, hanging, folding, stretching, acting out, and otherwise mutating and mobilizing. Since around 1966 there has been a body of work that questions all of the structures by which art exists in the world—the modernist myths, the commodity status, effects on the ecology, male and white dominance, the precious object, the specialized or upper-class audience, and the cultural confinement of artists themselves.

Paralleling the development of a socially aware experimental art since the sixties, a fragile movement for cultural democracy has recognized art as useful, though not necessarily utilitarian. Thanks in part to the women's art movement, which since the early seventies has emphasized social structures as formal innovation (more women make and write about participatory public art than men), we have seen a broadening of the notion of public art into a nurturing as well as entertaining, pleasure-giving, or critical enterprise.

By the late eighties, rather surprisingly, this impetus was relatively accepted into the mainstream, though its antecedents are never acknowledged. But there is, in fact, little fully realized "new genre public art" out there yet. The relationships between artist and community have usually been serially monogamous. The artist (who may live in situ or may have parachuted in) goes on to something else, and the community is often insufficiently involved to continue or extend the project on its own. Too many artists who had hoped to help change the world through making issue-oriented art for larger audiences in more accessible places have become disillusioned with the accompanying bureaucracy. "Public art sucks" is the opinion of one much-respected and long-committed public artist. Another tells me she is finished with public art after working for years on a project that was fully okayed and funded until an officially concocted glitch appeared and wiped it off the screen. Idealistic artists all over this country are being strung up with red tape, martyrs to the hopeful cause of a truly public, interactive, participatory, and progressive art. The money

and energy that should be going into the mutual and collective education of artists and bureaucrats and audiences isn't available.

Of the people I've written about since 1981 in my columns on art, politics, and community,[15] most are still on track. Collaboration and organizational support seem to sustain outreach energies, while "success" and the attraction of conventional venues tend to weaken grass-roots involvement, even as they offer higher profile opportunities to work in public. A few highly visible progressive artists have been able to get their messages across to truly large, though not necessarily broad, audiences by expanding their media access.

The art world's novelty express train, which often rewards the superficially "new" and ignores those who are in for the long haul (unless their products are saleable), is partially responsible for the attrition among public artists, as is the political and economic climate. Even as it fails to reach its goals, however, hit-and-run (or hug-and-sidle-off) art offers tantalizing glimpses of new entrances for art into everyday life.

Modernist art is always moving figuratively into "new" terrain, testing "new" parameters, demanding "new" paradigms. It remains to be seen whether the "new" genre public art with which this book is concerned can transcend the boundaries (and the commercial demand for novelty) that shelter or imprison even that art which moves out into the world. Although I've used the word as much as anyone, I've come to understand that a truly public art need not be "new" to be significant, since the social contexts and audiences so crucial to its formation are *always* changing. As I go over the ecological art that has been made in the last twenty years (especially the ephemeral landscape art of the late sixties and early seventies, and the spiritually oriented feminist art of the seventies), I am simultaneously heartened by its variety and disappointed by its communicative limitations. Helen Mayer Harrison says, "We haven't spoken the voice of the river; cultivate humility."[16] The interactive aspects of the outreaching art-about-place that has been developed during the last few years may be fragile and tentative, but they are budding, composted in a renewed sense of memory, ready to blossom if we can create a welcoming out-of-art context for them to venture into.

WHERE WE COULD BE

There is no reason to cut the ties that bind such art to its home in the community, which at worst constricts and regulates it and at best shares its concerns, offering *response*-ible criticism and support. Instead, the task is to establish an additional set of bonds radiating out to participant communities, audiences, and other "marginalized" artists, so that the art idea becomes, finally, part of *the* center—not an elite center sheltered and hidden from public view, but an accessible center to which participants are attracted from all sides of art and life.

To affect perception itself, we need to apply ideas as well as forms to the ways people see and act within and on their surroundings—in museums, parks, and educational institutions. Ideas catch fire in dialogue, when one person's eyes light up as another conjures images. Art itself, as a dematerialized spark, an act of recognition, can be a catalyst in all areas of life once it breaks away from the cultural confinement of the market realm. Redefinition of art and artist can help heal a society that is alienated from its life forces. As Lynn Sowder has said: "We must shift our thinking away from bringing great art to the people to working with people to create art that is meaningful."[17] Feminism and activism have created models, but we've barely touched the depth of complexity with which art could interact with society.

To change the power relations inherent in the way art is now made and distributed, we need to continue to seek out new forms *buried in social energies not yet recognized as art.* Some of the most interesting attempts are those that reframe not-necessarily-art practices or places by seeing them through the eyes of art. This, too, is an idea that originated in the midsixties. At that time such "looking around" was the product of a rejection of art as "precious objects," as more *stuff* filling up the world. The idea was to look at what was already in the world and transform it into art by the process of seeing—naming and pointing out—rather than producing.

If the rat's nest of problems that accompanies any foray out of the studio has deflected many artists from new or old genre public art, no artist who has ventured out returns without being changed, and charged. How can we build these changes into art education, into the career

mechanisms, into the possibilities that a life of art making holds for those tempted by such risks? With few exceptions, the art schools and departments in this country still teach a nineteenth-century notion of the function (or functionlessness) of art. There are a few "art in a social context" courses sprinkled around the world,[18] but they remain overwhelmed by conventional views. Most art students, even sophisticated ones, know little or nothing about the history of attempts to break down the walls. The fact is, we need to change the system under which we live and make art as citizens and as art workers. We are laying out the ingredients but still looking for the recipe. Once there are more cooks, everybody will use the ingredients differently. We could be "teaching" future art—not what's already been made, and not necessarily in institutions. We could be propagating the sources and contexts of the art that hasn't been made yet. This is where the absolutely crucial multicultural and interdisciplinary components of art about place come in.

Culture is what defines place and its meaning to people. The apolitical and "cultureless" culture in which most of us live in the United States inevitably leaves us placeless. Today, in the nineties, some artists have ventured to make known a broader sense of culture as a part of our lives that's not hierarchal but temporal, ongoing. Some art has become a catalyst or vehicle for equal exchange among cultures, helping us find our multiple selves as opposed to one-dimensional stereotypes. Regardless of class and opportunity, we all harbor several identities—religious and political affiliations or lack thereof, cultural and geographical backgrounds, marital or parental status, occupation, and so on. To learn to use these multiple identities, not just to know ourselves but to empathize and work with others, is one of the lessons an interactive art can offer. One of the work groups at the "Mapping the Terrain" conference summarized: "Aesthetics shapes relationships between people. Constant negotiations of life are reenacted and released in art. You can't do community work unless you listen, use intuition."

Community doesn't mean understanding everything about everybody and resolving all the differences; it means knowing how to work within differences as they change and evolve. Critical consciousness is a

process of recognizing both limitations and possibilities. We need to col-
laborate with small and large social, political, specialized groups of people
already informed on and immersed in the issues. And we need to teach
them to welcome artists, to understand how art can concretize and envi-
sion their goals. At the same time we need to collaborate with those whose
backgrounds and maybe foregrounds are unfamiliar to us, rejecting the
insidious notions of "diversity" that simply neutralize difference. Empathy
and exchange are key words. Even for interactive art workers who have
all the right ideas, elitism is a hard habit to kick. Nothing that excludes the
places of people of color, women, lesbians, gays, or working people can be
called inclusive, universal, or healing. To find the whole we must know
and respect all the parts.

So we need to weave a relationship and reciprocal theory of multi-
plicity about who we are, what is our place, and how our culture affects
our environment. We need to know a lot more about how our work affects
and disaffects the people exposed to it, whether and how it does and does
not communicate. This too can be built into experimental education in
both art history and studio courses (the two remain absurdly separated at
most schools).

To return to the notion of place, art cannot be a centering (ground-
ing) device unless the artist herself is centered and grounded. This is not to
say that the alienated, the disoriented, the deracinated, the nomadic (i.e.,
most of us) cannot make art. But *some* portable place must rest in our
souls. Perhaps we are lucky enough to have some sustaining chunk of
"nature" to nourish us. Perhaps the city is just as satisfying. Perhaps the
studio is the den where we lick our wounds, dream up images, plan new
strategies, gather the strength to go out again. Perhaps the limitations of
the ivory gallery and the pages of art magazines are stunting the growth of
an art that dreams of striding fearlessly into the streets, into the unknown,
to meet and mingle with others' lives.

As "envisionaries," artists should be able to provide a way to
work against the dominant culture's rapacious view of nature ("Manifest
Destiny"), to reinstate the mythical and cultural dimensions to "public"
experience and at the same time to become conscious of the ideological

relationships and historical constructions of place. We need artists to guide us through the sensuous, kinesthetic responses to topography, to lead us into the archaeology and resurrection of land-based social history, to bring out multiple readings of places that mean different things to different people and at different times. And there is much we can learn from the ironically labeled "primitive" cultures about understanding ourselves as part of nature, interdependent with everything in it—because nature includes everything, even technology, created by humans, who are part of nature.

What would it be like, an art produced by the imagination and responses of its viewers or users? How can art activate local activities and local values? With adequate funding resources, public artists might set up social and political spaces in which energies could come together, dialogue and alternatives or opposition could be concretized. These might be seen in relation to the familiar "framing" strategy, in which what is already there is put in sharp relief by the addition of an art of calling attention. "Parasitic" art forms, like corrected billboards, can ride the dominant culture physically while challenging it politically, creating openly con-tested terrains that expose the true identities of existing places and spaces and their function in social control. Another set of possibilities is art that activates the consciousness of a place by subtle markings without disturb-ing it—a booklet guide, walking tours, or directional signs captioning the history of a house or a family, suggesting the depths of a landscape, the character of a community.

Art is or should be generous. But artists can only give what they receive from their sources. Believing as I do that connection to place is a necessary component of feeling close to people, to the earth, I wonder what will make it possible for artists to "give" places back to people who can no longer see them. Because land plus people—their presence and absence—is what makes place resonate. Alternatives will have to emerge organically from the artists' lives and experiences. And they won't unless a broader set of options is laid out by those who are exploring these "new" territories. The artist has to be a participant in process as well as its director, has to "live there" in some way—physically, symbolically, or empathetically.

NOTES

The ideas in this essay are expanded in my forthcoming book *The Lure of the Local*.

1. Lawrence Grossberg, quoted in George Lipsitz, *Time Passages* (Minneapolis: University of Minnesota Press, 1990), p. 22.

2. Ibid., p. 24.

3. Kenneth Helphand, in Kenneth Helphand and Ellen Manchester, *Colorado: Visions of an American Landscape* (Boulder, Colo.: Rinehart, 1991), pp. xxiv, xxv.

4. Wendell Berry, *The Unsettling of America: Culture and Agriculture* (San Francisco: Sierra Club Books, 1986), p. 22.

5. Jeff Kelley, "Art in Place," in *Headlands Journal* (San Francisco: Headlands Center for the Arts, 1991), p. 34. Although I was working on this subject before I read Kelley's work on place, I have gained many insights from this important essay and its longer unpublished version.

6. John R. Stilgoe, *Common Landscape of America, 1580 to 1845* (New Haven and London: Yale University Press, 1982), p. 45.

7. Rosalyn Deutsch, "Uneven Development: Public Art in New York City," in *Out There*, ed. Russell Ferguson et al. (New York: The New Museum, 1990), p. 119.

8. See, for instance, Jack Weatherford's books, including *Indian Givers*.

9. Mary Ann Bonjorni, *Leaving Is Becoming About* (Carson City, Nev.: Western Nevada Community College, 1989), n.p.

10. Donna J. Haraway, "A Cyborg Manifesto," in Donna J. Haraway, *Simians, Cyborgs and Women: The Reinvention of Nature* (New York: Routledge, 1991), pp. 164–65.

11. James Baldwin, "A Talk to Teachers" (1963), in *Graywolf Annual: Multicultural Literacy*, ed. Rick Simonson and Scott Walker (Saint Paul, Minn.: Graywolf Press, 1988), p. 8.

12. Lucy R. Lippard, "The Dematerialization of Art," in *Changing* (New York: E.P. Dutton, 1971), p. 255.

13. Lucy R. Lippard, "Hot Potatoes: Art and Politics in 1980," *Block*, no. 4 (1981), p.17.

14. In her brilliantly concise article "Debated Territory: Artists' Roles in a Culture of Visibility," NACA Journal 1 (1992), Suzanne Lacy has offered another approach to the spectrum, diagramming practices from private to public, from artist as experiencer to reporter to analyst to activist. Of course these are not mutually exclusive, and no activist is effective unless s/he goes through the whole spectrum, beginning with lived experience.

15. In my columns devoted primarily to this subject matter in the *Village Voice*, *In These Times*, and *Z Magazine*.

16. Helen Mayer Harrison, at the symposium "Mapping the Terrain: New Genre Public Art," organized by the California College of Arts and Crafts, Oakland, November 14, 1991.

17. Lynn Sowder, at "Mapping the Terrain" symposium.

18. The title comes from a course founded at Dartington Hall in Devon, England, in the early '80s; the idea is now defunct, but it has spread to North American colleges, including Carnegie-Mellon University, University of Massachusetts, Amherst, and the California College of Arts and Crafts, Oakland, among others.

WHOSE MONUMENT WHERE?
PUBLIC ART IN A MANY-CULTURED SOCIETY } *Judith F. Baca*

Using the term "public art" in an audience of many cultures brings differ-
ent images to mind in each of us. Perhaps some of us envision the frescoes
and statues of the Italian Renaissance or Christo's umbrellas, while others
see the murals of Los Tres Grandes or the ritual sand paintings and totems
of Native peoples. Someone said that the purpose of a monument is to
bring the past into the present to inspire the future. Monuments may be
like the adobe formed from the mud of a place into the building blocks of
a society; their purpose may be to investigate and reveal the memory con-
tained in the ground beneath a "public site," marking our passages as a
people and re-visioning official history. As artists creating the monuments
of the nineties, the ultimate question for us to consider is, What shall we
choose to memorialize in our time?

Over the past twenty years as a public artist, I have been struck by
how our common legacy in public art is derived from the "cannon-in-the-
park" impulse, which causes us to drag out the rusty cannons from past
wars, polish them up, and place them in the park for children to crawl over
at Sunday picnics. The purpose was to evoke a time past in which the
"splendid triumphs" and "struggles of our forefathers" shifted the course
of history. These expositions were meant to inspire an awe of our great
nation's power to assert its military will and prevail over enemies. Running
our hands over the polished bronze, we shared in these victories and became
enlisted in these causes. Never mind if for us as people of color they were
not our forefathers, or even if the triumphs were often over our own people.

A more contemporary example of displaying cannons in the park
occurred during the promenade of military weapons on the Mall in Wash-
ington, D.C., immediately after America declared victory in the Gulf
War. In an exhibition prepared for American families in the adjoining
Smithsonian Institution Hall of Science, a grandfatherly voice (sounding

remarkably like Ronald Reagan) soothed us into believing the war was a bloodless, computerized science demonstration of gigantic proportions. Young American men with adroit reflexes trained by a video-game culture demonstrated our superiority as a nation over Saddam Hussein through video-screen strategic air strikes.

From the triumphant bronze general on horseback—the public's view of which is the underside of galloping hooves—to its more contemporary corporate versions, we find examples of public art in the service of dominance. By their daily presence in our lives, these artworks intend to persuade us of the justice of the acts they represent. The power of the corporate sponsor is embodied in the sculpture standing in front of the towering office building. These grand works, like their military predecessors in the parks, inspire a sense of awe by their scale and the importance of the artist. Here, public art is unashamed in its intention to mediate between the public and the developer. In a "things go down better with public art" mentality, the bitter pills of development are delivered to the public. While percent-for-art bills have heralded developers' creation of amenable public places as a positive side effect of "growth," every inch of urban space is swallowed by skyscrapers and privatized into the so-called public space of shopping malls and corporate plazas. These developments predetermine the public, selecting out the homeless, vendors, adolescents, urban poor, and people of color. Planters, benches, and other "public amenities" are suspect as potential hazards or public loitering places. Recent attempts in Los Angeles to pass laws to stop or severely restrict push-cart *vendedores* from selling *elotes*, *frutas*, *paletas*, and *raspados* made activists of nonaggressive merchants who had silently appropriated public spaces in largely Latino sections of our city. *Vendedores*, loved by the people for offering not only popular products but familiar reminders of their homelands, provide a Latino presence in public spaces. Any loss of *botánicas*, *mercados*, *vendedores*, and things familiar reinforces segregation, as ethnic people disappear to another corner of the city.

Los Angeles provides clear and abundant examples of development as a tool to colonize and displace ethnic communities. Infamous developments abound in public record, if not consciousness—Dodger Stadium,

which displaced a historic Mexican community; Bunker Hill, now home to a premier arts center, which displaced another; and the less well documented history of how four major freeways intersected in the middle of East Los Angeles's Chicano communities. One of the most catastrophic consequences of an endless real estate boom was the concreting of the entire Los Angeles River, on which the city was founded. The river, as the earth's arteries—thus atrophied and hardened—created a giant scar across the land which served to further divide an already divided city. It is this metaphor that inspired my own half-mile-long mural on the history of ethnic peoples painted in the Los Angeles river conduit. Just as young Chicanos tattoo battle scars on their bodies, the *Great Wall of Los Angeles* is a tattoo on a scar where the river once ran.[1] In it reappear the disappeared stories of ethnic populations that make up the labor force which built our city, state, and nation.

Public art often plays a supportive role in developers' agendas. In many instances, art uses beauty as a false promise of inclusion. Beauty ameliorates the erasure of ethnic presence, serving the transformation into a homogenized visual culture: give them something beautiful to stand in for the loss of their right to a public presence. Two New York–based artists were selected to decorate the lobby of the new skyscraper of First Interstate Bank in downtown Los Angeles. To represent multiculturalism in Los Angeles, they chose angels from the Basilica of Santa Maria degli Angeli near Assisi, Italy. They then tacked ethnic emblems onto the European angels, "borrowing" the pre-Columbian feathered serpent Quetzalcoatl from the Aztecs, the crowned mahogany headpiece from Nigerian masks, and the eagle's wings from our Native peoples as "emblems of a variety of cultures." These symbols replaced the real voices of people of color in a city torn by the greatest civil disorder in the United States in decades. At the dedication, which took place shortly after the rebellion (the Los Angeles riots of 1992), black and Latino children unveiled the angels in an elaborate ribbon-cutting ceremony. Hailed by the developers as a great symbol of "unity," these artifacts stood in for the real people in a city terrified of the majority of its citizens. Tragically, the $500,000 spent on this single work was more than the whole city budget

to fund public murals by ethnic artists who work within Los Angeles's diverse Chinese, African American, Korean, Thai, Chicano, and Central American neighborhoods.

No single view of public space and the art that occupies it will work in a metropolis of multiple perspectives. While competition for public space grows daily, cultural communities call for it to be used in dramatically different ways. What comes into question is the very different sensibilities of order and beauty that operate in different cultures. When Christo, for example, looked for the first time at El Tejon Pass, he saw potential. He saw the potential to create beauty with a personal vision imposed on the landscape—a beauty that fit his individual vision of yellow umbrellas fluttering in the wind, marching up the sides of rolling hills. The land became his canvas, a backdrop for his personal aesthetic.

Native people might look at the same landscape with a very different idea of beauty, a beauty without imposition. They might see a perfect order exemplified in nature itself, integral to a spiritual life grounded in place. Nature is not to be tampered with; hence, a plant taken requires an offering in return. Richard Ray Whitman, a Yaqui artist, said, "Scientifically cohesive—I am the atoms, molecules, blood, and dust of my ancestors—not as history, but as a continuing people. We describe our culture as a circle, by which we mean that it is an integrated whole."[2] Maintaining a relationship with the dust of one's ancestors requires a generational relationship with the land and a respectful treatment of other life found on the land.

Or perhaps Native peoples could not think of this area without recalling Fort Tejon, one of the first California Indian reservations established near this site in the Tehachapi Mountains, placed there to "protect" Indians rounded up from various neighboring areas, most of whose cultures have been entirely destroyed. In Christo's and the Native visions we have two different aesthetic sensibilities, as divergent as the nineteenth-century English manicured garden is from the rugged natural New Mexican landscape of the Sangre de Cristo Mountains.

Perhaps a less benign implication of Christo's idea is that landscape untouched by man is "undeveloped land." This is a continuation of the

concept of "man over nature" on which this country was founded, a heritage of thought that has brought us clear-cutting in first growth forests and concrete conduits that kill rivers as an acceptable method of flood control. These ideas find their parallel in the late modernist and postmodernist cults of the exalted individual, in which personal vision and originality are highly valued. As a solitary creator the artist values self-expression and "artistic freedom" (or separateness rather than connectedness). He is therefore responsible only to himself rather than to a shared vision, failing to reconcile the individual to the whole.

When the nature of El Tejon Pass—a place known to locals for its high winds—asserted itself during Christo's project and uprooted an umbrella planted in the ground, causing the tragic death of a woman who had come to see the work, Christo said, "My project imitates real life." I couldn't help musing on what a different project it would have been had the beautiful yellow umbrellas marched through Skid Row, where Los Angeles's 140,000 homeless lie in the rain. Art can no longer be tied to the nonfunctionalist state, relegated by an "art for art's sake" tyranny. Would it not have been more beautiful to shelter people in need of shelter, a gesture and statement about our failure as a society to provide even the most basic needs to the poor? Why is it not possible for public art to do more than "imitate" life? Public art could be *inseparable* from the daily life of the people for which it is created. Developed to live harmoniously in public space, it could have a function within the community and even provide a venue for their voices.

For the Mexican sensibility, an important manifestation of public art is a work by Mexican artist David Alfaro Siqueiros on Los Angeles's historic Olvera Street. This 1933 mural, painted over for nearly sixty years by city fathers because of its portrayal of the plight of Mexicanos and Chicanos in California, is currently in restoration. Siqueiros depicted as the central figures a mestizo shooting at the American eagle and a crucified Chicano/Mexicano. While this mural is becoming *museo*-fied, with millions of dollars provided by the Getty Foundation for its preservation and re-presentation to the public, it is important to recognize that the same images would most likely be censored if painted today on Los Angeles's

streets. The subject matter is as relevant now, sixty years later, as it was then. Murals depicting the domination of and resistance by Los Angeles's Latinos or other populations of color provoke the same official resistance as they did in 1933. Despite these struggles, murals have been the only interventions in public spaces that articulate the presence of ethnicity. Architecture and city planning have done little to accommodate communities of color in our city.

As competition for public space has grown, public art policies have become calcified and increasingly bureaucratic. Art that is sanctioned has lost the political bite of the seventies murals. Nevertheless, a rich legacy of murals has been produced since *America Tropical* was painted on Olvera Street by the maestro. Thousands of public murals in places where people live and work have become tangible public monuments to the shared experience of communities of color. Chicano murals have provided the leadership and the form for other communities to assert their presence and articulate their issues. Today, works appear that speak of children caught in the cross fire of gang warfare in the barrios of Sylmar, the hidden problem of AIDS in the South-Central African American community, and the struggles of immigration and assimilation in the Korean community. These murals have become monuments that serve as a community's memory.

The generations who grew up in neighborhoods where the landscape was dotted by the mural movement have been influenced by these works. With few avenues open to training and art production, ethnic teenagers have created the graffiti art that has become another method of resisting privatized public space. As the first visual art form entirely developed by youth culture, it has become the focus of increasingly severe reprisals by authorities who spend *fifty-two million dollars* annually in the County of Los Angeles to abate what they refer to as the "skin cancer of society." It is no accident that the proliferation of graffiti is concurrent with the reduction of all youth recreation and arts programs in the schools.

Working with communities in producing public artworks has put me into contact with many of these youths. On one occasion, I was called to a local high school after having convinced one of the young *Great Wall* production team members that he should return to school. The urgent

message from the boy in the principal's office said, "I need you to come here right away because I'm going to get thrown out of school again." My deal with the boy, formulated over a long mentorship, was that he would not quit school again without talking to me first. I arrived to find the principal towering over the young *cholo*, who was holding his head in a defiant manner I had seen over and over in my work with the gangs. This stance, reminiscent of a warrior, called unceremoniously "holding your mug," is about maintaining dignity in adverse circumstances. The principal was completely frustrated. "You've written on the school's walls and you simply do not have respect for other people's property. Tell me, would you do this in your own house?" I couldn't help but smile at his admonition, despite the seriousness of the situation. This boy was an important graffiti artist in his community. I had visited his house and seen the walls of his room, where every inch was covered with his intricate writings. Two different notions of beauty and order were operating, as well as a dispute about ownership of the school. The boy's opinion was that he had aesthetically improved the property, not destroyed it.

At this time the conditions of our communities are worse than those that precipitated the civil rights activism of the sixties and seventies. Fifty-two percent of all African American children and forty-two percent of all Latino children are living in poverty. Dropout rates exceed high school graduation rates in these communities. What, then, is the role of a socially responsible public artist? As the wealthy and poor are increasingly polarized in our society, face-to-face urban confrontations occur, often with catastrophic consequences. Can public art avoid coming down on the side of wealth and dominance in that confrontation? How can we as artists avoid becoming accomplices to colonization? If we chose not to look at triumphs over nations and neighborhoods as victories and advancements, what monuments could we build? How can we create a public memory for a many-cultured society? Whose story shall we tell?

Of greatest interest to me is the invention of systems of "voice giving" for those left without public venues in which to speak. Socially responsible artists from marginalized communities have a particular responsibility to articulate the conditions of their people and to provide

catalysts for change, since perceptions of us as individuals are tied to the conditions of our communities in a racially unsophisticated society. We cannot escape that responsibility even when we choose to try; we are made of the "blood and dust" of our ancestors in a continuing history. Being a catalyst for change will change us also.

We can evaluate ourselves by the processes with which we choose to make art, not simply by the art objects we create. Is the artwork the result of a private act in a public space? Focusing on the object devoid of the creative process used to achieve it has bankrupted Eurocentric modernist and postmodernist traditions. Art processes, just as art objects, may be culturally specific, and with no single aesthetic, a diverse society will generate very different forms of public art.

Who is the public now that it has changed color? How do people of various ethnic and class groups use public space? What ideas do we want to place in public memory? Where does art begin and end? Artists have the unique ability to transcend designated spheres of activity. What represents something deeper and more hopeful about the future of our ethnically and class-divided cities are collaborations that move well beyond the artist and architect to the artist and the historian, scientist, environmentalist, or social service provider. Such collaborations are mandated by the seriousness of the tasks at hand. They bring a range of people into conversations about their visions for their neighborhoods or their nations. Finding a place for those ideas in monuments that are constructed of the soil and spirit of the people is the most challenging task for public artists in this time.

NOTES

1. The *Great Wall of Los Angeles*, painted over a nine-year period by a team of inner-city youths (over 350 have been employed), is a community-based model of interracial connection, community dealings, and revisionist historical research. Each panel depicts a different era of California's history from the perspective of women and minorities. When completed, the mural will extend over one mile in the Los Angeles flood control channel.

2. Richard Ray Whitman, quoted in *El Encuentro* (Venice, Calif.: Social and Public Art Resource Center, 1992).

COMMON WORK ⟩ *Jeff Kelley*

Over the past decade, those of us interested in a serious and challenging
public art have heard often of the benefits of collaboration between artists
and architects. The conventional wisdom is that artists bring a fresh, unen-
cumbered sense of design to architectural projects, and that the peculiari-
ties of the artist's ego-center somehow enliven the otherwise conventional,
corporate*sque* environments architects come up with too much of the time.
The artist is assumed to be freer than the architect, and freedom is assumed
to be art. The architect is regarded as a relative technician by comparison,
constrained as he or she is by the legal, fiscal, and material limitations of
the trade. The idea is that as artists and architects "collaborate" architec-
ture will be made more human, or at least more art-like. Art-likeness is
assumed to be more humane.

Conventional wisdom aside, true collaboration among artists and
architects rarely happens. Given the stereotypical ways in which we see
each other, it's no wonder. What passes today for collaboration tends in
fact to be a frustrating process of compromise and concession. The archi-
tect is almost always in charge, and artists, who are paid very little for their
services, often must fight for recognition as members of a "design team."
Moreover, in our society the conditions are not usually safe for collabora-
tion to occur. The loss of professional identity is at stake, and in corporate
America, professional identity is often all one has. Given this territorial
antagonism and the bureaucratic hassles of the public sector (which is
usually the designated "client" in a public art/architecture project), many
artists have simply given up and gone back to the studio.

Perhaps the most typical misunderstanding architects have about art-
ists is that they want to build "art" into the project, or that they want to make
the architecture itself; that is, that artists want to *play* at being architects.
There is some truth to this. Perhaps the most typical misunderstanding

artists have about architects is that they also play at being artists, mistaking formal elegance for meaning, historical reference for tradition, and an abstract equation of form-to-function for use. As we look at the built environment around us, we can see that there is some truth to this as well. But there is always some truth to a stereotype.

Artists and architects who should *never* work together are those who share these misunderstandings, because to do so means they are probably each locked into pretty stereotypical ways of thinking about what they *themselves* do, and the resources for their works likely come from within their professions rather than from the world around them. Conversely, the artists and architects who might well collaborate are those who believe in neither their own nor each other's claims to professional uniqueness, historical authority, or artistic authenticity.

The best public artists tend *not* to be interested in displaying objects of art in, near, or around architecture. They don't make follies. Nor are they interested in making over architecture into sculpture. Rather, when the work they do calls for collaboration with architects or landscape architects, artists want to be partners in a creative process. It is out of that process that their work emerges and has meaning. In this sense, an artist's "work" may be more like a verb than a noun, visible not only in space but over time.

Collaboration is a process of mutual transformation in which the collaborators, and thus their common work, are in some way changed. Most importantly, the creative process itself is transformed in a collaborative relationship. For artists and architects, that relationship may involve thinking together about designs, thinking about design in different ways, or rethinking design altogether.

More than anything, collaboration means that artists and architects may *not* make art or architecture together. Instead, they will look for those hybrid moments in a collaborative process when art and architecture, as such, disappear into something else, something *other than*. With luck, they will recognize in these zones of something "other than" the potential for a serious and challenging public art. And that's what this is about: debates not about relative artistry or professional prerogatives but about

"de-professionalizing" the process of public design in order to make it more responsive to ideas, resources, and constituencies outside the design professions, including the public wing of the arts.

For their part, artists may bring to a collaborative partnership such nonarchitectural media as video, photography, performance events, or sonic phenomena in an effort to invest public sites with a sense of local history, collective memory, and community scale. That is, they may help to awaken in the social landscape its latent sense of place (a concern of many artists since the sixties). In time, we may witness a provocative exchange in which architects offer artists a truly social site in which to work, and artists offer architects a truly human content with which to build. For me, a social site filled with human content is a place.

At some moment in the late seventies, we crossed an important threshold: we moved beyond sites and into places. At the time, this crossing went largely unnoticed, in part because thresholds are not so much boundaries as matters of dawning awareness, and also because any collective arcs drawn by that awareness come into focus only in retrospect. Even so, one can now discern in much site-oriented and socially driven art of the past two decades an emerging consciousness of the thresholds at which the sites of art become the arts of place.

One such threshold lies at the boundaries of art itself, and with the advent of minimalism and earthworks those boundaries were extended to circumscribe the sites in which artworks were made and placed. Sculpture, by then a disintegrating academic category that included all manner of art making (to the chagrin of many sculptors), became "site-specific." Site specificity, though, often referred more to the perceptual precision fitting of disembodied modernist objects into dislocated museum spaces than to an acknowledgment of the social and cultural contents of a place.

Even now, the term "site" tends to mean a place for art rather than the art of place. Over the past decade, though, artists have begun to acknowledge that it feels very different to be in a place than to be on site. This sense of the human particularity of places—as distinct from the art-like specificity of sites—has informed and even become the contents of the best "public" art.

One might say that while a site represents the constituent physical properties of a place—its mass, space, light, duration, location, and material processes—a place represents the practical, vernacular, psychological, social, cultural, ceremonial, ethnic, economic, political, and historical dimensions of a site. Sites are like frameworks. Places are what fill them out and make them work. Sites are like maps or mines, while places are the reservoirs of human content, like memory or gardens. A place is useful, and a site is used. A used-up site is abandoned, and abandoned places are ruins.

Places are held in sites by personal and common values, and by the maintenance of those values over time, as memory. As remembered, places are thus conserved, while sites, the forgotten places, are exploited. This conservation is at root psychological, and, in a social sense, memorial. But if places are held inside us, they are not solipsistic, since they can be held in common. At a given threshold, our commonly held places become communities, and communities are held together by what Wendell Berry calls "preserving knowledge." As he sees it, a community is "an order of memories" in which "the essential wisdom accumulates in communities much as fertility builds in the soil." Conversely, sites are depleted communities, and any artist who works in places must be ready to work on a scale that is commonly held.

The problem is that most architecture displaces place, and most art is made for specialized architectural sites. Neither has very much to do with place except to testify, inadvertently, to our loss of it. Perhaps rediscovering places is what artists and architects can do together. To do so would be a critique of architecture as it is commonly practiced; it would also be a critique of art. Embedded in places is a record of how our professions have become divorced from their roots in human-scale, social experience, and in each other, leaving them historicized but ungrounded, glancing anxiously at posterity for assurance.

But posterity is neither a place nor a constituency. It is a hallucination about the future as history, and about our presumed place in it. Appeals to posterity are means of avoiding both the present and the memory of the past it holds. We need to be social archaeologists rather than futurists.

"At the core of a formalist architecture and urban design," writes James Wines, "lies an abiding belief in the integrity of some superior plan."[1]

All around us is a "present" littered with corny, naive, and occasionally endearing anticipations of futures that never happened, and layered with the natural and social landscapes that happened instead—landscapes that are usually vernacular, subversive, and sometimes chaotic adaptations of a failed master plan. This ambiguous present testifies to our mired ambitions for a "design solution" to the questions of modern(ist) life. (If *post*-modernism means anything, it is that there are no structural solutions to social problems, only controls.)

Artists and architects will have to learn to see and trust the reservoir of human memory in the social landscape around them. In that soil is a human impulse for the future, but no longer a futur*ism*. As Berry puts it:

Having some confidence in family continuity in place, present owners would have future owners not only in supposition but in sight and so would take good care of the land, not for something so abstract as "the future" or "posterity," but out of particular love for living children and grandchildren.[2]

In other words, places are where time takes root. And it is time in its forms of personal and social memory, and in its connection to the cycles of nature, that we have designed *out* of industrial society, and for which the relentlessness of the clock, the "timelessness" of art, and now the data banks of cyberspace have become shallow substitutes.

Like steel, dirt, or space, time is a medium in which things get made, and unmade. Across it, the cycles of life and death unfold. As artists and designers, we often resist the destructive aspects of those cycles. But it was precisely these aspects that artists of the sixties and seventies uncovered in their earthworks and specific sites. As Robert Smithson wrote:

Separate "things," "forms," "objects," "shapes" with beginnings and endings are mere convenient fictions: there is only an uncertain disintegrating order that transcends the limits of rational separations. The fictions erected in the eroding

*time stream are apt to be swamped at any moment. The brain itself resembles
an eroded rock from which ideas and ideals leak.*[3]

During this prosaic renaissance of American art, formalism, with its shield
of "timelessness," began to deteriorate. In its place, we sensed the contin-
gencies by which time and matter, nature and culture, coexist. With the
women's movement, female artists acknowledged the cycles of fertility that
accompany time and strove to recover memory itself as a medium of his-
tory, and in it, to reclaim cultural memories of themselves as artists. (One
can speculate, at some risk, that among artists of this period, the men were
like miners and the women were like gardeners; something was destroyed
but also cultivated.) With the recent political awakening of artists of color,
memory as history begins to tap its roots outside the mainstream, shaping
a landscape of wellsprings and tributaries that irrigate the promise of a
pluralistic society we made to ourselves so long ago. And it is this con-
sciousness of time as both an erosive and creative medium, and as a form
of multicultural memory, that artists of the nineties will bring to the places,
processes, and partnerships of public art.

As part of a project to widen the North Central Expressway in
Dallas, a cemetery for freed slaves dating back to the Civil War has been
recently rediscovered and is being excavated in order to move as many as
eight hundred graves. Archaeologists estimate upwards of two thousand
black Americans are buried in a site all but forgotten since the thirties.
Because of this unprecedented excavation, we are learning about the role of
African religious beliefs and funereal customs in the lives and deaths of the
first free American blacks. And because the cemetery was a focal point for
Dallas's turn-of-the-century blacks, its excavation is spurring a reclama-
tion of social memory within the present-day African American commu-
nity, as old family photographs are dusted off and stories retold.[4] But in its
disappearance, the site also attests to our mainstream cultural denial about
eras in history, classes of people, and what some of us did to others of us.
As a place, Freedman's Cemetery is steeped in social and personal mean-
ing, and like a vague but disturbing memory, it may serve to remind us of
the roots of our current crises of race and class while offering us, finally,
both a place and a time to celebrate the lives of these free Americans.

Might such places as this be subjects, or even resources, for collaboration among us?

While many artists of place are motivated toward social engagement through their works—and are thereby romantic and utopian to that degree—they are neither social nor aesthetic idealists, basing their practice, instead, upon the particular, pragmatic, and ever changing conditions of particular places. They do not design society; they represent place. If their works become models for social design, all the better. But an art of place is not about abstract equations of function to form, which is the legacy of mid-century utopian architecture. It is human-scale work about human-scale work. The extent to which the content of a place resonates in other places is the extent to which an art of place has resonance. The place, not the art, is the metaphor. In another place, one would need another art.

Places are experienced concretely, not as equations of function to form. In this sense, architecture is *not* place until and unless we subvert it with the contents of our lives. It has been tempting over the past decade to accept architecture as the primary analogue for artworks of and in place, in part because artists have so often adopted the shelter motif, and because the discourse between art and architecture has been such a significant aspect of modernism.

Perhaps the better analogue for an art of place is theater—not that of the proscenium stage, but rather the latent theater of our personal and social lives. In 1966 Michael Kirby described the participants in Allan Kaprow's Happenings as "nonmatrixed performers," as the conscious enactors of scripted tasks that did not require the affectation of a dramatic persona. You just performed the task as yourself. Around the same time, Kaprow wrote in *Assemblage, Environments, and Happenings*, "If there are to be measures and limits in art they must be of a new kind. Rather than fight against the confines of a typical room, many are actively considering working out in the open. They cannot wait for the new architecture." Of course, the new architecture never came, although its precedents existed for Kaprow in Kurt Schwitters's Merzbau, Frederick Keisler's concept of the "endless room," and also in the ceremonial and living spaces of Native American and African societies. In retrospect, Kirby's notion of a

nonmatrixed performance and the kind of flexible, organic architecture Kaprow had in mind were parts of a broad intention to integrate artists and art into nonart settings. Beyond the new theater or the new architecture, what they unwittingly predicted was the convergence of the two in the context of place.

In a particularly American sense, the theater of modernism has been scripted by the act of work. As such critics as Leo Steinberg and Harold Rosenberg have noted, we have tried since the early nineteenth century to convert works of art into an art of work, to peel away from artworks that frosty European patina that keeps us from a direct experience of the world. "Americans," wrote Rosenberg, "dream of taking home hunks of raw nature." In this sense, work has been seen as a penitential ethic by which American art is stripped of aristocratic pretensions and made common, especially if that work is tied to the land.

And yet, in the context of North American cultural mythologies the reification of work feels like a fundamentally male, specifically Anglo conceit. It is a way of paying one's Protestant dues for being an artist in a culture of welders, cowboys, and scientists; but the terms of that bargain were not forged by women or non-Europeans. Tellingly, the archetypal worker of American modernism was Jackson Pollock, an abusive, alcoholic tough guy for whom painting was where the action was. Behind him was the hard-nosed, journalistic sensibility of the American regionalists, and ahead were the street theatrics of Happenings, the industrial materials of minimalism, and the hunks of raw earthworks, all infused with a sense of the common, the literal, process and of the capacity of work to demystify art in the name of life.

At its worst, this ethos of work perpetuates a stereotypical, masculine standard for the redemption of artists as workers. At its best, it suggests that art is a process in which we can all participate. The environmental sound-sculptor Douglas Hollis once said that while he didn't know if people understood his work as art, he was certain they understood his art as work. The point is not to romanticize work. Rather, in an age when the tangibility of the world has been flattened by the ubiquitous formalist criticism of culture called "the media," one might think of an art of place as a theater of social engagement in the context of our common work.

Common work. Perhaps that is what collaboration means. Not so much art as work, not so much mine or yours as ours in common. On a social, architectural scale, the process of common work is embodied in the commons, a traditional open space in American towns in which public life, and especially social and political change, was enacted in perhaps its most vivid, contested, and refreshing ways. Many of today's best public artists continue this enactment, even though the commons as a physical place has been largely paved over by the urban grid and bypassed by highways, superhighways, and, now, information superhighways. Their commitment, as Patricia C. Phillips points out, is not to a vanishing notion of small-town space but to the experiences of social change and communal continuity embodied by the commons. "Public art," she writes, "is about the commons—the physical configuration and mental landscape of American public life." A stage where "the predictable and unexpected theater of the public could be presented and interpreted," the commons was also a social extension of "the dialectic between common purpose and individual free wills."[5] It was here that we became citizens.

Today's public artists struggle to relocate that common ground—no easy task given the decay of the inner cities, the stratification of the social classes, the balkanization of the races, the virtual disembodiment of experience, and the almost total mediation of political life. What this means is that the commons of the future will not be a physical site so much as the places and occasions of our common work. Artists can provide instances where common work becomes visible on a public scale, in a public space, over a public time. In this respect, collaboration is a prerequisite of both communal experience and public art.

The terrain of collaboration has been tentatively mapped since the sixties by artists and architects interested in exploring the social and ecological landscapes that lay beyond the range of formalist canons. Whether earthworks, the entropic ruminations of Robert Smithson, feminist ritual performance, James Wines's model of dearchitecturization, notions of site specificity, the public art movement, or recent speculations on the sociopsychological nature of places, these forays beyond the ideological cells of late modernism represent, in the broadest terms, a rejection of abstraction and an embrace of the particular. Modernist utopianism dissolves into a

Jeff Kelley

landscape of what might be called a postmodern social realism. Abstract space becomes particular place.

It is here that mass audiences become local constituents, that personal and social memory are beheld as resources, that the human scales of family and community are sensed, that time is respected as a cultivating force (even as it destroys), and that the vernacular multiplicity of cultural, ethnic, and linguistic difference is explored, smelled, tasted, and embraced.

Perhaps the value of collaboration is that through it we may liberate each other from the institutional modes of thinking that narrow us, rediscovering—as we have again and again throughout this century—that the gaps among the arts, or among the arts and sciences, tend to be full of life. The question of whether artists and architects collaborate is only one among many in the current public art debates, but it does help to identify what is at stake: the loss or recovery of our common senses. Clearly, we are no longer talking about art or architecture alone but about the social and ritual landscape of human artifice that surrounds us, and about the common work that lies ahead.

NOTES

1. James Wines, "De-Architecturization," in *Esthetics Contemporary,* ed. Richard Kostelanetz (Buffalo, N.Y.: Prometheus Books, 1978), p. 278.

2. Wendell Berry, "People, Land, and Community," in *Multi-Cultural Literacy,* ed. Rick Simonson and Scott Walker (St. Paul, Minn.: Graywolf Press, 1988), p. 55.

3. Robert Smithson, "A Sedimentation of the Mind," in *The Writings of Robert Smithson*, ed. Nancy Holt (New York: New York University Press, 1979), p. 90.

4. Toni Y. Joseph, "A World Apart," *Dallas Morning News,* October 21, 1990, sec. F, pp. 1–2.

5. Patricia C. Phillips, "Temporality and Public Art," in *Critical Issues in Public Art,* ed. Harriet Senie and Sally Watson (New York: HarperCollins, 1993), p. 298.

Section Four } THE PROBLEM OF
CRITICISM

SUCCESS AND FAILURE WHEN ART CHANGES } *Allan Kaprow*

In the late sixties, an educational experiment called Project Other Ways took place under the wing of the Berkeley, California, Unified School District. Educator Herbert Kohl and I were its stewards, assisted by a Carnegie Corporation grant. Its purpose was to bring the arts into a central role in the public schools' curricula. To do this, the project acted as an agency which drew together school administrators, teachers, and their students with young poets, storytellers, sculptors, architects, photographers, happeners, and even athletes who saw their sport as art.

Participation was more informal than strict; membership varied from individuals to teachers and their classes (K through 12). Some attended only workshops while others were committed to semester projects. We were located in a storefront not far from the Berkeley high school, which made us pleasantly accessible to passersby, but much of our work extended out into the city's classrooms and the everyday environment.

At the time, Berkeley, along with nearby Oakland and San Francisco, was the scene of massive social upheaval, and armed forces were everywhere. It is important to mention this because our activities rarely addressed the conflict directly, yet they reflected its paranoias and powerful energies, as well as the surge of utopian fervor that fueled it. Most of our efforts, in fact, focused on learning staples such as reading, writing, math, and community studies, and we believed that the arts could foster them. But no one could ignore the tension and the smell of tear gas, and our experiments sometimes approached the edges of social boundaries.

For example, there was a sixth grade class in one of the Oakland schools whose kids were considered unteachable illiterates. I forget the official label but it was enough to sentence them to permanent societal rejection. Their days in school (when they showed up) were largely a matter of disciplinary supervision, not education. Some of them came to

our storefront with their teacher one afternoon. We had just been given a number of cheap Polaroid cameras and film, and I invited the kids to take a walk with me and snap pictures of anything they liked. On the way, they took pictures of each other making faces, of their shadows, of helicopters in the air, of army tanks and cops; but mostly, they seemed to prefer graffiti on the sidewalks and walls of buildings. I wondered why, if they were illiterate, they were so interested in words, especially sexual ones.

So I said let's take photos of the graffiti in men's and women's public toilets. The kids thought that was a great idea, especially if the girls could go into the men's toilet stalls and vice versa. We went around town to filling stations and motel restrooms and shot off dozens of film packs, most of which didn't come out. But of those that did, it was clear that the kids understood four-letter words and related descriptions around certain drawings. Illiterate? Not quite.

Kohl and I saw the germ of an idea in what had just happened. We covered the walls of our storefront offices with large sheets of brown wrapping paper, provided felt-tip pens, paints and brushes, staplers and rubber cement. We invited the kids back the following week and put on a table the photos they had taken. They were asked to make graffiti, using the photos and any drawings they wanted to make, like the graffiti they had seen on our tour. At first they were hesitant and giggled, but we said there were no rules and they wouldn't be punished for dirty words or drawings, or even for making a mess. Soon there were photos all over the walls. Drawn and painted lines circled and stabbed them, extending genitalia and the names of locals they obviously recognized. These names, like Huey (probably Black Panther Huey Newton, then under arrest), Bobo (an area gang leader), and Cesar (Cesar Chavez, farmworkers labor leader), were painted in large letters. Sometimes opposition names would be followed by verbs like "sucks" and other equivalents.

Their own names and images began to appear in the next days, often with the help of our staff, occasionally by helping one another. Later on, the kids were encouraged to tell stories about what they had done and what they saw on other parts of the walls. The better writers were asked to print the stories at the appropriate places. These were usually no more

than two- or three-word labels (like much public graffiti), rarely complete sentences. But after a week, a guarded enthusiasm replaced shyness and a core of active literacy began to emerge.

Kohl heard that the school system's textbook depository was discarding outmoded Dick and Jane early reader books, and that we could have as many as we wanted. The thought was to have our small group rewrite and reillustrate them. If any young people could possibly have been interested in the primers' stereotyped narratives in those years of social challenge, they could only have been the sons and daughters of patently sexist and racist parents. But there didn't seem to be many of them willing to speak out in Berkeley then, and that was one of the reasons the city was getting rid of the books. Our assumption was that the kids' sensitivity to these biases (the majority were black or Hispanic) would provide us the openings for frank discussion, and would make attractive the prospect of wholesale revision of the texts. We were right.

Dick and Jane were transformed into monsters with wildly colored hair. Images were cut out and replaced by drawn ones. Pages were reordered to create time reversals. And the text became a parody of "Run, Spot, run!," as "Run, man, fuzz!" seemed suddenly more real. One of the kids was helped in typing the texts on the office typewriter, while others hand-lettered the books. A small exhibit of the results was shown to the school officials, who were impressed enough to consider reclassifying the students.

Was the experiment a success? It depends on our criteria. Conventionally, in our culture, something is either art or it's something else; either a poem or a telephone call to a relative. But Project Other Ways was intent on merging the arts with things not considered art, namely training in reading, writing, math, and so on. Significantly, the innovative art movements of the day provided the models for our objectives. The Japanese Gutai, Environments, Happenings, Nouveau Réalisme, Fluxus, events, noise music, chance poetry, life theater, found actions, bodyworks, earthworks, concept art, information art—the list could go on—confronted publics and arts professionals with strange occurrences bearing little resemblance to the known arts.

The identity problem these movements caused in arts circles (that is, what exactly were these new creatures, and how should we deal with them?) was nothing compared with the potential confusion we could sense lying a short distance away in the education community. We at Project Other Ways were privileged in this regard, by grant money and experience as artists, to play and change as we saw fit, where in the average classroom it would have been almost impossible. Educational philosophy and teacher training would have to be radically revised. We said so, and were under no illusions that the task would be easy.

If the new arts were bewildering to many within their own arts circles, they shared two conditions. One was that the borders between the arts and the rest of life were blurred. The other was that their makers wanted them to be still known as art. And in order to be considered art, they had to be acknowledged and discussed within the arts' institutional frameworks.

So the artists saw to it that this connection with the machinery of validation was solidly maintained. Their work was widely promoted as art, in the form of photo documents, recordings, and descriptive texts, by galleries, new music and dance impresarios, collectors, and arts journals. Although I personally intended our educational experiment at the project to be art at the same time as it was a way to increase literacy, and some students and colleagues heard me say so, the work was never published or exhibited. Thus, by the rules of the game at the time, it failed to count as art.

Today, twenty-five years later, the story is about to be printed in an art book. The art frame will descend upon it. Does it become art at last? And if so, is it good art? A complicating factor is that in my own thoughts and writings about Happenings and their progeny in the sixties, I placed a strong emphasis on identity ambiguity: the artwork was to remain, as long as possible, unclear in its status. By this standard, the experiment at Project Other Ways was good art (up to now, to me at least), as long as I kept the story mere hearsay among friends. My guideline was simple: one shouldn't rush too quickly to label life as art; it may deaden the game.

Has enough time elapsed to allow the story of the event to become useful gossip today—useful because it could act as permission for others to

leave straight art for the art/life game? Hard to answer. Or, instead, have I devalued the game by casting it in the cement of art history, that is, as nothing but art? Maybe. Being merely art, the potential influence it might have on public education, and on art itself, can be shelved indefinitely.

As a safeguard against this possibility, suppose that right here I withdraw all art status from a past event that I once designated art. Suppose that a consensus of art and education professionals in the nineties is willing to go along (and why not?). Then what we did in the sixties was an educational experiment quite separate from art. This maneuver, at least, would maintain for the art reader the necessary ambiguity of meaning I referred to, and would save the event from being limited by art and its special discourses. It could remain open to educational review.

For the educator, therefore, who may not be concerned with art, a particular goal was achieved. A group of children was helped toward literacy and some degree of interest in learning. But was that an example of good education? Here, again, difficulties arise. Without some controls and measures, some ways of replicating the activity, what happened between us and a dozen kids in Berkeley can hardly be considered a textbook classic. Almost anyone will seem to flower if unusual attention is paid to them. It's what happens over the long term that matters. Rephrasing the question above to "What happened to the kids after they left us?" probably must be answered: "They returned to the way they were." And so, if sustained instruction and growth are necessary for lasting value, as I believe they are, the whole thing was an educational diversion. At best, they were entertained. Superficially, that's what art can do. Can experimental art and experimental education get together more substantively for the common good? Perhaps, like most new art, such investigations may be, and should be, only on a laboratory, model-making level.

This may seem unduly skeptical, but over the years I have come to see that on the rare occasions when the arts are introduced on a professional level into the nation's schools, they arrive as bright spots, dashes of salt, in an academic atmosphere normally devoid of the arts. They appear one day and are gone the next. Artists themselves tend to view their own fields as "something special" in a drab or afflicted world. They have shows,

plays, concerts, poetry readings, each offered piously as a moment of joyful creativity. Except in professional schools of the arts serving adults, exhibiting artists usually don't teach in the public schools on a daily basis. So it is no surprise that they share with the schools the same cultural bias in which the arts are marginal to a central education. Real education goes on every day; art comes on holidays (holy days).

Project Other Ways explicitly tried to correct this entertainment notion of the arts, by urging that they be taken seriously as core subjects of a normal school's program. It was hoped that, ultimately, the project could train and refer full-time teachers to the school system. But limited funding, combined with exhaustion from the political upheavals in the Bay Area, ended the experiment after about two years. To have had some basis for evaluating its effectiveness, in my view, we would have needed at least ten years.

Most artists, of course, are less keenly interested in ambiguity of identity and purpose than I am. Open-endedness, to me, is democratic and challenges the mind. To others, it is simply waffling and irresponsible. It depends on what kind of art one is talking about. And on what segment of the public. When art as a practice is intentionally blurred with the multitude of other identities and activities we like to call life, it becomes subject to all the problems, conditions, and limitations of those activities, as well as their unique freedoms (for instance, the freedom to do site-specific art while driving along a freeway to one's job, rather than being constrained by the walls of a gallery; or the freedom to engage in education or community work as art). The means by which we measure success and failure in such fleeting art must obviously shift from the aesthetics of the self-contained painting or sculpture, regardless of its symbolic reference to the world outside of it, to the ethics and practicalities of those social domains it crosses into. And that ethics, representing a diversity of special interests as well as the deep ones of a culture, cannot easily be disentangled from the nature of the artwork. Success and failure become provisional judgments, instantly subject (like the weather) to change.

Once the artist is no longer the primary agent responsible for the artwork but must engage with others, sometimes undefined and loosely

organized like the school kids, sometimes highly defined like government or corporate structures, the artwork becomes less a "work" than a process of meaning-making interactions. Once art departs from traditional models and begins to merge into the everyday manifestations of society itself, artists not only cannot assume the authority of their "talent," they cannot claim that what takes place is valuable just because it is art. Indeed, in most cases they dare not say it is art at all. Serious public art in an America untuned to art culture may one day become a vital presence in the forms and places most resembling ordinary living. The situation, then, would be truly experimental.

The late artist Robert Filliou once said that the purpose of art was to reveal how much more interesting life is. The task for contemporary experimental artists may well be to probe that paradox, day by day, again and again. Then, perhaps, their gift to the public could be the mystery of tying a shoelace.

WORD OF HONOR } *Arlene Raven*

THE CRITIC'S VOICE

I came of age as an art writer just before conceptualism hit M.F.A. programs. I might have identified myself as a conceptual artist had I attended graduate school five years later than I did. A translator, I put words to forms. And I regard critical writing at its best as containing the truth of art—of fiction and metaphor—rather than merely of facts.

As an art writer working in the late sixties and still working in the nineties, I grew up with Clement Greenberg's formalist language and presentation of his subjective opinion as objective reality, then experienced a shift to issues-oriented criticism on the one hand and to the theoretical language of French analysis as applied to art on the other. Today, art criticism seems less and less connected to art. Instead, ideas bump against ideas in complicated, self-referential "critical" sentences.

I have lost interest in giving opinions and constructing arguments that lead to judgments about the "value" of artworks. Such judgments, I believe, are irrelevant to this time. Pronouncements and negations of worth also lead to a kind of conformity of thought within a monolithic merit system that is now hidden in an academic philosophical vocabulary but is antithetical to art as I know it.

Those who deal in the praise-and-blame school of contemporary art criticism wax sentimental, eyes on the art market, when they lay out unacknowledged biases as a gold standard in their spoken and written work. Critics still influence sales yet benefit less from them. Is that why some seem to be perpetually boiling over with sour, self-righteous vituperation when art worlds do not meet their criteria for value?

Without a criticism based on creating market value through personal value put forth as "objective" worth, what is left? Crucial for me is

that my writing, arising from my seeing, attempts to be educational and includes information gleaned from interviews, research, and a knowledge of art and history. There *is* something that can be added to the experience of artworks—data and insights that will place them in literary, geographical, historical, critical, political, or thematic contexts.

I consider my profession to be a vocation to which I have been called (although I couldn't tell you by whom). I've never heard a child say, "When I grow up, I want to be an art historian." Yet I feel some art in such an intense way that I am urgently compelled to try to put it into words—for myself first, and then for others.

Georgia O'Keeffe made a sharp distinction between artists and art writers. For O'Keeffe, a color was always more definite than a word. For me, the opposite is true. Today's practice—mixing language with color, line, and shape—has challenged the necessity of choosing one over the other.

There are critics of every sort, among them poets and visual artists. Some artists, in turn, use texts as a primary element of their visual work. The extreme word orientation of conceptual artists who work exclusively with language seems to carry their work as the forms and color of it. Verbal components often introduce social issues, act as formal elements as well as narratives, and become metaphorical parts of speech. The inclusiveness of verbal inquiries within word-oriented artworks, on elemental as well as literary levels, mirrors the inclusive spirit of the art under consideration. Here the line between art and criticism blurs.

I think of my work as "writing alongside of" the visual or performative efforts of other people. The dialogue, and even collaboration, of my work and their "shows" visually in some of my written commentaries. Because I want artists to be seen and heard, I often use more than one voice in my prose. Even when others are not physically represented by varying typefaces or areas on the page, they are written into the text.

My books and the essays I have written for magazines and newspapers with readerships in the hundreds of thousands are my most "public" art/criticism, because of the larger audiences for that work and its archiving in libraries. A relatively tiny "audience"—those written about—

becomes (during my process of consulting with artists, seeing work in progress, and submitting most of my texts to them for their consideration) an informed company who have also, in a sense, collaborated. Thus a given subject may "own" the text in a different way than traditional artist-subjects of criticism can. I enter into a reciprocal relationship with the artists whose work I interpret. In this relationship, my process parallels that of artists working in the public interest in the past decade who have crossed the boundary between the creation of artworks and the formulation of their critical context.

The critical context is part of the concept of "community." Unlike standard definitions of community as individuals with common interests based on location alone (such as a state or commonwealth), the community that consists of artist and audience for artworks contains, as well, the commentative structure in which the audience and artist may view the process and product of art making. This "critical" component is present whether or not it is discerned or declared. Furthermore, community, like art itself, must be created from a practice that begins with the blank page or empty canvas.

My stance against opinionated judgments about good art and bad art in critical writing does not attempt to substitute an uncritical advocacy. Instead of working from and back again to ideation, I struggle to gain an understanding of artists' intentions and to assess their fulfillment within the audience.

"Intention" means stated or unstated purposes and goals; "fulfillment" is the achievement of intentions. To what extent the ambitions of artists have been put into action through art objects and dramatizations or via public information avenues is an essential index of the ultimate success, or value, of the work.

Points of appraisal differ widely according to artists' ambitions, the environments into which their work will be placed, and the audience they hope to reach. For instance, a public art work in a nontraditional environment, such as a mall or street corner, will have quite different aesthetic and social goals than a painting made for a gallery or museum. Nevertheless,

the personal, psychic, and spiritual environment in which artists create their work can be extrapolated from such factors as similar dates, places where the work was constructed, and themes.

In contrast, I also "value" every work I choose to write about according to my known and unknown biases and taste. My preselection of themes and subject matters based on my own preferences may explain why I don't write so-called bad reviews. The moral and ethical aspects of art making, showing, and interpreting, moreover, concern me more than other evaluative issues—aesthetic, didactic, or monetary.

THE DESIRE FOR COMMUNITY

The public art that has most moved me in the last three decades is that which attempts to draw together a community and to participate with its audience in the definition and expression of the whole physical and social body in both its unity and diversity. Often these works are temporary, leaving traces in the hearts and minds of all those affected by the process rather than merely leaving monuments in their midst.

A definition of contemporary public art as well as of public space is complicated. You can take as a given here that the aspirations of artists who want to contribute on community turf may be entirely constructive. But community itself is more often than not out of reach. How much change can art effect in the social climate of the United States in the nineties? Limitations of time and restrictions of the theoretical breadth of an idea or object, the self-enclosed art-critical or ideological location of any artist within her or his artistic environment, the fixed resources that can be brought to bear on any one project, and the improbability of reaching the critical mass needed to effect change, despite the hope of widespread impact, make achieving artists' aspirations daunting. The larger environment, in which the decay of nineties-style capitalism colors the changing face of artistic professionalism, has forced citizens, including many artists, to direct themselves to emergency level issues of survival and autonomy, thus eradicating the possibility for an experience of *authentic* community.

Authentic community distinguishes itself from colonized townships or nations through the commonality of its citizens. This commonality expresses each individual and finds a like pattern in the whole, one that may be inherited but is also chosen, and not only bonds individuals in solidarity but also inspires a potent, propelling, and cooperative collectivity.

For the purposes of this essay, then, community is not only an ever present construct of contemporary life by virtue of human nature alone but a self-conscious assembly united by geography, values, goals, or social conditions. Even without geographical unity, in groups such as "the feminist community" or "the art community," a society can still exist. Even without goals or values held in common, save baseline survival—the one imperative that connects "the global community"—people can form a populace. In the transformation from colony to credible community and from state to society of mutual support, art can be a vehicle for creating a consciousness that represents commonality as well as difference and self-consciousness about one's role in the "common good."

In many ways, the feminist community in Los Angeles in the early seventies was exemplary. My own attempt to wed the personal with the political and professional brought me to California in 1972 to work with Judy Chicago, Sheila Levrant de Bretteville, Miriam Schapiro, Faith Wilding, Suzanne Lacy, Deena Metzger, and many other feminists in the arts. Individuality and common qualities were symbiotic in creating the principles of this community. We were women. We were art professionals. We shared a sense of social justice. We believed in the possibility of social change. We were reacting against both broad social and specific professional issues, with defined and measurable goals.

Our processes prefigured the emerging public art practice today that moves fluidly among criticism, theory, art making, and activism. Our work was interactive and collaborative, our criticism of each other's work mutual and participatory. We team taught, worked together on performances, created conferences, developed exhibitions, and wrote contextualizing theory, drawing inspiration from feminist writers such as Mary Daly, Susan Griffin, and Adrienne Rich. Out of this activity we formulated

the Feminist Art and Design programs at California Institute of the Arts, Womanspace Galleries, the Feminist Studio Workshop, the Woman's Building, the Center for Feminist Art Historical Studies, the Lesbian Art Project, Ariadne: A Social Art Network, the Feminist Art Workers, and the Waitresses.

Our notion of common good centered on ideals of equality. To effect this, we believed it imperative that we reclaim the history of women artists, develop an art of personal expression, take art to where a broad audience lived, and link our idiosyncratic experience to a possibility of cultural transformation in gender, racial, and class roles. Ours was a purposeful community—self-created, self-conscious, and self-critical.

A dilemma arises when the vision that moves most social systems— that of cooperation toward a perceived interest in the common betterment (however differently one would define "common")—is vague rather than broad. It is not so much in intention that such systems fail but in the illusory hierarchical assumptions about members of the human assemblage upon which they are based. In the early seventies, spokeswomen defining "the women's community" emphasized commonality and ignored pluralism, inconsistency, variability, and diversity. In *Evidence on Her Own Behalf: Women's Narrative as Theological Voice,* Elizabeth Say suggests that this may have been because "the vision of community is seductive. Women have been so long excluded that the invitation to 'belong' seems enticing." False premises remained uncontested beliefs for almost two decades, due to the strength of this desire and perhaps also to plain ignorance and a turning of deaf ears. But the strength of the desire for community remains in feminist and public art as well as in social discourses.

Experiences particular to their decade separate feminist- and art-oriented community building of the seventies from that of the mid-nineties—"alternatives" to galleries or schools, for instance, now would not as readily be conceived of as self-sufficient satellite systems with physical plants, recruitment strategies, and sales quotas. These would not, moreover, assume emotional, financial, and political resources unavailable to neighborhoods on the edge of the social and political upper crust. And they wouldn't be so naive as to create designs that duplicate existing forms.

Today's proposals for a better future may seem less elevated. However, projects such as a statistical study of breast cancer or a neighborhood shelter for homeless women are a part of that earlier sweeping vision and can actually be accomplished. Any gathering of people, moreover, can now be a fuller celebration of diversity and includes marginalized voices not audible twenty years ago.

The fact that "community" is used as a descriptive term for art which utilizes the concept as subject matter compounds problems of defining the dynamic gathering of people and the work that they produce cooperatively. The use of community is often symbolic—rather than actual or activist—when it is segregated from general usage and placed into an art vocabulary. The meaning of community has, in this specialized language, become narrowed to near uselessness. To imagine community as a changeable factor in an artistic structure is far different from building a community in an actual place with real individuals.

A case in point: Manhattan in the summer contains public art of every description. But these days, outdoors and in, I notice that more artists attempt to communicate to their self-selected communities a sense of significance and high purpose that wants to be comparable to that of the rituals and monuments of birth, death, marriage, and personal rites of passage. This milieu tells me there is a pressing need and burning desire for family and community, with their attendant commemorative events of continuing kinship. But the artworks in public that attempt to meet those needs must do so not only in the midst of "real life" but as an organic part of it. Although the grounding of social authority in concrete existence and common sense, rather than through "leadership" of the few over the many, is more plausible than before multicultural awareness broadened the field of perception, the community that can embody authentic democracy does not exist a priori and has to be made from scratch.

THE LANGUAGE OF VIRTUE: WHAT MAKES ART VALUABLE?

No artist has been granted a powerful enough role in neighborhood, city, state, or country to create the community she or he envisions as a

verb—that is, as ongoing or evolving, yet remaining a permanent social phenomenon. At this writing, in the atmosphere of ever diminishing genuine "people power," common goals are obscured by those arguing diversity as a struggle between opposing ideologies. Since these arguments are all alienated from the goods, the weight that they wield is ultimately fictitious. As a result, the dialogues between "marginal" societal groups in the arts these days, instead of flowering from a sense of power and primacy, are informed by each group's embrace of an exclusionary language of virtue.

Using gender as an example, "virtue" connotes moral excellence, but also "manliness." The truly democratic gender-neutral contents of honor have not yet been defined in practice. Although the problem of inequality is not only gender specific, genders and gender oppression remain fixed. Progressive thinking can be weakened by the unstated notion that New Men (still, and for better reasons) have a direct line to the Almighty. And women, using a defensive strategy common to groups without power, are better than ever in the exercise of pious intonations of self-righteousness. Righteousness of rhetoric has actually risen proportionally as the economy has declined over the past decade.

Artists who utilize and participate in this social environment need not idealize to deny current realities. Their work cannot be put into practice anywhere but in the imperfect here and now.

This rhetorical claiming of the high ground of moral authority is not limited to the disenfranchised. A Museum of Modern Art curator remarked that even the mention of morality can bring out the worst in people. A senior critic finds the idea that art involves anything imperative discomforting. If that imperative is "moral," his discomfort is compounded. But both of these art professionals have their own words of honor—judgments made and values that surround their points of view are critical in creating their own pantheon of art heroes. The curator's sensitivity to the physical properties of the works he addresses is informed by high art hierarchies as well as the social agendas of his formative critical years during the seventies. The critic's overlay of a seemingly unrelated theory onto art and artists is often brilliantly stated, with concepts and insights that resonate way beyond the particulars of any discussion. Yet,

in his system, good art and bad art are determined by concepts of the health or illness of practitioners, as demonstrated in their work, and in effect become associated with moral virtue.

The term "recovery" connotes the change of consciousness thought by some to be the moral imperative of this time. Are we a sick society in need of reclamation by art and artists? Are artists different from others in their ability to point the way to the light? Is art that "heals" a priori good art? According to what value system or what assumed social paradigm can the art in question claim to be effective?

Adrian Piper writes, "I want my work to contribute to the creation of a society in which racism and racial stereotyping no longer exist."[1] Although Piper hopes that her contribution as an artist and writer is a positive one within the framework she establishes, she does not think she has created the society without racism that she envisions simply by so stating or by evoking it in her work.

The indexical present, the here and now, is, rather, the reality conjured and addressed. Piper writes, "I have great respect for what I call *global* political art. . . . But I worry that the ultimate effect of this work on a viewer's subsequent behavior in the world may be very slight. Because however forceful, original, or eloquent it may be, global political art is often too removed from the indexical present to situate the viewer, him or herself, in the causal network of political responsibility."[2] Piper's ideals are also perhaps couched in a language of virtue. But the high hopes in her work are always placed alongside the actual and immediate environments she addresses—and into which they cannot fit. Consciousness of the discrepancy is the first premise of a new order.

What, in the end, makes art valuable? Is it the worth of materials used, the skill with which media is applied, or the expression of a powerful personal experience? The point of view from which issues are confronted? The number of people to whom the work can speak? If the answers were certain, then art criticism would be a hard science or at least a measurable form of assessment rather than a literary genre and craft. (Look at the educational program for "appraisers" to see how few criteria there are even for bankable estimates of art value.)

Do artists with good intentions have an edge on making good art? Good intentions and even hard work to actualize them don't ensure good art. True, much of the work made with a social agenda is of high aesthetic quality. And so are the paintings and sculptures with no such agendas in the collections of the Metropolitan Museum of Art and the Museum of Modern Art.

The body of contemporary public art about social issues needs a language to articulate its compatibility with and also its difference from art made for galleries, museums, and corporations and that made as therapy or for private view. Critical language must take its cue from the character of the communication of the art it seeks to elucidate.

How do artists and critics declare their intentions, describe their artworks and processes, and identify their audiences? Often, unfortunately, in a specialized vocabulary known only within their common field of interest. Highly literate intellectuals, easy with linguistic convolutions, could find a home in this critical prose, but not the majority of readers. Is this language appropriate? And does this choice of vocabulary adhere to truth in labeling? If we scrutinize politicians and clergy for what might be hiding behind their perceived "plain speech," might we not likewise examine the evaluative literature that claims to describe and at least partially determine the worth of art? The issues and feelings in populist art that recognizes the complexities of contemporary social contracts are still without commonly understood words and images among those about and to whom the work is offered. A scrupulous look at the artistic process, review and input by the constituency of the work, visual accomplishment, and staying power— these can go a long way toward securing the effectiveness of new public art. This assessment, needed at every stage of the development of public art projects, is not an exact science. But it is a giant step closer to accountability between artist and audience.

Make no mistake: accountability is a concept, like community, at odds with tradition in art. Even as they deny it, artists and critics use their own language of virtue to counter arguments about ethics in art. Frequently cited as the opposition for values of democracy and community in art, Jeff Koons, for example, calls himself an optimist and is

confident that moral issues (whatever they may be) will take care of them-
selves—"things" beneficial to humankind, he has said, will be absorbed
into evolution, and things that are negative will be destroyed. Jeff Koons
may be the last member of the public who doesn't know that racism, child
abuse, homophobia, war, and disease do not take care of themselves.
Thinking in the moment as well as in the evolutionary millennium, we are
continuously confronted with the hard facts of neglect and ill will.

An "objective" critical observer may wish to remain distant from
her own body and from the larger units of family and social (community)
bodies. Like some artists, such an observer must see herself as an outsider
while at the same time she laments her marginal position in society. Inter-
esting metaphorical and political implications may emerge from such a
perspective, but these will invariably be academic. My work (and, I be-
lieve, anyone's) is always tied to the personal experience of current events
and their psychological reverberations, acknowledged or not.

The relationships between art and morality, like those between
idealism and consensus, are at their most intense when actually applied in
physical form and in real time and space. These philosophical and ethical
relationships are also at their most tenuous in art that has been placed in
the midst of, created especially for, or made in the name of a community
because of the diverse nature of community itself.

Sentiments of goodness can be a comfort in light of a national body
of art in decline, an art market in similar economic and moral decay, within
an endangered world. I appreciate the optimism of artists in the face of
these challenges. Perhaps, like Jeff Koons, I am also optimistic. Why not?
Hope and the possibility of transformation have always been the truly
inspirational elements in all art. These ideals, tempered by specific contem-
porary realities, form the bare basics of any current notion of community
and of art created in the public interest. More and more, I turn my closest
attention toward those bodies of works that offer ambition and desire
with practicality and candor. Hope springs eternal, always embarking
from ground zero.

NOTES

1. Adrian Piper, "Xenophobia and the Indexical Present," in *Reimaging America: The Arts of Social Change*, ed. Mark O'Brien and Craig Little (Philadelphia, Pa.: New Society Publishers, 1990), p. 285.

2. Adrian Piper, "The Joy of Marginality," *Art Papers* 14, no. 4 (July/August 1990).

DEBATED TERRITORY:
TOWARD A CRITICAL LANGUAGE FOR PUBLIC ART } *Suzanne Lacy*

I got a call from Mom and Dad as they sat in front of their television set in Wasco. They were watching news reports of the obscenity trial of Dennis Barrie, director of the Cincinnati Contemporary Arts Center, for displaying Robert Mapplethorpe's photographs. Was Mapplethorpe an artist or a pornographer? Later they sent me clippings from the local newspaper on *The Umbrellas* by the artist Christo, which was located a few miles from their home in a small farming community in California's Central Valley. Judging from the tone of the articles, the local people, after questions early on, seemed ready to believe that Christo was indeed an artist, although not one that fit their preconceptions.

What do modern artists do? Mom and Dad have their opinions. The media has made them armchair connoisseurs in a time of tremendous transition in the role of visual artists. Whether through studio art (for a specific art world audience) or public art (for a broader popular audience), artists have achieved a level of public visibility not experienced in several decades, if ever. This is in part a consequence of an increased level of personal visibility in the culture at large. From an assumed "right to know" about the lives of politicians, to the revelation of family secrets, including spouse abuse and incest, formerly private lives have assumed the character of public property through the media. Visual artists are no exception, and many have catapulted into national prominence overnight by virtue of controversies surrounding their work. What artists do and what they "ought" to do constitutes a territory of public debate in which we seek a broadened paradigm for the meaning of art in our times.

The discussion is elaborated. In art schools faculty argue over the place of craftsmanship, subject matter, exhibition venues, and the relationship between new genre public art and more traditional art forms. The art world struggles with multiculturalism and its implications for different

audiences and approaches to making art. Public art has become a highly competitive alternative gallery system in which artists are thrust into contact with a broad and diversified audience, each group bringing its own contributions to the debate.

Clashes occur—we ask questions that have not, in this country, been asked of visual artists since the New Deal, when government support for artists evoked a dialogue about art's service to society. One of the central questions at the heart of the recent censorship controversies is, in fact, about public right and private accountability. Should people fund, through the National Endowment for the Arts, artworks that offend "public sensibility"? Our curiosity has been stimulated: just what is public art, how does it get made, by whom, and for whom?

Within art criticism, public art has challenged the illusion of a universal art and introduced discussions on the nature of public—its frames of reference, its location within various constructs of society, and its varied cultural identities. The introduction of multiple contexts for visual art presents a legitimate dilemma for critics: what forms of evaluation are appropriate when the sites of reception for the work, and the premise of "audience," have virtually exploded? When artists decided to address Mom and Dad in Wasco as one potential audience, criticism itself had to change, since the nature of meaning is perceived so differently by various audiences.

One temporary solution has been to emphasize descriptive writing. Some writers have assumed a more participatory role with artists in the process of the work, feeling that recontextualizing the work within other frames of reference—the larger social context prescribed by the issue—is an appropriate critical response. (This approach, however valuable, begs the question of evaluation at the heart of art criticism.) Other critics simplistically apply criteria inherited from early artist practitioners of new public art forms to work that is well advanced in concept, intention, and complexity. It is evident that criticism has not caught up with practice.

In the instances throughout this century when art has moved outside the confines of traditional exhibition venues, or even remained within them and challenged the nature and social meaning of art, analysis has been a contested and politicized terrain. Until a critical approach is realized,

this work will remain relegated to outsider status in the art world, and its ability to transform our understanding of art and artists' roles will be safely neutralized.

Misconceptions and confused thinking abound. What is needed at this point is a more subtle and challenging criticism in which assumptions—both those of the critic and those of the artist—are examined and grounded within the worlds of both art and social discourse. Notions of interaction, audience, artists' intentions, and effectiveness are too freely used, often without sufficient interrogation and almost never within comprehensive conceptual schemes that differentiate and shed meaning on the practice of new genre public art. What follows are discussions of these notions, along with suggestions for expanding our critical approach.

INTERACTION

Current attempts to deal critically with new forms of public art often assume an unexamined partisanship with the public through a vaguely constituted idea of interactivity. In a recent article in *Art Papers,* one writer critiqued the notion of audience engagement in *Culture in Action,* a series of art projects in Chicago communities, because, as she said, if the artists really meant to be interactive, they would have used interactive video technology![1] In fact, interaction cannot be measured exclusively by either the artist's methodology or media, or by other commonly used criteria, such as audience size.

What might a more complex critical analysis entail? In looking at this one aspect of new genre public art—the interactive quality that, by definition, is characteristic—a more comprehensive scheme might incorporate all of the above, along with the artist's intention and the work's meaning to its constituencies. For example, the diagram below represents a model in which a continuum of positions is represented. These are not discrete or fixed roles, but are delineated for the purposes of discussion, allowing us to more carefully investigate aesthetic strategies. At any given time, an artist may operate at a different point on the spectrum or may move between them.

PRIVATE			PUBLIC
o————————o————————o————————o			
artist as experiencer	artist as reporter	artist as analyst	artist as activist

Subjectivity and Empathy: Artist as Experiencer

In more traditional art, the artist's experience is thought to be represented in a visual object; such subjectivity, in fact, is taken to be fundamental to art. Performance and conceptual art helped to isolate the *process* of art, sometimes even substituting process for object. To investigate what interactive skills visual artists might bring to the public agenda and to assess how these might relate to a larger audience, we could start here, with one of the most basic elements of art: the experiencing being.

In August 1991, I sat for seven days in an abandoned hospital room at Roswell Park Cancer Center in upstate New York, charting the private conversations I had with patients, nurses, doctors, scientists, and administrators. The artwork was located in the interaction between myself as artist and the members of the community, framed by the hospital room and fueled by the human need to reflect on the meaning of one's life and work. In this and countless other works that take place largely within the domain of experience, the artist, like a subjective anthropologist, enters the territory of the Other and presents observations on people and places through a report of her own interiority. In this way the artist becomes a conduit for the experience of others, and the work a metaphor for relationship.

Although we tend to pigeonhole subjectivity as nonpolitical, one of the major contributions of feminist thought in the past two decades is that individual experience has profound social implications. Experiencing has been manipulated in the service of advertising and politics, for example, where products and politicians are linked to desire and values. Private experience has lost an authenticity in the public sector that art may, at least symbolically, return to us. To make of oneself a conduit for expression of a whole social group can be an act of profound empathy. When there is no

quick fix for some of our most pressing social problems, there may be only our ability to feel and witness the reality taking place around us. This empathy is a service that artists offer to the world.

Information Revealed: Artist as Reporter

In the role of reporter, the artist focuses not simply on the experience but on the recounting of the situation; that is, the artist gathers information to make it available to others. She calls our attention to something. We might divide this practice of presenting information along lines of intentionality. Some artists claim simply to "reflect" what exists without assignment of value; others "report," implying a more conscious, less random selection of information.

Reporting might be compared to aesthetic framing. Roland Barthes, in commenting on Diderot, explains with analogies from theater and painting how intentional framing is inherently political: "In order to tell a story, the painter has only an instant at his disposal, the instant he is going to immobilize on the canvas, and he must thus choose it well."[2] What will be seen is what the artist *will have* seen, and thus the chosen image is an instant in which the historical meaning and political surround of the reported information can be read in a single glance. In this way the artist as reporter may be said to engage with an audience not only to inform but to persuade. Perhaps for this reason, when artists first enter the sociopolitical arena they often adopt this role.

Reporting implies a conscious selection, though not necessarily an analysis, of information. In *Amazonia*, performance artist Rachel Rosenthal dramatizes the destruction of the South American rain forest and the slaughter of its inhabitants. The strength of this soliloquy is its inexorable rage, conveyed in a theatrically choreographed incantation of the names of the native peoples, trees, and animal species from this rapidly disintegrating environment. No answers are posited (indeed, is there any appropriate response other than *stop*?), save the artist's belief that after experiencing, revealing information is the next compassionate step.

Situations and Solutions: Artist as Analyst

From reporting, or presenting information, to analysis is a short step, but the implied shift in an artist's role is enormous. In the first two modes of working—experiencer and reporter—we see an emphasis on the intuitive, receptive, experiential, and observational skills of the artist. As artists begin to analyze social situations through their art, they assume for themselves skills more commonly associated with social scientists, investigative journalists, and philosophers. Such activities position artists as contributors to intellectual endeavor and shift our aesthetic attention toward the shape or meaning of their theoretical constructs.

Reporting is inevitably followed by analysis. In the mid-eighties contemporary photographers from the United States and other countries found themselves moving naturally from simple observation of environmental disasters to political theorizing. In 1986 they formed the Atomic Photographers Guild to pursue projects related to nuclear issues. For example, Richard Misrach's *Bravo 20: The Bombing of the American West* presents a tongue-in-cheek proposal to convert a test bomb site into a national park.

When an artist adopts the position of analyst, the visual appeal of imagery is often superseded by the textual properties of the work, thus challenging conventions of beauty. Their analysis may assume its aesthetic character from the coherence of the ideas or from their *relationship* to visual images rather than through the images themselves. In this way, art of analysis draws on the history of conceptual art during the sixties, when artists explored the dematerialization of art as object and its rematerialization in the world of ideas.

Building Consensus: Artist as Activist

The last step along the proposed continuum is from analysis to activism, where art making is contextualized within local, national, and global situations, and the audience becomes an active participant. Martha Rosler explored New York City as an artist-analyst, but her work could be said to cross over into activism. *If You Lived Here . . . The City in Art, Theory,*

and Social Actions,[3] an assemblage of exhibitions, symposiums, photo-graphs, and writings sponsored by the Dia Art Foundation in New York, amassed the work of artists and activists dealing with the current crisis in American urban housing policies. The works considered how artists have found themselves squarely in the midst of real estate speculation and shortsighted housing policies. An analysis of housing and homelessness was punctuated by proposed and actual interventions that served as mod-els for activism.

In seeking to become catalysts for change, artists reposition them-selves as citizen-activists. Diametrically opposed to the aesthetic practices of the isolated artist, consensus building inevitably entails developing a set of skills not commonly associated with art making. To take a position with respect to the public agenda, the artist must act in collaboration with people, and with an understanding of social systems and institutions. Entirely new strategies must be learned: how to collaborate, how to de-velop multilayered and specific audiences, how to cross over with other disciplines, how to choose sites that resonate with public meaning, and how to clarify visual and process symbolism for people who are not edu-cated in art. In other words, artist-activists question the primacy of separa-tion as an artistic stance and undertake the consensual production of meaning with the public.

To the preceding scheme (or any other developed by the critic), one would then *add* a discussion of such issues as audience size, use of media, and artists' methodology, contextualizing those evaluations within a more specific analysis of the work's interactivity.

AUDIENCE

We have traditionally considered the relationship between artwork and audience as a dyad, with more or less exchange between the two. Some would have it that communication proceeds from the artist, through the artwork, toward a receptive audience. At various moments in art history the passivity of that audience has been challenged, for example, during abstract expressionist "happenings" when the audience and its movement

through the site of the work were considered to be part of the art. Many public artists today suggest that the communication is two-way, some going so far as to propose that the *space* between artist and audience is, in fact, the artwork.

Contemporary critics, following the lead of artistic practice, have begun deconstructing the audience, most often along the specific identity lines of gender, race, and, less often, class. But the *relationship* of the audience to the work process is not clearly articulated. Of interest is not simply the makeup or identity of the audience but to what degree audience participation forms and informs the work—how it functions as integral to the work's structure.

One possible evaluative construct might be to see the audience as a series of concentric circles with permeable membranes that allow continual movement back and forth. Nonhierarchical in intention, such a description allows us to deconstruct in an audience-centered model the notion of interactivity that in the previous section was premised in the artist's role.

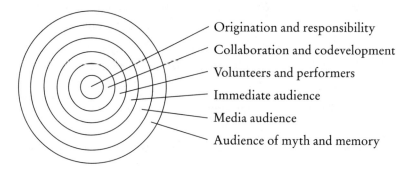

Origination and responsibility
Collaboration and codevelopment
Volunteers and performers
Immediate audience
Media audience
Audience of myth and memory

If we represent the genesis of the work as a point in the center of the circle, radiating out—like the waves caused by a rock in a pond— would be the individuals or groups of people who assume different degrees of responsibility for the work. Genesis and responsibility are paired in this model, the center equaling the creative impetus. From this center, the basis of which varies from artwork to artwork, emerge images and structures (though not necessarily the meaning—that is completed by the audience). The center of the circle are those without whom the work could not exist. In the case of Houston Conwill, Estella Conwill Májozo, and Joseph De

Pace, for example, their interactive public works are centrally driven by the creative energy of the three collaborators.

The next circle out from the center includes the collaborators or codevelopers, shareholders who have invested time, energy, and identity in the work and who partake deeply in its ownership. Often these consist of both artists and community members, and without their contribution the work would not go forward. Nevertheless, at this level of involvement, the loss of any single member, though perhaps serious in implication for the work, will not dramatically alter its essential character.

It is important to emphasize here that such divisions are somewhat arbitrary and used for the sake of clarifying our thinking about audience. In reality, those in the center and in the first concentric ring are not always so clearly defined, and, more important, in an actively functioning participatory work, movement between levels of engagement is designed into the system. The more responsibility assumed, the more central the participants' role in the generation of the work. Collaborative partners become more or less central as the work finds its shape.

The next level of participation would be the volunteers and performers, those about, for, and with whom the work is created. In Danny Martinez's project for *Culture in Action,* this level would be represented by the busloads of community members who paraded through two neighborhoods in Chicago. It would include the community members and representatives of various organizations who volunteered to organize the parade.

Another ring of the circle consists of those who have a direct experience of the artwork. Traditionally called the audience, these are the people who attend a performance or visit an installation. Because of the open-ended invitational properties of a community-based artwork and the time involved in creating it, those attending the final presentation or exhibition are often more engaged than, for example, museum-goers. Among those who visit Maya Lin's Vietnam Veterans Memorial each year are a large number of veterans and their families who bring to the wall a deep level of experiential engagement (and account in large part for the work's success). Among the audience for Sheila Levrant de Bretteville's Little Tokyo Project will be those who have lived and worked there and whose words and experiences are memorialized in the concrete beneath their feet.

The effects of the work often continue beyond the exhibition or performance of interactive public art, and are magnified in the audience that experiences the work through reports, documentations, or representation. This audience includes people who read about the artwork in newspapers, watch it on television, or attend subsequent documentary exhibitions. They expand the reach of the work and are, depending on the artist's intention, more or less integral to the work's construction. At least a part of this audience carries the artwork over time as myth and memory. At this level the artwork becomes, in the literature of art or in the life of the community, a commonly held possibility.

Fundamental to the above construction of the audience is its flexible and fluid nature. At no point is the level of participation fixed, and depending on the criteria established through the work, participants move back and forth between levels. Thus a street person who observes a performance by the Los Angeles Poverty Department (LAPD) might be inspired to attend a workshop and serve as an "extra" in a performance. By LAPD's criteria, which include willingness to dedicate time and a certain level of theatrical ability, someone from the audience could move progressively toward the center of generation and responsibility. In such large-scale public artworks, many of which exist over long periods of time, the reverse movement also takes place, such as when life circumstances or interests move participants toward an outer circle in which they may remain engaged and informed audience members. This model charges the construction of audience with activity rather than simply identity.

These models of audience engagement are of course useful only if they encourage appropriate complexity when considering the notion of interaction. But through such scrutiny an important implication is revealed: the educative function of new genre public art. Often such art puts forth specific information or content to substantiate its pedagogical claims, but we may also ask what learning results from the interactive forms of the work, and whether the very structure, including artist and audience roles, predicts the success of the educational intention.

INTENTION

If criticism follows artistic practice, though many contemporary examples might show the reverse to be the case, then particularly when art changes form, critical constructs must take into account the artist's expression of intention. Arlene Raven underlines the potential discrepancy between intention and results when she asks, "Does the artist's intention to do good mean that the work is, in fact, good?"[4] The hitch is that artists' stated purposes do not express the multiple, including unconscious, levels on which art operates. Perhaps most dubious when they evaluate the "success" of their work, artists' expressions of intention are nevertheless signposts for future directions in criticism, because intention suggests real or potential contexts for the art. Intention portends criteria for evaluation. Most important, intention establishes the values premised within the work, and assembled values are the artist's construction of meaning.

Now we enter a familiar terrain for art theory. What questions does the artwork ask of art itself? How does it enter into or challenge contemporary discourse? What questions does it ask of life? In this interrogation, we encounter the artist's philosophical and political biases, what he or she believes to be true about people, culture, and action. Assuming that we can at the very least comment on belief systems and meaning within the work, what role does an issue like "depth" play? That is, is the work a substantive and meaningful addition to cultural or intellectual life? Does it add to our understanding?

With these questions comes a particular dilemma for new genre public art critics: can, or how can, a materialized belief system be evaluated? Raven's deliberate use of "good" underscores our vulnerability in matching our beliefs to the artist's, comparing and holding as good any mutuality. One critic values contemplation and the other activity; one espouses leftist politics and the other right fundamentalism. In fact, while all art represents artists' understandings of meaning, the often culturally interventionist intentions of some artists threaten the stance of "objectivity" by which criticism attempts to deify art.

With a candidness born of necessity, critics writing about this work often acknowledge up front their passionate advocacy of the worldview embodied in the work they describe. If we choose not to ignore the question of artists' intentions (too risky on the cusp of change in art practice—artists often lead us in new and unpredictable directions), then perhaps partisan criticism is the most honest approach. Critics must inevitably enter the discussion personally and philosophically when approaching work that intends toward social meaning. Likewise, the audience's beliefs and intentions with respect to the art and its subjects become part of the total picture.

EFFECTIVENESS

One evaluative criterion heretical to common assumptions about art is effectiveness. Art is assumed to be effective if it is beautiful, despite differing cultural constructions of beauty, and if it fulfills functions of revelation or transcendence. Once it departs from this inherited ideology, art criticism flounders before unexamined critical assumptions. Is public art effective, as Arthur Danto suggests, when it reflects some fundamental harmony of shape or perspective? Is it effective when the audience takes action or is changed in some fashion? As forms, intentions, and strategies for making art depart from tradition and—in public art—as audiences change, multiply, and become more complex, the critical consideration of effectiveness has remained relatively unexamined.

Rooted in vague sociological, or more precisely, sociometric, precepts, critical response to new genre public art suggests but does not actually deliver measurement. Scale is sometimes deemed a measure of effectiveness, as is a hypothesized change in the makeup of the audience. These assumptions actually do lead to provocative questions that must be answered to develop appropriate criticism for this art. Is, for example, Mierle Laderman Ukeles's proposed but only partially realized public art display in a marine transfer station in New York City (*Flow City*) more or less successful than Mel Ziegler and Kate Ericson's completed project for *Culture in Action?* In one case the work would *potentially* involve a large public audience; in the other a small handful of people was actually affected. Is an actualized work more effective than a proposal? Is the

number of people involved a criterion for success? Is a work more effective if a community is mobilized toward some end? Does it matter what the end is, what the actions are? What if, as in the case of John Ahearn's sculpture for a plaza in the South Bronx, the community is mobilized against the work itself? Does shape, eloquence, or visual appeal take precedence over the work's accessibility to community residents?

Artists themselves participate in a conflation of art and sociology. Unlike sociologists, however, our measurements are often assumed rather than stated. Whereas a sociologist might measure the number of times within a given period that an issue was referred to in the media, in art we guess at the distribution of ideas.[5] We do not take surveys to determine to what extent art changes its constituencies' beliefs or practices. Nor, in fact, do we carefully assess the actions stimulated by a work of art. We assume a host of causal effects, often on the basis of unexamined political notions.

We assume, for example, that the LAPD is effective in changing ideas about homelessness, but how do we evaluate this? Do we accept the subjective reports of those few homeless company members? Hungry for change and exchange and impact, artists often grasp at the experience of one or more individuals, recounted in narratives that attest to the work's effect. We leap from individual experience to much larger assumptions. If three people's lives, by their own recounting, are affected, if thirty people's lives are affected after the work, can we draw any conclusions about either the scale or duration of change? Such evaluations must be taken as one component of understanding, one piece of a larger puzzle, but must be more carefully explored.

Perceived notions of change based on political and sociological models and extrapolated from personal experiential reports are necessary but insufficient in evaluating new genre public art. This work also functions, as does all art, as a representation or model. The work might, for example, hypothesize potential collaboration among people rather than demonstrate actual interaction. It might suggest a possibility for cooperation and exchange that does not currently exist, or it might be a model for artists themselves, stretching the boundaries, incorporating new forms, giving permission for invention. It is possible that process-oriented public

art is at its most powerful when, as with most visual art forms, it operates as a symbol. The relationship of demonstrable effects to the impact of a metaphor must be grappled with as this work attempts to function simultaneously within both social and aesthetic traditions.

I got a call from Mom and Dad in Wasco. Although our politics are worlds apart, my father—a congenial and loving humanist but only slightly to the left of Jesse Helms on some social issues—believes deeply in the expressive and communicative potential of art. In fact, Dad is a painter of oil landscapes. Representative of one of many new art audiences, my working-class parents serve as a touch point for me as I consider the conflicts in our values, our profound points of agreement, and the potential role of art in an examination of meaning. The intersection of "high art" with expanded audiences demands a rigorous examination of our premises and the development of new skills and strategies. The introduction of Mom and Dad into a hermetic discourse demands a change in art criticism.

What do public artists do? Inevitably we must come to understand this work's relationship to what is called "real life." Art as a profession, taught in art schools and displayed in museums, has created a paradoxical division between its practice and its public locus. The confrontational framing that figures prominently in recent art controversies is in part a product of the modernist model of the artist. Alone in her studio, the artist creates through a struggle that, at various times, pits the individual against nature, culture, society, or the art world itself. It could be argued that this heroic tradition serves the integrity of an intensely private studio practice, which might still have some value in maintaining the pure, individualist expression that enables artists to serve society from a vantage point of outside observer. But in the studio of the public sector, in the culture of visibility, such conventions of artistic practice are challenged. My dad knows this. The audience for his work—family, neighbors, and friends— is intimately connected to his communicative and expressive intentions.

The extensive body of artistic work from the past three decades in the compendium of this book at the very least expands artists' repertoires to

include a more intimate and engaged relationship with an audience. At the most, it illustrates that the modernist model is no longer viable in a multi-cultural and globally interconnected world, that visual artists are, as theorist Suzi Gablik suggests, struggling to find new roles more appropriate to our time. The question is, can criticism match the scope of this endeavor?

NOTES

1. Susan Snodgrass, "Culture in Action," *Art Papers* 17, no. 6 (November/December 1993), pp. 7–11.

2. Roland Barthes, "Diderot, Brecht, Eisenstein," in *Image—Music—Text* (New York: Hill and Wang, 1977).

3. *If You Lived Here . . . The City in Art, Theory, and Social Activism,* Discussions in Contemporary Culture no. 6, ed. Martha Rosler and Brian Wallis (Seattle: Bay Press, 1991).

4. Arlene Raven, "Doing or Making Good," *The Village Voice,* May 3, 1988.

5. In October 1982, I raised several of these issues in the "Speakeasy" column of *New Art Examiner.*

}
DIRECTIONAL SIGNS:
A COMPENDIUM OF
ARTISTS' WORKS

Susan Leibovitz Steinman

ALFREDO JAAR, *Untitled Billboard, San Diego, 1990*

Vito Acconci

John Ahearn and Rigoberto Torres

Juana Alicia

Jerri Allyn

Nancy Angelo

Ant Farm

Art Attack (see Robbie Conal)

Conrad Atkinson

Helene Aylon

Judith F. Baca

Joseph Beuys

Richard Bolton

Border Art Workshop/Taller de Arte Fronterizo

Gloria Bornstein

Shu Lea Cheang

Judy Chicago

Mel Chin

Christo

Robbie Conal

Houston Conwill, Estella Conwill Májozo, and
 Joseph De Pace

Betsy Damon

Lowell Darling

Sheila Levrant de Bretteville

Kate Ericson and Mel Ziegler

John Fekner

The Feminist Art Workers (see Cheri Gaulke)

Cheri Gaulke

Guillermo Gómez-Peña

Bolek Greczynski

Group Material

Guerrilla Girls

Hans Haacke

DeeDee Halleck

Anna Halprin

Ann Hamilton

David Hammons

Jo Hanson

Helen Mayer Harrison and Newton Harrison

Margaret Harrison

Hachivi Edgar Heap of Birds

Suzanne Hellmuth and Jock Reynolds

Donna Henes

Lynn Hershman

Nancy Holt

Jenny Holzer

Mildred Howard

Jim Hubbard

Alfredo Jaar

Patricia Johanson

Marie Johnson-Calloway

Allan Kaprow

Barbara Kruger

Leslie Labowitz

Suzanne Lacy

Loraine Leeson and Peter Dunn

Andrew Leicester

Maya Lin

Hung Liu

Yolanda López

James A. Luna

John Malpede

Daniel J. Martinez

dominique gw mazeaud

Richard Misrach

Mujeres Muralistas

Viet Ngo

Paper Tiger Television (see DeeDee Halleck)

Adrian Piper

Poyesis Genetica (see Guillermo Gómez-Peña)

Tim Rollins and K.O.S.

John Roloff

Rachel Rosenthal

Martha Rosler

Robert Sanchez and Richard A. Lou

Bonnie Sherk

Charles Simonds

Buster Simpson

Sisters of Survival (see Nancy Angelo)

Jaune Quick-to-See Smith

Alan Sonfist

Mierle Laderman Ukeles

Carlos Villa

The Waitresses (see Jerri Allyn)

Fred Wilson

In the preceding essays, most descriptions of specific artists' works were downplayed, if not eliminated outright. Instead, writers suggested artists for inclusion in the compendium whom they considered illustrative. We deliberately separated the artworks from the contextualizing theory because in fact most of these artists carry with them their own more or less articulated ideas about context, speaking and writing about why they do what they do and what they think it means.

At this stage of creating a critical context for new genre public art—indeed, even daring to coin the name—it seemed falsely assured for us to categorize these artists too carefully. Often, a very few well-known artists are held up as examples of this "emerging" form, when in fact this book attempts to connect a great number of works that use different media, organizing principles, aesthetics, and strategies. Since most criticism of this type of public art has not evolved past simple description, the writers were encouraged to develop their arguments without relying on descriptions of artists' work, except when specific examples were necessary to clarify their points.

In considering the contents of this section, we began with a fairly clear-cut list of twenty or so artists, most of whom had been working since at least the mid-seventies. These artists had conclusively demonstrated the following criteria: they had been working long enough to develop a structural language that was unique to their own practice; they premised their work in social issues; they had developed strategies for reaching a broad audience and for defining the diverse and multilayered composition of that audience more clearly than had been done before; and they understood there was no universal way to communicate. Often they were marginalized within art by virtue of their relationship to their chosen audience, but

generally the sheer scale and breadth of their impact made them visible to the art world if not understood by it.

Since these first artists selected had been working for more than twenty years, we could also see how their ideas had developed over time. We understood that while in the seventies the examples of this work were few, by 1990 the field had expanded so dramatically that any attempt to be truly comprehensive would be difficult. Moreover, since our premise is that these ideas within new genre public art are not in fact new at all, and that the practice as we currently know it has deep roots in the art, identity, community, and social movements of the sixties and seventies, we wanted to stress how those ideas had evolved over time with particular artists. Contemporary criticism, as pointed out several times in these essays, is simply not subtle enough to distinguish between an artist practicing in this manner for twenty years and one that started last year. However, it stands to reason that the ideas and aesthetic approaches of longtime practitioners will shed light on the current situation.

As our first list was passed around to each writer, it became apparent that our categories could be stretched in a number of directions. For example, should we include work that, while social in nature and radical in form, is nevertheless seen almost exclusively in museums and that accepts a traditional relationship to its audience? Should we include only works that present the major aspect of an individual's practice, or give as examples an occasional work by an artist following a path of art making that does not otherwise fit our descriptions, such as when a painter does an interactive installation? What about when a curator introduces interactive art processes to an artist?

Is a work done in 1982 an example of an early (in our classification) or late work? After all, the time span under consideration, twenty-five years or so, is relatively short to make too fine a distinction. If a more recent artist is more skilled in articulating ideas that were in fact developed earlier, out of sight of the art world, so that he or she now stands as an authority, would we prioritize the later work for its clarity or the earlier work for its origination under more contested conditions? The quest for

novelty is corrosive in the art world, much more ironic when applied to artists supposedly working for social change.

Striking out bravely, we cited two examples of artwork for those artists, still working, who had begun socially engaged work before 1984 or so, and one example for those artists whose work, in this area, either stopped after that point or began after the mid-eighties. It is here that we are most vulnerable, because around 1987–88 the field virtually exploded. There are many interactive artists doing very fine work today whom we did not include, simply because of our limited time or our lack of knowledge of them. Our bias was toward artists working for longer periods of time. Because all but one of these artists (Joseph Beuys) are alive, well, and making art as of this writing, and because this work is temporal by nature and often inadequately documented, we have probably misrepresented specific works. The work modes of this art defy simple authorship, and we were perplexed about whether to list collaborative groups separately or under a particular instigating artist's name. We chose the latter for the most part, but recognizing that artists often deliberately adopt a stance of collaborative authorship, we also cross-referenced the collaborative group in the list of entries. In some cases we did list the group separately, particularly when it was still a functioning and recognized entity.

We selected works based on whether or not they constituted models for art making, models that might be held up and considered for the insights they provide as a working strategy. Although we could have included, for example, scores of great mural artists who work in collaboration with an identified constituency, we chose a few to represent the range of that practice. In the end, it's likely we did not resolve these questions of category. Some readers may find among the examples works that, in their mind, don't address the central issues of this area of public art or, for that matter, of public art at all.

If we erred, it was on the side of inclusion, adding names until the last minute like a hostess overcooking for a party. We regretted not being able to include every artist we remembered after the publication deadline. This bias is a reflection of the aesthetic position of most of the work, one

of open rather than closed systems, preferring questions about art (in spite of the declarative nature of the subjects) rather than answers. In spite of our rhetoric, neither the editor of this book nor the writers have the final word or the exclusive perception of this expanding body of work. Our interest is for readers to make their own connections, draw their own conclusions, and in so doing perhaps question the nature of art and the relevance of new artistic strategies.

—*Suzanne Lacy*

VITO ACCONCI For more than twenty-five years New York–based conceptual artist Vito Acconci has produced provocative interdisciplinary works of astute social criticism that embody the paradox of "both genuine belief in community and fear of the conformity a community imposes" (curator Linda Shearer). Acconci was a poet when, in 1969, he began to incorporate photographs with words to describe simple actions. In the early seventies he used video and words to document actions in which he manipulated his own body and gender. A pioneer in performance art, he became known throughout that decade for his prolific investigations, which integrated daily activities, personal identity, and body explorations. Later, he moved toward more elaborate works in the social, political, and philosophical constructs of "community" and the "public." Since the eighties he has concentrated on creating installations that employ forms such as houses, cars, furniture, and boats. Acconci states: "The person who chooses to do public art might be considered a refugee, in flight from the gallery/museum which has been established as the proper occasion for art in our culture. Escape from the confines of that space means losing the privileges of its laboratory conditions: the luxury of considering art either as a system of universals or as a system of commodities. Abdicating the accustomed space of art, the public artist declares himself/herself uninterested in art questions, and no longer involved in the development of art as we've known it. Public art revises the present of art and conjectures its future: a time when art might be considered not as a separable category, in its own arena and with its own products, but as an atmosphere instilled, almost secretly, within other categories of life."

House of Cars, #1 and #2 *1983, 1988*
In 1983 and 1988, Acconci built housing complexes with junk cars that had been gutted and then welded together. In the 1988 version, installed at New York City's Museum of Modern Art for three months, seven cars sit under and fall out of a row-house-shaped skeletal steel frame. The ground level and the second story are connected by stairs. The interior of each car, painted a single color, contains realigned car seats, tables, shelves, and a mattress. The original 1983 version was four battered, painted cars, stacked two-high in an abandoned vacant lot in San Francisco. Acconci's upgraded designs for living on the streets are biting commentaries on gentrification and urban reality. His intent was to create real, usable housing out of society's throwaways. He never considered the works as models but hoped they would be lived in. Today, however, they remain a culture-prototype, sited in Manilow Sculpture Park at Governor's State University, located south of Chicago.

House of Cars, #1 and #2 *1983, 1988*
Vito Acconci

Mobile Linear City *1991*
Vito Acconci

Mobile Linear City *1991*

In *Mobile Linear City* Acconci built portable housing that can be replicated to become an entire "city." A semitrailer truck carries six self-contained housing units that can telescope down into one compact module for hauling, to be set up wherever housing is needed. There are five living units, each essentially a studio apartment (living room/bedroom/dining room combined), with a last unit housing shared utilities (toilets, shower, stove, and refrigerator). *Mobile Linear City* traveled to several European locations to be exhibited on streets in front of museums in France, Spain, Italy, and Austria. To Acconci's disappointment it is now dismantled and in storage in Vienna. He had hoped it would become a lived-in "traveling city," but soon realized that the museum-front locations presented problems of legal responsibility, permits, etc., which precluded human occupancy.

JOHN AHEARN AND RIGOBERTO TORRES

John Ahearn and Rigoberto Torres are collaborating artists who live and work in the South Bronx, New York. Although they also work independently, for fifteen years they have joined forces to create colorfully painted life-size casts of their neighbors which are installed on the exteriors of apartment buildings, schools, community centers, and in clinic waiting rooms. They met in 1979 when Ahearn showed his painted casts of friends at Fashion Moda, a lively alternative storefront art gallery in the Bronx. Raised in the Bronx in a close-knit Puerto Rican–American family, Torres was familiar with casting, having worked in his uncle's nearby statuary factory. Attracted to the process, he suggested that they cast the Walton Avenue locals. In 1980 Ahearn moved permanently into the neighborhood and set up a studio with Torres. The castings have become a source of passionate community involvement. Many are owned by those portrayed and are displayed in their homes. The art now travels internationally to galleries and museums, documented evidence of South Bronx pride.

South Bronx Hall of Fame *1979*
John Ahearn and Rigoberto Torres

South Bronx Hall of Fame *1979*

This exhibition at Fashion Moda was the culmination of Ahearn and Torres's first year of working together. They began by casting the people who came into Fashion Moda, but Torres quickly proposed taking the process out to neighborhood sidewalks. The public castings grew into a recurring and spontaneous neighborhood event. Casts would be hung on a wall as a signal to the local community, word would spread, and soon people would line up to take part. Sitting through the process of being cast became a sign of individual bravado and initiation, uniting individuals in a unique community coalition. The *Hall of Fame* exhibition opening became an enormous block party as residents came to view the portraits of themselves.

Bronx Sculpture Park *1986–91*

John Ahearn was commissioned by the New York City Department of Cultural Affairs Percent for Art Program to design a park next to a new police station in his own neighborhood. Authorities hoped Ahearn's sculpture would be seen as a positive bridge between the police and the community. Instead, the artwork incensed a large segment of the community, who read it as negative racial stereotyping, glorifying drug dealers and "unambitious and out-of-work" African Americans. The bronze casts of three neighborhood residents, mounted on large concrete pedestals, were Ahearn's first freestanding artwork. A shirtless, overweight man held a basketball and leaned on a boom box, and a young man with a hooded sweatshirt knelt next to a fierce-looking dog with a studded collar; a young woman wearing a Batman T-shirt roller-skated between them. Although they were casts of actual South Bronx residents, Ahearn voluntarily dismantled the sculpture, stating, "I was convinced I had made a mistake. No one forced me to take it down." The community's anger and Ahearn's reaction became the focus of intense critical debate on such issues as whether public art should present only positive imagery, and the extent of the artist's responsibilities toward those who have to live with the art. From the beginning, Ahearn has voiced a keen sense of personal responsibility toward the community, stating that he never wanted to be considered an artist who "exploited" his models or his audience. His actions were consistent with his concerns.

Bronx Sculpture Park *1986–91*
John Ahearn

JUANA ALICIA Born and raised in Detroit and Salinas (a California farmworker community), Juana Alicia has been called "the most prolific and influential muralist in the San Francisco Bay Area" (mural historian Timothy W. Drescher). Since arriving in California in the early eighties, she has painted more than twenty murals, often designed after extensive involvement with local communities. Reflecting her passionate and positive politics, the murals deal with a range of human rights and ecological issues—a concern for women and children, a desire to protect nature, Latin American oppression by the United States, celebration of indigenous cultures, pride of ethnic heritage, the role of education in maintaining rights and culture, and outrage at the treatment of farmworkers. Alicia is currently a faculty member at the New College of California in San Francisco.

Las Lechugueras (The Women Lettuce Workers) *1985*

This fifteen-hundred-square-foot mural in the San Francisco Mission District, a commission from the Mayor's Office of Community Development and the San Francisco Arts Commission, is about women immigrant field workers. The central figure is pregnant (a fetus can be seen inside her body). Striding purposefully forward, a harvested lettuce in one hand and a machete in the other, she is sprayed with

Las Lechugueras (The Women Lettuce Workers) *1985*
Juana Alicia

pesticides from planes overhead. Alicia based this mural on both personal and related experiences. As she was working on the mural, people on the street would often come up to her and begin telling stories of their own experiences as agricultural workers. They would ask where she was from and would exchange anecdotes about where they had lived and worked. The act of mural painting became a canvas for collective storytelling, offering a personal and communal catharsis around issues taking place in the street. The viewers and passersby thus participated in the construction of their own visual culture. In a later work (collaborating with artist Susan Kelk Cervantes), *El Lenguaje Mudo del Alma/The Silent Language of the Soul* (1990), Alicia examined language and education with the students, teachers, and parents in a San Francisco Mission District elementary school where the predominant spoken language is Spanish.

JERRI ALLYN Influenced by her studies at the Feminist Studio Workshop at the Woman's Building in Los Angeles (1976–78), Jerri Allyn has developed her own unique multimedia performance style that allows members of the audience to participate in her humorous and poignant political narratives. Her work explores the intersection of personal experience with public issues, covering topics as diverse as cancer (after her mother died of the disease), lesbianism, disability, and race. An innovator during the seventies in feminist collaborative political art, Allyn cofounded two important performance groups, the Waitresses and the Sisters of Survival (1982–85). The latter was a feminist antiwar collaborative with Cheri Gaulke, Nancy Angelo, Anne Gauldin, and Sue Maberry, whose members toured Europe and the United States in multicolored nuns' habits to network with artists and activists, confronting war and the threat of nuclear disaster. Their "arsenal" included lectures, international exhibitions, performances at war memorials, billboards, books, and graphics.

The Waitresses *1977–85*
Jerri Allyn

The Waitresses *1977–85*

During consciousness-raising sessions at the Feminist Studio Workshop, several students began to compare their experiences working as waitresses. Out of their observations "that the 'waitress' is analogous to the position of women worldwide," they developed a humorous and politically insightful series of performances that were staged during working hours in several Los Angeles restaurants. The Waitresses, cofounded by Allyn and Anne Gauldin, originally included Patti Nicklaus, Jamie Wildman, Leslie Belt, and Denise Yarfitz. Chutney Gunderson, Anne Mavor, and Elizabeth Canelake later joined. The events revealed specific working conditions (e.g., sexual harassment) and situated women's roles within a larger picture of labor. The prolific work of the group over the next several years included projects with labor unions, performances and installations in restaurants, posters, and the 40 Woman All-Waitress Marching Band,

which appeared in an alternative to the Pasadena Rose Bowl Parade. Allyn left the group in 1981, and it disbanded in 1985. Returning to live in New York City in 1982, Allyn continued to explore "the restaurant as a metaphor for the world." Two relevant works were *The Placemat Series* (1982), in which she worked with members of the Restaurant Workers Union, and *American Dining: A Working Woman's Moment* (1987), which took place in restaurants in six cities throughout the United States. Allyn's intent was "the transformation of a restaurant into a living work of art."

Angels Have Been Sent to Me *1991*

This traveling interactive art project, with a sound composition by Helen Thorington, was sponsored by Creative Time, Inc., in New York City. Allyn transformed wheelchairs, crutches, blindfolds, and safety helmets, which she then offered to viewers at schools, community centers, and art spaces throughout New York City. Members of the audience, including passersby and observers, were invited to temporarily "disable" themselves by moving around with the various devices provided. As they did so, they listened to stories about aging and disability on Walkman headphones. The audiotape by Thorington included hospital sounds, interviews, and piano music, mixed with Allyn's poignant and humorous bilingual tales about her grandmother and other residents of a critical care home.

Angels Have Been Sent to Me *1991*
Jerri Allyn

NANCY ANGELO In the mid-seventies, Los Angeles performance and video artist Nancy Angelo cofounded two successive feminist collaborative groups that grew out of the Feminist Studio Workshop at the Woman's Building: the Feminist Art Workers (1976–80; see Cheri Gaulke) and the Sisters of Survival (1982–85; see Jerri Allyn). These groups combined techniques of feminist education, performance, and grass-roots activism on issues ranging from sexism to the threat of nuclear war. Working with Leslie Labowitz and Terry Wolverton, and involving the contributions of many Woman's Building artists, Angelo was instrumental in developing a groundbreaking multidisciplinary educational outreach program called the Incest Awareness Project (1978–80). Cosponsored by Ariadne: A Social Art Network (founded by Leslie Labowitz and Suzanne Lacy) and the Gay Community Services Center, the project created a national media campaign to make the pervasive tragedy of incest a public issue; curated an exhibition of art by incest "survivors" (adults and children); organized lectures and group discussions led by sociologists, psychologists, and activists; and produced Angelo's interactive video *Equal Time in Equal Space.* The entire project was an important model of art in the service of bringing to light previously hidden information, one of many during the seventies that served as prototypes for today's public art on violence against women. Angelo

is also known for her many solo performances in the persona of the Nun, a character she developed to explore spirituality within the feminist community.

Equal Time/Equal Space *1979*
Nancy Angelo

Equal Time/Equal Space *1979*

Called "the first public presentation of incest, created by women about women" by Ariadne, this interactive community video project was created and directed by Angelo for the Incest Awareness Project. The installation included fifteen to twenty chairs placed in a circle. On five of these chairs were television monitors, arranged at shoulder height, facing inward; the audience sat on the other chairs. At intervals, the monitors came on, each one showing a woman's head perfectly synchronized with the others, so that when one talked, others listened, responded, and so on. The separation between the women on the monitors and the live viewers seemed to evaporate, and the audience soon discovered that it was in the middle of a consciousness-raising support group talking about incest experiences. Viewers were transformed into active participants when, at the screening's end, Angelo and a counselor led a discussion. Mindful of the fact that at that time incest was not publicly discussed or understood, and knowing a percentage of her audience would have experienced incest themselves and had probably never had the chance to talk about it, Angelo took responsibility to provide a passage for her audience, making the viewers' own experiences an integral part of her work. *Equal Time/Equal Space* is a model for art as healing, one emerging directly from feminist activist art of the seventies.

ANT FARM From 1968 through 1978, the collaborative art and architecture group Ant Farm lured media coverage to their presentations while bringing complex media analysis to performance art. The group captured mass media attention and a public following with humorous theatrical events and "roadside attractions" utilizing such quintessential American icons as the automobile and the television set. Originating in Texas with Doug Michels (Yale University School of Architecture) and Chip Lord (Tulane University College of Architecture), the group quickly expanded to include Curtis Schreier (Rhode Island School of Design) and Hudson Marquez (Newcomb Art School). In their ten-year history, Ant Farm received little recognition from galleries and museums, instead executing works directly in the public domain, supported by "a few visionary collectors," according to Lord. Early projects reflected the group's interest in architecture but also included performance, media, and sculpture. Relocating to the Bay Area in 1971, Ant Farm discovered the relatively low-cost Sony Porta-Pak video camera. They toured the state, staging performances with video in an inflatable structure that folded out of the "Media Van," a futuristic customized unit built onto a Chevrolet truck. With

Raindance (a New York group), they coproduced the first alternative Porta-Pak video coverage of political conventions. In 1974 they created *Cadillac Ranch,* an earthworks sculpture of ten Cadillacs buried fins-up in chronological order of fin development, from 1949 through 1964. *Citizens' Time Capsule* (1975) at Artpark, Lewiston, New York, featured a car containing over two thousand articles, magazines, and videotapes, to be buried until the year 2000. Ant Farm disbanded in August 1978, though members continue to work together occasionally as well as pursue individual careers.

Media Burn *1975*

More than four hundred spectators gathered at San Francisco's Cow Palace for this Fourth of July performance. The figure of artist-President "John Kennedy" addressed an audience of fifty cameras (some from networks) among the crowd of spectators: "Mass media monopolies control people by their control of information. . . . I ask you, my fellow Americans, haven't you ever wanted to put your foot through your television screen?" Amid roars from the crowd, and the playing of the "Star Spangled Banner," two brave artist-astronauts rammed a customized 1959 Cadillac Biarritz at fifty-five miles per hour through a wall of fifty burning television sets. The reconfigured Cadillac's windshield was covered, giving the car the appearance of a spaceship or submarine. The daredevil drivers steered the car via a monitor on the floorboards and a camera mounted on a spire on its trunk. The impact sheered off the camera spire and hurled flame- and smoke-filled television sets into the air. The crowd roared as burning television sets continued to implode. The irony of the event could not have been lost on viewers when it was broadcast locally on news stations: media was used in a critique of media. For all its lighthearted buffoonery, *Media Burn* was a precise parody of news clips, with all the newsworthiness that political ceremony, demolition derbies, and fiery acts of destruction can provide. An early precursor of media deconstruction, the event was designed through a calculated analysis of media language, form, and content—two to four bold images, and a message that can be explained in thirty seconds.

Media Burn *1975*
Ant Farm

CONRAD ATKINSON Conrad Atkinson was born in West Cumbria, England, and his work is rooted in Wordsworth's poetic and political legacy as well as the region's strong socialist philosophy and a postindustrial inheritance of pollution that has contributed to many early deaths among district residents. He has developed a practice whereby he lives within a community, researches an issue, collects visual data, combines ideas into paintings or other primarily two-dimensional works, and presents his findings in public art spaces. For more than twenty years he has worked to make visual such issues as

working conditions and unemployment, health, world food supply, violence, the powers of mass media, consumerism, the limitations of high culture, and the erosion of civil liberties. This work has been shown in trade union halls, in subway stations, and on buses as well as in galleries and museums. Many pieces are research projects sponsored by groups who invite his response to particular social and economic situations. For example, in 1975 the Irish Council of Trade Unions and the Arts Council of Northern Ireland invited him to create an artwork dealing with the deep local divisions stemming from British control of Northern Ireland. Intent on representing the objective reality of Irish Protestant and Catholic as well as British viewpoints, Atkinson researched and mounted a successful but controversial Belfast exhibition. He was pleased by the positive Irish response, although one sample of found wall graffiti that was included in the show caused such dissension that it had to be removed. Despite British resistance to his work on Irish issues (a 1974 work of his was banned), Atkinson developed subsequent exhibitions in London, Nottingham, and Dublin. His 1979 New York City show entitled *Material* influenced the name and philosophy of Group Material. While Atkinson's work methods essentially resemble those of many of today's artists, he was among the earliest of a small number of artists worldwide to develop these strategies as part of an art language. In an era when such practices were outside the purview of art, Atkinson was a highly visible, political, and formidable member of the British art community.

Strike at Brannon's *1972*

At London's Institute of Contemporary Art, in a pioneering use of research and archival materials as art, Atkinson displayed documents relevant to the one-year-old strike (mostly by women) at Brannon's thermometer factory in Cleator Moor (Atkinson's hometown). The exhibition of newspaper coverage, case histories (one woman's daily diary), wage slips, local people's photographs, films, and videos attracted media attention and became the organizing center for strikers. Atkinson sold copies of a print—strike committee signatures over the factory license— to raise money for the strikers. Although the Cleator Moor strike eventually failed, Atkinson's project positively influenced the unionization of Brannon's London factory.

For Emily *1992*

In an installation at the Henry Moore Sculpture Trust in Halifax, England, Atkinson explored the connections between the Asian immigrant community now working in the carpet industry and Emily Brontë's characters in *Wuthering Heights*. Atkinson's work used a British literary classic to discuss the damage incurred by both sides in acts of cultural, political, and economic exclusion. He connected the

Strike at Brannon's *1972*
Conrad Atkinson

tragedy of Brontë's protagonists Cathy and Heathcliff, destroyed by barriers of class and race (Brontë alludes to Heathcliff's unknown parentage: "Who knows, but your father was Emperor of China, and your mother an Indian queen"), to the contemporary British tragedy caused by the racist ostracism of immigrants. Atkinson's installation consisted of several interdependent but distinct objects that fluidly mixed Asian and Western imagery to show important cross-cultural influences. The Henry Moore Sculpture Trust is located in a former carpet factory—a fact Atkinson built upon when he employed British Asians to weave two modern-day carpets that told their own stories. The two rectangular carpets were arranged parallel to one another to form an equal sign, representing the parallel life situations between nineteenth-century and contemporary immigrant labor forces.

HELENE AYLON A ritual performance artist, peace activist, and committed ecofeminist, Helene Aylon began her career in the sixties as a conceptually based painter. A 1980 speech by Dr. Helen Caldicott, the Australian antinuclear activist, inspired Aylon to take her art out of the studio and use it to try to "stop the arms race." She has spent more than a decade working on one expansive, evolving, ceremonial artwork (*The Earth Ambulance*) that has become a personal international crusade for nuclear disarmament and ecological awareness. This performance has required organizing hundreds of participants—mostly women, mostly nonartists—to work cooperatively on its local, national, and international aspects. Through it, Aylon has orchestrated large-scale ceremonies of cooperation among Arab and Jewish women in Israel, Americans and Japanese in Japan, and Americans and Soviets in the former U.S.S.R.

The Earth Ambulance *1982–92*
In 1982 "sacs" of "endangered earth" were rescued from twelve nuclear weapons sites across the United States. For Aylon, "sac" stands for "survive and continue" as opposed to the acronym for the U.S. Armed Forces Strategic Air Command. She drew the symbolic image from an all-too-common photograph of women fleeing war with only a sackful of belongings. For her, the sack has developed into a universal symbol of women working together to gather the essentials for survival and healing. More than eight hundred women began the collaboration by contributing pillowcases with dreams and nightmares written on them, filled with earth they considered endangered. The sacks were picked up on a cross-country tour by *The Earth Ambulance* (a real, converted ambulance) and delivered to the United Nations on old army stretchers. The sacks were emptied and hung on a clothesline across Dag Hammarskjold Plaza. Later that year, these pillowcases were exchanged with those of Soviet women, and in 1983 an international group of women rehung the pillowcases and camped under them for two weeks at the U.N. plaza. Pillowcases

The Earth Ambulance *1982–92*
Helene Aylon

201

were also delivered to the Seneca Women's Peace Encampment in upstate New York, where they were used to cover two miles of military fence. In 1985 Hiroshima survivors in Japan wrote on pillowcases and floated them downriver, where they were collected and filled with sand from Hiroshima and Nagasaki. In 1992, under the Brooklyn Bridge in New York, a new *Earth Ambulance* installation appeared with pillowcases on clotheslines and blue corn seeds from Pueblo lands, and ecofeminist writer Susan Griffin read from her antiwar book, *A Chorus of Stones: The Private Life of War*, an appeal to halt the atomic "march toward death."

JUDITH F. BACA Judith Baca has extended and transformed the great Mexican muralist tradition to meet the cultural needs of California's contemporary urban and farm-belt Latino communities. Born in a Los Angeles barrio, she organized her first mural project in predominately Latino East Los Angeles as a strategy for teaching youths from opposing street gangs to work together. With support from the city, she founded the Citywide Mural Project in 1974, an organizational umbrella under which scores of artists produced interactive community murals. Since that time, through the Social and Public Art Resource Center (SPARC), which she founded, she has not only responded to these issues in her own murals, which give long-overdue recognition to ethnic minorities, but has also contributed to the recognition of murals and public art in the culture at large. Baca is a teacher who creates pedagogical structures within her expanded-scale artworks, training young artists from around the country in political art. Her work is distinguished by the scope of its vision, the sophistication of community organizing techniques employed, and its impact on national and international audiences.

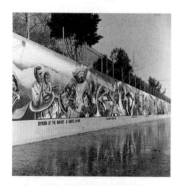

The Great Wall of Los Angeles
1976–continuing
Judith F. Baca

The Great Wall of Los Angeles *1976–continuing*
Perhaps the world's most extensive mural—2,400 feet long and still unfinished—this project is located in a flood control channel in the Los Angeles River. It was painted over the course of several summers by hundreds of teenagers (including parolees from the juvenile justice program) who were hired, taught, and directed by Baca. The organization for this project is monumental and includes eliciting cooperation from the Army Corps of Engineers, the city, local politicians, teachers, anthropologists, teenage gang members, and the criminal justice system, among others. Its strategy aims at political activism and education through art. An alternative history of California, *The Great Wall* portrays the struggles and contributions of indigenous peoples, immigrant minorities, and women from prehistory to the fifties. A 1982 *Los Angeles Times* editorial stated: "This is no normal art project. Nor does it portray conventional history. Recorded already, far more dominantly than history book

images, are unfamiliar ones: Dust Bowl refugees and blacklisted actors, Mexican Americans being deported, and Japanese Americans being dragged off to internment camps. Only rarely can an art project teach so much."

The World Wall: A Vision of the Future without Fear *1986–continuing*
This is a traveling mural project that explores the possibilities of social transformation through our ability to visualize global peace. Inspired by peace activists, Baca designed the installation as a movable space within which actual dialogues could take place. For three years she gathered historians, scientists, military strategists, visionaries, artists, writers, and students to discuss "a vision of the future without fear." From these group conversations complex images with extended narrative and elaborate symbolism began to emerge. When completed, the work will include fourteen murals—seven inside and seven outside the space. Baca is painting the interior murals, with four completed to date: *Triumph of the Hands* (on the need to change from a war-based economy to a peaceful one); *Triumph of the Heart* (about how change begins with individual transformation); *Balance*; and *Non-violent Resistance.* As the piece travels, selected artists from each country paint the exterior murals. At each staging site around the world, people meet to discuss world peace within the circular area created by the contiguous ten-by-thirty-foot mural panels. *The World Wall* premiered in June 1990 in Finland, at the Meeting of the Worlds peace festival. After Finnish artists painted a panel, *Dialogue of Alternatives,* the project then traveled to Moscow's Gorky Park, where fifty thousand people visited it in one week, and Russian artist Alexi Begov added *The End of the Twentieth Century. The World Wall* was subsequently exhibited in the United States, and other international venues are planned.

The World Wall: A Vision of the Future without Fear *1986–continuing*
Judith F. Baca

JOSEPH BEUYS German artist Joseph Beuys (1921–86) was a pioneer in conceptual art. Emerging from years of depression, he discovered the transformative powers of art at the Düsseldorf Academy of Art while studying with a sculptor who believed in the unity of art and life. For the next ten years he worked in rural isolation, developing an ideology that shaped his lifework and an iconographic language unique to his sculptures and installations. He believed that everyone is an artist, and that creativity is the most powerful tool for societal transformation. In the sixties he joined Fluxus, a group of international artists opposed to art as a static commodity and committed to erasing what they saw as arbitrary divisions between the performing arts, visual arts, and life. Beuys called his performances "actions" and moved freely from performance, installation, and sculpture to politics, which he saw as inseparable from art. He also founded his own political party and twice ran unsuccessfully for Parliament. A highly influential teacher for more than twenty years at the Düsseldorf Art

Academy (where he was fired for political views and then re-hired by court order), he helped to found the Free International University for Creativity and Interdisciplinary Research in Ireland.

Coyote: I Like America and America Likes Me *1974 (see page 18)*
This performance work linked animal rights (the threatened extinction of the American coyote) with American Indian persecution and the destruction of an indigenous culture by U.S. forces in Vietnam. After turning down numerous invitations to visit America because of its Vietnam involvement, Beuys agreed to make his first trip only after U.S. troops had left Southeast Asia. His entire visit was an "action." An ambulance with lights flashing met his plane, and he was carried on a stretcher to a downtown Manhattan gallery, wrapped in gray felt, a trademark of his sculptures since an experience during World War II, when he was wrapped in felt to keep from freezing. A large, well-lit exhibition area was cordoned off with industrial chain-link fencing. Inside the fence were a live coyote, a mound of hay, fifty copies of the *Wall Street Journal* (changed daily), two felt blankets, and a water dish. The ambulance attendants carried Beuys into the gallery and left him inside the cage. He shared this space with the coyote for three days and nights, "engaged in total communication and dialogue," while throngs of visitors viewed their cohabitation.

7,000 Oaks *1982–87*
With Free International University students, Beuys began a massive tree-planting campaign in Kassel, Germany, to dramatize the need to revitalize urban ecology. Anyone could participate by donating money to sponsor a tree, for which they received a receipt stating that "small oak trees grow and life continues." Many trees were planted for the 1982 *Documenta VII* exhibition, and Beuys and his students successfully organized a worldwide campaign in other cities to plant seven thousand oaks. The site of each new oak tree was marked with one of seven thousand mountain stones.

RICHARD BOLTON Social critic, artist, and writer Richard Bolton is involved in works that analyze a broad range of issues concerning mass media, popular culture, democratic participation, and the social function of art. Early on a documentary photographer, Bolton began to question the assumptions upon which the documentary mode is based. Following a move to Boston in 1986, his work changed. He spent three years as an editor, working in a radical teaching organization, helping to create textbooks on controversial political subjects for K–12 classrooms. At the same time, he began developing a more interactive, less rhetorical format for his art. He writes: "Also important to me is my 'double life' as a writer and as an artist. I don't think of criticism as a completely separate prac-

tice from art production. I have been trying to reexamine all points of the compass, including the role of the audience and the presenting institution in the formation of meaning. If I had to define my practice, I would define it loosely—it is 'context-specific.'" Bolton's recent projects have explored the media portrayal of patriotism and militarism, demagoguery in mainstream politics, television's depiction of the family, and the portrayal of sexuality in mainstream and pornographic materials.

Subject: Male Violence *1992*

First presented during a three-month residency at the Capp Street Project in San Francisco, Bolton's multimedia installation compared the real conditions of male violence with the projection of violence in the media. Specially constructed reading tables were stocked library-style with books, magazines, and videotapes of popular films, newspaper and magazine clippings, and reports from the San Francisco Family Violence Project. In videotaped interviews, former batterers who had become counselors explained their urges toward violence. Women who were hotline workers for battered women's shelters also described their experiences. In an adjacent room, visitors were invited to contribute written responses to the exhibition or to recount their own stories of violence and post them to walls labeled "male" or "female." As part of the work, Bolton spent three to four months in the community in meetings and phone conversations with people running battered women's shelters, men's counseling groups and family counseling services, heads of social service agencies, medical and legal professionals, and the police force, thus involving the art directly in the community. For his exhibition at the Bellevue Art Museum, in a suburb of Seattle, Bolton responded to the museum's shopping mall location by adding material relevant to an adolescent audience. Social service agencies held their board meetings and fundraising events at the museum, and a domestic violence shelter held training sessions for museum docents.

Subject: Male Violence 1992
Richard Bolton

BORDER ART WORKSHOP/TALLER DE ARTE FRONTERIZO Founded in 1984, the Border Art Workshop/Taller de Arte Fronterizo (BAW/TAF) is a San Diego–based, politically active performance collective focusing on issues specific to the border shared with Mexico and the broader implications for all Latinos living under the influence of a dominant U.S. culture. Founding members were Isaac Arnstein, David Avalos, Sara-Jo Berman, Philip Brookman, Jude Eberhard, Guillermo Gómez-Peña, Victor O. Ochoa and Michael Schnorr. They were joined by Emily Hicks, Berta Jottar, Richard A. Lou, Robert Sanchez, and Rocio Weiss. Claiming the border as their intellectual territory, the original group was an interdisciplinary, multiethnic mix of artists, writers, and educators who emphasized collaboration and

downplayed individual work. They employed a wide range of multimedia techniques to produce billboards, signs on buses, free public performances in neighborhoods, and an annual open show at the Centro Cultural de la Raza in San Diego. San Diego art critic Robert L. Pincus wrote: "Implicit in the [BAW/TAF] work is the understanding that the border is not only a terrain of great tragedy, but a place where social upheaval also produces the possibility of constructive transformation of both Mexican and American cultures. Art, in this context, becomes a tool, a catalyst." In 1989, in a two-month residency at the Capp Street Project in San Francisco, the group set up a multimedia alternative mass communications network to gather, analyze, and disseminate pertinent political information via photocopy, phone, and fax to community and art centers in San Francisco, San Jose, San Diego, Mexico City, and Managua, Nicaragua. Later that year internal strain caused half the members to leave. The rest stayed to carry through two more important works, *Border Sutures* and, as described by Gómez-Peña, the "legendary Venice Biennale piece, which, paradoxically, crowned the collective as an international superstar right when the original group was disbanding." BAW/TAF re-formed with new members in late 1990. Original members have gone on to develop important solo works, with several continuing to also work in collaborations.

End of the Line *1986*
A popular early work that attracted media attention, *End of the Line* took place directly on the U.S.-Mexican border where it meets the Pacific Ocean. Portraying border stereotypes, performers sat across from each other at a huge binational table bisected by the borderline—Mexicans in Mexico and Chicanos and Anglos in the United States, holding hands and exchanging food "illegally" across the border, and eventually "illegally" switching sides. Guillermo Gómez-Peña writes: "The Mexican media reported the event as news, and we became aware of the political power of site-specific performance. A cultural act emerging from such a politically charged site . . . carries much more weight and many more implications than similar gestures in the interior of either country."

Border Sutures *1990*
At the time *Border Sutures* took place, BAW/TAF members were Yareli Arismendi, Carmela Castrejon, Berta Jottar Palenzuela, Richard A. Lou, Robert Sanchez, and Michael Schnorr. They were joined by collaborating artists Patricio Chavez, Lourdes Grobert, and Victor O. Ochoa. For three weeks in July, the group zigzagged two thousand miles along the U.S.-Mexican border from the Gulf of Mexico to the Pacific Ocean, enacting a series of performance rituals: *Border Staple, Border Baptism, Border Beds,* and *Border Tug of War.*

Richard A. Lou writes: "The project consisted of . . . part border re-search, part performance/interventions/suspension, part travelling medicine show, part humble acts of healing, and part osmosis. A sixty-two-foot-long motor home was used as an intrasocial labora-tory, studio on wheels, conference room, and living quarters to traverse the entire border. . . . The distinction between artists and audience was consciously nonexistent. . . . The structure . . . was kept fluid enough to allow any participant—artists, residents, and undocumented migrants, to alter the direction." *Border Staple* con-sisted of informal interviews with border residents and undocu-mented migrants, and the healing act of physically stapling the two countries back together. Twenty-four steel staples, ranging from two feet to six feet long, were pounded into the earth or floated on small rafts down the Río Bravo/Rio Grande. In *Border Baptism,* the artists blessed the staples with waters from the Pacific Ocean, Gulf of Mexico, and Río Bravo/Rio Grande. *Border Tug of War* was per-formed at known illegal border crossing sites in El Paso, Texas, and Tijuana, Mexico, after gaining permission from migrant workers there. In a ritual tug-of-war, one team wore BAW/TAF wrestling masks whose design incorporated elements from the U.S. and Mexi-can flags, and the other team wore Border Patrol masks.

GLORIA BORNSTEIN Born in New York City, Gloria Bornstein spent the seventies in San Diego, first studying art (she was impressed by the work at the Woman's Building in Los Angeles) but later switching to psychology. In 1980 she settled in Seattle, where she declined a mental health job and instead explored community-driven art as a healing medium. She began by working with homeless seniors of Seattle's Cas-cade community who had been displaced by arson, eviction, and gentrification. The resulting performance, *Soupkitchen-work* (1980), brought homelessness to the Seattle public's at-tention. Bornstein has dedicated dual careers as community artist and psychotherapist to revealing the hidden voices within culture—what Gillian Rose calls "the geography of silence." In interactive performance and documentary installations, she uses "the critical mobility of diverse forms to make tactical in-terventions, revealing the connections between private and public worlds and showing the social interactions between people, history, objects, and the land." Bornstein is working with members of the Native American tribes of the Northwest and Alaska on *Neototems,* an ecological work to be completed in 1995.

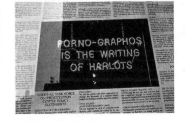

Porno-Graphos *1984*
Gloria Bornstein

Porno-Graphos *1984*
This was the third installation in a trilogy that voiced outrage at the "violence of silence" behind the Green River serial murders in Wash-ington—the still unsolved deaths of forty young female victims,

mostly teenage runaways from abusive homes, stereotyped as prostitutes by the press and largely ignored by the police. Bornstein developed a relationship with representatives from COYOTE (Call Off Your Old Tired Ethics), the national organization to protect the rights of sex workers. Through a dialogue with them on these rights, pornography, and violence, she created a voluminous text that filled street-front window installations at both New York City's Printed Matter and Seattle's 911 Media Arts Center. "Pornographos" is Greek for "the writing and advertising of prostitutes"; in the center of her text, Bornstein installed a neon sign reading, "PORNOGRAPHOS IS THE WRITING OF HARLOTS." COYOTE's National Task Force on Prostitution presented this text of rights to the Meese Commission Hearings on Pornography in 1986.

Shore Viewpoints *and* Voice Library *1991*

For these works, Bornstein collaborated with painter-sculptor Donald Fels to create signage that served as a counterpoint to historical markers along Seattle's waterfront. Official signs extolled pioneer and military events that displaced the indigenous population, filled in tidal flats, and created the commercial port. The new signs addressed histories not officially recognized but particular to the site, with images and text that acted as an ironic approximation of the historical markers. Next to a sign denoting a "Shore View," the artists' sign read, "WILL IT WORK TO HAVE A HARBOR THAT EXISTS ONLY FOR VIEWING? WILL WE JUST SEE OURSELVES LOOKING?" Other signs directed visitors to a nearby park without amenities occupied by homeless Native Americans—the irony being that the park is set on filled-in tide flats taken from their ancestors. The *Voice Library* was a voice-mail system offering listeners six channels of information about waterfront inhabitants in the past and present, and those who might live there in the future. Listeners had options of leaving messages or listening to other responses. Hundreds of phone messages were recorded and shared by residents and tourists.

Shore Viewpoints *and* **Voice Library**
1991
Gloria Bornstein

SHU LEA CHEANG Video artist Shu Lea Cheang combines video installations with cross-cultural readings on urgent topical issues. Born in Taiwan, she was trained in filmmaking at the National Taiwan University and New York University. Disenchanted with the commercial film world, in 1981 she joined the alternative cable collective Paper Tiger Television (see DeeDee Halleck), which became the base for her continuing interest in video collaboration and interactive media. Throughout the eighties she produced a series of tapes for the collective dealing with race and the media, and created a series of installations in museums and alternative spaces.

The Airwaves Project *1991*

Shu Lea Cheang's video installation at the Capp Street Project—an alternative, nonprofit exhibition space in San Francisco—provided an

opportunity for the viewer to select an alternative view of the news offered by national networks. These alternative reports were produced by some twenty local activist organizations and individuals across the country who were invited to participate. On television monitors suspended overhead, the viewer could view Peter Jennings through binoculars. The network news delivered by Jennings was intermittently interrupted by images of transoceanic barges carrying toxic waste. The interruptions juxtaposed the worldwide dissemination of mainstream news by the United States with its export of hazardous waste. By tugging on the binoculars, viewers could also trigger a break into the network version of the news and replace it briefly with a broad menu of alternative reports on issues related to the news coverage.

The Airwaves Project *1991*
Shu Lea Cheang

JUDY CHICAGO Judy Chicago is an artist, writer, and teacher whose work and philosophy have had a worldwide impact on both art and society. Chicago was first recognized in the sixties for her minimalist metal and plastic sculpture. In 1970 Chicago pioneered feminist art education while a faculty member at California State University in Fresno, and in 1971, with painter Miriam Schapiro, she founded the Feminist Art Program at the California Institute of the Arts in Valencia. In their first project, *Womanhouse,* Chicago, Schapiro, and their students converted an unoccupied, dilapidated house into a series of installations about their experiences as women. Then, with Sheila Levrant de Bretteville and Arlene Raven, Chicago cofounded the Feminist Studio Workshop and, later, the Woman's Building in Los Angeles. Chicago, perhaps the best-known feminist artist of her era, is a broad-ranging thinker whose scope of inquiry, in multiple contexts and expanded multimedia forms, includes the meaning of art in contemporary culture, social activism, and the nature of audiences. The sheer scale of her work, as well as the implications of her vision, places Chicago in a league with such groundbreaking conceptual pioneers of new genre public art as Beuys, Christo, and Kaprow.

The Dinner Party *1973–79*
This monumental multimedia installation presented the history of women in Western civilization through a series of thirty-nine ceramic place settings, set on a triangular banquet table forty-eight feet long on each side. In making *The Dinner Party,* Chicago ventured into realms of creative activity outside the art establishment, honoring art forms traditionally sustained by women. To learn china painting for the piece, she exchanged information with a national network of women; they in turn directed her to needleworker volunteers who rendered the elaborate runners at each place setting. Project personnel grew in number, beginning with the research team that named and compiled the histories of the 999 women honored on *The Dinner*

The Dinner Party *1973–79*
Judy Chicago

Party's triangular ceramic tile floor. Chicago's original isolation as an artist eventually gave way to a studio full of needleworkers, ceramists, carpenters, photographers, researchers, and administrative staff. By 1976 a core of fifteen women plus approximately three hundred volunteers was working on the project. After an initial and highly publicized showing at the San Francisco Museum of Modern Art in 1979, a museum tour collapsed owing to controversy over the work's feminist content, and the project was warehoused. But a year later a grass-roots organizing drive in Houston raised money for an exhibition, and this unprecedented pattern was repeated in city after city. *The Dinner Party* has now traveled extensively throughout the United States and to Canada, Scotland, England, Germany, and Australia, and has been seen by approximately one million viewers during its fourteen exhibitions.

The Holocaust Project: From Darkness into Light *1985–93*
Judy Chicago

The Holocaust Project: From Darkness into Light *1985–93*

The Holocaust Project is an exhibition of a series of images that combine Chicago's painting with photographs by her husband, Donald Woodman. These combined paintings and photographs reveal information about the Nazis' treatment of women and homosexuals not commonly known and link the Holocaust in significant ways to other forms of human transgression, prejudice, and cruelty. The exhibition also includes works in stained glass and tapestry designed by Chicago and executed by skilled artisans. Chicago and Woodman began their research for the work in the museums and archives of Los Angeles, New York, and Washington, D.C. They established a dialogue with scholars and survivors in the United States and abroad, and then went on to spend an exhaustive two and one-half months traveling to nine countries to view concentration camps, extermination sites, and other significant Holocaust locations. They researched what little remains of Eastern European Jewish culture, and traveled to Israel. The exhibition, which is accompanied by a book, will travel to several U.S. cities during the mid-nineties. The connective worldview of the exhibition, and the breadth of audience it attracts, remains an important hallmark of Chicago's work.

MEL CHIN A first-generation Chinese American born and raised in Houston, Mel Chin is a conceptual artist whose multimedia work explores three principal themes: the environment, human rights, and our relationship to the universe. His work combines philosophy, religion, magic, politics, history, myth, natural sciences, environment, and mathematics. He researches, accumulates and analyzes data, and compares notes with experts in different fields. He then explores the materials themselves and frequently invents the tools with which to realize his concept. His installations, staged both in museums and nontraditional venues, may take the form of a scientific experiment or an architectural memory. His work *Conditions for Memory: Passenger Pigeon* (1989) names an ecological prob-

lem (accelerated species extinction), while in *Revival Field* he visualizes possible solutions.

Revival Field *1989–continuing*
This artwork uses plants to clean contaminated soil at a 307-acre toxic waste site near Minneapolis/St. Paul. Cosponsored by the Walker Art Center, the Science Museum of Minnesota, and the Minnesota Pollution Control Agency, the artwork is also an experimental, low-cost, "green remediation" site. Working in collaboration with U.S. Department of Agriculture agronomist Rufus Chaney (who developed the scientific techniques), Chin planted rare plants called hyperaccumulators that absorb poisonous heavy metals from the ground. When the plants are harvested, the toxins they contain can be removed. The work's formal configuration comprises a cross inside a circle inside a square. The square and the circle are outlined by two standard chain-link fences. The circular area, planted with the hyperaccumulators, serves as the test site, while the area between the circle and the square, unplanted and of equal area, serves as the control. Looking like a crosshair view from above, the central cross is formed by the two intersecting paths to the test site. There was a short-lived controversy when NEA funding was pulled and then reinstated; Chin had to prove that *Revival Field* was "art." Chin's project is a model for successful art/science and multi-institutional collaborations.

Revival Field *1989–continuing*
Mel Chin

CHRISTO Christo's elaborate sculptural events involve large numbers of people working toward the completion of outdoor works on an environmental scale that may typically alter buildings, monuments, or miles of landscape. These projects require years of planning, negotiation on all levels of government, and extensive public outreach in order to win support, permission, and enactment. Every project, requiring millions of dollars, is self-funded through the sale of studies, preparatory drawings, collages, scale models, early works, and original lithographs. Born and educated in Bulgaria, Christo left Eastern Europe by concealing himself under a truckload of medical supplies bound for Vienna. In 1961, when he enlisted the help of dockworkers in Cologne to cover stacks of oil cans with tarpaulins, the resulting exchange of ideas motivated him to engage "ordinary" people in a dialogue about art. Later, when Christo wrapped Chicago's Museum of Contemporary Art with ten thousand square feet of brown tarpaulin, the media attention for the museum confirmed his belief in art as social dialogue.

Running Fence *1972–76*
Running Fence was a twenty-four-mile curtain that rambled across the countryside forty miles north of San Francisco. Over a period of

several months, skilled construction workers planted the poles, and then in three days 350 local college students hung the 165,000 yards of nylon cloth. According to Howard Smagula, "From the beginning, *Running Fence* had been embroiled in what Christo optimistically calls 'process.'" To win permission, the artist endured three years of legal battles, numerous public hearings, and a maze of bureaucratic rules. Groups filing lawsuits led to a formal defense of the project in three sessions of the California Supreme Court. When the California Coastal Zone Conservation Commission, concerned about the effect the fence would have on the marine ecology, denied the construction permit to extend the work into the Pacific Ocean, Christo defied the law and erected the section without official approval. He viewed the act as part of the process—a challenge to the legality of the system. The Committee to Stop Running Fence demanded an environmental impact report and sued successfully to require one. After eight months and thirty-nine thousand dollars, the 265-page report concluded that "the only large-scale irreversible change may very well be in the ideas and attitudes of people. . . ." In the end, Christo won the support of many local ranchers. The fence remained in place for two weeks, and thousands of people saw it from their cars or on foot. Afterward, with the bare spots of earth reseeded, all traces of the work disappeared.

The Umbrellas, Japan–U.S.A. *1984–91*
(top: Japan site; bottom: California site)
Christo and Jeanne-Claude

The Umbrellas, Japan–U.S.A. *1984–91*

Christo's umbrellas project took six and one-half years to build and spanned twelve miles in Japan and eighteen miles in the United States. Freestanding umbrellas, over twenty-eight feet wide and nineteen feet high, dotted the two landscapes—1,760 yellow umbrellas in the dry California Tejon Pass, sixty miles north of Los Angeles along Interstate 5, and 1,340 blue umbrellas in a verdant region around the Sato River, seventy-five miles north of Tokyo. In the limited landscape of Japan the umbrellas were positioned close together, following the geometry of the rice fields. In the vast uncultivated grazing land of California, the configuration of *The Umbrellas* was whimsical, spreading in every direction. The six years of preparation included negotiations with hundreds of private landowners and government agencies in both countries. *The Umbrellas* could be seen by car or close up by walking. As with Christo and Jeanne-Claude's other works, when the project was removed the land was restored to its original condition. The umbrellas were taken apart, and all elements were recycled. In reference to the project's twenty-six-million-dollar cost, Christo said that his money was "spent for a work of art that cannot be bought, cannot be purchased, cannot be controlled, because I believe that possession is the enemy of freedom." In California, the Umbrella Coalition, a group of fifteen nonprofit organizations benefiting children, the deaf, the disabled, the homeless, and the Red Cross, managed over one thousand volunteers and sold food and commemorative items. All proceeds went to the organizations.

ROBBIE CONAL The son of New York labor organizers, Los Angeles–based Robbie Conal began to combine painting with his political beliefs in the early eighties. Conal calls his critical and unflattering caricatures of public figures "adversary portraiture." The message is carried in his thick, aggressive, gestural brushstrokes and the body language of the pose, somehow grotesque and darkly comic. Crediting the influence of another politically astute artist, Leon Golub, Conal notes that he paints to expose issues that disturb him: politics, power, and their abuses. To take his message to the mainstream, he reconfigures his paintings as posters with bold, simple texts that are mass-produced and nationally distributed. At first the posters were mounted as informal street actions with strangers. "I made posters and ran around the streets like a midnight maniac, spattering glue in every major city I could on my no-budget, nonscheduled, total loss, rock 'n' roll poster tours . . . building up a volunteer guerrilla-postering army as I went." Now his "strikes" are well-coordinated volunteer efforts, with posters plastered to every imaginable kind of public surface. Although the posters are vulnerable to attack, graffiti, or removal, Conal views graffiti on his work as "letters to the editor" or spontaneous art "reviews."

Art Attack *1983*

Art Attack was an art-based political action group organized by Conal and composed of students and colleagues at the University of Connecticut. Art Attack called for social and political change with printed T-shirts, posters, and postcards of conflicts in Central America. One postcard featured two panels from Conal's painting *Foreign Policy,* his first large-scale work on American actions abroad, comparing the American military presence in the Middle East and war-torn Central America. Politicians confer, mothers mourn deceased children, and, in counterpoint to the malevolent politicians, innocent figures react to an unknown cataclysmic event. This bipartite structure is a precursor of later works such as *Doublespeak* (1989), in which a panel depicting Roy Cohn and Joseph McCarthy is the mirror image of a panel with Brendan Sullivan talking to Oliver North.

Freedom from Choice *and* Gag Me *1991*

"After *Rust v. Sullivan* and the confirmation hearings of Clarence Thomas," wonders Conal, "who could even pretend that the Supreme Court is above politics?" In *Rust v. Sullivan,* the Court ruled that doctors in federally funded family planning clinics were not allowed to mention the word "abortion" to their patients. While discussing the "gag rule," Conal's wife, Debbie, came up with the title phrase "freedom from choice," which Conal paired with a painted

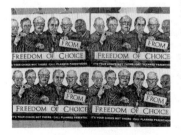

Freedom from Choice *and* **Gag Me**
1991
Robbie Conal

lineup of six of the nine members of the Supreme Court—the five who upheld the rule and Clarence Thomas. The Greater Los Angeles Coalition for Reproductive Rights asked Conal to develop a second poster, a menacing portrait of Chief Justice William Rehnquist pointing his finger, with the text "Gag me with a coat hanger" and subtext "Abortion is still legal. For information call your local family planning clinic." The coalition then mobilized its network of volunteers to distribute six thousand posters from San Diego to San Francisco. *Freedom from Choice* was also used by Planned Parenthood in a prochoice march on Washington, D.C., and in its ad campaign.

HOUSTON CONWILL, ESTELLA CONWILL MÁJOZO, AND JOSEPH DE PACE Harlem-based sculptor Houston Conwill and his sister, poet Estella Conwill Májozo, collaborate with architect Joseph De Pace to create experimental installations on African American heritage. Conwill first created assemblages of found objects, combining them with "petrigraphs"—scroll-shaped objects covered with pictographic reliefs carrying references to blues lyrics, African American life, and West African culture. These sculptures resembled both time capsules and objects unearthed in archaeological digs. In 1983 Conwill, Májozo, and De Pace invented a new form, "the cosmogram," a world map that enabled them to physically involve the audience. In these interactive works, viewers literally and metaphorically "dance" a journey along a layered map on the floor, blending history, folklore, music, dance, and sermon with a political manifesto for contemporary African Americans.

The New Charleston *1991*
Houston Conwill, Estella Conwill Májozo, and Joseph De Pace

The New Charleston *1991*
An enormous map, painted on the gymnasium floor of the Avery Research Center for African-American History in Charleston, South Carolina, makes up this "cosmogram." Inside a golden rectangle is a large flat blue sphere containing an interior gold landmass. Directional lines are story lines, meant to be followed. This is both a water journey and a diagram based on the popular twenties dance the Charleston. The viewer learns a dance and takes a journey, following that taken by African Americans arriving in Charleston on slave boats after the Middle Passage. These waterways are also associated in the piece with baptism, with the River Jordan of spirituals, and with healing, purification, and rebirth. The cosmogram includes a song line of spirituals and freedom songs, recounting the African diaspora that brought people and their ways to this side of the Atlantic Ocean. The work, created for the Spoleto Festival USA, remains on long-term display at the center.

BETSY DAMON For more than twenty-five years, multi-media performance artist Betsy Damon has been an influential teacher, ecofeminist, and community organizer. In 1973 she founded one of the first feminist education programs, the Feminist Studio, in Ithaca, New York. Much later, she founded No Limits, an ongoing national women artists' support network; she also remains active in women's rights through teaching, lecturing, and organizations. Her *Shrine for Everywoman* (1985)—an installation place for women to meet and exchange ideas—was part of the International Women's conference in Nairobi, Kenya. In 1986 she created *A Memory of Clean Water,* in which she cast two hundred feet of a Utah dry riverbed with papier-mâché and interviewed residents who disclosed that the local water was undrinkable. Damon spent the next several years creating works based on water quality issues. In 1989 she moved from New York to Minnesota, which has more water than any state in the Union. Damon travels the country, working on environmental issues, and is writing a book, *Your Body Is Water.*

The 7,000 Year Old Woman *1975–79*

This work marked the beginning of Damon's public performances held in the streets of New York City which involve the audience as both spectators and performers. Her face and hair painted white and lips blackened, Damon tied sixty pounds of colored flour to her body in 420 small sacks, transforming herself into a matriarchal character embodying seven thousand years of female lineage. The performance was a ritual for gaining knowledge about women's relationship to time using hypotheses (new at that time) about female mythology. In one performance on Prince Street, Damon stood vulnerable and motionless within a circle of sand, while admirers threw flowers and hostile onlookers threw eggs at her. Damon then ritually cut and slashed each bag of flour. Moira Roth writes, "Of primary concern for Damon in playing the roles of these characters are the intellectual and emotional transformations that she effects in the viewers of her performances. Embracing both an art public and an urban public, Damon's performances enable the artist to construct a new type of community with her audiences."

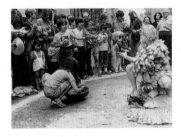

The 7,000 Year Old Woman *1975–79*
Betsy Damon

Keepers of the Waters *1991–93*

In this two-year project about water, in a collaboration with the Hubert H. Humphrey Institute for Public Affairs at the University of Minnesota, Damon worked with other artists, scientists, public policy makers, and grass-roots community groups to protect and preserve water quality in Anoka County, Minnesota. The project involved a broad range of community organizing techniques and

Keepers of the Waters *1991–93*
Betsy Damon

comprised a spectrum of programming from art events and festivals to educational projects within schools. Damon's success in raising civic awareness and generating community activism inspired groups beyond Anoka County, prompting reactions statewide: 4-H groups devoted a year to water, and the Minneapolis Institute of Art developed a docent-led program of artworks relating to water. Damon also worked with the Pollution Control Agency in Duluth. The city of Anoka, too, plans to create a theme park on water issues. Damon states: "The most important aspect of this project is people working in the Department of Natural Resources and Public Works coming together with artists and environmentalists. This coalition building gives the community an opportunity to express issues they previously felt powerless to address, and can lead to significant changes in policy."

LOWELL DARLING According to the description on the back of his book, *One Hand Shaking,* Lowell Darling is a "modern artist and anthro-apologist." In the late seventies he took it upon himself to end the social problems plaguing the West Coast, using a technique that saved several cities: Urban Acupuncture. He calculated what areas of a city or state correspond to the human body, found out what the symptoms were, and placed his very large needles accordingly. He claims that so far he has reduced the flow of heroin in Vancouver, B.C., revitalized the inner city of Portland, Oregon, saved Los Angeles from economic collapse, healed the Port Costa, California, sewage system, and ended the drought in California. Darling's art has its roots in the West Coast Dada movement of the late sixties and seventies. His work continues the witty social commentary and renegade investigation that first brought him wide media attention during the seventies.

One Hand Shaking *1978*

In 1978 Lowell Darling ran for governor of the state of California. His campaign diary, published in 1980, claims "he found modern politicians too wishy-washy to portray, so decided to make himself the subject of a political portrait. Besides, he wanted to live in the governor's mansion. If he won, he planned to have Jerry Brown run the state." The candidate officially announced his intention to run and succeeded in having his name placed on the primary ballot against Jerry Brown. He took the project seriously and devoted to it the energy required of any campaign, touring the state, giving television, radio, and newspaper interviews, making appearances at parties and benefits, and holding press conferences. When asked at one press conference, "Why are you running?" he replied, "To understand a problem one must become part of the problem." Using an oversized hand on a stick to save his own grip and artificial lips worn on his hand for kissing babies, Darling "stumped the state for four months in his 1956 pink-and-black Plymouth, doing whatever it is politicians

One Hand Shaking *1978*
Lowell Darling

do." His list of the "Inevitable Campaign Slogans and Promises" included such items as "Ban 1984," "Replace Taxes with Incredible Good Luck," and "Wednesdays Off for Everybody." At the final tally, Lowell Darling received nearly two percent of the total vote, or sixty thousand votes.

SHEILA LEVRANT DE BRETTEVILLE Working for more than twenty years on the politics of boundaries, feminist graphic designer and public artist Sheila Levrant de Bretteville explores ways for the marginalized to make their way into the cultural mainstream. In 1971 she created the first Women's Design Program at the California Institute of the Arts in Valencia. Two years later she cofounded, with artist Judy Chicago and art historian Arlene Raven, the Woman's Building, a multifaceted facility that housed the Womanspace Gallery, the Feminist Studio Workshop, and various feminist organizations. In the late eighties, with historian Donna Graves and architectural theorist Deloris Hayden, she cofounded Power of Place, a small nonprofit corporation founded to sponsor public art, historic preservation, and urban design projects that make visible the contributions of different ethnic communities to the history of Los Angeles. De Bretteville is a leading theorist and practitioner of an activist women's culture, one that emphasizes ethnic and gender equality through rigorous public communication.

Pink *1973*
In art and design schools during the early seventies, when the color pink, traditionally associated with women, was considered regressively "feminine," de Bretteville handed out pieces of pink paper to women in Los Angeles—her own circle of friends as well as people on the street. She asked them to describe what pink meant to them. Assembling the responses, she created a poster with a number of squares left blank for audience comments. The original project, commissioned as part of an invitational exhibition at the Whitney Museum of American Art in New York on the subject of color, became the property of the Whitney. Meanwhile, de Bretteville made posters of the image and posted them all over Los Angeles, so that they became the property of everybody in the streets.

Biddy Mason—Time and Place *1991*
This permanent Los Angeles public artwork, sponsored by Power of Place, is an eight-by-eighty-two-foot sculpted timeline in a wall created to honor Grandma Mason, a former slave who became a midwife, a landowner, and a well-respected member of the Los Angeles community. Located at the site of Mason's original homestead, which si now adjacent to a downtown parking garage, the wall includes engraved squares of text and photographic images that trace Biddy

Biddy Mason—Time and Place *1991*
Sheila Levrant de Bretteville

217

Mason's life and the parallel history of the city of Los Angeles for eight decades (1820–1900). Neither politician, lawmaker, warrior, nor outlaw, Biddy Mason did not lead the kind of life that is typically immortalized in history textbooks. To learn more about her, a public history workshop was held that included historians, a screenwriter, and one of Biddy Mason's descendants. De Bretteville and collaborating artist Betye Saar brought proposals and maquettes to present their ideas and sought feedback from the workshop participants. At the meeting, the community pointed out that Biddy Mason's contribution as a founder of the African Methodist Episcopal Church, the first African American church in Los Angeles, should be added to the project. With this approach, de Bretteville equated the value of a city with the contribution made to that city by one person's life.

KATE ERICSON AND MEL ZIEGLER Kate Ericson and Mel Ziegler have been working together since they met in art school. Their public-directed projects actively engage people outside the art world, sometimes reaching them in their own homes. An individual or a family is related to the larger social fabric through public-scale works. Ericson and Ziegler draw lines down streets, paint houses, and move stones to mark physical arenas of inclusion and exclusion. They have deconstructed the ideas underlying house construction by writing relevant quotes on wood that was then sold to build an average home. In Durham, North Carolina, in *Loaded Text* (1989, see page 7), they provided full public disclosure of the city's revitalization plan by writing the complete text on a one-hundred-fifty-foot length of damaged downtown sidewalk. They then had the sidewalk broken up, repaired, and the concrete recycled as riprap in a nearby eroding streambed. For Chicago's Harold Washington Library Center, they created an elaborate word game, *Wall of Words* (1990), that is installed in the building's upper windows and changes with the active participation of librarians and community residents. Their work uses physical and architectural forms from both public and private life as well as research on housing and building materials to point to the intersection between personal and public.

Camouflaged History *1991*

At the Spoleto Festival USA in Charleston, South Carolina, Ericson and Ziegler drew attention to the gentrification that occurs when a district is designated historic. After working out their design collaboratively with the U.S. Army's camouflage team at nearby Fort Belvoir, the artists "disguised" a house just outside the edge of Charleston's historic district by painting it. The house was sited next to a line dividing historic and nonhistoric status. In this predominately black neighborhood, homeowners often found it difficult to

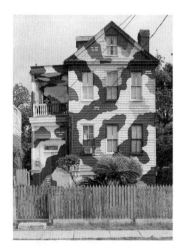

Camouflaged History *1991*
Kate Ericson and Mel Ziegler

afford repainting. Residents had turned down historic status to avoid being driven out of their neighborhood, a process that had happened to African Americans in other parts of the city where "preservation" campaigns had taken hold. After consultation with the homeowners, Ericson and Ziegler painted the house in a distinctive camouflage pattern using the colors stipulated for historic district houses. After the festival, the house was repainted to "fit in" with its neighbors, truly making it inconspicuous (that is, camouflaged from gentrification).

JOHN FEKNER Called "caption writer to the urban environment, adman for the opposition" by Lucy Lippard, street artist John Fekner has been involved in direct art interventions within New York City's decaying urban environment since the mid-seventies. His best-known guerrilla artworks are large, stenciled, politically critical, acerbic captions applied directly to tenement walls, abandoned automobiles, and blighted urban infrastructures. Although his basic intent is to address the local community, he first realized the stencils could have a wider impact when the word "Decay," painted on the crumbling Williamsburg and Queensborough bridges, drew mass media and city government attention. Newspapers widened the response with articles commenting on the sad condition of New York's infrastructure. Fekner's use of words on walls comes out of his love of poetry. He is interested in identifying situations that could be transformed or that already embody a form of local historical memory about a particular site. Fekner also constructs street sculptures—assemblages of found junk, often items that point out how technology has run amok. *Building Blocks of Life,* a 1985 mixed-media installation in an abandoned lot, consisted of seventeen broken television sets stacked on a pile of leaves, with letters stenciled on their screens reading "A B C D E F G H I J K L M N O T V."

Charlotte Street Stencils *1980*
Fekner spray-stenciled words onto the walls of gutted, ruined buildings in five different locations on Charlotte Street in the South Bronx. The stencils read "Broken Treaties," "Lost Hope," "Save our Schools," "Decay," *"Falsas Promesas,"* and "False Promises." People from the community were involved informally on an impromptu basis as they offered their opinions and street-side art direction. Some also helped Fekner spray-paint the graffiti late at night. The work took place during the People's Convention, in the summer of 1980, a national gathering of people from different backgrounds (including the local Latino and African American communities) planned to coincide with the Democratic National Convention. Fekner's work drew media attention and led to a South Bronx visit by then presidential hopeful Ronald Reagan, who was looking for a photo opportunity. Claiming

Charlotte Street Stencils *1980*
John Fekner

he would fix the buildings, Reagan was photographed standing in front of Fekner's *"Falsas Promesas"* sign. The now-famous image appeared on television, in the *New York Times,* and in the *Washington Post.*

Slow Down, Children Growing *1991*

This work was a guerrilla poster campaign staged by Fekner. He printed large yellow posters with stenciled letters reading "Slow Down" on top, and "Children Growing" below; in the middle of the poster is the image of a child's running silhouette being chased by a large computer disk. The posters were pasted on neighborhood walls alongside the regular commercial and political announcements. At first the poster appears ordinary and benign; it takes a second reading to question the harm the computer disk may cause the child. Fekner intends to critique runaway technology, working as he does on the streets of New York City, and seeing the surrounding evidence of industrial and commercial waste. His posters question the uncritical acceptance of technology as inherently good for children.

CHERI GAULKE An educator and a feminist performance and video artist, Cheri Gaulke offered her first socially interactive performance in a small-town square in Scotland in 1974. She moved to Los Angeles in 1975 to study performance at the Feminist Studio Workshop at the Woman's Building, where she later taught. Her explorations of gender issues included women's sexuality, domestic violence, and women's spirituality. Gaulke cofounded two successive activist performance groups, the Feminist Art Workers (1976–80) and the Sisters of Survival (1982–85), with Jerri Allyn, Nancy Angelo, Anne Gauldin, and Sue Maberry. From 1985 to 1990 Gaulke worked on a series of community projects with nonartists to develop postcards and bus posters celebrating women's achievements. Since 1989 she has been working on video projects with at-risk teenagers, and she is currently designing a mass transit station in Los Angeles.

The Feminist Art Workers *1976–80*
Cheri Gaulke

The Feminist Art Workers *1976–80*

Founded in 1976 by Cheri Gaulke, Nancy Angelo, Candace Compton, and Laurel Klick, and later joined by Vanalyn Green, this collaborative performance group grew out of the artists' experiences at the Woman's Building, where feminist theory was combined with art, education, and activism. The group toured the Midwest twice and traveled to New York, Las Vegas, and San Francisco, offering performances and workshops at women's conventions and exhibitions. A precursor of groups like Carnival Knowledge and the Women's Artist Coalition (WAC) in New York, the Feminist Art Workers addressed gender issues including economics, work, violence against women, history, religion, and women's culture. Their name emphasized the contributions artists might make as "workers" within the social structure, and was part of a conscious political agenda to demythologize

and reinvigorate artists' roles. Their work included *Bill of Rites,* a performance in New Orleans supporting the passage of the Equal Rights Amendment, and *This Ain't No Heavy Breathing,* on obscene phone calls to women.

L.A. River Project *1989–92*

For three years Gaulke worked with teenagers and their teachers at Wilson High School in East Los Angeles as part of an innovative approach to interdisciplinary education called the Humanitas Program. As Gaulke helped students produce their own video programs, they also learned how to use video as a form of documentation and art, integrating history, literature, politics, and natural science in their work. Their piece, *L.A. River Project,* a twelve-monitor video "river" installed on the floor, shows different ecological and social aspects of the river. It became part of the nationally touring environmental exhibition *Fragile Ecologies,* sponsored by the Queens Museum of Art, New York. The students also produced an eight-monitor installation called *El Sereno Serenade,* about the East Los Angeles community, and award-winning commercials on AIDS awareness and environmental pollution. The program's effectiveness was rooted in its success in linking environmental and social problems directly to students' lives by using education, technology, and art.

L.A. River Project *1989–92*
Cheri Gaulke, with Susan Barron, Jose Esquivel, Leonard Martinez, Manuel Ortega, and Susan Boyle

GUILLERMO GÓMEZ-PEÑA Born in Mexico and educated there as well as at the California Institute of the Arts in Valencia, Gómez-Peña writes, directs, and performs social commentary on the issues of race, class, and international cultures. He began exploring the metaphor of borders, with a focus on the border between the United States and Mexico, but soon explored the borders, physical and metaphoric, between any two cultures where one is in a position of power and the other is not. He alternates between highly theatrical and political performances; flamboyant, acerbic bilingual writing to which he adds his own invented language (a Spanish-English hybrid called "Spanglish") interactive public installations; and video and CD-ROM publications. Gómez-Peña was a cofounder, writer, performer, and instrumental member of two dynamic, politically active collaborative groups: Poyesis Genetica from 1981 to 1985, and in San Diego, the Border Art Workshop/Taller de Arte Fronterizo from 1984 to 1989. A recipient of a MacArthur Fellowship, Gómez-Peña travels internationally to present art about current social crises (racism, sexism, homelessness, xenophobia, and AIDS) and contemporary forms of colonization.

Poyesis Genetica *1981–85*

Gómez-Peña calls Poyesis Genetica a "neotribalist" performance troupe. He and choreographer Sara-Jo Berman cofounded it in 1981

with a fluctuating core of eight to ten artists who met while they were students at the California Institute of the Arts. A distinguishing mark of the group was its broad mix of disciplines and ethnic backgrounds. Gómez-Peña writes: "Perhaps the only thing we had in common was our willingness to step outside of our cultures and to experiment. In a sense we were a bunch of rejects of monoculture." The group developed a performance style that combined "Mexican *carpa* [a tradition of urban popular theater], magical realism, kabuki, and U.S. multimedia." It was Gómez-Peña's "first conscious attempt to make art in a culturally pluralistic, collaborative, and interdisciplinary mode. . . . Though the scripts were written by me, the images and movement were conceived collectively through long discussions that would often take place in more than three languages." Dismantling and regrouping several times—including a year touring the streets and alternative spaces of Europe—Poyesis moved with Gómez-Peña and Berman to the San Diego–Tijuana border in 1983. There they discovered an ideal venue for exploring the politics of culture. New collaborators included Luke Theodore Morrison, formerly of the Living Theater, Chicana performance artist Yareli Arismendi, and Mexican journalist Marco Vinicio González, subdirector of the Casa de la Cultura (then the largest alternative space near the border). In 1985 the last Poyesis group disbanded, with Gómez-Peña and Berman blending into the newly cofounded Border Art Workshop/Taller de Arte Fronterizo.

The Year of the White Bear (Two Undiscovered Amerindians Visit Madrid) *1992*
Guillermo Gómez-Peña and
Coco Fusco

The Year of the White Bear (Two Undiscovered Amerindians Visit Madrid) *1992*

In a collaboration with Coco Fusco, Gómez-Peña lived for three days in a gilded cage on a central plaza in Madrid, Spain. On display as "Amerindians," with "cultural" costumes and props such as a laptop computer, television, and kitchen table, they performed "authentic and traditional" tasks before a random street audience. Passersby could observe them writing on the laptop computer, watching television, sewing voodoo dolls, and doing physical exercises. They were hand-fed across the bars and taken to the nearest bathroom on a leash. Interested audience members could pay for authentic dances, stories, and Polaroid photographs of the artists who posed with them. This performance parodied the way conquered peoples were brought back to Spain and put on display by "explorers," commenting upon that year's quincentennial Christopher Columbus celebrations. More than half the viewers confused the social commentary art performance with a "science" exhibit in Madrid. This work was re-created in various countries and contexts over the next two years, including a performance at Chicago's Field Museum of Natural History.

BOLEK GRECZYNSKI Bolek Greczynski graduated from the Academy of Fine Arts in Crakow, Poland, in 1975. He associated with Wprost—a group of political artists with a strong base in expressionistic painting—and began doing a series of site-specific and street works. For seven years he

worked with the Polish avant-garde Theatre STU, an important and popular young group from the seventies that merged political subjects with romantic traditions, performing in a circus tent. In 1976 he opened Gallery STU, which combined visual art shows with sociology, politics, and theater. He came to the United States in 1978 and received an M.F.A. from Columbia University in 1982. In this country, Greczynski works with nontraditional formats in nonconventional spaces to engage people who may never visit an art gallery.

The Living Museum *1983–continuing*

At the Creedmoor Psychiatric Center in Queens, New York, *The Living Museum* is a forty-thousand-square-foot chain of installations created in collaboration with one hundred resident artist/patients of a state mental institution. Invited on staff as an artist-in-residence, Greczynski insists his work is not "art therapy" but a collaboration with other artists, all of whom happen to be patients at Creedmoor. He and the patients have turned an abandoned building into a true museum of life—a working studio and an installation gallery for residents' paintings, sculptures, poetry, and performances. The permanent but constantly evolving exhibit is entitled *Battlefields,* suggesting the psychic and institutional contentiousness of the spaces these artists inhabit. The installation is structured around four corner rooms representing home, hospital, church, and workplace. In addition to this continuing display, *The Living Museum* creates exhibits for the world outside of the hospital. After being exhibited, the artwork is never sold but is brought back to Creedmoor. Greczynski has written: "Art happens where the energy for art is present. And here art means the urgency to communicate, the need to express, [and] the confrontation of problems and surroundings in an immediate way. *The Living Museum* has become a place to study, to experiment; a place which allows one to manipulate the environment and then analyze the changing effects."

The Living Museum *1983–continuing*
Bolek Greczynski

GROUP MATERIAL Group Material is a New York City–based collaborative team that has been working continuously since 1979. Tim Rollins was instrumental in cofounding the original group of twelve artists. Since then it has been principally the work of Julie Ault, Doug Ashford, and Felix Gonzalez-Torres, with participation by others (such as Karen Ramspacher) from time to time. Working with the expressed goal of including diverse groups and circumventing the elitism historically associated with curating, Group Material organizes thematic exhibitions inside and outside of traditional art institutions. Ashford has written: "Often the social purpose of a particular artwork has been clouded by the way it gets seen within the [art] market and the museum. The juxtaposition with other practices, some not even by artists, shows that art

has other possible functions and readings." The group's exhibitions include eclectic, pointed mixes of well-known and unknown artists, artwork displayed with everyday objects such as washing machines and Coke cans, and art that incorporates texts and commercial advertising to deconstruct museum displays and present political information.

People's Choice *1979*

With a stated philosophy that "presentation and selection of art was as important as production," Group Material opened their own storefront alternative gallery in a primarily Latino section of the Lower East Side, predating other galleries that came with later gentrification. Their leaflet read: "Group Material will be directly involved in the life of our neighborhood . . . [including] housing, education, sanitation, community organizing, and recreation." For their first exhibition, initially called *People's Choice* and later renamed *Arroz con Mango,* they went door to door, inviting local residents to contribute "precious" objects displayed in their own homes that they felt represented cultural values. The resulting collection included religious icons, souvenir calendars, sports posters, a carved bowl, family mementos and photographs, and even "real" art. The democratic presentation of objects was an essential component of the exhibition. The neighborhood came en masse to view the show and celebrate the opening.

AIDS Timeline *1989*

AIDS Timeline *1989*
Group Material

At the University Art Museum, Berkeley, California, Group Material members Ault, Ashford, Gonzalez-Torres, and Ramspacher chronologically organized an exhibition on the AIDS crisis. They created a timeline from 1979 to 1989 that ran along the museum walls. Along the timeline they installed medical, social, and personal histories accompanied by objects, artifacts, artworks, and advertisements. Magazine articles and activist posters showed simultaneously occurring historical, cultural, and social events. The group used pushpins, masking tape, and paste to install the work, maintaining a rudimentary classroom history-project look that was inspired by the adjacent university campus. Outside the museum, the wall facing the street sidewalk was covered with ten blue-and-gold panels (the school colors) with responses from students and locals who were asked, "How does AIDS affect you and your lifestyle?" and "How do you see the future in terms of AIDS?" Local AIDS activists, artists, and victims were contacted well in advance of the exhibition so that they could collaborate by contributing objects, artworks, and information. This important facet of the exhibition both validated and supported local AIDS organizing efforts and "personalized" their material for the audience.

GUERRILLA GIRLS Billing themselves as "the conscience of the art world," the Guerrilla Girls were founded in

1985 as an anonymous group of feminist artists, art critics, and provocateurs. They perform public political actions while wearing gorilla costumes to protect their individual identities. Their political actions and the posters and press releases they broadly disseminate are meant to "combat sexism and racism in the art world." The posters are bold texts designed like advertising slogans on billboards—the language is pointed, humorous, and satirical. Copied as flyers, they inexpensively reach a wide grass-roots population, which in turn is encouraged to recopy flyers for distribution to an even larger, more diverse audience. One representative poster reads: "When racism and sexism are no longer fashionable, what will your art collection be worth?" While the original group is still based in New York City, independent chapters have formed in several cities, creating a loose federation that can disseminate materials in response to national and local issues.

The Banana Report: The Guerrilla Girls Review the Whitney *1987*
Exhibited in the Clocktower at the Institute for Contemporary Art's public gallery in the TriBeCa area of Manhattan, this installation featured an analysis of recent curatorial and acquisition practices of the Whitney Museum of American Art. Included were statistics, texts, and billboard art. One text read: "Can you score better than The Whitney Curators? Biennial Record, 1972–1987: 71.29% White Men; 24.31% White Women; 4.10% Non-white Men; 0.30% Non-white Women." Subsequently a poster/flyer campaign (1988) listed the thirteen advantages of being a woman artist, including: "working without the pressure of success," "Not having to be in shows with men," "Being reassured that whatever kind of art you make it will be labeled feminine," and "Not being stuck in a tenured teaching position." Later campaigns included social commentaries on homeless women, the Anita Hill/Clarence Thomas hearings, and the Los Angeles insurrection. One example is "Guerrilla Girls Social Studies Quiz: How long did it take to loot South Central L.A.? A. 81 seconds (length of videotaped beating of Rodney King); B. 72 hours (length of L.A. riots); C. 12 years (length of Reagan-Bush administration)."

The Banana Report: The Guerrilla Girls Review the Whitney *1987*
Guerrilla Girls

HANS HAACKE West German–born conceptual artist Hans Haacke incorporated physical processes of change and renewal in his early work in the sixties. Haacke was one of the first contemporary artists (along with Joseph Beuys, Helen Mayer Harrison and Newton Harrison, and Alan Sonfist) to focus on natural and biological systems. In 1966 he grew grass in a Manhattan gallery, and, in 1969, inside Cornell University's museum, he seeded a mound of earth, calling it *Grass Grows*. Haacke believes that most art exists in "mythical time," an ideal historical time separated from daily life. In contrast, he considers his work to take place in "real time"—a computer

term that he uses to signify the "real world" time of politics, money making, ecology, industry, and other life activities. Since the seventies he has made works using research data, statistics, photographs, advertisements, and quoted texts to investigate social systems—for example, how museums and other cultural institutions are financially dependent on powerful corporations that exploit Third World countries. His controversial works include analyses so thorough and pointed that he frequently encounters the ire and occasionally the repressive responses of the corporations and institutions he critiques.

Shapolsky et al. Manhattan Real Estate Holdings, Real-Time Social System *1971*
Hans Haacke

Shapolsky et al. Manhattan Real Estate Holdings, Real-Time Social System *1971*

Following an invitation to exhibit at the Solomon R. Guggenheim Museum, Haacke began to investigate the museum board members' real estate holdings and discovered they owned at least 142 slum properties. He created a documentary-style installation of black and white photographs—street-front images of decaying buildings accompanied by text tracing their acquisition, sale, assessed values, and mortgage lenders—and pinpointed the properties on a map of New York City. When he realized the nature of the artwork, six weeks before the scheduled opening, Guggenheim Museum director Thomas Messer canceled Haacke's solo exhibition and fired its curator, justifying the cancellation by stating that the work breached the museum's nonpartisan stance as a public educational institution. The show was subsequently exhibited at the New York Cultural Center and in Milan, Italy.

Helmsboro Country *1990*
Hans Haacke

Helmsboro Country *1990*

A six-foot-long pop-style cigarette box, open on its back with a half-dozen six-foot-long cigarettes spilling aggressively onto the floor, was the central image for Haacke's exhibition at New York's John Weber Gallery. The distinctive red and white graphics on the cigarette box mimicked those of the Philip Morris Company's Marlboro cigarettes, and the title is a pun on their advertising campaign, "Come to Marlboro Country." Humorous in appearance, the work is a well-researched critique of the complex relationship between the Philip Morris Company's funding of art exhibitions (at the Museum of Modern Art and the Metropolitan Museum, among others), its advertising campaign that distributes thousands of copies of a Bill of Rights (the "right to smoke"), and its contribution ($200,000 in 1988) to the ultraconservative political organization of Jesse Helms, who vociferously opposed federal funding for the arts. The Surgeon General's Warning on Haacke's cigarette box is replaced by Helms's homophobic statements and a Philip Morris Company executive's comment: "Our fundamental interest in the arts is self-interest." Two Haacke collages, *Cowboy with Cigarette* (1990) and *Violin and Cigarette: Picasso and Braque* (1990), were based on famous works that were part of a 1989 Museum of Modern Art exhibition of cubist art

funded by Philip Morris. Haacke's collages used newspaper clippings on the corporate economic benefits of arts funding, and the skyrocketing public cost of caring for American smokers' health problems. *Helmsboro Country* received extensive newspaper coverage, sparking an independent newspaper exposé by the Raleigh *News and Observer* that linked the powerful Jesse Helms Citizenship Center in Wingate, North Carolina, to special corporate lobbying interests.

DEEDEE HALLECK DeeDee Halleck is an independent media producer, film and video director, and community activist. Educated in Chattanooga, Tennessee, she received a political education at the Highlander Folk School's leadership training workshops. Halleck also studied art at the Brooklyn Museum Art School and at Pratt Institute. In the early seventies, she joined video pioneers in using Sony's first portable video cameras, and, later, with a New York City video collective, she created five nights of unconventional live coverage at the 1976 Democratic National Convention for cable television. Halleck became the president of the Association of Independent Video and Filmmakers in 1978 and continues to be a leader in alternative media. A longtime advocate of media democracy, Halleck wants to know why "the left [can't] get itself a round-the-clock, round-the-world satellite TV channel? . . . Aren't there enough believers out there hungry for a left counterspin on the corporate news product that pours from the idiot box?"

Paper Tiger Television *1981–continuing*
Skeptical that independent producers would ever get their share of funds or airtime from PBS, DeeDee Halleck shifted her efforts to public-access programming on local cable television. She started Paper Tiger Television, a nonprofit collective of some thirty Manhattan-based media artists and activists. Designed to "demystify the information industry by investigation into the corporate structures of the media and critical analysis of their content," Paper Tiger's "readings" (a friendly term for detailed analysis and dissection of a magazine or news program) explore the links between the media's producers, audience, and sponsors. Each Paper Tiger video features a writer, teacher, artist, or media critic familiar with the style, message, and history of a particular show or publication. These "hosts" give informal analyses, often with humor and always with their unique personal style (for example, Martha Rosler reads *Vogue* or Joan Braderman reads the *National Enquirer*). Crewed by volunteers, the program's handmade look is peppered with technical "transgressions" such as shots of the production crew, cartoonlike backdrops, and hand-held graphics; actual production budgets are revealed in the final credits. Recent shows deal with immediate political controversies and feature participants in social struggles such as labor strikes

Paper Tiger Television
("TV Turn-On," 1990)
1981–continuing
DeeDee Halleck

and abortion rights battles, all the while focusing on how media representations do not reflect the realities of life for most people today. Paper Tiger spawned Deep Dish Television, the national network for access and alternative programming.

ANNA HALPRIN A pioneer in the field of dance, Anna Halprin stands out from scores of other concerned artists in the scope of her personal vision and the scale of her works. She brings together enormous audiences of strangers and persuades them to collaborate in dances to heal themselves and the world. In the fifties in San Francisco, Halprin abandoned current styles in dance and instead began to investigate its roots in movement and the creative process. She attracted a diverse group of like-minded people working in theater, music, literature, psychology, education and health. In 1959 she founded the Dancers' Workshop, dedicated to performances that wed individual process, group interactions, and diverse value systems and skills. In the sixties she sought to extend the dancers' experience to include audience participation events ("happenings") that took place at bus stops, busy streets, beaches, prisons, churches—any place other than a theater. When she developed cancer in 1973, she used movement to cope with her fear and later, in remission, she shared her work with cancer patients at Menlo Park's Creighten Institute. Pursuing her investigation of illness and healing, Halprin formed a theater company of HIV-positive performers.

Ceremony of Us *1969*
Anna Halprin

Ceremony of Us *1969*
After the Watts riots in Los Angeles in 1965, Halprin taught for a year at Studio Watts, where this work was collectively evolved by young blacks living in the neighborhood and visiting young whites from the San Francisco–based Dancers' Workshop company. The audience for the performance experienced their own positions on and discomfort with racial issues as they were given a choice of entering one door with the all-black group, or another door with the all-white group. At the end of the performance, in a collective wave of feeling against polarization, the audience responded by spontaneously forming a united procession and dancing together.

Circle the Earth *1981–continuing*
Subtitled *Dancing with Life on the Line,* Halprin and HIV-positive performers in great numbers dance with, for, and about those who have ARC or AIDS. The work is a large-scale dance ritual for over one hundred dancers and nondancers and addresses personal, communal, and global issues. According to Halprin, it is "based on the commonality of the movement experience, the potential of dance to heal, the generation of community as a resource for our survival, and the power of personal stories to forge a collective experience."

Halprin and various members of her troupe travel around the world with this work, performing with local people and tailoring the issues to cultural specifics.

Circle the Earth *1981–continuing*
Anna Halprin

ANN HAMILTON Installation artist Ann Hamilton creates art that is so labor-intensive that she cannot do it alone. Knowing that many others work with her is intrinsic to understanding her overall body of work. In the beginning she relied on a core group of friends, artists, and others, but her work has grown to involve many people who live in the communities where the projects are sited. Relevant to the appreciation of her art is her frequent exploration of the history of the American labor movement, or rather the absence, in history books, of stories of those men and women who toil repetitively with their hands. Curator Mary Jane Jacob wrote: "Other hands always join in for Hamilton's projects . . . in which they have a real place and find a sense of purpose. The bond created with these participants extends to the value of laboring together. . . . The value of manual labor is intrinsic to her art; this aspect often lives on in the form of a person who occupies and tends the piece." Hamilton, a MacArthur Award recipient, has an exquisite visual sensibility that is reflected with great presence and power in works exhibited in museums or in specific sites under the auspices of museums or galleries.

indigo blue *1991*
At the Spoleto Festival USA in Charleston, South Carolina, in an abandoned automotive repair shop, Hamilton continued her investigation of American labor history. This work was inspired by the site itself—a "blue collar" workplace—and by Charleston's historic link to the manufacture of indigo blue dye, introduced there in 1744 and grown by plantation slaves. In the garage's center, Hamilton loaded a platform with fourteen thousand pounds of laborers' clothing: forty-eight thousand blue pants and shirts, folded and stacked with evident care, layer upon layer and side by side. Someone (often Hamilton) sat for hours each day at a desk behind the shirts, silently erasing pages of old logbooks, suggesting that space could be created for frequently omitted working-class people's histories. The sheer quantity and physical weight of the shirts stood as an overwhelming physical tribute to those who work manually and repetitively.

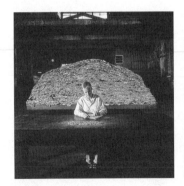

indigo blue *1991*
Ann Hamilton

DAVID HAMMONS Maverick sculptor David Hammons began making his art on the streets of Harlem with materials found there, such as bottles, bottlecaps, and hair. He was first known for his guerrilla-type architectural bricolages, street sculptures, and actions that engaged passersby. Artist-writer Seitu Jones has compared Hammons (whose work combines "equal doses of humor, social commentary and charm") to

229

Eshu-Elegba, the imaginative, unpredictable, and mischievous trickster god from Yoruba mythology. Jones writes: "Hammons is steeped enough in African-American culture and life outside the studio to be able to make critical analyses and comments on day-to-day life. He does this not only by challenging Western perceptions of what art is, but by challenging many of our own aspirations and dreams." In a billboard installed for the Washington Project for the Arts, in Washington, D.C., Hammons depicted a blonde-haired blue-eyed Jesse Jackson with text that read, "How ya like me now?" Irate black citizens from the neighborhood tore it down, responding to the double-edged irony. Hammons, a recent MacArthur Fellow, continues his site-specific installations and museum exhibitions with witty and pointed commentary on the African American experience.

Higher Goals *1983, 1986, 1988*

A basketball hoop installed atop a fifty-five-foot-tall telephone pole in a vacant Harlem lot was Hammons's comment on young black men's precarious and often misplaced desire to become basketball stars. His second version of the work, in Columbus Park, Brooklyn, in 1986, included five telephone poles covered with bottle caps and topped with hoops. A 1988 version was cut down anonymously.

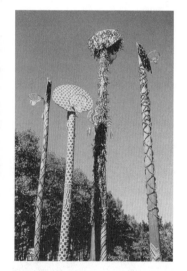

Higher Goals *1986*
David Hammons

American Street/House of the Future *1991*

For the Spoleto Festival USA in Charleston, South Carolina, Hammons collaborated with a local builder to construct a narrow house (the width of a single door), which the locals dubbed the "House of the Future." The house was built as an educational project on construction materials and methods, and after it was completed, Hammons used it as a place to meet and talk with neighborhood people. A young unemployed man with artistic ambitions was invited to use the *House of the Future* as a studio and gallery to display paintings. In a neglected lot adjacent to the house, Hammons exchanged the billboard advertisement overlooking the lot for a photo of local children looking up at Hammons's version of the stars and stripes in red, black, and green installed on a nearby building. The site will be maintained permanently for the neighborhood.

American Street/House of the Future
1991
David Hammons

JO HANSON Since 1970 Jo Hanson has focused on the environment and human behavior relative to it. Her work grew out of a close scrutiny of the ongoing activities of her own life as they intersected with the public aspects of her neighbors' lives. For more than twenty years she swept the sidewalks in front of her San Francisco house, collecting and using the litter as a source of art and social-historical commentary and as a catalyst for community organizing. She framed this sweeping activity as both performance and political action. Her audience

is the general public, whom she reaches through grass-roots but sophisticated media campaigns and by siting her work in public spaces, including sidewalks, schools, churches, and City Hall. Her daily life/art activities have included "farming" garden snails and developing interfaces between artists, sanitation administrators and workers, and civic leaders.

Public Disclosure: Secrets from the Street *1980*

In the San Francisco City Hall, Hanson designed an exhibit as an anti-litter campaign and a public appreciation of those who clean city streets. On display was a ten-year accumulation of material that Hanson had collected through her street-sweeping actions, dated and bound in plastic covers to preserve it as an "archaeological" find. Her neighbors came to view themselves in a slide presentation that showcased their efforts to clean up their own community. Across the street from City Hall, the San Francisco Museum of Modern Art installed a companion exhibition of artists' videotapes on trash, solicited by Hanson, along with more found-object street sweepings. A media campaign was intrinsic to the project, as were her negotiations with community groups and municipal agencies and staff. In one example, a community cleanup day was designated by the mayor, and politicians showed up to support the community members' efforts.

Public Disclosure: Secrets from the Street *1980*
Jo Hanson

Sanitary Fill Company's Artist-in-Residence Program *1990–continuing*

Hanson conceived of, designed, developed, and continues as consultant to a rotating artist-in-residence program at San Francisco's waste collection agency. The program, modeled after Hanson's earlier work, uses art to promote public awareness of environmental issues. Three artists per year are chosen to work in a studio on-site at the company's waste transfer station to create art from the twenty-five tons of materials that San Franciscans throw out daily. Some artists extend the residency by collaborating with schools and other community groups. Interaction with on-site workers is an important component of the program. Community outreach involves an extensive media strategy as well as collaboration with schools, youth agencies, and environmentally concerned organizations; exhibitions in art and nonart spaces; and material assistance to artists and agencies outside the program for environmentally oriented, publicly accessible artwork. The program is a prototype for the waste industry and for successful collaboration among artists, industry, and civic organizations.

HELEN MAYER HARRISON AND NEWTON HARRISON
Helen Mayer Harrison and Newton Harrison are early pioneers of an ecological art that is conceptual, sculptural, site-specific, and interactive. Collaborating since 1970, the Harrisons have made artwork as an ongoing and inseparable conversation between each other, the environment, and the community. Their work includes written texts of their conversations, performance, photography, drawings, mapmaking,

installations, and actual modification of the landscapes that are the subject of their projects. Throughout the early seventies, the Harrisons produced a series of artworks that were also recognized as scientific experiments exploring the development of alternative food sources. Each of their projects, staged as metaconversations, leads to others; works involving brine shrimp and Sri Lankan crabs led to explorations of water in lagoons from California to Sri Lanka. Rebecca Solnit writes: "While they are usually thought of as public artists or site artists whose work is a prelude to massive landscape projects, the Harrisons themselves seem to have a more subtle vision of their effectiveness, recognizing that no investigation is ever closed, and that the impact of any action or intervention is impossible to measure, and that the landscape of the communal imagination is as much the territory in which they operate as is the natural world."

The Lagoon Cycle *1970–83*

The Lagoon Cycle is a pictorial and poetic installation that represents the Harrisons' research and journey into the meaning of water in various cultures. Issues ranging from ecological to economic are staged within the metaphor of conversations between "the witness" and "the lagoon keeper," and within the paradigm of proposals for public works. As the narrative progresses in this many-year project, the two report with the logic of a scientist and a businessman. They move to wider fields of inquiry, to the prehistory of water in the southwestern United States, the possibility of transforming the Salton Sea (in Southern California) into a huge lagoon for crab raising, and finally to the consideration of the whole globe as an ecosystem. Rising to a crescendo of expansive possibility, the narrative finally collapses as the lagoon keeper and the witness abandon the course of increasing management of the natural world in favor of contemplation. This project exists, metaphorically and educationally, on a grand scale but is invisible in the actual environment, existing instead as possibility.

Breathing Space for the Sava River, Yugoslavia *1988–90*
Helen Mayer Harrison and Newton Harrison

Breathing Space for the Sava River, Yugoslavia *1988–90*

In 1988 the Harrisons were invited to look at one of Europe's last great floodplains, the Sava River ecosystem, in what was then Yugoslavia. Running through Slovenia, Croatia, and Serbia, the Sava River is rich with plant and animal life and places where farmers still practice sustainable farming. However, the long-term effects of industrial development, irrigation, and flood control measures have taken their toll on the river's system, overburdening it with sewage and chemical waste and destroying its wildlife. Working with botanist Hartmut Ern and ornithologist Martin Schneider-Jacoby, the Harrisons traveled the length of the river, talking to those who depend upon it: farmers, factory workers, business people, engineers, environmentalists, and regional bureaucrats. Treating the river as one extended,

interdependent ecosystem, the Harrisons proposed creating a corridor of unpolluted land along its entire length, introducing wetland plants in adjacent swamps and ponds to absorb pollutants naturally, promoting organic farming along the river's edge to eliminate chemical fertilizer runoff, and even raising warm-water fish in water released for cooling from a nuclear power plant. The proposal was exhibited as 125 running feet of color photo-collages and text discussing the river's plight and the potential for healing it. The plans were seen and approved by the Croatian Department of the Environment, with the World Bank expressing an interest in financing it, but the civil war that broke out in the area in 1991 has put the project on indefinite hold.

MARGARET HARRISON Born in Yorkshire, England, Margaret Harrison was trained as an abstract painter in London and Italy. She came of age during the years of pop, minimal, and conceptual work. A central figure in the British feminist art movement, Harrison helped form the first Women's Liberation Art Group in London in 1970. A 1971 display of her drawings was the first solo feminist exhibition in London; it was shut down by police because of "offensive" material—a drawing of *Playboy*'s Hugh Hefner depicted as a "Bunny girl" with a "Bunny penis." In 1972 Harrison joined the Artists' Union of Great Britain, leading the organization to adopt the goal of ending discrimination in the arts. She helped form the Women's Art History Group and the Women Artists' Slide Library—Britain's largest and most significant archive of historical and contemporary material on women artists and publisher of *Women's Art Magazine.* Named after Virginia Woolf's statement, her 1977 painting *Anonymous Was a Woman: From Rosa Luxemburg to Janis Joplin* has become a feminist art history icon. Below the stenciled quote are portraits of eight famous women who suffered for *not* being anonymous, most dying a violent death. A major theme in Harrison's work is the excavation of the work of women formerly lost to history. Her work on Dorothy Wordsworth (the diarist sister of poet William) and Mary Wollstonecraft Shelley (author of *Frankenstein*) reports on the hidden influence of women's creativity and the collective nature of art.

Homeworkers *1978*
In this multimedia, documentary-style installation, Harrison combined painting on canvas with fragments of text, newspaper and magazine articles, photographs, and found objects. The fragmented format relates to the fragmented nature of the women's lives depicted. Harrison discovered the plight of homeworkers while doing an earlier work with women in factories. As the recession deepened, women were disappearing from the recognized work force. Harrison

Homeworkers *1978*
Margaret Harrison

realized that they had to still be working somewhere. *Homeworkers* documents the economic exploitation of people who do piecework at home (ninety-nine percent of whom are women) for industries that are not legally required to pay minimum wage or cover health benefits. The women live at a subsistence level, paying the overhead that should be borne by the industries. Harrison's work, requiring extensive research and interviews, led to efforts to organize these workers. This installation, first exhibited at the Battersea Arts Centre, in a district where vast numbers of women do cottage industry work, was later shown in other contexts such as the General Municipal Workers National Conference. Revealing the "invisible structures of exploitation," Harrison presents complex ideas in an accessible, nondogmatic form that communicates the need for social reconstruction.

Common Land/Greenham *1989*
Margaret Harrison

Common Land/Greenham *1989*

This installation at the New Museum of Contemporary Art in New York City told the story of the ongoing attempt to close down a cruise missile site outside of London by masses of ordinary people. Greenham Common Air Force Base was bought in 1951 by the Ministry of Defense, against the wishes of the local community, and leased to the American military. The Greenham Common movement began when a small group of women was arrested for trespassing. Arguing that as commoners they had long-established rights to use the land, mothers, children, and grandmothers became politicized and have become the pillars of an international peace movement. Harrison developed a relationship with a core group of people during her stay there. Her installation replicated a 1982 demonstration. A wire fence topped with barbed wire was hung with objects symbolizing the demonstrators' values—pots and pans, clothes, snapshots, a shopping cart, baby clothes, and toys. A grid of quotations was inscribed on the gallery wall, representing the tens of thousands of women who have come to protest and the twenty-five women who had been encamped at the base for the previous eight years.

HACHIVI EDGAR HEAP OF BIRDS Based in Oklahoma, conceptual artist Hachivi Edgar Heap of Birds uses the English language to challenge stereotypes about Native American history and culture. After studying, traveling, and living in Philadelphia, London, and continental Europe, Heap of Birds returned to the Cheyenne-Arapaho Reservation to experience his own culture. He describes his work as falling into four distinct categories: public art, most often using text, that deals with politics and his understanding of history; articles, "which deal with global issues like the rain forest and its link to the Third World debt via Wall Street"; drawings with text, called *Wall Lyrics*, which "reveal something about myself, my values, and my sexuality"; and paintings that "are so personal that they almost go back to the ceremonial. I can call them abstract, but an old lady once called them spirits." Heap of Birds

writes: "Describing my work in four different ways makes it an elusive target. Often it's hard for critics to understand how my descriptions fit into Native American art or mainstream American Art. My work tends to make you ask questions: What is this? What are we doing? What is history? What is my perception of a Native American person? What's America?"

Don't Want Indians *1984*

This text/painting/broadside begins with the word "Natural" on top, which has been reversed, in mirror-image, a device to force the viewer to think about direction and misappropriation of words. The middle text reads: "We Don't Want Indians Just Their Names Mascots Machines Cities Products Buildings." Enlarged letters at the bottom read: "Living People." This work is a precursor of many by Heap of Birds in which the white population is admonished for its misuse, misspelling, and blatant appropriation of Native Indian tribal names for commercial products, places, and sports teams (e.g., the Jeep Cherokee), forgetting that these names are taken from "living people" without permission or regard for their well-being. In a later use of mirrored text, *Native Hosts* (1988), Heap of Birds installed six commercially printed signs in New York City parks reminding the city's current residents that they are guests of people whose land they occupy—the Shinnecock, Seneca, Tuscarora, Mohawk, Wepoe, and Manhattan tribes. Each sign begins with a mirror image text of "New York," followed by a middle text of "Today Your Host Is"; the final line is one of the above Native American tribal names.

Building Minnesota *1990*

Commissioned by the Walker Art Center in Minneapolis, this work takes the form of forty commercially printed signs resembling typical city signage, posted in a long line following the banks of the Mississippi River. Each sign bears a different man's name, but the rest of the text is similar: "HONOR Nappe'psni Fearless DEATH BY HANGING Dec. 26, 1862, MANKATO, MN—EXECUTION ORDER ISSUED BY PRESIDENT OF THE UNITED STATES ABRAHAM LINCOLN." The text remembers forty Dakota men executed for their role in the 1882 U.S.-Dakota conflict fought on nearby riverbanks. Historical accounts cast the dead as villains; Heap of Birds commemorates them as war victims. Today this area is bordered by the looming structures of industries that have harnessed the Mississippi River. This, for Heap of Birds, is also lamentable. Curator Joan Rothfuss writes: "His choice of this site relates the events of 1862 to the complex economic and cultural history of this country. The execution of forty men 128 years ago is linked to Native peoples' ongoing struggle for land rights, and thus to a respect for the earth that is traditional in Native culture. He implies that unless our society develops an attitude of respect for the earth, his sculpture may be read as an obituary not only for forty Dakota men, but also for the land that nourishes us all."

Building Minnesota *1990*
Hachivi Edgar Heap of Birds

SUZANNE HELLMUTH AND JOCK REYNOLDS

Collaborators since 1975, Suzanne Hellmuth and Jock Reynolds create site-specific performances and installations of photographs and objects that link community values and identity with specific sites. Currently living and working in Massachusetts, they met in San Francisco, where Hellmuth was a founding member and codirector of Motion (1970–76), a performance collective with Nina Wise and Joya Cory (who had met at Anna Halprin's Dancers' Workshop). In the mid-seventies, Motion was a highly experimental blend of theater and performance art known for its presentations in theaters, parks, homes, churches, streets, and museums. Reynolds, then a sculptor, collaborated on specific projects with installations and stage design. Both Reynolds and Hellmuth have actively participated in the development of artist-run, community-oriented spaces: 80 Langton and New Langton Arts in San Francisco and the Washington Project for the Arts in Washington, D.C. Their work has been presented widely in the United States and abroad.

Hospital 1977

A Magic Theater Production presented from April through June at Fort Mason, San Francisco, *Hospital* was an hour-and-twenty-minute performance of images, actions, and sounds, performed by nineteen participants, written and directed by Hellmuth and Reynolds. Interested in "natural actions in real time," they researched and documented the experiential stories of real hospital workers and of patients and hospital visitors who recalled traumatic or memorable events. The accumulated material was presented in an objective, noneditorial manner that evoked the physical and psychological presence of a hospital, including, for example, using the exaggerated sound of squeaking nurses' shoes to underscore the straightforward repetition of mundane daily hospital tasks.

Table of Contents *1990*
Suzanne Hellmuth and
Jock Reynolds

Table of Contents 1990

Commissioned by Pittsburgh's Three Rivers Art Festival, this installation was designed by Hellmuth and Reynolds with neighborhood volunteers who were working to build a community center at a run-down historical site, a Carnegie library in the city of Braddock. (Andrew Carnegie, the steel baron philanthropist, had built many such libraries following his retirement in 1901.) By 1990 the building was, like most of the abandoned main street of Braddock, in a state of total disrepair. Financially and socially the residents of Braddock had been devastated as the steel industry abandoned the area. Local residents, with no funds or publicity, were trying to restore the library when Hellmuth and Reynolds met them in 1988. The artists determined to use the visibility of the exhibition to help the volunteers gain recogni-

tion and raise funds. Hellmuth and Reynolds's installation at Point State Park was a functional reading room—patterned after the standard Carnegie library children's reading room plan—but built entirely in steel. A large steel library-style table and shelves were filled with photographs and documentation, collected over two years, recounting the history of the steel mills, of Andrew Carnegie and the Carnegie libraries, and of the Braddock volunteer efforts to save the space. Donated books were sold to raise money, and Hellmuth and Reynolds gave part of their honorarium to the group.

DONNA HENES Brooklyn-based urban shaman and celebration artist Donna Henes has spent more than twenty years producing public ritual ceremonies that encourage active participation, connecting people to each other and to the natural cycles of the universe. Staged on specific relevant lunar holidays in open public spaces—parks, plazas, beaches, museums, and universities—the events (especially the annual ones) attract hundreds of participants. Henes calls the public street events that she began in 1973 "random interactions." She adopted the pseudonym "Spider Woman" to describe a series of works that involve her audience in webs, cocoons, and streamers as public environments. Henes's most popular media-covered event has become a New York City folk legend. Annually, since 1975, she orchestrates a spring ritual, *Eggs on End, Standing on Ceremony* in the United Nations or World Trade Center plazas. Hundreds of participants gather to stand eggs on end at the exact moment of the vernal equinox. Afterwards they cook and eat the eggs. In 1989 New York City mayor David Dinkins presented her with a citation "in honor of her dynamic and enlightening works as a performance artist and urban shaman."

Dressing Our Wounds in Warm Clothes *1980*
Done on the grounds of the Manhattan Psychiatric Center on New York City's Wards Island, Henes's participatory work pooled the creative energies of 4,159 mental patients, staff members, and visitors. An "outpost of civilization" hidden in the middle of the East River, the hospital imprisons New York's criminally insane. Henes placed public donation boxes in strategic Manhattan locations and collected individual contributions of favorite pieces of "healing clothing"— worn-out items that "you won't throw away because you wear them when you're depressed to feel better." Recalling the women who tore fabric into bandages for World War I, Henes worked on Memorial Day with patients and staff to tear the "healing clothing" into long strips. Then, at the summer solstice, Henes checked herself into the institution for three weeks to live and work with residents. They tied 4,159 knots onto trees, shrubs, and fences throughout the facility grounds, "in the tradition of women from almost everywhere who

Dressing Our Wounds in Warm Clothes *1980*
Donna Henes

visit healing waters to make supplications by knotting torn clothing into the trees." The center's director wrote: "This is what we have been looking for, life, thought, interaction. The banishment of apathy and spiritual neglect which have so long been the fate of the most severely mentally ill."

Flashlights *1986–87*

In December 1986 Henes designed a grass-roots December celebration of light for the economically depressed rural community of Rosendale, New York. In preparation, she conducted workshops in which local youth crafted sixty four-foot-wide snowflakes covered with Mylar. Hung across downtown streets "not as a Christian celebration but as a festival of light during times of dark," the snowflakes were connected with webbed nets of lights—six thousand of them, one for each resident. The community-made alternative holiday decorations were so popular that Henes was invited to design a larger public event the next year—a citizen-made parade. Under the banner "Light Is Hope," locals decorated with Mylar and flashlights marched alongside floats incorporating themes of light, peace, and community spirit, while along the parade route residents turned on porch lights. The success of this project in turn led to a 1988 invitation by the divided community of Bay Shore, Long Island, to create a Festival of Lights "to re-spark the community spirit [and] mark the year they turn their image around."

Flashlights *1986–87*
Donna Henes

LYNN HERSHMAN Art world inequities and personal experiences of powerlessness initially brought San Francisco–based Lynn Hershman to move her art out of museums. During the sixties and seventies Hershman created specific installations and performances that were integrated into "real life." From her innovative *Dante Hotel Room* (1972), installed in a vacant hotel as a psycho-sociological exploration of the meaning of the site, to her private/public exploration of a working-class woman's reality through her appearance as the alter-ego character Roberta Breitmore (1975–78), she invented new situations to engage non-museum-going audiences. From 1975 to 1979, Hershman created the Floating Museum, an institution without walls that foreshadowed current curatorial trends. Hershman also curated temporal presentations by other artists in public spaces. *Herrata* (1979), for example, was a series of site-specific installations by women displayed simultaneously and at the same locations as works by male artists who were included in an exhibition held at the San Francisco Museum of Modern Art. *Herrata* cleverly called attention to the blatant lack of women in the museum show. Hershman began working in video in 1977 and has since produced forty-five tapes and four interactive installations. While she continues to exhibit and be reviewed in a fine arts context, Hershman's work is also

extensively acknowledged and supported by experimental filmmakers and European television. Her use of technology is based on the belief that it represents a new globally accessible language structure. Equally important to her is that the media become two-way and interactive—forming a dialogue that respects and invites multiple points of view.

25 Windows: A Portrait of New York *1976*

This work claimed the street-front windows of the Bonwit Teller department store in midtown Manhattan. In each window a scene relevant to urban dwellers and their often hostile environment was developed as an expanded public narrative. In one, for example, a mannequin was posed to recount the murder of a balloon seller, which had been reported in the *New York Times*. Another dealt with energy usage and prospects for the future. In another, passersby were confronted by a mannequin's hand that literally shattered and penetrated the glass, reaching out into the traditional territory of the audience. At certain times, a panel of futurologists sat in one window and answered questions from audiences who gathered at a microphone on the street. At others, an "escaped" mannequin sat on a nearby park bench. The scale of this work and the media attention it received position it as an early forerunner of current public installations and performances.

Lorna *1984*

The innovative, interactive videodisk *Lorna* is among the first of its kind produced by an artist. It offers a technological model for opposing authoritarian, media-induced passivity. In this narrative, Lorna is suffering from agoraphobia. She hides in her apartment, relating to the world through objects that ironically exacerbate her neurosis: her television, wallet, and phone. These and other possessions act as lightning rods to draw fearful images and concepts into Lorna's space. Using her possessions as starting points, viewers can open video avenues in new directions that elaborate on issues from women's rights struggles to the threat of nuclear war. By choosing various channels, the viewer determines Lorna's fate: suicide, continued existence as an agoraphobe, or leaving her apartment to start a new life. *Lorna* urges aggressive media deconstruction and provides a model through which to contemplate the possible socialization of technology.

NANCY HOLT Initially a photographer and video artist, Nancy Holt is internationally recognized for her large-scale environmental works dealing with the perception of nature. In 1972 she constructed her first "locator" piece, a periscopelike sculpture that viewers could enter or look through to locate specific stars or observe constellations related to planetary events such as the summer solstice. This pivotal sculpture was a simple concrete pipe set into a Rhode Island sand dune

25 Windows: A Portrait of New York
1976
Lynn Hershman

Lorna *1984*
Lynn Hershman

through which one could see a limited, framed view of water, sky, and sun. Her most famous work, *Sun Tunnels* (1973–76), is on a site she purchased in the Great Basin Desert of northwestern Utah. Four concrete pipes, large enough to walk through, frame the solstitial sunrises and sunsets for participant/viewers. Holt claims that *Sun Tunnels* is "more accessible really than art that is in museums, as accessible as the Grand Canyon." Since 1979 Holt's work has become increasingly socially involved, as it brings to urban areas a growing environmental awareness that the sun's energy is essential to life and that humans are part of the cyclical patterns of the universe.

Dark Star Park *1979–continuing*
Nancy Holt

Sky Mound *1987–continuing*
Nancy Holt

Dark Star Park *1979–continuing*

Commissioned by Arlington County, Virginia, as part of an urban renewal project for the city of Rosslyn, Holt salvaged a blighted, trash-covered two-thirds-acre site as a refuge for community residents. Located in a fast-growing suburb of Washington, D.C., the site is a hub of vehicular and pedestrian traffic. Holt set important precedents for public art in her teamwork with administrators and planning commissions. Hired as a sculptor, she envisioned a more expansive work of art and convinced the planning commission to give her the larger job of park designer and landscape architect. She then became a temporary area resident and immersed herself in the social and political web of the community to make the park integral with its needs, demonstrating that artists can make a meaningful contribution to the public planning process. She also collaborated with local artisans and experts to construct the park's components. For pedestrians, the park offers not only comfortable resting places but planetary, cyclical, and historical insights. For example, one alignment of shadows occurs at 9:32 a.m. on August 1 to commemorate the date in 1860 when William Henry Ross acquired the land that became Rosslyn, thus bringing universal time and local history together at the site. The park has become a landmark, enthusiastically embraced by Rosslyn's residents.

Sky Mound *1987–continuing*

Visible for miles, an enormous pyramidal mountain in Kearny, New Jersey, that was formerly a municipal landfill is the site of Holt's newest public park. Before its 1987 closing, nearly one-third of New Jersey's garbage was being dumped there—eleven thousand tons per day. Covering fifty-seven acres, it may become the largest artwork in the Northeast. More than 125 million people a year see *Sky Mound* as they drive the New Jersey Turnpike and the Pulaski Highway, ride Amtrak, or land and take off in planes at Newark Airport. The park was commissioned by New Jersey's Hackensack Meadowlands Development Corporation, the agency charged with closing and sealing the landfill. Holt has been collaborating with waste engineers, scientists, landscape architects, environmental experts, and governing agencies to make the site a publicly accessible, ecologically

educational park that is also an artwork. A staggering reclamation project, Holt's master design includes metal arches that operate as methane recovery pipes, the planting of grasslands and wildflowers to encourage the propagation of natural wildlife, a pond to collect fresh water for migrating birds, and gravel paths, small earth mounds, gunite spheres, and poles that function as a naked-eye, mountaintop observatory and seasonal calendar. Still under way as Holt resolves a complex maze of scientific and bureaucratic issues, the park is scheduled for a mid-nineties opening.

JENNY HOLZER Born and educated in Ohio, Jenny Holzer found her public art voice in the "heartland's" laconic Standard American English (the vernacular of radio and television broadcasts). For her earliest text art (1977), printed on flyers that were stuck to walls, phone booths, and bus stops, she used a dialect that was genderless, impersonal, seemingly honest, deceptively simple, humorous, often cruel, painfully confrontational, and "ultimately populist." Since her 1986 Survival series, her language has become more personal, complex, and situational. Throughout all her work, Holzer remains what curator Michael Auping calls "a public orator voicing private fears," her preferred themes being "sex, death, and war." In 1980 she joined Colab (Collaborative Projects), an alternative artists' group dedicated to placing art (often anonymously) in nontraditional public settings. Invited by the Public Art Fund to display her *Truisms* on the Spectracolor board of Times Square as a part of their "Messages to the Public" program, she discovered her signature medium, the electronic message board. Since then, Holzer's texts have flashed from LED signs in San Francisco's Candlestick Park, Las Vegas's gambling strip, and taxi stands in Italy. Although her work is exhibited in museums, Holzer maintains a strong allegiance to public art, as she creates concurrent texts on public LED boards, billboards, buses, television commercials, T-shirts, posters, and hats.

Truisms *1977–79*
In 1976 Holzer, then a student in the Whitney Museum of American Art Independent Study Program, synthesized and restructured weighty philosophies from a monumental reading list into a sequence of one-line aphorisms. This first public art work consisted of anonymous text, a provocative list of thirty-five one-line adages printed as commercial flyers and posted on building walls and fences around Manhattan. The *Truisms* were, in fact, contradictory. They included: "ABUSE OF POWER COMES AS NO SURPRISE . . . ACTION CAUSES MORE TROUBLE THAN THOUGHT . . . AN ELITE IS INEVITABLE . . . ANY SURPLUS IS IMMORAL . . . EATING TOO MUCH IS CRIMINAL . . . ENJOY YOURSELF BECAUSE YOU CAN'T CHANGE ANYTHING ANYWAY . . . FATHERS OFTEN

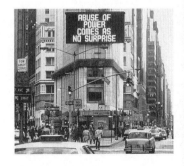

Untitled *1982*
Jenny Holzer

USE TOO MUCH FORCE . . . OFTEN YOU SHOULD ACT LIKE YOU ARE SEXLESS . . . MONEY CREATES TASTE . . . PRIVATE PROPERTY CREATED CRIME. . . ." The public often responded by scratching out lines they disagreed with or positively emphasizing favorites, and writing their own opinions alongside Holzer's. A subsequent installation of *Truisms* was removed, after initial approval, from the Marine Midland Bank in New York City when an employee noticed the line "IT'S NOT GOOD TO LIVE ON CREDIT." The *Truisms* have taken on a life of their own as they continue to be published and sold commercially on inexpensive posters, T-shirts, and baseball caps.

Jenny Holzer *1989*

In this "retrospective" exhibition at the Solomon R. Guggenheim Museum, New York City, Holzer challenged the museum's hierarchical, linear viewing format dictated by Frank Lloyd Wright's design for the building. Visitors ascend a spiral ramp to view art installed in a linear sequence on interior walls, their perspective thus controlled by the architecture. Holzer placed her work outside this prearranged space, leaving the gallery walls bare. She used the outer face of the spiral ramp's parapet wall to install 535 feet of continuous electronic board that flashed yellow, green, and red words in a surreal vortex. Some 330 messages took 105 minutes to complete the climb to the interior roof. She also set seventeen carved marble benches in a circular pattern on the lower floor, creating a site where the audience was "stage center" for the spiraling works. Through their own movements, the audience could discover that viewpoints were equally advantageous anywhere along the spiral ramp. Holzer's installation challenged the architectural management of the audience's position.

MILDRED HOWARD Mildred Howard draws on African American family, community, and cultural history to develop multilayered installations based on the power of memory to reveal and to heal. She combines archival materials (stamps, photographs) and culturally imprinted found domestic objects to construct spaces where an audience may enter and respond, in a pattern similar to the "call and response" of African-based music. The youngest of ten children in a family that migrated from Texas to California in the forties, Howard was raised to remember "where you came from." Her parents, both strong role models as union and civic leaders, encouraged her to develop her skills and confidence in "making, doing, and knowing." She both affected and was affected by the politically active Bay Area arts community in the sixties and seventies. In 1979 she created her first audience-participatory installation, *The Reverend Doctor Magnolia Brown, Reader,* deriving the fictional character Dr. Magnolia Brown from Southern preachers who "read" the future. Since then she has continued to use participatory installation as a medium to reach larger

audiences. In 1991 her installation *Ten Little Children Standing in a Line (one got shot, and then there were nine)* paid tribute to the youthful victims of the 1976 massacre in Soweto, South Africa.

The Gospel and the Storefront Church *1984*

Invited to produce a participatory installation in the Bay Area's Marin County, noted for its high incomes, Howard stated, "I wanted to show respect to the Blacks of Marin County. I wanted to connect Marin City (a predominately black neighborhood) to Mill Valley (a predominately white neighborhood), to bring those communities together." Howard converted a former post office into a storefront church, using found objects, architectural salvage, drawings, hand-painted windows, projected slides, and borrowed objects such as a pulpit doily. The opening was an audience-participatory performance in which each guest received a screen-printed fan to wave while listening to the music of the Marin City Choir and Bishop Normon Williams from San Francisco's Church of John Coltrane. Howard based this work on research in her own Berkeley neighborhood, where storefront churches are a vital neighborhood force. In 1985 the performance and part of the installation were included in an exhibition curated by artist Betye Saar at the Museum of African American Art in Los Angeles.

The Gospel and the Storefront Church *1984*
Mildred Howard

JIM HUBBARD Jim Hubbard is an award-winning veteran photojournalist based in Minneapolis, who refers to himself as an "advocacy journalist" and an "issue artist." In 1967, when the Detroit riots broke out, Hubbard's photos were picked up by United Press International (UPI) and published worldwide. He then worked as a staff photographer for the *Detroit News* and, from 1969 to 1987, for UPI bureaus in Omaha, St. Louis, Minneapolis, and Washington, D.C., covering events such as the 1972 Munich Olympics massacre, the 1973 Wounded Knee takeover, the Cambodian exodus into Thailand, and White House assignments during the Reagan administration. Hubbard enrolled in Wesley Theological Seminary and received his Master of Divinity degree in 1990. When he started photographing the homeless in the early eighties, a project for which he was nominated for the Pulitzer Prize, "it was a time in history when President Reagan was talking about how there were no homeless. I thought it was an insult to poor people," he says. "That's what prompted me to get serious about documenting homeless people." His work in the late eighties focused on photographing the process of eviction and its impact on poor families. During that time Hubbard founded the Shooting Back Education and Media Center to teach photography, writing, and media skills to homeless and at-risk children in the Washington, D.C., area.

Shooting Back Project
1989–continuing
Jim Hubbard (photo by Daniel Hall, ten years old)

Shooting Back Project *1989–continuing*

Shooting Back is a nonprofit organization founded by Hubbard that seeks to increase the self-esteem of children with limited opportunities. While documenting homeless families, Hubbard realized that the children he was photographing were interested in taking their own pictures. He responded by recruiting professional photographers, all volunteers, to conduct informal workshops at shelters and welfare hotels among over five hundred homeless and formerly homeless children in the Washington, D.C., area. A three-year traveling exhibition of these children's photos opened in 1990 at the Washington Project for the Arts and has been seen by thousands of visitors in ten major U.S. cities. That same year, the Shooting Back Education and Media Center was established in Washington, D.C., to conduct ongoing workshops with at-risk youth ages ten to nineteen. The workshops give them skills and creative outlets to help them communicate and to change their world. Exhibitions of the children's work at the newly opened Shooting Back Photo Gallery and the subsequent media exposure served to alert the public about the condition of youth in America. In 1991 Shooting Back opened a center in Minneapolis to launch the Native American Youth Project, documenting American Indian life through the eyes of young people. The outreach component of the project traveled to twelve American Indian reservations nationwide in a special van fully equipped as a mobile darkroom, with artists and photographers assisting interested schools and communities in establishing their own permanent photography programs.

ALFREDO JAAR Born in Santiago, Chile, photo-installation artist Alfredo Jaar left a stifling political situation to move to New York City in 1982. His artwork has continuously dealt with "the issue of the widening gap between the so-called Third World and the industrialized world." An inveterate traveler, he journeys around the world, taking his photographs in non-Western countries, "to have personal contact with the people and issues that I am dealing with. I go myself to take the photographs of children with chemical burns, vomiting blood because we have contaminated their environment." In his installations he employs photographs, light boxes, and mirrors to create uncomfortable, complex situations in which the viewers' awareness of their own complicity is an important component. His intent is to properly contextualize his photographs, so that they become a call to action. In *Rushes* (1986), Jaar filled the entire advertising space of New York City's Spring Street subway station with eighty enormous photographs of Brazilian Indians mining for gold under dehumanizing conditions, and alongside posted the going prices for gold on the world market. Madeline Grynszteyn writes: "Having grown up amidst tyrannical conditions, futile protests, and profound

unhappiness, Jaar has, not unnaturally, gravitated towards an art practice pivoting upon socio-politial issues. Further, the pieces he has so far made evidence a powerful aversion to dogma. The oblique form of address—in Chile a necessity for the survival of any form of artistic and/or political expression—has matured in Jaar's work into an elegant form of barbed political understatement."

¡Es Usted Feliz! (Are You Happy?) *1980*

For this work, Jaar leased three billboards, one in central Santiago, one on the road to the international airport, and one next to a freeway interchange, and on them printed the question *"¿Es Usted Feliz?"* (Are You Happy?). He also posted the question on newspaper stands, under public clocks, and at other pedestrian locations. Enlarging on a question that is casually asked in daily salutations, Jaar provoked a public dialogue about Chileans' most private thoughts. In a time of intense censorship, the cautious but inflammatory language asked how people were faring under General Augusto Pinochet's repressive military dictatorship. The project included a one-thousand-hour event (eight hours a day for 125 days) at the Museo de Bellas Artes, in which Jaar taped people's answers to the question. Some answers were silly; others were political, social, or personal. Some people held a hand or newspaper over the camera lens while they talked so that no one could identify them.

¡Es Usted Feliz! (Are You Happy?)
1980
Alfredo Jaar

The Booth *1989*

A site-specific interactive photographic installation at the National Museum of American Art in Washington, D.C., this project was inspired by its location next door to the National Portrait Gallery. On three sides of a large, black, cube-shaped booth were huge back-lit photo transparencies of individuals he had worked with in non-Western countries, distant but eager faces that stared directly at the camera and, thus, the viewer. In the fourth wall of the cube was a doorway, and inside visitors could have a Polaroid portrait taken. However, upon receipt of the completed picture, they discovered their own face surrounded by a circle of faces of Third World people like the ones in the transparencies. Patricia C. Phillips writes: "This surrounding filigree was the human evidence of suffering, of struggle, of the insidious perpetuation of *the other* in order to confirm the centrality of the self. Making the viewer complicit in the process of distancing, Jaar enacted a startling betrayal of individual security and complacency."

The Booth *1989*
Alfredo Jaar

PATRICIA JOHANSON Trained as a painter, sculptor, and art historian (she worked for several years as Georgia O'Keeffe's archivist), Patricia Johanson returned to school in the seventies for a degree in architecture so that she could "break down the barriers between the arts—painting, sculpture, architecture, landscape, and planning—and create

'relationships' rather than 'objects.'" Curator Debra Bricker Balken writes: "Responding to the distance that mainstream contemporary art has set from nature, she has countered by planning environments in which art, site and humans are thoroughly integrated. By placing humans in the landscape, she has attempted to reorient our experience from merely looking at art to actively participating in the world." A pivotal work for Johanson was a solicited, but eventually rejected, manuscript she wrote for *House and Garden* magazine in 1969. Instead of destroying and restructuring the natural environment, Johanson advocated ways of retaining and understanding the existing terrain; the editors wanted more conventional garden designs. Perhaps even more in the field of environmental design than in art, Johanson was an early pioneer whose ideas have influenced contemporary practice. Over thirty years her intimate drawings of plants and wildlife have grown into large-scale designs for parks, sewers, pathways, bridges, housing, and other public infrastructures.

Fair Park Lagoon *1981–86*
Patricia Johanson

Fair Park Lagoon *1981–86*

In 1981 the Dallas Museum of Art asked Johanson to design an "environmental sculpture" for Fair Park Lagoon. Later renamed *Leonhardt Lagoon,* the work began as a featureless, polluted, stagnant body of water over five blocks long in the middle of Dallas's largest park. Johanson worked closely with the science staff of the Dallas Museum of Natural History to select native plants and fauna, and with the Parks Department to stop the detrimental practice of fertilizing the lawn around the lagoon. She attempted to reconcile traditional aesthetic considerations with strategies that would allow the lagoon to perpetuate itself. Landscaping became plantings that served as food and habitat for regional wildlife. Fish, reptiles, and waterfowl were selected not only for their decorative qualities but because they were part of the food chain. Elements of the project delineate microhabitats, create animal habitat islands and bird perches, and provide public access to the life of the lagoon: eating, nesting, spawning, and being eaten in turn. The lagoon functions on many levels, from the mundane benches, paths, and bridges of traditional parks to the ecological functioning of a living landscape. Conceived as a multilayered ecosystem, social center, and site reclamation, Johanson's "sculpture" is an early example of a contemporary practice that links public use with environmental design and education about ecology.

MARIE JOHNSON-CALLOWAY California artist Marie Johnson-Calloway merges grass-roots politics with social realism to create positive scenes of African American life, while quietly underscoring racial inequities. Raised in racially segregated Baltimore, she saw harsh deprivation but developed

a strong cultural identity through early exposure to African American history and culture (W. E. B. Dubois's daughter and Thurgood Marshall's mother were two of her teachers). A civil rights activist in the sixties, she had trouble reconciling her formal university art education with her life experience. In 1968 she resolved to employ her art for social change through exploring her ethnic roots. She writes: "Now is not the time for me to be so esoteric, so obscure, or so individualistic that my meaning is lost to all except the narrow world of the 'art-minded.' Blacks are a family, bound and unified by common experiences in a hostile land. I aim to speak to, of, and for my family." Her work consists of paintings, installations, collages, and, with her daughter, a recently completed mural for the city of Oakland.

Hope Street *1968–85*

First exhibited in 1987 at the Oakland Museum in California, this installation is an assemblage of fourteen separate mixed-media constructions that evolved over a number of years. Installed as a street along which viewers can walk, the piece consists of a succession of vignettes within an African American neighborhood. Partially painted silhouettes of people dressed in secondhand clothes lean on clapboard sheathing, stand behind screen doors, look out windows, and sit on a church bench. Some have been given human hair trimmed from Johnson-Calloway's sons and nephews. Her intimate world mixes politics with home, church, street, and school. The people are modeled after people she knows on a daily basis, including her Baptist minister father and her grandmother. The "Church Mothers," for example, are important elders in the church she attends. Many of the individuals that Johnson-Calloway portrayed—like the neighborhood school's crossing guard—visited a museum for the first time to view their portraits.

Hope Street *1968–85*
Marie Johnson-Calloway

ALLAN KAPROW One of the most significant artists and teachers of this era, Allan Kaprow, through his pioneering work, has had a profound influence on the work of contemporary artists. Coining the term "lifelike art," Kaprow writes: "Artlike art holds that art is separate from life and everything else, while lifelike art holds that art is connected to life and everything else. In other words, there is art at the service of art, and art at the service of life. The maker of artlike art tends to be a specialist; the maker of lifelike art, a generalist." Influenced by Jackson Pollock, John Cage (with whom he studied), Brechtian theater, and Zen philosophy, Kaprow was one of several artists who invented "Happenings" in the late fifties. Over the years, he has shifted from public spectacle to more intimate work in which the privileged sensibility of the artist becomes

the shared experience of the participant. Much of Kaprow's work consists of a set of instructions to follow. For example: "Suppose you watch a clear sky and wait for a cloud to form— you might learn something about nature. Suppose you wait longer, for the sky to clear—you might learn something about yourself." Jeff Kelley writes: "From his first major writing, *The Legacy of Jackson Pollock* [1959] to his recent essay, *The Meaning of Life* [*Artforum*, June 1990], Kaprow has conducted a sustained philosophical inquiry into the paradoxical relationship of art to life, and thus into the nature of meaning itself."

Fluids *1967*

Fluids, an activity for large groups of nonartists and artists, centered on the cooperative construction of twenty rectangular nine-foot-high ice-block "ice houses." One hundred people worked on the project, which was built over three days by separate work teams and site managers in locations throughout Los Angeles. The simplicity of the "activity" belied the complexity of organizing teams, schedules, permits, and insurance, hiring the ice company, and notifying the police. There were also technical problems: how to stack melting ice in a warm climate, how to anticipate and prevent collapse, and how to secure foundations. The laborious but playlike activity drew a diverse group of spontaneous participants—from a McDonald's manager and an off-duty policeman to neighboring children—who joined the work in a celebratory fashion. Other onlookers were nonplussed, or even took the "play" aspect as an affront to their own hard work. For Kaprow the project's importance lay in the unpredictable experiences it evoked: "What remains vivid in my memory is not so much the esthetics of the event as its social interactions . . . and the possibility that my quasi-art could be planned to disappear like a piece of used Kleenex."

Fluids *1967*
Allan Kaprow

Trading Dirt *1980s*

This is an example of Kaprow's more private performances, one in which there is no spectacle, only the stories generated by a shared action between the artist and a series of participants over time. Kaprow recounts the fablelike narrative as a seasoned storyteller, beginning: "I woke up one day and had an idea. I would dig a bucket of dirt from the garden, and I would put the bucket of dirt and a shovel in my truck. On some future day, I'd trade my dirt for someone else's dirt." And so he does. But each time he exchanges a bucket of dirt he must converse with the participant, who wants to know why he wants to exchange dirt, what will happen to the dirt, what it all means, and just how serious he is. His bucket-of-dirt work takes him to the basement of a Zen center, to a local roadside farm stall, and so on, for three years. Every time there is an exchange, it leads to a discussion of philosophies far beyond the simple material. (Dirt is also slang for "truth" or "basic meaning," as in "Tell me the real

dirt.") Kaprow writes: "When I stopped being interested in the process, I put the last bucket of dirt back into the garden."

BARBARA KRUGER Conceptual artist Barbara Kruger alters commercial advertising imagery, censoring portions of the original with broad strips of sloganistic text that is aggressive, sardonic, questioning, and disquieting, and then places the new work in overtly commercial sites—billboards, T-shirts, posters, matchbooks, museums, and art galleries. Kruger says: "I don't think of art per se, I think of how words and pictures function in culture. We're used to being bombarded with incredible amounts of images in very quick sequences. I think that one has to understand how to read those images, not to duplicate [them], but to reconstruct the machinations that are behind the presentation of those images." In the seventies Kruger worked as an art director for Condé Nast women's magazines. "I learned that you designed a page for someone to look at . . . in a relatively short time; it was important to get people's attention. If you didn't you were fired." Kruger employs, alters, and critiques this methodology in her own work. She uses "I" and "You" in her text to imply the two sides of a struggle for survival: the "I" is abused, exploited, and angry, while the "You" holds the power, the money, the tools of abuse. She says, "I am concerned with who speaks and who is silent. I think about works which address the material conditions of our lives and the oppression of social relations on a global level; in work which recognizes the law of the father as the calculator of capital. I want to be on the side of surprise and against the certainties of pictures and property."

Untitled (We Don't Need Another Hero) *1985*
Reproduced and disseminated in multiple manifestations (posters, postcards, etc.), this image was originally produced in 1985 as a ten-by-twenty-foot billboard on a busy London thoroughfare. Reminiscent of Norman Rockwell's magazine-cover Americana, Kruger's image is of a young girl with ribboned pigtails and a polka-dot dress gingerly touching a young boy's flexed biceps as he grimaces and holds up a clenched fist. A large bisecting strip of block text reads, "We don't need another hero." Kruger's "We" embraces the viewer as partner to throw off the gender stereotypes reinforced by media and advertising.

Untitled (Questions) *1990–91*
In 1989 the Los Angeles Museum of Contemporary Art commissioned Kruger to create an outdoor wall mural. The installation of her original design was delayed eighteen months, while Kruger conferred with the Little Tokyo community. Sited on a windowless wall nearly three stories high and more than two-thirds the length of a football

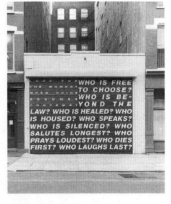

Untitled (Questions) *1990–91*
(Manhattan version)
Barbara Kruger

249

field, the original proposal included the Pledge of Allegiance and other texts, framing the image of the American flag. It was the flag that caused painful memories; the wall faces the embarkation point from which thousands of Japanese Americans were sent to relocation camps during World War II. Their loyalty in question, they had to recite the pledge daily. Approximating the American flag, the upper left corner of the image is a blue rectangle with white letters that read: "MOCA at the Temporary Contemporary." The rest is a red field with four long "stripes" of white-lettered text asking nine questions: "WHO IS BEYOND THE LAW? WHO IS BOUGHT AND SOLD? WHO IS FREE TO CHOOSE? WHO DOES TIME? WHO FOLLOWS ORDERS? WHO SALUTES THE LONGEST? WHO PRAYS THE LOUDEST? WHO DIES FIRST? WHO LAUGHS LAST?" A second "flag" painted in 1991 on the Manhattan street front door of the Mary Boone Gallery was so popular with passersby that the gallery maintained it long after Kruger's show closed.

LESLIE LABOWITZ During the seventies Los Angeles performance artist Leslie Labowitz was an inventor of media events that focused on issues of violence against women. She began her work in Germany and spent five years using public art "to facilitate the collective expression of large groups of people, activating them toward social change." Labowitz's model had five components: "collaboration with a political organization; use of the skilled artist as director/organizer; a focus on issues of current concern; use of the language of the audience addressed; and economic accessibility of materials." A sixth component, the use of media techniques, was developed when she returned to California. In Los Angeles she became active in the Woman's Building, working with Suzanne Lacy from 1977 to 1979 on several major performance "structures" on the subject of violence against women. In works such as *In Mourning and in Rage* (1977, see page 150), they invented a model for media event as performance, attracting significant public attention to the Hillside Strangler murders. In 1978 Labowitz and Lacy cocreated Ariadne: A Social Art Network, a three-year project that brought together artists, politicians, activists, and journalists as a pressure group for the representation of a feminist perspective in the media. With Nancy Angelo and Terry Wolverton, and with contributions by many others, Labowitz was instrumental in developing the Incest Awareness Project (1978–80); since 1980 she has been working with the metaphor of urban farming.

Record Companies Drag Their Feet *1977*
In 1977 Women against Violence against Women and the California National Organization of Women organized a boycott campaign against record companies to protest album covers that "glorified

violence against women." Labowitz designed a performance to generate television news coverage to publicize the issues and to demand that record companies act with social responsibility. On Sunset Boulevard, directly under a violent billboard of the rock group Kiss, record executives, portrayed by women dressed as roosters, began the event by driving up and down Sunset Boulevard in a gold convertible. Entering the "office" they strutted and performed rooster/executive clichés. Women carrying signs reading, "I wish the media wouldn't insult, demean, dehumanize me by their images" and "Love is not violence" tried to communicate with the roosters, who ignored them. The simple Brechtian scenario was designed to coincide with a media convention and was extremely successful, receiving extensive local and national television coverage. The boycott eventually resulted in a record industry policy on violent graphics.

Record Companies Drag Their Feet
1977
Leslie Labowitz

Sproutime *1980–81*
After years of work on violence against women, Labowitz discovered the relationship between this painful subject and her own experience as the child of a Holocaust survivor. Embarking upon a personal healing through her art, she developed a metaphor in sprout growing, one that eventually became a self-sustaining business. In a series of lifelike performances, she explored her relationship with the Holocaust, her mother, planetary survival, and art making as it relates to life. In one performance, the audience entered the artist's garden. Surrounded by racks of sprouting seeds, with taped sounds and in a dimly lit atmosphere, the audience heard a reading from the classic children's book *The Secret Garden,* by Frances Hodgson Burnett, about the creative and emotional liberation found within a "secret garden." Labowitz then extolled the benefits of freshly grown sprouts, fed the viewers a healthy lunch, and conversationally explained "how sprout growing had become not only my art, a social statement, and a means of making money, but a metaphor for my own self growth." Viewers participated by making their own salads and, as the performance ended, Labowitz sold the remaining sprouts to participants. This piece united normally disparate parts of an artist's life: art work, economic work, and caring for one's own physical and mental health.

Sproutime *1980–81*
Leslie Labowitz

SUZANNE LACY One of the first artists to use performance to explore and publicly expose violence against women, California-based conceptual performance artist Suzanne Lacy is a feminist pioneer of temporal, large-scale public events strategically designed to focus mass attention on vital social issues. Lacy was studying for a graduate degree in psychology at California State University at Fresno when she discovered and entered Judy Chicago's Feminist Art Program. In Los Angeles, she was a vital force—teaching at the Feminist Studio Workshop, organizing, and performing. During the seventies Lacy appeared in more intimate performances as an old lady, a bag

lady, and a nineteenth-century missionary, with the overall intent of exploring questions of economic, racial, gender, and age discrimination against women. Her later work has become more elaborate. Dependent on long-term involvement of participants and long-range planning, Lacy now orchestrates complex behind-the-scenes scenarios, directing teams of collaborating artists and choreographing the movement of scores of nonartist participants who come together in the spirit of community. Over the last twenty-plus years, Lacy has developed a deft work strategy that borrows commercial media techniques to exploit the media itself into disseminating her bold images and political messages on themes ranging from cancer to international peace.

Three Weeks in May *1977*
Suzanne Lacy

Three Weeks in May *1977*

The first of Lacy's enormous performance structures, this extensive and complex umbrella work was composed of some thirty events held citywide: performances, speak-outs, art exhibits, and demonstrations, all amplified by media coverage. Community organizing and media strategy covering the entire city of Los Angeles publicized the project and educated the community by revealing the crisis issue of rape within the city and, by extension, throughout the country. For three weeks, two twenty-five-foot maps of Los Angeles were placed in the City Hall shopping mall. On one map, as daily rapes were reported by the Los Angeles Police Department, red marks were dramatically stamped at each location where a rape occurred. Eventually the map became a sea of red. The other map indicated locations of women's helping agencies. Also included in the project were works by other artists, ranging from personal ritual to public street presentations, such as Lacy's *She Who Would Fly,* a private, cathartic exchange among women who had suffered sexual assault, which culminated in a gallery installation. As the weeks progressed, city officials offered their support; public awareness continued to grow, and the closing rally was well attended by both press and audience.

The Crystal Quilt *1987*
Suzanne Lacy

The Crystal Quilt *1987*

In Minneapolis Lacy worked for two and one-half years to develop a network of five hundred volunteers, twenty staff members, and a team of fifteen collaborating artists for the Whisper Minnesota Project—Lacy's umbrella organization for multifaceted work with older women. *The Crystal Quilt*, the culminating performance, was a vast spectacle honoring 430 elderly women participants, sixty to one hundred years old, who performed on Mother's Day in the Crystal Court (an enormous, elegant atrium in a downtown commercial building designed by Philip Johnson). Dressed in black, the women entered the glass-enclosed public court while an audience of several thousand stood on surrounding balconies. Seated at red and yellow covered tables, in a design by painter Miriam Schapiro, the women shared their common problems and accomplishments. An audio

collage by Susan Stone of their prerecorded conversations was broadcast over speakers. The women rearranged their hands in unison at synchronized points during the one-hour piece, the prearranged choreography of hand movements suggesting the process of quilt making. At the end, audience members were invited onto the "quilt" to present the women with hand-painted scarves. Ten of the elderly women went on to organize statewide leadership training programs for older women. Televised live by KTCA public broadcasting, the performance received extensive exposure and newspaper coverage.

LORAINE LEESON AND PETER DUNN

British artists Loraine Leeson and Peter Dunn work and live near a London neighborhood called the Docklands, situated along the River Thames. They began collaborating in 1980 to develop a series of art strategies in support of community efforts to fend off trendy upscale redevelopment that threatened homes and livelihoods. Called a "wasteland" by the Thatcher government, the Docklands was home and workplace to more than fifty thousand politically invisible people; it was a working-class district of low-cost family homes, inexpensive artists' spaces, and commercial businesses and warehouses. Developers designed luxury flats too expensive for locals, and rather than creating new jobs, caused established firms to relocate, thereby disrupting the work force. Diverse local groups united in an opposition that took many forms, from direct action to long-range initiatives. Against great odds, the community stood its ground for ten years, winning small victories over the inevitable encroachment. Leeson and Dunn, with a team of artists, provided art and design services to meet tenants' and action groups' requests for publicity materials—posters, banners, news sheets, exhibitions, badges, and T-shirts for conferences—and created events and performances for meetings and festivals. In over ten years of their residence within the same community, Leeson and Dunn have demonstrated how visual artists can actively participate as an integrated part of sustained social activism.

The Docklands Community Poster Project *1981–91*
Working closely with an organized federation of community groups and trade councils, Leeson and Dunn developed a series of changing photomurals that were displayed on billboards in the Docklands. The series of eight-by-twelve-foot photomural billboards was actually a cycle of images; different sections of the whole picture gradually changed over an extended period, with each change creating a distinct new composite image, unrolling like a "slow-motion animated film." The photomurals were a counterpoint to the slick, commercial ads put up by developers depicting "a luxury apartment, a view of the river, and a free Porsche." Not designed for passing

The Docklands Community Poster Project *1981–91*
Loraine Leeson and Peter Dunn

motorists, the Docklands billboards were sited for pedestrians who walked by regularly, allowing an argument to unfold through time. Messages included, "WHAT'S GOING ON BEHIND OUR BACKS?," "BIG MONEY IS MOVING IN," "DON'T LET IT PUSH OUT LOCAL PEOPLE," and "OUR FUTURE IS IN THE DOCKLANDS" —this last a monumental photomontage bringing together images of the neighborhood's diverse residents. Though these images, quite sophisticated and visually complex, were not developed by a committee, the community did, over a period of months, discuss the fundamental issues and how the images could meet them. Also distributed as posters and postcards at meetings and festivals, the images were instrumental in self-empowerment strategies for the Docklands community, and by garnering media attention, let the area's struggle for survival be known to the rest of England.

The Docklands Roadshow *1987–91*

The intent of this work was to take the Docklands survival lessons to other British communities threatened by the government's ubiquitous pro-development Urban Development Corporation (UDC). Leeson and Dunn printed a color brochure, stating: "We believe that UDCs are a major threat to local democracy. The people of London's Docklands have experienced the effects of market-led planning and development and a reduction in democracy. The purpose of the *Docklands Roadshow* is to bring this experience—as presented by local people, local councilors and trade unionists—to your area and to your community. Most of all we want to create a dialogue between our communities." The *Roadshow* included a whole range of exhibitions, selected photomurals, and audiovisual materials on such issues as the history of the docks; the impact of the Urban Development Corporation's strategies on the environment and the local economy; and housing, child care, and transport. "Community fightback" and community planning workshops were set up at each site, using the expertise of local tenants and action groups, sympathetic planners, and economists. This work has become a worldwide model for activist art.

ANDREW LEICESTER Born and educated in England, sculptor Andrew Leicester emigrated to the United States in 1970. His grass-roots-inspired sculptures honor communities, their pivotal events, and their essential industries. Leicester feels strongly that his art should be in the public domain and be understood by those people who will live with it. His intent is to develop public works that "people can care about, and that honor, inspire and delight them." Leicester converses with residents, planners, city council members, the mayor, and others connected to the site. He researches written and oral histories, local myths and legends, and the area's landscape, artifacts, and architecture. The sculpture is constructed with indigenous materials and, once built, is adopted and maintained by the

community as a source of civic pride. The most hotly disputed of Leicester's sculptures was *Cincinnati Gateway* (1988), commemorating that city's two hundredth anniversary, which proposed, among other things, four three-foot-high winged pigs, a tribute to Cincinnati's pork-producing past. At first opposed by the city council, in the end the pigs stayed, and the bicentennial became a "celebration of pigs" with a parade float featuring pigs with wings, flying pig caps, postcards, T-shirts, and a fairy tale, "How the Flying Pigs Came to Cincinnati." All product royalties went to the city.

Prospect V-III *1982*

Located in Frostburg, Maryland, the historical center of western Maryland's coal mining industry, this project is the first and only regional memorial to acknowledge and commemorate the importance of coal mining for the people there. Funded by the state of Maryland, it was built with equipment donated by local miners. Leicester conducted extensive interviews with community members to plan the project. As word spread, widows and other family members offered mining implements, and a room of memory was added to house the artifacts. The donations included picks, shovels, lunch pails, and photographs, all incorporated directly into the work. The 123-foot-long sculpture incorporates nineteenth-century coal-mine architecture, with three small huts on piers leading to a mine shaft, representing stages in a miner's life from birth to death. The smallest, decorated with butterflies that collapse into black lungs, contains a coal car cradle on a one-way track. The center hut re-creates the region's method of extracting coal. The last hut has an octagonal rotunda with a fractured track below and ghostly miners' uniforms hanging above. An observation tower houses the artifact collection and museum, and community members proudly maintain the site and conduct tours.

Prospect V-III *1982*
Andrew Leicester

Flood Memorial Park *1993*

A Dayton, Ohio, citizens committee selected Leicester to make a public work in the old North Dayton neighborhood. As community representatives showed him around the area, relating significant historic incidents, the event remembered most intensely was the Great Flood of 1913, in which thirty-six people lost their lives. Although the flood was a tragedy, the recovery was remembered as Dayton's finest hour. The community agreed that Leicester should design a flood memorial. The local children's hospital donated land, and the project expanded to become a community park. Construction materials included memorial bricks etched with the victims' names along with donor bricks, similarly engraved, which were sold to raise funds to build the park. Newspaper articles solicited recollections from people who had experienced the flood, and their vivid accounts provided some of the images incorporated in the final project. Survivors of the flood spoke at the dedication ceremony, and they and their families toured the site in search of familiar names.

Flood Memorial Park *1993*
Andrew Leicester

255

MAYA LIN Sculptor and architect Maya Lin was born in Athens, Ohio. In 1981 the twenty-two-year-old Yale University architecture student was propelled into the national limelight when she won a blind competition to design the Vietnam Veterans Memorial for Washington, D.C. Controversy arose when it was announced that the memorial was to be her first realized work. Some have speculated that her age was in fact an advantage; having spent her formative years living under the divisive shadow cast by the Vietnam conflict, she had experienced the war as a concrete social presence. A second controversy surrounded the nonrepresentational nature of the design. Its art influences include the "truth in materials" dictum of minimalism, the earthworks of Robert Smithson and others, and the sociopolitical art of the seventies that insisted on inclusiveness and naming. On completion of the Vietnam Veterans Memorial, Lin returned to Yale to complete her Master of Architecture degree. In 1987 she set up a studio in New York City where she continues to design projects combining sculptural, architectural, and public interests, including *TOPO,* an environmental sculpture park for Charlotte, North Carolina, and the 1993 Museum for African Art in New York City's SoHo district. Her black and white granite *Civil Rights Memorial* installed in 1989 at the Southern Poverty Law Center in Montgomery, Alabama, honors those who died for racial equality and commemorates key historical events in the American civil rights movement.

The Vietnam Veterans Memorial *1982*
Maya Lin

The Vietnam Veterans Memorial *1982*
Situated in Washington, D.C., close by the Lincoln Memorial and within sight of the Washington Memorial, *The Vietnam Veterans Memorial* is an elegiac wound in the historical landscape. A 220-foot-long, V-shaped, polished black wall descends into the earth and rises out of it again. Its deepest point, the corner of the V, is ten feet below ground level. As one travels down the slope and the wall rises, one reads the first engraving, "1959," the year the war began. Then, listed in order of their death, without mention or regard for military rank, come the overwhelming names of the individuals who died in Vietnam. The last engraving is the year the war ended, "1975." It is impossible to visit the memorial without being physically and emotionally moved. The living visitors are reflected amid the names of the dead in the shiny granite surface. Mourners have adopted the wall as their own place of remembrance and healing, leaving family photographs, personal mementos, flags, medals, and flowers. Vietnam veterans dressed in their camouflage-patterned clothing are a continual, visible presence at the wall, a site inhabited by the living who cannot forget the dead. Nonheroic, Lin's memorial is based on war's grief, loss, and rupture. Its uniqueness resides in what it has become with

time: a place of pilgrimage and healing. Today it has the distinction of being the most visited monument in Washington, D.C.

HUNG LIU With life and art experiences that span two continents, Hung Liu combines portrait painting and cultural artifacts to explore the theme of cross-cultural immigration—the state of being suspended between languages, histories, and gender roles. Born in Chanchung, China, and trained as a muralist in Beijing's Central Academy of Fine Art, Liu emigrated to the United States in 1984. This training has influenced the public component of her art, as she creates work to address specific communities. In these projects and in her paintings, she uses a larger-than-life scale to enlarge the visibility of unacknowledged citizens. A permanent public installation at San Francisco's Moscone Convention Center, *Map No. 33* (1992), consists of forty-one shaped canvases representing the skewed geometry and handwritten place names of an 1839 map of the city. The work also incorporates historical artifacts retrieved from the ground under the center during construction excavations. Objects from everyday life, the artifacts commemorate the diversity of the cultures that contributed to the building of San Francisco between the Gold Rush and the 1906 earthquake and fire.

Reading Room *1988*
Reading Room was an installation on the history of Chinese immigration to San Francisco. The project had autobiographical significance for Hung Liu, a recent immigrant from Beijing, who, like her ancestors, entered America through the port of San Francisco. Unlike them, however, she was not assimilated into an age of great industrial development but rather into a postindustrial culture of images, clichés, and stereotypes. A metaphor for larger questions of change and continuity, the work was an actual reading room developed under the sponsorship of a community activist group, Chinese for Affirmative Action in Chinatown, at the site of what had been the first bookstore in San Francisco. Noticing that very few magazines or books in Chinese were available to the citizens of Chinatown, Liu wanted to return lost fragments of their written language. She borrowed an array of books in Chinese from an Asian bookstore. A scroll-like mural represented the historical development of Chinese characters, and the accompanying artifacts—such as clay and bronze vessels and bamboo books—offered a historical timeline from the Neolithic period to the present (much of the ancient Chinese language has literally been recovered from the soil). Above the scroll hung poems written in anonymity, homesickness, anger, and despair, recovered from the walls of Angel Island, the Ellis Island of Chinese immigration. Also shown were pictographs so ancient (perhaps four thousand years old) as to have lost their original meanings. Whether

Reading Room *1988*
Hung Liu

old or recent, the voices that inhabit these forms are all in some sense equally lost; only in Liu's reading are they reclaimed and honored.

YOLANDA LÓPEZ Since the late sixties, California artist Yolanda López has worked in a variety of art forms, including prints, posters, drawings, videos, and installations, to debunk media myths of Mexicans and Mexican Americans that have become a false common language in American society. Born in San Diego, López became politically active in the sixties when she moved to Northern California to study, and then dropped out of college to work more actively in the burgeoning rights movement in San Francisco's Latino Mission District. There her "art, politics and personal history all came together," as she worked in a neighborhood health clinic, provided legal aid for Mission residents, recruited for Vista, did social work at the Bayside Settlement Housing Project, and worked as court artist for the 1969 political trial of "Los Siete" (seven Latinos tried and acquitted of a police murder). Through her community work, López developed a direction and "a sense of who I was doing my art for. The streets were my gallery. I did posters, leaflets, lapel buttons, and graphic art for neighborhood newspapers. I saw my work everywhere, and unsigned." When the unsigned work was exhibited at Galería de la Raza in 1970, viewers voiced surprise, having assumed that it was done by men. After nine years of intense political activity, López returned to San Diego to complete her formal art training. There she completed her powerful contemporary Guadalupe series— over-life-size images of family and self that incorporate the iconic halo found in Virgin of Guadalupe folk paintings. Amalia Mesa-Bains writes: "The art in this series does not simply reflect an existing ideology; it actively constructs a new one. It attests to the critique of traditional Mexican women's roles and religious oppression in a self-fashioning of new identities." In 1979 López returned to San Francisco, where she continues to work and teach as a committed Latina activist.

Cactus Hearts/Barbed Wire Dreams: Media Myths and Mexicans *1986, 1988*
Yolanda López

Cactus Hearts/Barbed Wire Dreams: Media Myths and Mexicans *1986, 1988*
This installation exhibition and accompanying film, entitled *When You Think of Mexico: Commercial Images of Mexicans,* analyze how the entertainment industry, food manufacturers, and other corporate interests create mythic Mexicans—the "good" picturesque Mexican and the "bad" illegal Mexican. López critiques how men and women are portrayed in electronic and print media, and shows how symbols deliver both subtle and overt meanings through an unspoken cultural context. These pervasive popular images of Mexicans made by non-Mexicans—such as the Frito Bandito—reveal how American culture perceives Mexicans and Mexican Americans. Naming these media-

promoted images "Mexicana," she says, "What we have visible in mass culture is a corrupted artifact passing itself off as Mexican culture." López travels widely, presenting the film with lectures that promote discussions in community centers and universities. She states that "'Mexicana' affects not only how we perceive ourselves as Americans, but . . . how others will perceive us. The problem of a corrupted understanding of who we are becomes extremely important because it affects our access to education, employment, housing, health care and economic resources." López works to promote a critical visual literacy in the hope that more relevant depictions will begin to be produced and disseminated.

JAMES A. LUNA James A. Luna is a conceptual artist who works primarily in installation, performance art, and video. Born on the La Jolla Indian Reservation near San Diego, to a Luiseno Indian mother and a Mexican father, Luna grew up in Orange County, received an art degree from the University of California at Irvine, and moved back to the La Jolla Reservation, where he works as a full-time counselor at Palomar College. His work is concerned with parody, ritual, and autobiography and focuses on bicultural experiences in North America, often exposing myths and stereotypes about contemporary Native American culture. Luna explains: "I make my art for Indian people. In this way I do not separate myself from my community. In doing work about social issues, I use myself to explore conditions here on the reservation." He declines offers to exhibit outside North America, feeling that his audience and the issues he works with are particular to the continent.

Relocation Stories *1991*

Relocation Stories, a multimedia installation and performance work, drew on oral histories of Native Americans in the Bay Area. In the work, Luna described the experience of a group of Native Americans who participated in the Bureau of Indian Affairs Relocation Program in the fifties and sixties. The experience was an abrupt transition for many who had to adapt to urban life without the support system and familiarity of the reservations. "The reality is that moving here was a shock. Indians are not urban," Luna said. Over the course of a year, Luna conducted over two dozen interviews with people who relocated to Oakland through this program. He asked them to describe what life was like at the reservation and why they decided to accept the U.S. government's offer to move them. He also asked them about their first impressions and whether they regretted their decision. Personal artifacts, archival photographs, videotapes, and audiotapes were included in an installation at the ProArts Gallery in Oakland that explored the impact of this government program on individual lives and the life of a community. A solo performance piece was presented at the InterTribal Friendship House in Oakland and at the

Relocation Stories *1991*
James A. Luna

Capp Street Project in San Francisco. Through the portrayal of three characters, Luna described lives of alienation, poverty, success, and survival.

JOHN MALPEDE Los Angeles–based homeless advocate and performance artist John Malpede has produced more than one hundred street and theater performances reflecting the social, psychological, and political forces shaping the lives of the homeless. His troupe's work is chaotic and potent, unapologetic and "truthful" (qualities Malpede struggles to maintain), because it is rooted in the living autobiographies of its performers, who are themselves homeless. Malpede founded the Los Angeles Poverty Department (LAPD) shortly after moving from New York City in 1985. His earlier work in socially active experimental theater, including performances with the Bread and Puppet Theater, his theatrical parades that rambled through ethnic neighborhoods, and his monologues on social issues, prepared him for his work on Los Angeles's skid row. Working as both artist and paralegal for the Inner City Law Project, Malpede recruited for LAPD by holding weekly talent shows in the streets and in shelters. Unscripted scenarios and improvisation are LAPD's trademarks. Grounded in a gritty reality that is complex, unpredictable, and sometimes hostile, their shows dispel any romantic notions about living on the streets. Malpede says: "I think that one of the values of the LAPD is that we don't offer solutions. We put the facts on the table, and we feel that the solution is served by putting the facts on the table." Kevin Williams, who is assistant director and was formerly homeless, came up with a line for one of their shows that has since become their slogan: "You want the cosmetic version or you want the real deal?"

Olympic Update: Homelessness in Los Angeles *1984*

In 1984, while Malpede was still living in New York, the nonprofit art organization Creative Time, Inc., produced *Art on the Beach*, a series of collaborations among sculptors, architects, and performing artists on a landfill across the street from the World Trade Center in Manhattan. Deciding to do something explicitly about the homeless, Malpede researched the material presented in this "solo" performance by traveling to Los Angeles to see what was going on during the 1984 Olympic Games (a trip that later led to his relocating to Los Angeles). The performance of *Art on the Beach* was his "report" to New Yorkers. The installation included a monumental red megaphone aimed at the financial district through which Malpede told the story of LAPD—the other LAPD, the Los Angeles Police Department—which was making menacing helicopter sweeps over the city in an orchestrated removal of large groups of street people to "sanitize" the city for visitors to the Olympics. The performance ended

with taped excerpts from the Los Angeles County hearings on the homeless held in July 1984, in which a woman named Ella Graham tells what it's like for her to live on skid row in Los Angeles.

LAPD Inspects America *1988–90*

During LAPD's first residency at the San Francisco Art Institute Galleries, the members developed a strategy that allowed them to take their work to more cities, thereby solving worries regarding logistics, cost, and relevancy. When invited under the sponsorship of an arts organization in a host city, a small core group is sent to recruit local players, lead a workshop, and help to develop a production specific to that city. According to Malpede, "Even in six weeks an *LAPD Inspects* residency is a mission-impossible project, where we basically replicate our entire process in a hot minute. . . . We go to day centers, shelters, soup lines, health and mental health facilities (if there are any). We meet with the people who run the programs and with homeless people who use them. Our purpose is to figure out who we can work with and who we can't (whether to set up workshops in an existing service facility, whether to use the theater or gallery space of our sponsor, or whether to set up an empty storefront). . . . Once we're there we don't have enough time to start over, although, as usual, adjustment is the name of the game." When recruited from "day centers, welfare offices, shelters, bushes, boxcars, abandoned warehouses, and the streets," the novice company must be convinced that it's worthwhile to stay involved for two to six weeks of hard work and to perform in public. On the road, Malpede discovered that a loose scenario of multiple interwoven narratives worked best; "plays within a play" increased the odds of keeping the audience interested. A six-week residency in Chicago had three such interwoven stories, one about a wrongful firing and two about child abuse. The work went so well that local artists "are still working with the people we worked with, keeping the projects going on their own."

LAPD Inspects America *1988–90*
John Malpede

DANIEL J. MARTINEZ Born and based in Los Angeles, conceptual artist Daniel J. Martinez utilizes photography, video, computer technology, telecommunications, and text in his large-scale site-specific installations, performances, and public art projects. From his beginnings as a photographer, sculptor, and installation artist, Martinez has developed a cross-media vocabulary in public works and large-scale performances. His stated aim is "to strategically challenge city structures and mediums that mediate our everyday perception of the world . . . through aesthetic-critical interruptions, infiltrations and appropriations that question the symbolic, psycho-political and economic operations of the city." His confrontational work, often using the street as his forum, has drawn intense public debate. In 1991 he installed *Nine Ways to Improve the Quality of Your Life,* a series of street banners hung in the well-to-do shopping area of downtown Seattle. In

developing the work, Martinez interviewed Seattle's "haves" and "have nots." One side of each banner asked a "have" question, such as "DO YOU HAVE A BEACH HOUSE OR A MOUNTAIN HOUSE?," while the reverse, white with black text (with a generic image of a house and tree), asked "DO YOU HAVE A PLACE TO LIVE?" The benign-looking yet inflammatory work instigated a *Seattle Times* front-page story, editorial columns, and an unprecedented barrage of letters to the editor debating both the art and its messages.

Consequences of a Gesture *and* **100 Victories, 10,000 Tears** *1993*
Daniel J. Martinez

Consequences of a Gesture *and* **100 Victories, 10,000 Tears** *1993*
Martinez developed two distinct but connected works for Sculpture Chicago's *Culture in Action* program. The first was a grass-roots parade in celebration of community, produced in collaboration with Los Angeles composer VinZula Kara and Chicago's West Side Three-Point Marchers (Los Desfiladores Tres Puntos de West Side). More than thirty-five community organizations and one thousand Mexican Americans and African Americans participated, from children to senior citizens. Requiring two years to organize, the parade wended through three ethnically different, geographically separate neighborhoods, with marchers bused between them. Community organizers, inspired by the high level of participation, are considering restaging the parade annually. The second work was an outdoor public installation near Maxwell Street, Chicago's famous open-air market. Martinez intended to memorialize the neighborhood, marked for renovation by the University of Illinois. Working with the university, the Maxwell Street Market and its vendors, the city of Chicago, and architect Walter Netsch, Martinez moved thirty huge granite building slabs from another university renovation in what he called "literal decon-structions," resiting them in one of the university's recently purchased, fenced in lots in the Maxwell Street area. Attached to the cyclone fence surrounding this newly created "historical ruin" were twenty-four signs citing historic labor events specific to the area and philosophical thoughts. Examples are "Haymarket Square Desplaines & Randolph May 4, 1886—176 Policemen Attack 200 Workers 4 Die" and "I Am Nothing and You Are Everything."

DOMINIQUE GW MAZEAUD Ritual performance artist dominique gw mazeaud names herself a "heartist." Born in Paris, she emigrated to New York City in 1967 but in 1986 was drawn to settle in Sante Fe, New Mexico. Working in the spirit of Joseph Beuys, Marina Abramovic, and Allan Kaprow, mazeaud constructs and values daily life itself as a meaningful, interconnected performance. Since 1979 her quest has been to "find the spiritual in art in our time," which has led her to do "art for the earth." She worked in private until appearing in *Forgiveness Is the Key to Peace* (1986), a piece for which she spent one week living in a New York City storefront

window—one of fifty-two women in *Windowpeace,* inspired by England's Greenham Common women (see Margaret Harrison). Her methodology includes ceremony, performance, journal writing, poetry, teaching, curating, lecturing, and collaborating with other artists and nonartists. She says, "Listening, connecting, relating are key words." In 1993 she created *The Road of Meeting,* for which she traveled 2,500 miles throughout North Carolina in three weeks to meet with local environmentalists—especially "elders." She collected individual stories, photographs, handprints in local mud, and local water and soil samples which were then exhibited in a mandala-like installation. Her strategy promoted grass-roots networking, which she calls "netweaving," and brought attention to unsung stories and good works.

The Great Cleansing of the Rio Grande *1987–continuing*

On the seventeenth day of each month, continuously since September 1987, mazeaud walks the riverbed of the Sante Fe River, a small tributary of the Rio Grande that flows through Sante Fe, New Mexico, to repeat her "great cleansing" ritual performance. Armed with large garbage bags provided by the city, and often accompanied by friends and community members responding to her announcements of "art for the earth" in local newsletters, she stoops to collect trash—cans, household junk, garbage—thoughtlessly thrown into the river. Sometimes no one else shows up, and she walks alone, cleaning and listening, directing renewed energy toward the Rio Grande. Her original intent was clearly political: to act as a catalyst for environmental awareness, despite the acknowledged futility of single-handedly cleaning the river. Her intent transformed with time into the simple reverential act of being with the river. Essential to the project is a river journal called "riveries" in which mazeaud records her impressions of each event. She writes: "All rivers are connected; I have learned that frequenting my river. . . . People function in the same way. One way to activate these currents is through ritual. Rituals are icons of connections, they are the art of our lives."

The Great Cleansing of the Rio Grande *1987–continuing*
dominique gw mazeaud

RICHARD MISRACH Since the seventies, Northern California artist Richard Misrach has been best known for his Desert Cantos series: large format, nonromantic, light-saturated color photographs of the American desert invaded by U.S. military forces. At age twenty-two, as a psychology student at the University of California at Berkeley, Misrach was drawn to the social and political activity on crowded Telegraph Avenue. In the middle of the night, he set up a tripod on the sidewalk and began taking portraits of nocturnal wanderers. The result was his first photographic essay book, *Telegraph 3 A.M.,* published in 1972. His second book, *Desert Cantos,* established his national reputation. Broad desert vistas are

populated with the marks of human invasion: a strong military presence, uncontrolled fires, open pits of rotting dead cattle, and life destroyed by the flood of the human-made Salton Sea. The political content of his work is informed by his ongoing active involvement in the antinuclear and antiwar movement. Misrach's personal activism and his photographic and conceptual works implicitly support these movements.

Bravo 20: The Bombing of the American West *1990*
Richard Misrach

Bravo 20: The Bombing of the American West *1990*

Bravo 20 is the name of a U.S. Navy bombing range in the Nevada desert. Misrach has proposed transforming it into America's first environmental memorial park on November 6, 2001, when the Navy plans to withdraw from the site. This proposed national park, on sixty-four square miles of abandoned bombing range, would serve an educational function and include a theme park of destruction, a Boardwalk of Bombs, a self-guided automobile tour along Devastation Drive, and a museum. The idea for the project originated in 1986 when Misrach visited the small town of Gabbs, Nevada, to learn more about military activity in the area, and learned of night raids on rural residents by Navy helicopters, laser-burned cattle, the bombing of historical towns, and the "unbearable supersonic flights over rural America." There he met two residents, Doc Bargen and Dick Holmes, who were waging their own war against the U.S. military. They showed Misrach a desert littered with artillery shells (some still capable of exploding) and pitted with bomb craters that proved the military had been secretly using public land for testing high-impact bombs. Misrach joined the men's cause to bring the military destruction to public awareness. For five years his darkroom became an archive on the war the Navy had waged on Nevada and how people who lived in the area had retaliated. In 1990 Misrach published and exhibited the resulting photographs and proposal drawings with a text by Miriam Weisang-Misrach.

MUJERES MURALISTAS In 1973 San Francisco artists Patricia Rodriguez and Graciela Carrillo founded the Mujeres Muralistas (Women Muralists) as a protest against their exclusion from the male-dominated mural projects prevalent in California at that time. Their first collaborative mural was sited on an alley wall near Rodriguez's Mission District apartment. Called Balmy Alley, the alley is now famous for the many important Latino community murals that lined its walls in the seventies. By 1974 Consuelo Mendez, Irene Perez, Esther Hernandez, Xochitl Nevel, Tui Rodriguez, Miriam Olivos, and, later, Susan Kelk Cervantes had joined the group. Mural historian Timothy W. Drescher calls Mujeres Muralistas "the most influential mural group in the early seventies. . . . The mere fact that a group of Latinas were painting large-scale public murals caught the imagination of women muralists through-

out the state, and . . . everyone understood their dual significance: women painting murals, and an ethnic minority asserting its own culture." Their murals focused on highly visible images of women and everyday scenes emphasizing ceremony, celebration, caretaking, harvest, and the land. After painting nearly a dozen murals, the group disbanded in 1976, although some members continued to collaborate.

Latinoamerica *1974*
Latinoamerica was a mural in the Mission District of San Francisco that depicted a panorama of traditional Latin American cultures combined with current cultural manifestations. A family dominates the center of the mural, flanked by sun and moon, Bolivian devil dancers, Andean pipe players, and a pyramid of corn. Growing cornstalks were painted as a border on the lower edge. Influenced by the Chicano movement, the artists came together with a common cause, learning their own heritage, and connecting with their Latin roots. According to Susan Kelk Cervantes of Precita Eyes Muralists in San Francisco, the mural was created through a process of sharing and collaborating unique to mural art. Drawing images from their own resources and experiences, four women designed the mural—Esther Hernandez, Consuelo Mendez, Irene Perez, and Patricia Rodriguez (all American born except Mendez, who is Venezuelan)—and all eight members worked together to paint it. During production, passersby would comment on the mural's progress and its content, exchanging stories of their Latin American origins. Painted on a wall facing the parking lot of the former Mission Hiring Hall, the mural was lost in the late eighties when it was painted over.

VIET NGO Born and raised in Vietnam, Viet Ngo emigrated in 1970 to Minneapolis, where he received a master's degree in civil engineering while also studying sculpture. A fusion of engineering, architectural planning, ecology, and art, his community-specific works are "water parks" that resemble modern and prehistoric earthworks but are, in fact, utilitarian and organic wastewater treatment plants. Ngo states: "People have asked me if my work is public art. That is my intention, but I do not like to use those words because they segregate me from the working people." In 1983 he founded a company based on his patented system using duckweed (Lemnaceae) to clean wastewater. A simple floating geometric grid allows systematic control of duckweed growth, facilitates its harvesting for protein-rich animal food, and offers myriad aesthetic design possibilities. Ngo works with communities over long review periods to design parklike surroundings, interpretive areas where the public can study the systems, and recreational footpaths. Ngo believes that artists should design public infrastructures because "visual design determines the level of

consciousness and identification people have for their surroundings." His waste systems have been adopted by more than thirty small to midsize communities all over the world.

Devils Lake Lemna *1990*

Devils Lake Lemna *1990*
Viet Ngo

Seen from the sky, the Devils Lake Lemna project looks like a prehistoric snake-shaped mound or a giant animal's intestine winding its way across the landscape—an apt metaphor for the sixty-acre wastewater treatment plant, which is also a functional earthwork sculpture. Devils Lake, one of the largest lakes in North Dakota, has no outlets, and has become contaminated from farm fields and sewers. In 1988 the Devils Lake city commission approved Ngo's plan to install the world's largest *lemna* project to date. Requiring two years of community planning and construction, the project includes a four-mile-long canal compressed into sixty acres, two hundred feet across and ten feet deep. Excavated earth was packed into dikes or jetties and then landscaped and laid out with roads and footpaths. Numerous bends in the canal provide nesting areas for waterfowl, and two buildings anchor each end of the waterway, one a small testing station, the other a dome-shaped visitors' center. Public artist Richard Posner participated in planning specific interpretive pieces for the center. The work has engendered local involvement, civic pride, much public use, cost savings, and environmental stability for the Devils Lake community.

ADRIAN PIPER Adrian Piper's work as both a philosophy scholar (she holds a Ph.D. from Harvard) and a conceptual artist is characterized by a concern with racism and xenophobia, and a commitment to art's role in effecting social change. While the issues in her work derive from the circumstances of her life, she is not interested in self-revelation so much as in sociopolitical consciousness-raising. Born in New York City, Piper grew up in Harlem with a conflicted sense of identity. Black and poor, she attended on scholarship an exclusive, predominately white private school, where her light skin caused many to mistake her for white. Piper was influenced in the late sixties by conceptual art, but during the aftermath of the Kent State University killings her work became committed to sociopolitical ideology. In the early seventies, Piper performed improvisational events, unannounced exercises in social provocation, which she called the Catalysis series. In these confrontational pieces, she appeared in public places after altering her appearance to what she considered to be an extreme manifestation of Otherness. For instance, one day she might go out in foul-smelling clothing to ride the subway, on another day she might be seen walking around town with a red towel hanging from her mouth. The notion of catalysis—catalyzing a reaction

and inspiring consideration of social difference—has been central in her work ever since.

Funk Lessons *1983–85*

Funk Lessons, subtitled *A Collaborative Experiment in Cross-Cultural Transfusion*, was a performance modeled on the structure of a classroom lecture. Piper taught the audience members how to do black popular dances as a way to attack the myth of genetic aptitudes such as the ability of blacks to dance. During the performance, Piper frequently switched between an academic style and street talk. She originally performed the piece for small groups of six to ten individuals, and then for larger audiences of fifty to two hundred. The audiences were of mixed race and gender and included students, artists, street people, and passersby in differing proportions, depending upon the venue. As Piper describes the piece, "It began as a lecture/dance class format and gradually evolved into a Funk/Rhythm and blues dancing party in the course of the evening. In it I introduced the idioms of Funk, analyzing its musicological structure, origins, themes and influence on other genres of composition; and led the audience in practicing some of the basic dance movements. I also discussed with the audience some of the socio-psychological reasons for its denigration or rejection by the white mainstream, and the resistance of the art audience to acknowledging it as an appropriation from popular culture having the same validity as any other."

Funk Lessons *1983–85*
Adrian Piper

Out of the Corner *1990*

This installation at the Whitney Museum of American Art expanded upon an earlier piece, *Cornered,* in which Piper confronted the viewer via video from a large monitor barricaded in a corner behind an overturned library-type table. The monitor was flanked by two birth certificates; one identified Piper's father as white, the other as black. Piper appeared conservatively costumed, in a self-described "bourgie, junior miss style." She did not appear to be black. She assertively began by stating: "I'm black. Now let's deal with this social fact and the fact of my stating it together." Piper may have been "cornered" but she "cornered" the viewer as potentially racist, concluding: "But let's at least be clear about one thing. This is not an empty academic exercise. This is real. And it has everything to do with you." In *Out of the Corner,* she placed sixteen monitors in "battle formation" around the original monitor and table, each with a single white male or female from Western countries speaking in different languages. Foreign-language subtitles ran across the bottom of each screen, and at intervals, the pop song "We Are Family" could be heard. On the walls were sixty-four framed portraits of socially diverse black women from *Ebony* magazine. Halfway through Piper's *Cornered* monologue, the surrounding monitors activated in rapid succession with the speakers shifting to English to say, "Some of my female ancestors were so-called 'house niggers' who were raped by their white slave masters. If you're an American, some of yours probably were, too."

TIM ROLLINS AND K.O.S. Tim Rollins and K.O.S. have been making art collaboratively in their South Bronx studio since the early eighties. Rollins, cofounder of Group Material, a political artists' collective, began teaching special education classes at a South Bronx public high school in 1982. The self-named K.O.S. (Kids of Survival) evolved from a group of regulars in Rollins's after-school workshops. This pedagogic relationship is steered by Rollins, who has the role of mentor and director in a professional studio environment set up to study and produce art. The artworks produced there take the form of large collaborative collages, often of texts the students have read, to which painting is applied. These pieces became quite successful as paintings, commanding high prices in New York City galleries. But Rollins's "growing dissatisfaction with negative imagery led K.O.S. in another direction. Holding a mirror to the vital problems in the neighborhood wasn't enough, only serving to reinforce and reproduce the dominant culture's long-held, one-dimensional view of the South Bronx and its inhabitants. In the time just before the first *Amerika* painting, there was the pressure, the desire, and the need to create a work of art that was political, vital, critical, and yet *beautiful* all at once." Rollins was interested in an art that was political not only in its form and content but also in the way in which it was made.

Amerika *1984–89*
Tim Rollins and K.O.S.

Amerika *1984–89*

The Amerika series is the largest body of work by Tim Rollins and K.O.S. and is based on Kafka's unfinished novel with the same title. The first painting began in Rollins's classes, which included approximately one hundred students. Rollins read the book to each class and would ask the kids not to illustrate the story but rather to relate it to their everyday lives. The subject matter, a tremendous variety of horns and trumpets, comes from a passage in the book in which horns symbolize the opportunity for free speech in America, "where everyone has a voice and everyone can say what they want." The idea to use horns as a motif was inspired by a group of thirty drawings of strange and different horns brought into class by Gregorio Torres. When Rollins asked the kids to represent their freedom and their unique voice in the form of a golden horn, the project took off. Subsequent paintings in the series were created with a smaller group of students who visited museums and looked at art books and images from popular culture. Extensive drawing and painting study sessions preceded the final painting, completed directly on pages from Kafka's book mounted on a canvas.

South Bronx Academy of Fine Art *1991–continuing*

Rollins is now in the process of developing the South Bronx Academy of Fine Art, a free school for artistically gifted fourteen- to

eighteen-year-olds from the community. Rollins expects to be able to support this school at least in part with proceeds from art sales. The school's progress has been delayed due to the economic climate of the nineties and the art market crash in 1992. With its conceptual design finished, the project is currently in the negotiating phase with the city, state, and the Board of Education of New York for the seven million dollars needed to complete it.

JOHN ROLOFF John Roloff was born in Portland, Oregon. While studying marine geology at the University of California at Davis in the sixties, he was influenced by the civil rights and antiwar movements and switched to art. According to the artist, the politically active, staunchly populist philosophy of the art department at U.C. Davis changed his life. (An important mentor was the ceramic sculptor and social satirist Robert Arneson.) Exploring experimental ceramic sculpture, Roloff rediscovered his interest in science, which melded with his art in a series of participatory earthworks based on fire, landscape, and community. Historically, ceramics involved a community process of shared labor; prior to the invention of electricity, a kiln firing was often a prodigious group effort. Today the ceramics profession retains a strong ethic valuing collective effort and human labor. This community ethic is an essential element in Roloff's elegant pyrotechnical work, the Furnace series. Roloff began by working outdoors with geological ideas, uniting the fire of the ceramic process with the earth's internal fire (volcanic activity). His work compressed vast geological events into a human time frame and brought humans and nature together in the process. Spanning the late seventies to the early nineties, the furnace projects began as teaching workshops, in which fourteen to thirty people came together for up to four weeks to clear a site and construct a structure. By the late eighties, popular word of Roloff's furnace works spread, and the events were covered by the local press. The public was invited to witness the completed work, a dramatic pyrotechnical performance reminiscent of a prehistoric gathering around a collective fire pit. (The event's short duration belied the one year of design and planning that Roloff put into each work.) When the firing event was over, some works remained on site while others were dismantled. *Untitled (Earth Orchid)* (1988, Hartford, Connecticut), which was allowed to stand, altered with time to become a memory of the fire. *Humboldt Ship* (1989), permanently and prominently located on the campus of California State University at Humboldt, in Arcata, has inspired students to perpetuate an oral tradition about the work's origin. Roloff's recent public

work explores the relationships and dynamics of change in natural and environmental systems, often expressed in site-specific greenhouselike works that incorporate an image of a boat. For these projects he collaborates with other artists, architects, landscape architects, and civic professionals.

Wave Ship (of Fire) *1984*
John Roloff

Wave Ship (of Fire) *1984*

Roloff was invited to do an outdoor furnace work by the historically eminent Pewabick Pottery in Detroit. Drawn to the adjacent river as a visual backdrop, Roloff chose Owens Park, near downtown Detroit, as his site. For nine days a continuous stream of volunteers—often numbering thirty to forty and including students from the five colleges nearby—worked together to clean the site and build the structure. Crews moved materials, broke up concrete slabs, filled in washed-out areas to level the site, and built a low platform. It was comparable to a community barn raising or quilting party, especially since sewing was needed to attach the furnace's soft lining of Kaowool (a high-temperature ceramic fiber). Roloff chose construction materials relevant to the site's surrounding industries. Volunteers distributed flyers to invite the public to the pyrotechnical performance event. By the afternoon of the event, the structure was complete and its natural gas fire lit. In the early evening, people began to arrive, many carrying festive picnic suppers. As it grew dark, the furnace's fire glowed brighter. Emergency police and firefighters were on hand. As its temperature climbed, the sculpture became transparent with radiant light, a sculpture of contained fire that lit the night sky. At the height of the spectacle, the audience numbered three to four hundred people—strangers drawn together around the fire. When turned off, the furnace continued to glow for hours while cooling. Roloff says, "The piece tells you when it is done. It gets to a point where the fire is so powerful that I become a spectator. No one owns it; it's more powerful than any single person. It becomes a kind of conjuring. The firing creates a kind of memory, both as an intense image in the minds of the people who witness the event and in the alteration of the materials that come in contact with the heat."

RACHEL ROSENTHAL Animal-loving, earth-worshiping Rachel Rosenthal is a potent force in contemporary performance art. Combining elements of theater, dance, painting, sculpture, projected slides and texts, and taped and live music, she creates art oriented around ecological themes and animal rights, relating these to a coherent worldview that is at once apocalyptic and profoundly optimistic. Born in Paris to Russian parents, Rosenthal moved with her family first to Brazil, when the Nazis invaded France, and later to New York City. After studying with Hans Hoffmann and Merce Cunningham, she found her own voice when she moved to Los Angeles in 1955. The following year, she founded Instant Theater with her

husband which for several years became an experiment in improvisational performance for Los Angeles actors and artists. In the early seventies Rosenthal, then working as a sculptor, rediscovered her theatrical roots through performance art. Her first performance, *Rachel's Knee,* was presented at the Los Angeles Woman's Building. Since 1975 she has written, directed, and acted in close to thirty full-length performances in the United States and Europe. In *Performing Arts Journal* Bonnie Marranca writes, "One of the profound themes in Rosenthal's work is the understanding that the ecosystem is inseparable from the cultural system of a people. This insight returns to the ancient view of the world in which history, myth, religion, ecology, philosophy, and aesthetics were considered together in any reflection on human affairs." Rosenthal is the recipient of numerous awards, including a 1989 Obie for *Rachel's Brain.*

The Others *1984*

In *The Others,* a large-scale performance on animal liberation, Rosenthal shared the stage with more than three dozen live snakes, horses, goats, rabbits, hamsters, squirrels, cats, dogs, rats, doves, parrots, monkeys, macaws, and a turkey. The performance was a dramatic exploration of the theme of the exploitation of the weak by the strong. In the piece, Rosenthal first portrayed the oppression of blacks and the subjugation of women. This set the stage for an investigation of human exploitation of animals in sport, recreation, science, and agriculture. Speaking for their victimhood and reframing their exploitation by science as a rights issue, she delivered a message that animals are as deserving of simple justice as any of the earth's sentient beings. For each of several performances, Rosenthal placed an ad in local newspapers requesting participation from conventional and unconventional pets and their people. She visited over eighty-five respondents and their animals, making sure they understood what would be required to take part in the performance. At the University of North Carolina at Raleigh, Rosenthal worked with author Tom Regan, who wrote *The Case for Animal Rights,* and included new criteria: each animal involved had to have a history of abuse and rescue. Among the wide array of animals were an owl with a broken wing, big boas with cigarette burns on their bodies, and a horse that was left in a barn to starve to death. Biographies of each of the animals were printed in the program. The procession at the end of the performance included more conventional pets and cats and dogs from the local pound. By the end of the performance, every animal from the pound had been adopted by audience members.

The Others *1984*
Rachel Rosenthal

A Floater of Feelings *1994*

An important body of work parallel to Rosenthal's public-issue performance work has been direct community outreach. Through a format she developed in 1982 of a workshop followed by a performance,

she empowers community groups to create a public performance as a public information tool, with the intent of bringing the group's pressing social and political issues to the larger community's attention. Since health issues—personal, community, and planetary—are a priority in her own work, Rosenthal has a special affinity for working with grass-roots health groups. Representative of this work is *A Floater of Feelings,* the public performance dealing with problems of substance abuse and HIV/AIDS that she developed with the women residents and staff of PROTOTYPES Women's Center in Los Angeles. The performance consisted of collaboratively created and acted group scenes, interwoven with solo performances of three-minute-long "life stories" based on real personal experiences. Rosenthal says: "I believe performance art can accomplish a great deal in reinfusing these women with self-knowledge and energy. . . . [They] can overcome their situation and will learn to celebrate life, honor earth and develop skills that can help them in daily life."

MARTHA ROSLER The prolific career of New York–based activist-feminist artist Martha Rosler spans more than twenty years of critical writing, photography, performances, and installations. Based in Southern California during the seventies, Rosler worked within the multiple contexts of the Woman's Building in Los Angeles with its feminist activist theory, Marxist art theorists and practitioners, and performance explorers of the boundary between art and life. Her work continues to reveal the complicated influences of this rich heritage, ranging from lifelike performances to photography to theoretical writings. As such, her work addresses various audiences, from the critically sophisticated art world (through writing and gallery installations) to people in the street (through performances, postcards, and public installations). Her critical writings argue for a reassessment of the voyeuristic, elitist nature of documentary photography and video. Her art consistently addresses economics and consumerism within and outside the art world and analyzes how women and minorities figure into the political environment of capitalism.

Tijuana Maid Postcards *1975*
Tijuana Maid is the third in a series of serial postcard "novels" Rosler produced. She mailed one installment of these first-person narratives each week for twelve to fifteen weeks, depending on the length of the particular "novel." Each told the story of a woman and her relationship to food production and consumption. The works went to a varied list of community members, art world figures, and friends. *Tijuana Maid,* in Spanish and English, was based on discussions with undocumented women from Mexico working as maids in the San Diego area. *Tijuana Maid*'s composite character describes the economic and personal difficulties these women experience. The text, prepared

with Mexican friends living in the United States, includes phrases drawn from the manual *Home Maid Spanish,* sold in local supermarkets. *Tijuana Maid* and the two preceding postcard novels, *A Budding Gourmet* and *McTowers Maid,* portraying the personal effects of capitalism on workers in the food and home care industries, have been collected in a small book, *Service: A Trilogy on Colonization.*

If You Lived Here . . . *1989*
This project, a series of three exhibitions and four town-hall-style meetings, conceived of and directed by Rosler, identified the forces that dominate the structure and use of New York City itself. Exploring issues of housing, homelessness, and urban planning, the work in these exhibitions was made by high-profile professional artists, community groups, schoolchildren, homeless people, community-based artists, poor people, squatters, shelter residents, art students, and others. Siting the exhibitions inside a noncommerical gallery, Rosler tied the SoHo art presence to its real estate and the process of redevelopment. During the eighties, redevelopment in New York City resulted in a massive displacement of residents. This project illustrated the fact that eviction is no random by-product of gentrification but an essential component of it. *Home Front,* the first exhibition, suggested a war zone occupied by contested urban housing and directed embattled tenants to neighborhood advocacy organizations. *Homeless: The Street and Other Venues* was the second exhibition. The third exhibition, *City: Visions and Revisions,* offered solutions such as designs for urban infill housing, and housing for homeless women and people with AIDS. There was an effort throughout to erase the boundaries between the gallery inside and the community outside: couches and rugs faced video monitors, and billboards (signs of the street) were hung on the gallery walls. A reading room provided activist materials such as demonstration flyers, organizational brochures, and lists of private and public shelters and soup kitchens. On-site counseling was provided by Homeward Bound, a self-organized group of homeless people who opened a temporary office in the gallery. The public discussions were lively community events.

If You Lived Here . . . 1989
Martha Rosler

ROBERT SANCHEZ AND RICHARD A. LOU

Well-respected for their individually produced, socially critical art, Chicano conceptual artists Robert Sanchez and Richard A. Lou also work collaboratively as a conscious political strategy to democratize the art process and underscore the importance of community. Based in San Diego, they share common territory, the U.S.-Mexican border zone, with its politics of fear and exclusion and corrosive effect on family and community life. Employing the conceptual language of a third culture, a "border people," their work strives to deconstruct inflammatory media-derived misinformation about immigrants and to produce empathy and respect for the cultures of Others within

our own borders. Both say that their work also stems from childhood estrangement from a community mainstream. Born in Texas and educated in the East, Sanchez, whose father was in the Navy, moved frequently as a child. Lou was born and raised in San Diego–Tijuana neighborhoods and often felt excluded because of his mixed Mexican American and Chinese Mexican cultural background. The two began working together in the mid-eighties as members of the Border Art Workshop/Taller de Arte Fronterizo (BAW/TAF), which produced dynamic, community-interactive installations and performances. In 1990 both left BAW/TAF to concentrate on independent work while continuing to collaborate with each other. In one major solo installation, *Encinitas Gardens II* (1988), at the San Jose Institute of Contemporary Art, Sanchez exposed the use of lethal pesticides in the flower growing industry of North San Diego County. Hidden by the beauty of flowers, enormous profits are gained through blatant disregard for the health of a politically powerless migrant workforce, many of whom are children. One example of Lou's solo work is a photographic portrait series shown at the San Diego Museum of Contemporary Art in La Jolla that explores the fraudulence of social documentaries. Accompanied by compelling narratives written by Lou, the photos are self-portraits of him disguised as archetypal lower-class urban personalities.

Entrance Is Not Acceptance *1991, 1992, 1993*
Robert Sanchez and
Richard A. Lou

Entrance Is Not Acceptance *1991, 1992, 1993*

A collaborative multimedia installation by Sanchez and Lou, *Entrance Is Not Acceptance* originated in 1991 at the third biennial exhibition of the Newport Harbor Art Museum, near Los Angeles, and traveled to the 1992 biennial exhibition in Istanbul, Turkey, and in 1993 to the Civic Cornerhouse Gallery in Manchester, England. A recurring strategy in their collaborative work is to construct disorientating spaces in which the audience gains empathy for the physical and mental displacement experienced by immigrants. In this piece—a metaphor for the exclusion and confusion of border politics—a phalanx of battered, closed doors revealed, when opened by participating visitors, a maze of written text, slide projections of newspaper articles, and videotaped interviews. Some doors led to blind alleys, others to claustrophobic cells lined with the text of interviews with undocumented workers. Several doors opened onto a black wall with a viewing slit that revealed three sets of videotaped interviews. Sanchez and Lou taped these interviews themselves at U.S.-Mexican border settings. In one, undocumented migrants tell personal experiences. In another, the artists interview participants of "Light Up the Border," a 1989–91 series of anti-immigrant vigilante-like events in which people aimed their car headlights toward Mexico to thwart border crossings. In the third video, officials, educators, and theorists

discuss "marginality, institutional racism, internalized racism, cultural diplomacy and the future for the 'Multi-Cultural Reality.'"

BONNIE SHERK Bonnie Sherk coined the term Life Frames™ in the early seventies to describe the visual and conceptual aspects of her environmental performance art. The term as she now uses it relates to interactive participatory programs and curricula integrated into indoor-outdoor environments. Her earlier expanded artworks were "life-oriented" in their subject matter and choice of materials—people, animals, plants, and natural systems—and incorporated found environments and audiences. In the early seventies, for example, Sherk did a series of performances at the San Francisco City Zoo, which included publicly eating a meal inside a zoo cage adjacent to lions and tigers. Later, with artist Howard Levine, she made a series of portable parks, bucolic oases that included a live cow, a picnic table, potted palm trees, chickens, and turf. The parks could be transported from one urban site to another, set up for a day, and reassembled subsequently in another site. More developed manifestations of her ideas have resulted in complex social, cultural, and environmental educational programs that have brought her vision of an ecological, social, and participatory art to a broad cross section of the participating urban community.

Crossroads Community (The Farm) *1974–80*
Crossroads Community, commonly known as the Farm, was an award-winning urban environmental education and multiarts community center responsible for the transformation of seven acres of disparate land parcels—all adjacent to and incorporating a major freeway interchange—into a "city-farm" park near San Francisco's Mission District. This life-scale "performance sculpture" brought people from many different disciplines and cultures together with each other and with a diversity of plant and animal species. It was also the meeting place for a broad spectrum of ethnic groups from the neighborhood, including Latino, Filipino, Samoan, African American, and Caucasian people. The community included demonstration projects on responsible agriculture; children's art and dance classes; pottery and printmaking workshops; a rehearsal and performance space supporting local theater and music; activities for psychiatric patients and senior citizens; a solar greenhouse; organic vegetable gardens; and the Raw Egg Animal Theater, where children could observe and approach ducks, geese, rabbits, goats, and chickens. In Sherk's words, the Farm created "a way of calling attention to the connectedness that exists everywhere." The Farm was Sherk's most ambitious early Life Frame™, and though other alternative art spaces followed, it was distinguished by her aesthetic vision of sculpture and performance.

Crossroads Community (The Farm)
1974–80
Bonnie Sherk

A Living Library™ *1981–continuing*

Collaborating with teams of architects, landscape architects, and city planners, Sherk is developing her concept of a Living Library™ through proposals submitted to various institutions. Sherk defines a Living Library™ as "an indoor/outdoor culture-ecology" Think Park™ and "lifelong learning magnet that brings the local culture and ecology of a place to life," unifying disparate sectors of the community. This will be achieved by integrating the built and ecological environments with "the humanities, sciences, and social sciences . . . through plants, visual and performed artworks, programs of lectures, demonstrations and workshops, and video and computer arts and technologies." Sherk believes that linking natural, cultural, and technological systems is critical, and that an awareness of the essential connections becomes internalized when people are engaged in meaningful community actions.

CHARLES SIMONDS For more than twenty-five years, sculptor Charles Simonds has been propagating architectural microcosms. Constructed of miniature clay bricks on city sidewalks, vacant lots, and building ledges, and built of unfired clay, Simond's microcivilizations resemble archaeological ruins. Unpeopled, they are evidence of an abandoned culture Simonds has named "Little People" and has developed as a process of contemplation. "When I'm thinking about things, I'm not thinking about art. Which is to say I think about life, I think about how organisms go through changes." In the late sixties he turned his entire New York studio into a highly personal fantasy civilization composed of clay, his own body fluids, and found street objects. In the seventies he left the studio to work in the streets, and up through 1989, whenever he installed work in museums throughout Europe and the United States, he would construct a parallel civilization in a publicly accessible urban neighborhood. His dwellings have a loose resemblance to those of the Pueblo Indians of the American Southwest, but the forms and the philosophical meanings of the dwellings spring from Simonds's investigations into how people inhabit their bodies, their communities, and their natural environment. Lucy Lippard writes: "His tiny adobe houses and sensuous clay landscapes are a surprisingly universal image. In workers' neighborhoods in New York they recall Puerto Rico; in Paris, Tunisia; in Germany, Turkey."

Untitled "Dwellings" of the Lower East Side *1971–76*

Simonds became a local folk hero as he traversed New York City's Lower East Side, carrying clay, miniature handmade bricks, and sticks, working daily to build his fantasy civilizations. Ted Castle said of the work: "The *Lower East Side Dwellings* exist only in the past, very few of them having been photographed or written up. They were

everywhere and nowhere. They were underfoot and up in the sky, on ledges, nooks and windowsills. They were in gutters, sheltered by a curbstone, or just anyplace that looked like a good place to put one. At the same time they were invisible. Rushing by, you could completely miss them. Parking your car, you could smash one in a millisecond. But out looking around you might chance on a *Dwelling* being made [by] a guy usually surrounded by children, mostly little boys, sometimes girls and young men." Simonds talked to people as he worked. He got to know life stories and community issues, such as reclaiming abandoned lots for neighborhood use. A positive result was La Placita Park—more commonly called Charles's Park—collaboratively developed by Simonds and the community. The analogies made by his work were not lost on his audience when they witnessed his small decaying cities sited against the backdrop of the deteriorating neighborhoods of New York. Simonds's public artwork provoked local discussions of the surrounding environment, linking neighbors who had never conversed before, and even led to a rent strike for better housing conditions.

Untitled "Dwellings" of the Lower East Side *1971–76*
Charles Simonds

BUSTER SIMPSON Based in Seattle since 1973, sculptor and activist Buster Simpson first created projects that were unauthorized street works. *Downspout—Plant Life Monitoring System* (1978) at Seattle's Pike Place Market was a vertical landscape of ferns planted in U-shaped downspouts that, in addition to being an ideal plant habitat, worked as a cost-effective filtering system to improve water quality before the runoff entered the sewer system. He also worked in sanctioned civic art programs and museum projects, becoming well known in Seattle's nascent percent-for-art program. For over twenty years, his intent has remained consistent: to educate the general public and stimulate it to political change through community action, and to create art that functions pragmatically. His public sculptures double as benches, handrails, windmills, weather vanes, shovels, nests, reforestation projects, recycling bins, and even public toilets. In 1987, working cooperatively with county, state, and city health departments to comply with health and safety codes, he introduced composting commodes—portable public toilets—as an art project on Seattle's First Avenue (frequented by street people), one that concurrently enriched the urban hardpan soil so street trees could be planted. In *River Rolaids*, or *Tums for Nature* (1983–continuing), a gesture designed to mitigate the damage done to waterways by acid rain, he placed large hand-carved disks of limestone, weighing up to fifty pounds, in polluted rivers across the country. Simpson's *Rolaids* effectively neutralize the rivers' acidity for a limited time. His public sculptures have become a national model for innovative public design strategies that encompass public

When the Tide Is Out the Table Is Set *1978, 1984*
Buster Simpson

Host Analog *1991–continuing*
Buster Simpson

education, environmental concerns, and practical solutions to urban problems.

When the Tide Is Out the Table Is Set *1978, 1984*

Concern for water quality led to the development of this project at Artpark in Lewiston, New York. In 1978 the story of the deadly pollution at nearby Love Canal was coming to national attention. Simpson, learning that sections of Artpark were situated on toxic landfill, made concrete casts of paper plates used by Artpark picnickers, and he placed them in the nearby Niagara River near sewage outfalls. Over time, the plates were stained by the toxic effluent. He then displayed the multicolored plates as evidence of "our digestive cycle" and a damaged river ecology. In 1984 Simpson cast a series of china plates and steeped them in sewage outfalls in the rivers of several major cities, including Cleveland, New York, Houston, and Seattle. After firing, the plates were beautifully patterned, but the more colorful they were, the more toxic their origin. The work's title reinterprets a Salish Indian saying about the abundance of food at low tide, ironically pointing to the tragic poisoning of that food source by our own sewage.

Host Analog *1991–continuing*

Commissioned by the Convention Center in Portland, Oregon, this artwork "requires the patience of a thousand years." It educates city dwellers about a natural phenomenon indigenous to Oregon's endangered forests. In nature, a dead tree that falls onto the forest floor is known as a host log. It becomes a rich nursery for new growth as it decomposes, producing heat, nutrients, and water for seedlings collected in its broken bark. *Host Analog* is a poetic illustration of this cycle of life, death, and rebirth. The sculpture is composed of a monumental fallen giant taken from a local forest, a tree already in an advanced state of decay which is arranged like a collapsed Greek column. Kept moist by an irrigation system that periodically sprays it with mist, it will take ten to twenty years to sprout new trees, and much longer for the entire cycle to be completed. The piece provocatively and cleverly transfigures common civic design elements—Greek architecture, fountains, and foliage—to carry out a more social and political agenda. Since the work is dependent on public decisions for its continuing existence, the public becomes a crucial element; without cognizant caretaking there will be no regeneration.

JAUNE QUICK-TO-SEE SMITH An activist and spokesperson for contemporary Native American artists, Jaune Quick-to-See Smith is an enrolled member of the Flathead Tribe, born on the Confederated Salish and Kutenai Reservation in western Montana. Now living in Corrales, New Mexico, she is internationally known for her paintings, which combine modernist abstraction with figurative passages emblematic of American Indian identity, daily life, social issues,

and political struggles. The mother of two children, she worked many jobs to raise her family before turning to art in her thirties. Since receiving her M.F.A. in the mid-seventies, she has been an active force in Pan-Indian organizing—curating shows, teaching, lecturing, and creating networking organizations among Native American artists. She founded two cooperatives: the Coup Marks on the Flathead Reserve and the Grey Canyon Artists in Albuquerque. In 1994 alone she curated three nationally touring contemporary American Indian art exhibitions: *Our Land Our Selves: Contemporary Native American Landscape, The Submuloc* ("Columbus" spelled backwards) *Show or the Columbus Wohs* ("show" spelled backwards), and *We the Human Beings.* She is the subject of three Public Broadcasting System films, as well as Finnish and German documentaries; has collaborated with numerous Native American poets by providing the artwork for published works; and was one of six featured artists for Bill Clinton's presidential commemorative inauguration poster. Her public art projects include an outdoor collaboration celebrating the Ohlone, the San Francisco–area indigenous people, done with James A. Luna for Yerba Buena Park (1991), and the design of the main terminal terrazzo floor of the new Denver, Colorado, airport. She is also assisting in the design of a Cultural Museum on the Flathead Reservation, Montana, and is a design-team member for the National Museum of the American Indian to be built in Washington, D.C.

Northwind's Fishing Wheel *1991–continuing*
Smith is one of four artists commissioned by the King County Arts Commission (the Washington county in which Seattle is located) to create a work of art celebrating an important cultural tradition of the Duwamish Indians, an indigenous aboriginal tribe. Theirs is a fishing culture based on the life cycle of the salmon, and their villages were known by long (up to seventy-two feet) stilted canoe racks and tall, ingenious fishing wheels that lined rivers to catch and store salmon. In the infamous Treaty of 1855, which divided local land among resident tribes, the Duwamish were not named and received no land. Although the Duwamish have lived in the region for thousands of years and predate the Tlingit, Haida, and Tsimshian, they are still fighting today to gain federal recognition and regain their land. Numbering about one thousand dispersed members, the Duwamish are close to obtaining a primary goal: a tribal center, or longhouse, on a five-acre tract just south of Seattle along the Duwamish River. The King County Arts Commission took an unusual stance when it acknowledged a federally unrecognized tribe by commissioning artworks for the center. Smith, who feels personally connected because her tribe and the Duwamish are both Salish peoples, was determined to work directly

Northwind's Fishing Wheel
1991–continuing
Jaune Quick-to-See Smith

with tribal members; she began consulting with them before submitting a proposal. Smith's plan, approved by the tribal council, calls for a sculptural fishing wheel to be built near their proposed longhouse. The wheel will be built entirely by tribal members, under the direction of tribal councilman Frank Fowler, a master carver, and Smith. The functional fishing wheel sculpture will offer a source of pride for the Duwamish and symbolize their ongoing battle for fishing rights, legal recognition, and land of their own. Smith's wheel design celebrates the creativity, ingenuity, and resourcefulness with which the Duwamish have survived since the Ice Age.

ALAN SONFIST Alan Sonfist's artwork is dedicated to restoring lost historical natural landscapes to urban centers. Sonfist enlists the participation of local residents, botanists, and ecologists to gain support from those who run urban infrastructures—usually zoning and public works departments. He argues in favor of a "public art as public dialogue, a dialogue in which both the creator and the viewer take part, a dialogue addressing the most critical issue of our time, the survival of our land." He grew up in a self-described "hostile" area of the South Bronx filled with crime and gang warfare. Avoiding public school, he spent his days studying at the Bronx Zoo, the Museum of Natural History, and the Metropolitan Museum of Art. He proposed his first environmental installation in 1965, and since then has worked continuously, receiving numerous grants and commissions to plant *Time Landscapes* throughout the United States, Europe, New Zealand, and Australia. Two recent projects are the ten-mile-long *Narrative Environmental Landscape* (1991) in France and *Circles of Time* (1987) in Italy, which includes wheat and olive trees that are harvested yearly by local farmers.

Time Landscape of New York City
1965–continuing
Alan Sonfist

Time Landscape of New York City *1965–continuing*
This precedent-setting, permanent installation is located on an eight-thousand-square-foot plot at the corner of LaGuardia Place and Houston Street in New York City's Greenwich Village. Thousands of people pass it daily, probably not realizing that it is the first site specific sculpture to be maintained permanently by the city's public parks system. Sonfist's concept went beyond beautification or reclamation. He took the cement-covered, garbage-strewn, abandoned site of a torn-down tenement building and created a time warp, a place to experience how Manhattan might have looked three hundred years ago, before European settlement. Lucy Lippard writes: "It is an image of wild pre-Colonial land in the midst of a colonized and exploited urban site." Sonfist restored the soil, reestablished original elevations, included rock samples, and planted three stages of plant succession to re-create a historically accurate native woodlands. Nonromantic, it is

a living artwork in which plants grow, decay, and reseed themselves. Begun in 1965, the work required more than ten years of research and dialogue with city planners and community boards to gain the approval Sonfist needed to install it. Local residents and schools helped to plant and maintain the site, and community response has remained enthusiastic. *Time Landscape* is a permanent part of neighborhood life and a benchmark in urban environmental art.

Time Landscape, South Bronx Hemlock Forest *1977–continuing*
While working on the Greenwich Village *Time Landscape,* Sonfist was able to realize a smaller installation in the neighborhood where he grew up. His longtime goal had been to restore its hemlock forest, a surviving fragment of which had meant so much to him as a child. After presentations to the city and community boards, he knew he would have to talk to local gang members if he wanted the forest to escape vandalism. A social worker showed him an abandoned building where the ruling gang met. Sonfist spoke with them, acknowledging that he was entering their territory, and invited them to take part in the planting. Gang members did participate and continue to protect the forest. According to Sonfist, it was the first time there was cooperation between the community board and the local gangs. As part of this installation, Sonfist added a photomural of trees on an adjacent tenement wall to show how the forest would look in twenty years. The BBC made a documentary of it, and it was used in Alain Resnais's movie *Mon Oncle d'Amérique.* Further proof of its importance to the area is a community-produced Christmas card using a photo of the *Hemlock Forest.*

MIERLE LADERMAN UKELES Since 1970 Mierle Laderman Ukeles has been the unsalaried artist-in-residence for New York City's Sanitation Department. From this self-created official position, Ukeles builds and orchestrates major public projects to explore the social and ecological issues of waste management. Her art involves the community in reconsidering its common disregard of waste and disrespect for those who work with it. She has constructed installations with refuse, involved sanitation workers all over the world in elaborate performances, and reconfigured public sites, vehicles, and other paraphernalia of waste management in the service of her message. Always evincing an interest in systems as well as the people who create and inhabit them, Ukeles's later work has grown in vision and scale, as has her sophistication in the field of recycling technology and the waste crisis. Patricia C. Phillips writes: "For Ukeles, public art provides a unique position from which to forge connections between the public sphere and the private, and to show that public life is more a matter of routine activities than dramatic events. In this way, Ukeles uses art as a critical, constructive resource." In related

works, Ukeles has recycled glass to pave a park path ("glassphalt"), and created a "barge ballet" for two river barges filled with recycled glass. Currently Ukeles is developing a proposal for *Fresh Kills Landfill,* the gigantic open-air refuse dump in the borough of Staten Island.

Touch Sanitation *1978–79*
Mierle Laderman Ukeles

Touch Sanitation *1978–79*

In the mid-seventies, Ukeles's examination of women's roles led her to consider the various systems by which society maintains itself. For her first project as New York City Sanitation Department resident artist, Ukeles listened to garbage collectors' stories of being treated as if they were the garbage. She then set about to acknowledge the importance of sanitation work and to heal the rift between the workers and the community in a performance that was both private and public. Over an eleven-month period, wearing the orange jumpsuit of a New York City garbage collector, she walked the five boroughs of New York in order to shake the hand of every city garbage collector. With each handshake she said, "thank you," slowly building a relationship of respect between herself and the workers. From this simple gesture a complex body of exhibitions, events, and analyses grew.

Flow City *1985–continuing*
Mierle Laderman Ukeles

Flow City *1985–continuing*

During planning for the New York City Sanitation Department's Marine Transfer Facility—an enormous shed on a pier over the Hudson River at Fifty-ninth Street, Ukeles began, in 1985, to design a public artwork called *Flow City.* In this facility, trucks dump household, office, and industrial waste twenty-four hours a day, seven days a week, onto barges that transfer it to the landfill site on Staten Island. Still in the planning stages, *Flow City* is a walk-through installation for observing the maintenance process, a series of sequential, participatory observation points for the public. The artwork is a plan, integrated into the physical site, that will enable the public to observe this normally hidden work environment. When completed, *Flow City* will have three components: the Passage Ramp, a long corridor made of recyclables; the Glass Bridge, a clear-glass platform from which to view the dumping operations; and the Media Flow Wall, a bank of video monitors that will provide views of activity taking place throughout the facility interspersed with information regarding waste disposal and other environmental issues. By bringing people closer to the process of garbage disposal in a large metropolitan area, Ukeles hopes to raise questions about waste removal and relocation, and about the nation's rivers as natural but fragile circulatory systems that cleanse the cities.

CARLOS VILLA Carlos Villa is a multidisciplinary artist who began his exhibition career in 1958 as a painter. Villa has a distinguished record as a cultural community organizer as well as visual artist. In 1973, for example, he helped establish art and

literature archives at the Filipino Creative Center in San Francisco. In 1976 he curated *Other Sources: An American Essay,* a large multicultural exhibition at the San Francisco Art Institute, as part of the U.S. bicentennial celebration. In the late eighties he organized four symposiums, an exhibition, and a publication, *Sources of a Distinct Majority,* to explore multicultural issues in education. Utilizing his position as a faculty member of the San Francisco Art Institute, in 1990 Villa initiated the Sanchez School Project to give sixty disadvantaged fifth-grade school children an awareness of the arts. The kids, ninety-nine percent of them from economically depressed areas with little or no access to the arts, visit the fine arts school once a semester to experiment in workshops taught by institute students on painting, printmaking, photography, video, performance, and sculpture. Villa's practice exemplifies the mixture of roles assumed by artists working in new forms of public art, as it moves easily between artistic, curatorial, organizational, and educational forms to address a compelling social agenda.

Ritual *1980*

Colonialism, Catholicism, African and Oceanic belief systems, American modernism and its mythology, and avant-garde art all play important roles in Villa's enactment of this "painting performance" work. Although his readings about African ritual were an important source for this event, an awareness of Villa's education as a painter is crucial to understanding its form. Presented at the Farm (see Bonnie Sherk), the performance drew an audience of two hundred from the local art and Filipino communities. In a trancelike hour-and-a-half "dance," Villa evoked African cosmogony, Chinese t'ai chi, and the action painting of Jackson Pollock, all underscored by drums, gongs, and a saxophone. Villa ritualistically created an "action painting" by applying multilayered imprints of his own body, spray paint, animal blood, millet, and feathers. Screened concurrently were two films: Hans Namuth's famous documentary film Pollock's trancelike painting, and *Les Maîtres Fous* (The Crazy Masters), a film made in the fifties by Jean Rouch that depicts colonialism's effect on the rituals of the Songhay people of British West Africa. In this last film, the black population enact, in a trance, the white colonists' gestures as a ritual to rid themselves of them. *Ritual* was the product of Villa's decade-long investigation of his cultural genesis, in which he employed his own body as the artist's "body of work."

Ritual *1980*
Carlos Villa

Manongs *1991*

This performance at Mills College in California told the story of Filipino immigration and transition to American life. Revealing the relationship among four Filipino men—Villa, Al Robles, Manong Freddy, and Manong Mike (the latter two in their eighties)—it was a

deeply moving exploration of gender, aging, and race. In it, Villa and Robles (Villa's cousin) sat at a Formica table, eating fish and rice with their hands as they talked. Villa, in an elegant white suit, sometimes spoke in the accented voice of a *manong*. "*Manong*," which literally means "brother" in Tagalog, is used to describe the mostly young, uneducated, and unmarried Filipino men who came to this country primarily in the twenties and early thirties. The great majority of the *manongs* never married—there were many more Filipino male immigrants than female—and those who survived from this generation usually ended up as old and poverty-stricken bachelors. *Manongs,* now in their eighties and nineties, are part of a broader history of Filipino immigration: young men, recruited as a cheap and effective labor force, were admitted into the country on a quota basis of forty men to one woman, thus ensuring for this generation a life without families. Two of these older *manongs* entered Villa and Robles's conversation, playing a guitar and singing big-band songs from the forties. Particularly poignant because of the extreme age of the musicians, this moment in the lives of these four men revealed the reality of a disappearing culture and the dilemmas of assimilation.

FRED WILSON New York installation artist Fred Wilson critiques the museum environment in his work. As an artist of African American and Carib descent, Wilson creates installations intended to reveal how museums represent or fail to represent racial and ethnic minorities. This work has become a leading force in a relatively new movement to reexamine the cultural roles of museums, as museums invite Wilson to use their permanent collections to create revisionist readings. Wilson's awareness of race issues arose when, as a teenager, he saw the work of Romare Bearden and Richard Hunt exhibited at the Museum of Modern Art and realized just what the "absence, emptiness" was that had haunted his previous visits. After graduating from art school, he constructed large, usable public sculptures, while supporting himself by working in museums—what he considers "a linchpin experience." In the mid-eighties, he explored the importance of context in a pivotal South Bronx gallery installation in which he placed contemporary artworks in three different museum-type settings—ethnographic, Salon style, and "modernist white cube." Wilson's museum projects rely on his establishing a basis of trust with museum staff, including security guards. He sees the guards as symbols for the cultural divisions within institutions. A future goal is to create his own museum.

Mining the Museum *1992–93*
Wilson's installation involved a unique collaboration between two Baltimore museums, the Contemporary and the Maryland Historical Society (MHS). Founded in 1989, the Contemporary connects "the

art of our time [with] the world we live in" through community pro-
grams and exhibitions in temporary locations. In contrast, MHS is a
150-year-old institution with a large staff and an extensive art and ar-
chival collection. When the Contemporary invited Wilson to choose
any of the city's many permanent museum collections to work with,
he selected MHS. During a one-year residency, Wilson "mined" the
MHS collection for objects to install in a reconstruction of history
relevant to Maryland's African American residents. The Contem-
porary's curator Lisa Corrin writes: "The exhibition was designed to
address problems of concern to many museums, to confront the diffi-
culty of putting theories of diversity and historical revisionism into
practice, and to offer a model for change responsive to our particular
community." A video of Wilson talking, bare-chested, alerted visitors
to changes, while an elevator poster asked: "For whom was it created?
Who is represented? Who is doing the telling?" Using standard exhi-
bition techniques—artifacts, labels, selective lighting, slide projec-
tions, and sound effects—Wilson created "startling juxtapositions
representing vastly different historical facts, revealing stereotypes
and contrasting power and powerless." Three white marble busts
of Napoleon, Henry Clay, and Stonewall Jackson were juxtaposed
with three empty pedestals labeled "Harriet Tubman," "Benjamin
Banneker," and "Frederick Douglass"; in between was a trophy la-
beled "Truth." A Ku Klux Klan hood lay in an antique baby carriage.
In *Metalwork,* slave shackles were surrounded by period chairs.
The exhibition included public outreach programs, open studio visits
while Wilson worked, a continuing studies course, and lectures.

Mining the Museum *1992–93*
Fred Wilson

SUZANNE LACY, *Editor* Suzanne Lacy is an internationally known concep-
tual/performance artist whose complex performances address significant social
issues and engage local populations in a place-specific manner. Lacy's background
is in psychology and community organizing. Since the early seventies, her work
has explored themes of violence, oppression, racism, and homelessness. A found-
ing member of the Feminist Studio Workshop at the Woman's Building in Los
Angeles, Lacy pioneered the exploration of art as a force in the community and
within the media. Her best-known work to date is on aging; *The Crystal Quilt*
(1987), a performance with 430 older women, was broadcast live by public televi-
sion. In 1993 she created *Full Circle*, a site-specific work for Sculpture Chicago's
Culture in Action, curated by Mary Jane Jacob, featuring one hundred boulders
with women's names, placed overnight on the sidewalks of the downtown Loop.
An ongoing multi-site work on domestic violence with the Public Art Fund, *Auto:
On the Edge of Time,* culminated in 1994.

Lacy is a prolific analytical writer on feminist performance-art theory.
Her writing explores areas in which art and "real life" interface with and change
each other. For twenty years her art and writing have advocated activism, audience
engagement, and artists' role in shaping the public agenda. She has published
articles on public art theory in *Performing Arts Journal, Ms., Art Journal, High
Performance, Public Art Review,* and in several books. She was a Guggenheim
Fellow in 1993.

Lacy currently teaches performance and new genre art at the California
College of Arts and Crafts, in Oakland, where she is dean of fine arts.

JUDITH F. BACA A native Angelino, visual artist and activist Judith F.
Baca is recognized for her large-scale public murals, which involve extensive
community participation and address multicultural audiences. The half-mile-long
mural *The Great Wall of Los Angeles* (begun 1976) depicts the ethnic history of
California. *Danzas Indígenas* (1994), a permanent work collaboratively produced
in the Baldwin Park metro station, describes the California missions and their
effect on indigenous villages. Baca is currently working on *The World Wall: A
Vision of the Future without Fear,* which is touring cities around the world, includ-
ing Joensuu, Finland, Moscow, and Mexico City. Seven ten-by-thirty-foot portable
mural panels deal with themes of global interdependence and spiritual growth;
seven additional panels will be added by international artists.

In 1976 Baca founded the first mural program in Los Angeles, which produced over 250 murals and hired over two thousand participants in its ten years of operation. Also in 1976 she cofounded the Social and Public Art Resource Center (SPARC) in Venice, where she serves as artistic director. At the request of the Los Angeles mayor, in 1988 Baca developed the mural program Great Walls Unlimited: Neighborhood Pride Program.

Baca's work has been exhibited nationally and internationally, published in numerous periodicals and books, and documented in several films. She has received awards for her work from various community groups, the AFL/CIO, the California State Assembly, the U.S. Senate, the U.S. Army Corps of Engineers, two Los Angeles mayors, and the Los Angeles city council. Baca serves on the board of directors of the American Council for the Arts and the Tourism Industry Development Council. She is a professor of studio art at the University of California, Irvine.

SUZI GABLIK Formerly a practicing artist, Suzi Gablik is an art theorist and teacher. Her books about contemporary art and its relationship to the world include *Has Modernism Failed?, Magritte, Progress in Art, The Reenchantment of Art,* and *Conversations before the End of Time.*

Born in New York, Gablik currently resides in Virginia. She received a B.A. from Hunter College and studied with Robert Motherwell. She has been the London correspondent for *Art in America* and has written articles published in *Artscribe* (London), *Art and Australia, Art New Zealand, New York Times Book Review, New Art Examiner, Utne Reader, Psychological Perspectives, Michigan Quarterly Review,* and *The Quest.* Gablik lectures extensively on the philosophy of art, cultural criticism, and cultural politics at universities throughout the United States and in London, and at art museums throughout the United States. Lecture tours sponsored by the U.S. International Communications Agency have taken her to Hungary, Pakistan, Bangladesh, Nepal, India, Jordan, Sri Lanka, and Egypt. In addition to writing and lecturing about art, Gablik has taught at the University of California, Santa Barbara; University of Colorado, Boulder; Virginia Commonwealth University, Richmond; Virginia Polytechnic Institute, Blacksburg; and Sydney College of Arts.

GUILLERMO GÓMEZ-PEÑA Born and raised in Mexico City, interdisciplinary artist/writer Guillermo Gómez-Peña came to the United States in 1978. Since then he has been exploring cross-cultural issues and North-South relations through a variety of media that includes performance, bilingual poetry, journalism, video, radio, and installation art. Since the early eighties, Gómez-Peña has collaborated in a series of interactive performances and performance/installations dealing with cross-cultural issues, border culture, and immigration. These projects have been chronicled in the book *Warrior for Gringostroika,* published by Graywolf Press.

Gómez-Peña was a founding member of the Border Art Workshop/Taller de Arte Fronterizo and the editor of the experimental arts magazine *The Broken Line/La Linea Quebrada*. He has been a contributor to the national radio magazine *Crossroads* and the radio program *Latino USA*, and a contributing editor to *High Performance* magazine as well as *The Drama Review*. He is a 1991 recipient of a MacArthur Fellowship.

Gómez-Peña is currently collaborating with artists Coco Fusco, James A. Luna, Daniel Salazar, and Robert Sifuentes in various performance and video projects. A collection of his audio works will appear on CD, and he is developing a CD-ROM about Chicano history.

MARY JANE JACOB Independent curator Mary Jane Jacob holds an M.A. in art history with museum orientation from the University of Michigan. She has received fellowships from the National Endowment for the Arts and the National Endowment for the Humanities.

During the eighties, as chief curator of the Museum of Contemporary Art, Chicago, and subsequently the Museum of Contemporary Art, Los Angeles, she organized the first U.S. retrospectives of Magdalena Abakanowicz, Christian Boltanski, Jannis Kounellis, Rebecca Horn, and Gordon Matta-Clark, and such key surveys as *A Quiet Revolution: British Sculpture since 1975* and *A Forest of Signs: Art in the Crisis of Representation,* among others.

One of her first independent projects was *Places with a Past: New Site-Specific Art in Charleston,* an exhibition of installation works in historic locations for the 1991 Spoleto Festival USA. In Chicago, where she is based, she commissioned Ronald Jones to create a block-long park in the Loop and Louise Bourgeois to create a public memorial to Jane Addams as part of a new lakefront park. In 1993 for Sculpture Chicago she staged *Culture in Action: New Public Art in Chicago,* a series of community-based projects designed in response to social concerns. The publication on the project is entitled *Culture in Action: A Public Art Program of Sculpture Chicago* (Bay Press, 1995).

ALLAN KAPROW Artist and theorist Allan Kaprow explores the boundary between art and "real life" in work that has influenced a generation of performance and conceptual artists. He received a B.A. from New York University in 1949 and an M.A. in art history from Columbia University in 1951. In 1952 he cofounded the Hansa Gallery in New York, where he exhibited regularly. By 1957 his work had become exclusively environmental. In 1957–58 he developed the Happening as an extension of the environmental concept. His work has been sponsored by major institutions on both sides of the Atlantic, including the Museum of Modern Art, the Museum of Contemporary Art in Chicago, the Walker Art Center in Minneapolis, the Edinburgh Festival, the Academy of Art in Berlin, Documenta in Kassel, the Museum of Twentieth-Century Art in Vienna, the Venice Biennale, and the Centre National d'Art et de Culture Georges Pompidou in Paris.

Kaprow has been consistently active as an educator. He has taught at Rutgers University, Pratt Institute, and the State University of New York, Stony Brook. He has also served as associate dean of the art school of the California Institute of the Arts and, until 1993, when he retired, taught at the University of California, San Diego.

Kaprow's writings have been translated into at least ten foreign languages. His book *Assemblage, Environments, and Happenings* is a standard text in the field. He received the Catherine White Foundation award in 1951, the William and Noma Copley Foundation award in 1963, a Guggenheim Fellowship in 1967, the Skowhegan Medal and a grant from the National Endowment for the Arts in 1974, and a residency award from Berlin's DAAD (an international arts and science program of the West German government) in 1976. In 1979 he received a second NEA grant and a second Guggenheim Fellowship.

JEFF KELLEY A practicing art critic since 1976, Jeff Kelley has written for *Artforum, Art in America, Artweek, Vanguard,* the *Headlands Journal,* and the *Los Angeles Times.* He has also edited and introduced *Essays on the Blurring of Art and Life,* a collection of twenty-three essays by Allan Kaprow, and is currently working on *Childsplay,* a book about Kaprow's Environments, Happenings, and other works.

From 1970 to 1972 Kelley attended the California Institute of the Arts as a painter. He received an M.F.A. from the University of California, San Diego, in 1985. From 1986 to 1990 Kelley was the first director of the Center for Research in Contemporary Art at the University of Texas, Arlington. He currently teaches art theory and criticism at the University of California, Berkeley, the California College of Arts and Crafts, and Mills College.

LUCY R. LIPPARD Writer and activist Lucy R. Lippard is the author of more than a dozen books on contemporary art. Lippard has done performances, comics, and street theater. She cofounded Printed Matter, the Heresies Collective, PADD (Political Art Documentation/Distribution) and its journal *Upfront,* and Artists Call against U.S. Intervention in Central America; she has been active in the Alliance for Cultural Democracy. Lippard has been on the boards of the Center for Constitutional Rights, Printed Matter, Franklin Furnace, Society for the Preservation of Folk Art, and other groups.

As a freelance writer for thirty-five years, Lippard has written for art magazines, newspapers, general periodicals, and exhibition catalogs. Among her sixteen books are *Six Years: The Dematerialization of the Art Object; From the Center: Feminist Essays on Women's Art; Overlay: Contemporary Art and the Art of Prehistory; Eva Hesse; Get the Message? A Decade of Art for Social Change; Mixed Blessings: New Art in a Multicultural America;* and *Partial Recall: Photographs of Native North Americans.*

ESTELLA CONWILL MÁJOZO Estella Conwill Májozo is an associate professor of creative writing and literature at Hunter College (City University of New York). She holds a Ph.D. from the University of Iowa and has published several works, including *Jiva Telling Rites, Motion: An Album of Poetry & Song, Darkness Knows,* and her autobiography. She has collaborated with her brother, Harlem-based sculptor Houston Conwill, and architect Joseph De Pace to create experimental installations on African American heritage.

PATRICIA C. PHILLIPS Independent critic Patricia C. Phillips writes on art, public art, architecture, design, and landscape. Her work has been published in international art and architecture publications including *Artforum, Art in America, Flash Art, Public Art Review,* and *Sculpture.* Her essays have been included in books published by MIT Press, Princeton Architectural Press, and Rizzoli International Publications. In addition to her writing, she has held academic and administrative positions at the Parsons School of Design, the New School for Social Research, and the State University of New York, the College at New Paltz, where she is an associate professor in the art department. Her current projects include a book on temporality and time in modern art. She also curated exhibitions for the Queens Museum of Art (*City Speculations,* 1995) and the Katonah Museum of Art (*A Sense of Space,* 1995).

ARLENE RAVEN Art historian Arlene Raven writes criticism for the *Village Voice* and a variety of art magazines and academic journals. She is the East Coast editor of *High Performance* magazine and a member of the editorial board of *Genders.* Raven's selected essays were published as *Crossing Over: Feminism and Art of Social Concern.* She was an editor and contributor to *Feminist Art Criticism: An Anthology* and *New Feminist Criticism* as well as editor and contributor to *Art in the Public Interest.* She is the author of *Exposures: Women and Their Art* and the monograph *Nancy Grossman.* Raven is a founder of the Women's Caucus for Art, the Los Angeles Woman's Building and its Feminist Studio Workshop, and *Chrysalis* magazine. She has lectured and taught at the Corcoran School of Art, the California Institute of the Arts, the Maryland Institute, the Otis Art Institute, the Parsons School of Design, and the New School for Social Research. Raven has curated ten exhibitions, including major surveys for the Baltimore Museum of Art, the Long Beach Museum of Art, Artemisia Gallery, and the Hillwood Art Museum. She studied at Hood College, George Washington University, and Johns Hopkins University, and holds an M.F.A. in painting and M.A. and Ph.D. degrees in art history. She has received two National Endowment for the Arts Art Critic's Fellowships, and was honored by Hood College in 1979 with a Doctor of Humanities degree.

SUSAN LEIBOVITZ STEINMAN California artist Susan Leibovitz Steinman salvages materials directly from community waste streams to construct

public installations that reveal connections among personal, local, and global ecologies. Her work includes conceptual sculpture gardens that meld art, ecology, and community action. In *Urban Apple Orchard* (1994), sponsored by the San Francisco Art Commission, she worked with neighbors, teenagers, homeless people, and urban garden action groups to transform a blighted downtown lot under a freeway into a demonstration antique-varietal orchard. For San Francisco's waste transfer and recycling facility, Steinman designed a permanent sculpture garden (*River of Hopes and Dreams,* 1992) as a model of reclamation, recycling, resource conservation, and community involvement; one hundred public school students participated. Other public installations include *Seeking Shelter* for the Judah Magnes Museum, Berkeley; *Inside the Wave* for San Jose State University; *The Tree Museum* and *Earth Ark* for the Berkeley Art Commission's public site program; and *Power Tower* at the Oakland Museum. Steinman is a writer, lecturer, and curator on art and ecology as well as feminism and public art theory. She co-curated *Living in Balance,* a traveling environmental art exhibition originating at San Francisco International Airport, and has written a San Francisco public school manual for integrating the teaching of art and recycling. She teaches art at California State University at Hayward and develops special environmental art projects for inner city elementary schools.

Discussions in Contemporary Culture is an award-winning series of books copublished by Dia Center for the Arts, New York City, and Bay Press, Seattle. These volumes offer rich and interactive discourses on a broad range of cultural issues in formats that encourage scrutiny of diverse critical approaches and positions.

DISCUSSIONS IN CONTEMPORARY CULTURE
Edited by Hal Foster

VISION AND VISUALITY
Edited by Hal Foster

THE WORK OF ANDY WARHOL
Edited by Gary Garrels

REMAKING HISTORY
Edited by Barbara Kruger and Philomena Mariani

DEMOCRACY
A PROJECT BY GROUP MATERIAL
Edited by Brian Wallis

IF YOU LIVED HERE: THE CITY IN ART, THEORY, AND SOCIAL ACTIVISM
A PROJECT BY MARTHA ROSLER
Edited by Brian Wallis

CRITICAL FICTIONS: THE POLITICS OF IMAGINATIVE WRITING
Edited by Philomena Mariani

BLACK POPULAR CULTURE
A PROJECT BY MICHELE WALLACE
Edited by Gina Dent

CULTURE ON THE BRINK: IDEOLOGIES OF TECHNOLOGY
Edited by Gretchen Bender and Timothy Druckrey

FOR INFORMATION:
BAY PRESS
115 West Denny Way
Seattle, WA 98119
tel 206.284.5913
fax 206.284.1218